Kevin Kubota's Lighting Notebook

101 Lighting Styles and Setups for Digital Photographers

Praise For
Kevin Kubota's Lighting Notebook

"I've been writing about photography on the Internet since 1998. I've seen and reviewed a plethora of books on the subject of photography.

Kevin Kubota's is one of the best. He has the rare talent of combining useful knowledge, beautiful imagery, inspiration, and digestible education—all in an entertaining read! I highly recommended this book to photographers of all levels."

~Scott Bourne
Publisher Photofocus

"Kevin Kubota's Lighting Notebook is the kind of resource you simply need to have. Not only does it take the complexities of situational lighting and make it accessible for the rest of us, it's also comprehensively rich, insightfully organized and will empower you to command light like you never have before. It's genius in a bottle. Highly recommended!"

~Dane Sanders
Photographer, Author of Fast Track Photographer, The Fast Track Photographer Business Plan

"Most photographers are like great cooks. They can create a masterpiece in the kitchen as long as they've got a good recipe to follow. In the Lighting Notebook, Kevin Kubota takes you through the process of not just providing you with outstanding recipes, but he'll turn you in a great Chef! This is a book about ideas and helping you build diversity in your skill set. Anybody can take a picture, but the Lighting Notebook will help you stand out and create images to help you expand your client base. All the marketing in the world can't help you if you can't deliver a consistently outstanding product to every client! As only Kevin, one of the finest teachers and writers in professional photography, can do, he takes you through easy to understand steps to creating the ultimate image every time."

~Skip Cohen
President, Marketing Essentials International

"Kevin Kubota's Lighting Notebook: 101 Lighting Styles and Setups for Digital Photographers is a must-read for anyone wanting to beef up their technical lighting skills! I just loved the simple no nonsense approach. Kevin really took the mystery, and fear, out of photography lighting."

~Bambi Cantrell —"Empress of Imaging"
Cantrell Portrait Design, Inc.

"Kevin Kubota has pulled off a terrific trifecta in Kevin Kubota's Lighting Notebook: it's beautiful to look at, it's genuinely fun to read, and it also just happens to be a very practical, hands-on guide o learning some wonderful detail about lighting. I actually laughed out loud a few times while stepping through this - and I can honestly say that's the first time I've ever done that while reading any sort of useful guide about lighting. Kevin's writing flows so well, you get the feeling you're in an ongoing conversation with him page after page. My favorite part, though, is how Kevin's enthusiasm for his work and for delivering top-tier education really shines through in each chapter of this excellent book."

~Tamara Lackey
Author: Envisioning Family: A Photographer's Guide to Making Meaningful Portraits of the Modern Family,
Tamara Lackey's Capturing Life Through (Better) Photography,
The Art of Children's Portrait Photography

"Take a fun and exciting journey with Kevin Kubota through the history, theory and real world techniques used to create today's top lighting styles. *Kevin Kubota's Lighting Notebook: 101 Lighting Styles and Setups for Digital Photographers* takes you behind the scenes with one of the world's top photographers and teaches you the must have techniques you need to light like a pro. Photographers of all levels and budgets have a lot to gain from this complete, easy to understand, and inspiring step-by-step guide to one of photography's most important topics."

~Michael Corsentino
Photographer, Author, Workshop Leader

"I've known Kevin Kubota for many years. He has always had the deserved reputation of being a true professional—well regarded, thorough and very, very talented. After reading the first draft of his new book, the *Lighting Notebook*, I am sure this will be yet another home run."

~Bill Hurter
Author, Editor of Rangefinder and After Capture Magazines
Wedding & Portrait Photographers International

Kevin Kubota's Lighting Notebook

101 Lighting Styles and Setups
for Digital Photographers

Kevin Kubota

John Wiley & Sons, Inc.

Kevin Kubota's Lighting Notebook: 101 Lighting Styles and Setups for Digital Photographers

Published by
John Wiley & Sons, Inc.
10475 Crosspoint Boulevard
Indianapolis, IN 46256
www.wiley.com

Copyright © 2011 by John Wiley & Sons, Inc., Indianapolis, Indiana

Published simultaneously in Canada

ISBN: 978-1-1180-3510-8

Manufactured in the United States of America

10 9 8 7 6 5 4 3 2

For general information on our other products and services or to obtain technical support, please contact our Customer Care Department within the U.S. at (877) 762-2974, outside the U.S. at (317) 572-3993 or fax (317) 572-4002.

Library of Congress Control Number: 2011930286

About the Author

American Photo Magazine named Kevin Kubota one of the "Top 10 Wedding Photographers in the world." Kevin's wedding and portrait images speak to the heart—filled with emotion, joy, intimacy, and impact. His photos have been featured on the covers and within the pages of many popular magazines and photography books. Kevin has been sponsored by Nikon and Adobe, and his work with the Nikon digital camera earned him a spot as a Nikon "Legend Behind the Lens." Kevin is also a PPA Photographic Craftsman.

Kubota is an internationally recognized speaker, having presented for every major photographic convention in the United States. He created the popular *Digital Photography Bootcamp®* workshop, which has been running successfully since 2002. He authored the book under the same name, now in its second edition, published by Amherst Media. *Kubota Image Tools* products have won multiple *Hot One* awards as well as the *Readers Choice Award*. Kevin was personally awarded the *2009 Monte Zucker Memorial Humanitarian Award* for social service through photography.

Kevin lives with his Queen Bee, Clare, and two young boys in Bend, Oregon.

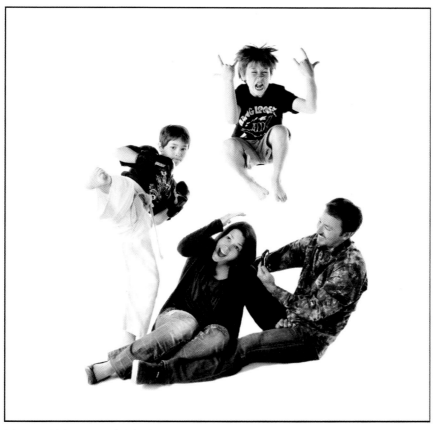

Life in the Kubota household is full of light! Photo by Benjamin Edwards.

Credits

Senior Acquisitions Editor
Stephanie McComb

Production Editor, Copy Editing, Layout, Proofreading, and Indexing
Abshier House

Design
Kubota Image Tools

Editorial Director
Robyn Siesky

Business Manager
Amy Knies

Senior Marketing Manager
Sandy Smith

Vice President and Executive Group Publisher
Richard Swadley

Vice President and Executive Publisher
Barry Pruett

Acknowledgments

"You can't create in a vacuum, unless you want to suck." I created this e-mail tagline years ago in one of my attempts at being witty, but it actually resonated with me as one of the real truths of my existence. I'm completely grateful to the many people who have inspired, supported, and put up with me. I could never do it alone, and even if I did, I probably wouldn't be writing this because I wouldn't be very good at what I did, and nobody would care to read about it. I truly believe that creativity is a collaborative effort—whether we choose to admit it publicly or not. Ideas come from everywhere and are built on the conscious and subconscious contributions of millions of daily bits of outside influence. Very, very few are completely unique and born of the fires of a divine creative spark—at least not for me. I depend on surrounding myself with creative and supportive people, and it's satisfying, fun, and infinitely more productive than trying to do it all myself.

The most important influence in my life is my wife, Clare. This will come as no surprise to anyone who knows me or her. She is a creative, intelligent, strong, opinionated, conscientious, caring, fair, gentle, and fearless leader of a woman. Clare gave me my two amazing boys, Kai and Nikko, for whom I strive to set a good example.

My father instilled in me my love of photography—with his marvelous and intimate black-and-white photographs of our family growing up. He loved to teach and share his creative vision, and I soaked it all in as a kid—fascinated by his seemingly limitless knowledge and stream of ideas. He would patiently explain and immerse us in his multitude of artistic passions. My mother was a music teacher and a creative bundle of energy that flows to this day. Her patience and compassion goes beyond extraordinary and borders on super-human. She found a way to believe in, and support, every wild idea I had—from being a pilot, to a fashion designer, to a shoe salesman, to a rock star, to a multilevel marketing mogul, to a photographer. She never gave up on me or discouraged an idea, which gave me the courage to believe I could do anything I set my mind to.

My younger sister, Kecia, has been the backbone—well, let's say a major artery, of our business for many years. She is incredibly intelligent, sensitive, creative, and dedicated. She may have bigger fish to fry someday, but I'll always be thankful for her creative contributions and belief in me.

Many photographers shaped who I am, illuminating me with their talent and knowledge. The first one to take me under his wing and believe in me, was George Carranza[1], a wedding, portrait, and fashion photographer in Southern California. George shot my wedding, and we quickly became friends. He let me tag along on jobs and taught me everything he could—inspiring me to start my own wedding business. Even though I was forming a competing business in the same town, he never stopped sharing and being a great friend. We continued to learn and grow together for many years until I moved out of the area. George taught me the value of openness and mentoring.

A great deal of the technical lighting skills I acquired came from working for a commercial photographer, Chuck Shahood, in Southern California. For years I assisted him while simultaneously working to grow my own business. I constantly marveled at his depth of knowledge, experience, and attention to detail. It fact, it made me feel quite inadequate, until the day I left to attend to my own business full-time and realized how much I had learned.

Today, there are photographers who inspire me daily or who have planted a seed at some point—growing inside me to a juicy creative fruit, or an alien being, depending on how you look at it. I wish I could acknowledge them all here, but I'm certain I'd miss someone very important and thoroughly embarrass myself. I do, however, need to spotlight

[1] www.carranzafoto.com

Benjamin Edwards[2], one of my dearest friends and a collaborator on this *Lighting Notebook* project. Ben is an amazingly creative photographer, in a way that is so humble and soft-spoken that you never realize you're in the presence of such inspiring talent. He encourages me with his grace, vision, and generosity almost daily, and I'm fortunate that we were able to work together in this creative endeavor. I love you, man!

I had some really amazing interns who signed on to help me with this project, too: Marina Koslow, Derek Oldham, Cindy Girroir, and Alycia Miller-White. They all kicked butt by volunteering time, talent, and creative ideas. They were there at every shoot to learn and help make things happen smoothly. It would have never happened without them; I'm quite sure of that. Alycia became my lead on the project and quickly earned the title of *Dynamic Details Diva*. She is a talented photographer and a go-getter like it's nobody's business. What would I have done without her!? We also created an educational DVD from all of our photo sessions, and my in-house video production expert, Craig, was literally thrown in to the project without a lifeboat. His natural editing abilities and creativity captured the essence of what we were trying to share in a fun and approachable way, contributing greatly to its success.

My gratitude would not be complete without thanking Stephanie and the kind folks at Wiley Publishing for believing in me and this project. Of course, the wonderful people on my team here at Kubota PhotoDesign and Kubota Image Tools deserve special kudos for having patience with me, my wild ideas, and the enormous amount of time it took to complete this project.

[2] www.benjaminimages.com

This book is dedicated to my mother and father. Thank you, Mom, for your blind faith and support throughout my life, and thank you, Dad, for your love—and for instilling in me the insatiable thirst for knowledge. I love you both!

Table of Contents

The Notebook 76

Foreword

Light can be many things. It can evoke emotion; it can be warm and inviting; it can be hard and cutting. However, in the photographic world, what it has to do and what it can do are two very different things. What it has to do is provide sufficient illumination to adequately light the film or digital sensor to create an image; it has to illuminate the subject in such a way as to build a photograph with highlights and shadows with depth and dimension, and it has to provide the look of three dimensions on a two-dimensional media or plane. What it can do when applied correctly in a photograph is create drama, make the viewer feel cold, give the impression of a specific era, or add excitement to an otherwise average image. What is of major significance is the control we have over light. Artificial or natural, we are individually responsible for the quality AND quantity of light. Understanding this aspect of our craft will serve us all well in creating images that have lasting power, tell the appropriate story for the situation, and offer up emotion and impact for the viewers of our work.

Much like in my own seminars and workshops, I've noticed over the years that Kubota will often quote Leonardo da Vinci on the topic of light. One of my favorite da Vinci quotes, is "He who avoids the shadows may be said to avoid the glory in art." Kevin Kubota has done a masterful job in understanding that light and shadow go hand in hand and understands the controls of each.

Kevin has established himself for more two decades as one of the best at understanding and creating light qualities that enhance his work. In fact, the work in this book is of such wide variety that some will question if the same person did the pictures. This has to be one of his strongest attributes and the primary reason for studying under this great master. His skills have taken him all over the globe teaching technique and theory to help photographers simply be better. He has changed the way many photographers see and think. Following the styles, examples, and teachings of Kevin Kubota will enhance any photographer's career. Not following his styles, techniques, and teachings just might make your clients run screaming into the night.

~Tony L. Corbell
Professional Photographer,
Internationally recognized Lighting Specialist,
and Nik Software Senior Manager

Introduction

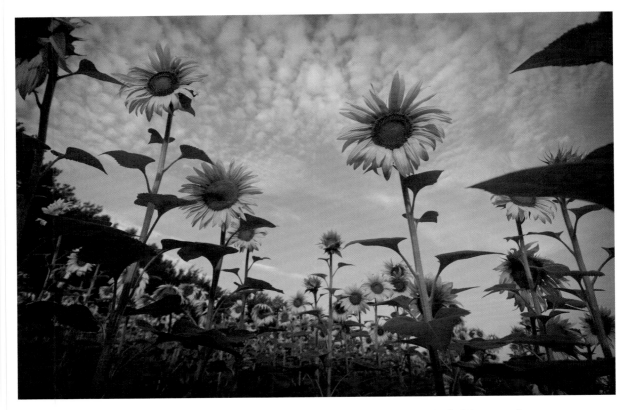

It's well-known that some of the very first words ever uttered were, "Let there be light." If these words were so fundamentally important that they warranted pre-empting "Somebody create a wheel." and "Slice the bread, don't break it," then we have to assume it was pretty significant to have light—beautiful light.

Entire books have been dedicated to the science of photographic lighting. It's fascinating stuff—if you're a geek. Yes, I've read them. Yes, I'm a geek. Most photographers that I've met, however, really just want to know the good stuff. You know, like when your friend starts to tell you a story, "OMG! You'll never guess what happened to Daisy Mae… OK, get this, so it all started a few years ago when I was in college and…" Just get to the point already! What happened to Daisy Mae? That's me, anyway; I just want the important details. Maybe it's a guy thing. I believe that most of you will appreciate it if I just get to the point and tell you what you really need to know to be a successful lighting guru on a daily basis. The science behind lighting really is fascinating, so if you are feeling informationally deprived, I can recommend a few other books that go into much more detail.[1]

This is *The Lighting Notebook*, however, and it's a field guide, not a lengthy technical manual. It's like being there with me on the shoot; seeing what I was seeing, knowing what I was thinking, why I chose the equipment I did, and witnessing how I overcame the unavoidable obstacles that inevitably present themselves. It is 20 years of photography and lighting experience in practical use. I have been successful as a commercial, portrait, and wedding photographer

[1]See appendix on resources.

and have been able to use and apply the lighting skills developed for each genre to the others. This book covers a broad range of styles and techniques for portrait photography—giving you a jumping-off point for your own jobs and creative projects.

This book will help you see the light, use the light, and create light better as a photographer. My hope is that it will function as an invaluable reference guide that you can take with you in to the field, on a shoot, and into bed for a little "light" reading. It should become tattered around the edges from frequent page flipping and use. In fact, you should probably order another backup copy right now so it will be there for you when you need it most—or better yet, check out the companion video and iApp[2] to round out your lighting resource kit. You may want to check out TheLightingNotebook.com for our latest adventures in lighting and continued educational resources.

The Lighting Notebook is uniquely, and thoughtfully, indexed to allow you to quickly find a solution to whatever lighting dilemma is flummoxing you at the moment. You can search by lighting type, subject type, equipment at your disposal, budget restraints, or time required to prepare. (You might be able to whip up a quick dinner using it, too, but I haven't verified that yet.) The focus of the book is on portrait lighting, but you'll find the lighting techniques are broadly universal, applicable to most anything you'll need to light. After you begin to understand lighting techniques, and to *feel* light, you'll feel the confidence to tackle just about any lighting challenge that presents itself.

My goal is to make you a wiz with lighting, to give you a wide variety of tips and tools. When you are at a loss for ideas, flip through the book and drop a finger anywhere; this might be the place to start. I'll give you just the right amount of technical information, so you can make educated decisions and impress your friends at parties. I also hope to inspire you with the images, which are not merely textbook style examples of a particular lighting setup, but thought-out, and professional images that are typical of real-world projects or assignments.[3]

I have to admit that I didn't know everything I included in the book before I wrote the book (no surprise there). I learned a tremendous amount via experimentation, trial and error, and assigning myself projects and challenges to be able to include in the book. *Herein lies the value of personal projects*—whether for a book, or your own personal growth. You just can't help but learn something new when you plan the time to create and challenge yourself beyond your current abilities. The key here is *planning* the time—put it on your calendar. Personal projects are every bit as important to your business growth (and motivation) as paying jobs. It took me many years to realize and acknowledge this, and now I find it vital to my happiness and business growth. Besides, learning is fun.

I've always been inspired by the notebooks of *Leonardo daVinci,* often indecipherable scribbling of a mad scientist, but fascinating insight to his mind at work and the underpinnings of ideas that very often came to light as world-changing inventions. I highly suggest you start your own lighting notebook; scribble down ideas that come to your mind, plan a new photo shoot, make a lighting diagram for a setup you really like. Although I can't claim to be a Leonardo, I want my notebook to provide similar inspiration, albeit with a bit more attention paid to the education of the end reader, and I promise not to write backwards like Leonardo, so you won't have to read it in a mirror.

[2] Available at www.TheLightingNotebook.com

[3] OK, there are some "textbook" images in the beginning chapters, but not so much in the actual Notebook.

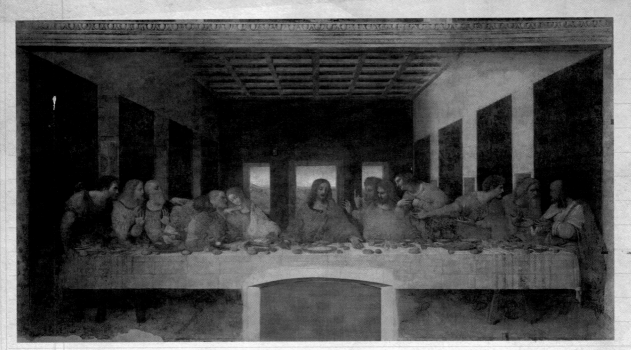

Chapter 1
A Brief History of the World (of Lighting)

I was having lunch with Leonardo daVinci one day; this was quite some time ago, and he was sharing his sentiment on the quality of the paintings that he'd seen from historical artists. "They are quite flat, you see." He explained to me as he wiped some olive oil from his beard, "People are not flat. They are vibrant in form and shape, alive with light and shadow—that which constantly evolves to evoke a visceral impression of the prevailing mood or emotion."

I had no idea what he was talking about, but I played along, "Um, yah, I was just thinking that myself." I took a larger than normal bite from my bruschetta and pretended to chew laboriously, giving him time to fill in the blanks in my stead. "I know, right?!" he said after a few moments. "Nobody is really capturing the depth and realism of the human form. And do you know why?" I was still chewing, so he answered himself, "Because they lack chiaroscuro baby!" His eyes were ablaze with excitement as he leaned over the table toward me, fully dousing his beard in the olive oil now. "Without chiaroscuro, there is NO emotion! Viewers are psychologically moved by a painting when the realism of the image allows them to draw upon, and relate, their own experiences deep within their psyche—they become sympathetic!"

"So wait…you mean that Spanish comedienne, flamenco guitar playing, 'cuchi-cuchi' girl has something to do with the realism of paintings?" I couldn't hide my confusion any longer at this point. "No!" he belly laughed, almost choking on his Chianti, "that's Charo, and she's definitely not flat, but that's not what I'm talking about." He continued slowly, "Key-are-oh-skyoo-ro is the beautiful contrast of light and shadow that shapes a subject, adds realism, and, most importantly, mood!" He slammed his fist triumphantly on the tiny wooden dining table, causing my fresh mozzarella ball to jump to its death on the floor. "Nobody is doing that! Nobody is using chiaroscuro in their paintings! I'm going to start doing

it. In fact, I've got a painting due for the pope in only 9 months and I need to get started on it now if I'm going to change the world with this concept."

"Why don't you just use a digital camera?" I offered up as he gathered himself to leave. "Because I haven't invented that yet!" He winked and headed for the door and then turned to me one last time, "Oh, can you spot me for lunch? I don't get paid for my helicopter idea 'til Tuesday."

And that's approximately when it started. I can't say for sure that Leonardo himself initiated the change in how chiaroscuro was used in paintings to depict depth, mood, and realism. But, I'm quite sure he was one of the first to fully embrace and promote it through his art. Of course, the most famous painting of all time, the *Mona Lisa*, is a perfect example of beautifully executed chiaroscuro.

By modern definition, chiaroscuro means "contrasting effects of light and shade in a work of art"[1] Prior to the Renaissance, most paintings were rather flat, lacking in realistic shading and perspective. When Leonardo and his contemporaries brought this technique into the mainstream, it was really the first hint at photorealism in art. In fact, if you squint your eyes while looking at some of these classic paintings, you'd swear you were looking at a photographic portrait. Then again, I see unicorns and rainbows in the clouds when I squint my eyes, so I guess that doesn't really prove anything. But you get the idea.

Another classic lighting technique born of the renaissance is the method of light *over* dark. In a sense, this could be another expression of chiaroscuro, but rather than expressing it as shading on the human form, it is represented as the main subject being lighter than the background. In effect, light objects appear to come forward to the viewer and darker objects recede. Knowing this, artists could make the subject of the artwork appear more three-dimensional and to have more impact as it literally "jumped" from the canvas in visual priority.

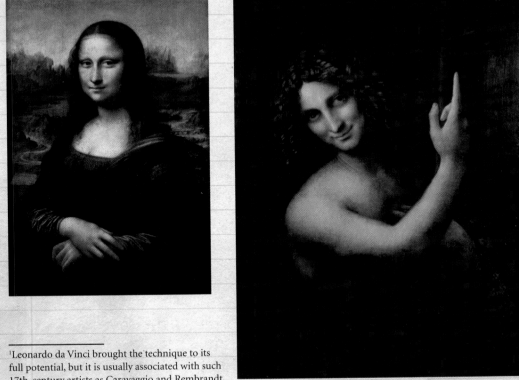

[1]Leonardo da Vinci brought the technique to its full potential, but it is usually associated with such 17th-century artists as Caravaggio and Rembrandt, who used it to outstanding effect.—*Encyclopedia Britannica Concise.*

A classic renaissance image by Leonardo da Vinci shows light over dark, and where to find enlightenment.

Photographers have used the technique of vignetting to darken the edges of the image, essentially emulating the classic artists' technique, since the earliest days of portraiture. The goal is the same: make the subject the brightest part of the image so it has the most visual weight. Did you ever notice that when a person with fair skin is wearing black, you more readily look to the face? Today, it's virtually a given that any photographer with access to a computer will have enhanced his or her images in some fashion by selectively darkening the edges, or parts of an image that are distracting. The same theory can be applied to your photographic lighting, *before* it moves to the domain of software. By carefully crafting your light, you can create beautiful chiaroscuro—both on the form of the subject and between subject and the background.

Photographic Lighting Styles of the 1930s and 1940s

Let's move forward in time just a little bit to the 1930s. During this Golden Age of Hollywood, photography began to display a distinct style from the quirky reportage photography of Weegee, to the dramatic and moody film style of George Hurrell. The lighting was crisp and directional. Reporters used flash bulbs to illuminate their subjects, and Hollywood style photographers were using hot lights, or Fresnel lights[2], to focus the illumination into deep, shaping, shadow-casting beams. This single, hard-light style was somewhat dictated by the limitations of the portable lighting equipment available at the time, as in the case of reportage photography. A single flash bulb was the primary light source, and it was usually positioned just above and slightly to the side of the lens or held in one hand slightly farther away, but in the same configuration. This positioning gave the subjects their distinct dark shadow slightly below and to the side of their features.

Hurrell exaggerated this effect and positioned his crisp lights for Rembrandt-style and butterfly-style lighting[3]—as well as many other creative variations of these techniques. Although the signature style of his images suggested the use of only one light source, he occasionally used other lights to enhance the background or to add some shadow fill. While the Hurrell style of photography fell out of favor for a period after his heyday, it has received a resurgence of interest and remains one of the most influential styles of photographic lighting to this day. Although George Hurrell didn't invent this particular style of lighting, he certainly put his signature on it.

My rendition of a Hurrell-style portrait. See another version of this image in the Notebook section.

The 1930s also began the Golden Age of Photojournalism—and with that, the ubiquitous use of smaller 35mm cameras and the inconspicuousness of natural-light photography. This was very different than the "in-your-face" style of the gritty street reporter and opened the door to an almost "anything goes" style of candid imagery that continued through the 1960s and '70s and on to this day. With natural-light "journalistic" photography, if the light creates or enhances the mood the photographer is seeking, then it's good. It was no longer all about perfectly controlled and exposed imagery, it was about freezing a moment in time and connecting the viewer to the image by its shear realism, which was often *enhanced* by the imperfection of the exposure or lighting.

[2]Fresnel lights will be explained in Chapter 2.

[3]Lighting styles will be discussed in Chapter 2.

The au Naturel 1960s and 1970s

In the 1960s and '70s (as in most cinematic eras), photographic lighting was heavily influenced by cinematography, and one specific influence was Raoul Coutard, a French cinematographer who used primarily natural light in his films. This was a departure from most previous filmmaking that relied on extensive artificial lighting. Coutard's desire to shoot with handheld cameras and to use or emulate natural light also led him to use bounced light, which was very soft and even in illumination. The photographer would "bounce" artificial lights into the ceiling or wall of a room to emulate or enhance the light that was already there. This natural light style became very prevalent among American cinematographers and photographers of the era as well—and continues to this day.

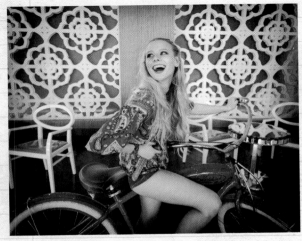

This image captures the fun, fresh, and natural style of the era.

Although the natural style of lighting became more prevalent in the '60s and '70s this was also an era of "anything goes"—in more ways than just photographic lighting! Photographers really began to experiment with composition, light, color, and challenging what was "normal." Rock-and-roll and fashion photography became a major influence on other photographic genres, and the work of icons like Annie Liebowitz and David Bailey influenced countless other photographers through the following years. Liebowitz, in particular, had a trademark style of using a very large, yet directional light source, which allowed for rich chiaroscuro even in her environmental portraits where the subject is a smaller part of a larger scene. In Chapter 3, we'll discuss how the relative size of the light source to the subject can affect the quality and depth of the shading.

Bold and Edgy 1980s

Not only were many of our favorite songs born in the '80s but also that fashion-centric, blown-out, cross-processed high-contrast look in photos, which has recycled itself—unlike mullets and shoulder pads. Nick Knight is arguably one of the best-known "fashionable cross-processors" of the era, and his work is still cutting edge and influential. Lighting was bold. Faces were overexposed. Colors were wacky. It sounds like one of those late nights in an '80s disco, doesn't it? Just like music and fashion, '80s photography was in-your-face and anything but subtle.

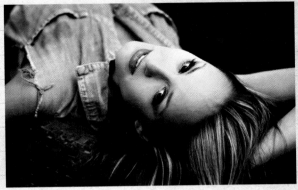

I enhanced this image in Photoshop using my cross-processing actions to achieve that 80s look.

The New Retro 2000s

Today, it seems, old is new again. Photography trends pull from the past—with Holga, sloppy borders, Diana, and vintage being the buzzwords. Digital photography is no longer new and experimental, but a well-understood and established method for capturing images. It has earned its respect, and the goal is no longer to get the cleanest image possible from digital, but to actually make it look less perfect, and more *analog*—just like in the early days of photography.

Photographers seem to be rediscovering lighting styles and processing techniques (or their digital equivalents) from the early days of photography. In the 1990s, digital imaging was still proving itself. Photographers either strived for the cleanest, sharpest images possible—eager to emulate what they could do with film, or they went crazy overprocessing their images with the plethora of software options. Why? Because they could! "I'll just fix it in Photoshop" became the jargon of the decade, and many photographers forgot to be, well, photographers.

THE IMPORTANCE OF LIGHTING TO PHOTOGRAPHY

In 2010 and beyond, photographers who are over the novelty of digital imaging are returning to the basics of good photography: subject matter, composition, impact, and *lighting*. Good lighting is not a trend in photography, it is the backbone. While lighting styles may shift and evolve, understanding how to light your subject for mood and flattery never loses importance.

The Emotional Response to Light

It is no secret, and it is well documented that the quality, quantity, and color spectrum of light can significantly affect our moods and even our health. People who live in northern parts of the country and are exposed to less natural daylight in the winter months are more likely to feel depressed. They can even be diagnosed with Seasonal Affective Disorder (SAD), which results in feelings of depression, gloom, or fear. Brighter, full-color-spectrum lights elevate our moods, creating a sense of happiness, well being, and trust. Dark shadows and contrast can be mysterious, threatening, or maybe even exciting. Softer, lower-intensity, and warm-colored lighting can relax us and calm our minds. It can also make us feel quiet and more intimate. It's no wonder that nightclubs and romantic restaurants have glowing amber lights and soft diffusers on their lighting fixtures. They would quickly lose their customers if the room was filled with bright, even illumination, or they'd attract the bingo crowd instead of the romantic interlude crowd.

Other light colors also have general effects on us. Red can stimulate and excite. Light blue calms and assures. Yellow can be cheerful and energetic. Green is relaxing and peaceful. Pink is comforting and friendly. Purple is unique and special, indicating you want to be noticed. Orange is energetic and creative. White is pure and innocent, and black might say, "I don't really want to be noticed" or "I'm a really sloppy spaghetti eater, and this hides it well." Although individual cultures can associate different emotions to colors, it is universally accepted that color does indeed affect our moods in a noticeable way. Healing arts are based around chromotherapy, or using light and color to improve health and mood.

Armed with this colorful knowledge, how can we affect the mood of a photograph by the strategic use of color and light? When planning a photograph, start with considering the three primary attributes of your lighting: *quality, quantity*, and *color*. I generally think about the concept for the photo, the theme, and the general *feeling* that I want to convey. Will it be fun and playful? Soft and romantic? Mysterious? Edgy? Steeped in metamorphic transfiguration (yah, I used the dictionary for that one)? When I have the generally feeling, I start to build a lighting plan in my head, or even on the well-lit pages of my notebook.

The general term, "quality of light" is usually referred to as a combination of contrast, softness, quantity, and color. However, I prefer to break it down to the three most distinct components. The *quality* of the light is defined by the hardness or softness of the shadow transition areas. The *quantity* of light equates to the overall brightness or darkness of the scene—for example in a high-key or low-key image. The *color* of the light could be an overall predominant color, or colorcast, in the image—or a mixture of colored lights in the same image. Even when there is a mixture of colored light in an image, usually a predominant color influences the mood of the photo.

So, back to my plan. Decide on the concept and then build the light to match. For a child's portrait, I may want something bright, soft, and warmer to enhance that embraceable cuddly feeling kids give us (generally speaking, of course). Brighter lighting, with open shadows, creates a feeling of trust and comfort—exactly what we want when portraying children. If I were creating an executive portrait for a man, I'd choose bolder lighting, with more contrast and more blue tones on the background to enhance the masculinity and "trust-ability" that blue, as a color, creates. For a female boudoir-type photo, I might use soft, shadowy light with darker luscious red tones to create mystery, passion, and romance. If only it were that easy in real life, sigh.

Every rule is made to be broken, of course, and many wonderful portraits have surely been made of children with harsh, moody, blue light, too (although I haven't personally seen them). The key is to match your lighting to the feeling, whatever it may be, that *you* want to convey or enhance in your photograph. A common mistake of beginning photographers is to use the same basic lighting setups that they are familiar or comfortable with, on almost every subject—whether it's appropriate or not. They go with what's safe for them rather than what's best

for the image. One of the goals of this book is to give photographers enough tools and ideas so they can pull a few more tricks out of their proverbial hats—lighting their way to more beautiful and poignant imagery.

Light Shapes and Defines the Subject

I suggested earlier that people often wear black when they really don't want to be noticed—when they want to blend in. But, what is one of the most common reasons people wear black clothing? You got it, because it's visually slimming. Nero is your hero, baby, when it comes to hiding the extra pizza. Wearing black clothing is like wearing shadows on your whole body. Shadows hide things, like burglars and cellulose.

Remember how renaissance painters would use light over dark to make parts of an image visually pop or recede? When you want to hide something, put it in shadow or wear black. By creating shadows on your subject, you can hide parts of the body that prefer to stay anonymous. You can make round shapes, like faces, arms, legs, and bodies, look rounder or thinner, by creating more or less shadow areas. This is extremely useful information when you consider that many people feel their face (or another body part) is too round or too thin, or too lumpy, and you can be the heroine and make it look juuuuust right—with the right light.

In the next chapter, we'll talk in detail about different styles of lighting and how they can shape and enhance your subject, but for now, scribble this in your own lighting notebook, "What kind of light will best flatter this subject?" It's an important thing to remember when building your lighting plan and should always be the first question you ask yourself before making portraits that you want clients to actually purchase. They won't buy it if they don't like how they look. So make them look good.

Chapter 2
The Lingo of Lighting

GENERAL LIGHTING STYLES

You can light your subject in countless ways—any of which could be completely awesome or completely awful. That's daunting! Most lighting styles, fortunately, stem from a few basic foundational ways of lighting the face and form. After you are familiar with these, you can use them for starting points to your own fabulous, trend-setting lighting style. The first few techniques I'll cover are not really styles, per se, but refer to the number of lights used and their standard placements. It is important to understand these placements, however, as they form the basis of most classic lighting styles.

2-Point Lighting

When you use one main light with a second light of lesser intensity filling in, or lightening, the shadows, this is 2-point lighting. The second light generally is placed behind the camera, directly above, or close by so that it lightens the shadows cast by the main light (as seen from the camera's position) but does not cast secondary shadows of its own. Its effect should really go unnoticed, except for softening, or opening of the main light shadows.

Single-Point Lighting

One light, pure and simple. Although other lights may be illuminating the background or other objects in a scene, when there is just one main light on the primary subject, it is single-point lighting. The light can come from any direction on the front half of the body (otherwise, it really becomes back, or rim lighting, which we'll discuss later). The single-point light is the main light that shapes and defines the subject.

3-Point Lighting

A third light often is used as a hair light or rim light. It's generally placed behind the subject and up higher than the head to emulate the sun beaming down on the head and shoulders. Classically, it is located behind and on the opposite side from the main light, but this is not a strict rule. The third light, when used as a hair light, might typically be a spotlight or something more focused and controlled so that it illuminates hair and shoulders, but not much else.

4-Point Lighting

Occasionally a fourth light is used on the same side of the face or body as the fill light, or sometimes on the side of the main light, but located slightly behind and to the side of the subject. It is often called a "kicker" when used this way. Its purpose is to add specular highlights and separation to the face without overpowering the main or fill light. A kicker takes a bit more control and practice to incorporate well, and as such, you don't see it as often in portraiture. The late, great Monte Zucker was one of the best at implementing it, and his portraits were some of the defining examples of its use.

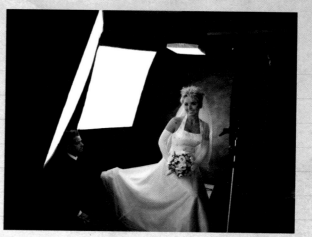

The setup for the 4-point lighting. Note that a reflector serves the purpose of the second, or fill light.

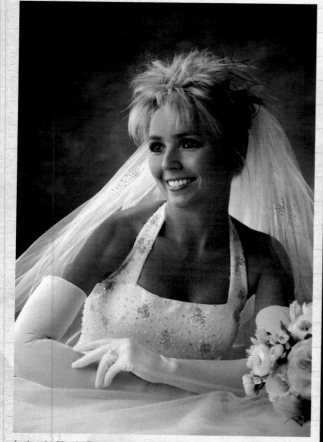

A classic Monte Zucker image showing 4-point lighting with the kicker on the side of the main light.[1]

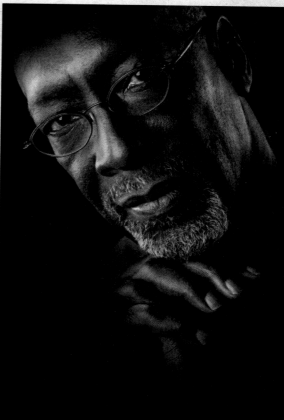

Another beautiful Monte portrait with the kicker on the fill side of the face.

[1] Monte Zucker images courtesy of Monte Zucker Photographic Education www.montezucker.com

Rembrandt Lighting

The famous Dutch painter loved to use this lighting style in his portraits, and his name now emblazons this particular light pattern in which the main light casts a loop-like shadow from the nose that extends toward, but does not touch, the lips, and a triangular patch of light under one eye. "Loop lighting" is similar to Rembrandt lighting, but the loop's nose shadow doesn't extend quite as far from the nose. Rembrandt lighting tends to be quite flattering on a wide variety of people and nicely shapes and complements the face.

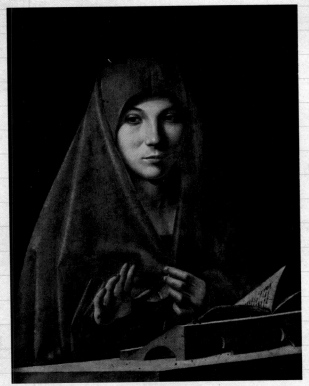

Rembrandt lighting exemplified by Antonello da Messina. Note the triangular patch of light on the cheek of the shadow side of the face.

Broad Lighting

No, this is not a slanderous way to reference lighting for women, it's about lighting the broader side of a person's

face. In many portraits, the subject's face will be angled one way or another, versus facing absolutely straight into the camera. One side of the face, where you see more cheek, appears broader to the camera. When you place the main light on the same side of the face, it is *broad lighting*. The effect is that the face is made to appear wider or fuller. Sometimes, as in the case of someone with a very narrow face, this can be helpful to fill them out. Generally, however, it is not as flattering to the face as short lighting, which is coming up next.

Short Lighting

You've probably already guessed that this is the opposite of broad lighting. When you main light a face from the

"short" side—the side that you see less of—it will slim and shape the face quite nicely. Many portraitists rarely use anything else, as it tends to work well on all but the narrowest of facial profiles. It will enhance the cheekbones and give nice shadowing down the broad side of the face, making it appear slimmer. When in doubt, try a photo both ways—moving your light from one side to the other. Review the images and see which one is more flattering on your subject.

Split Lighting

Generally reserved for character studies and dramatic lighting, split lighting does just that—it splits the face in half. Although this certainly is "slimming," it's also very mysterious and can be harsh, magnifying pores, wrinkles, and facial bumps. It's hard to trust someone who is split lit; something always appears to be hidden in that shadow side…like a bionic eye.

Butterfly Lighting

Although there is probably an entire science around lighting the Lepidoptera, this is not what we're talking about. Pure and simple, butterfly lighting is achieved when a small, butterfly-shaped (if you use your imagination) shadow lies just directly below the nose. When the main light is directly in front of the subject's face, and slightly above, the shadow magically appears. If the main light is too high, the shadow intersects the lips, and the eyes become black holes. This is not so good. If the light is too low, like directly above the lens, the shadow is not present, and there is very little shaping to the features. Butterfly lighting can be beautiful and dramatic, but will tend to flatten, or widen, the appearance of the face somewhat, so use it with caution on rounder faces.

Look closely. Do you see the butterfly under her nose?

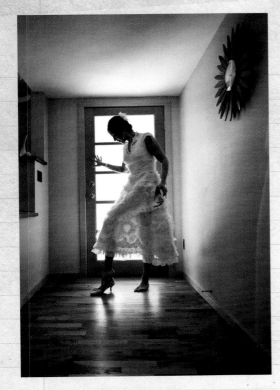

Backlighting

Although not necessarily a typical portrait lighting technique, backlighting is a distinct lighting style that deserves its own paragraph. When the main light is behind the subject, creating a silhouette or an obvious glow around him or her, you have backlight. A portrait doesn't have to be all about a well-lit face; it could be a figure study or a strong mood, achievable only via a strategically placed backlight.

Flare

Once upon a time, lens flare was a no-no. Photographers did everything they could to minimize or eliminate it from ever happening. Nowadays, when wielded properly, it can be downright fashionable! Flare can occur when a light source is pointing at the lens, whether it's visible in the image or not. It is the scattering of light inside the lens and its elements. Flare is often used purposely to create a feeling of realism and drama. When an image feels less "perfect," it often feels more authentic.

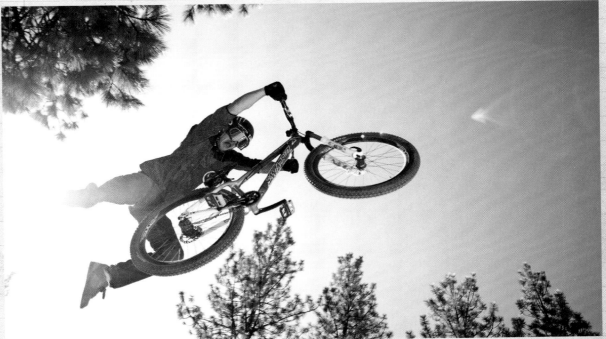

Lens flare can make a photo more dramatic and believable. Benjamin Edwards took this image during one of our shoot sessions. See one of my photos from the day in the Notebook section.

Shadowless Lighting

Sometimes called "beauty lighting," this type of lighting is created by evenly illuminating the subject. Typically, a large light source is placed directly above the subject's face, and a fill light or reflector is placed directly below, filling in all, or almost all, shadows. It can also be achieved with a ringlight. Although this lighting might be useful for close-up images of perfect faces, as in a makeup advertisement, it's generally not a very interesting way to light a face.

Shadowless lighting is great for young, perfect faces, as in makeup or hair product ads.

LIGHTING TERMINOLOGY TO THROW OUT AT DINNER PARTIES

The following are not lighting styles *per se*, but terminology you should be familiar with as a lighting guru. If nothing else, you can dazzle your friends with your impressive vocabulary.

Point light source. A single, relatively small light source, like the sun. Note that small is a relative term, as the sun is obviously quite large, but small as seen from its distance to a subject.

Main light. The primary light source that creates the most pronounced shadow shaping on the subject.

Fill light. A second light that lightens the shadows of the main light but creates no additional shadows of its own. Generally, it's placed behind or just above the camera, or next to the camera on the opposite side of the main light. Its intensity would be equal to, or less than, the main light.

Edge or hair light. A light placed behind and generally above the subject to create a bright edge on the body or highlights on the hair. It separates the subject from the background and adds depth and dimension. Sometimes called a rim light when its purpose is to create a rim of light on the subject's edge.

Background light. A light used to illuminate a backdrop or background separate from the subject. Sometimes a background light can serve as an edge light to the subject as well.

Kicker. A light used on the side of the subject in addition to a main and fill light. The kicker can be on the same side as the main light or on the side of the fill. It is usually controlled so as not to flare in to the lens or overpower the other lights. It adds separation from the background, but is more prominent than an edge light.

Catchlight. The reflection of the light source, or sources, in the eyes. Larger catchlights can be more appealing as they tend to make the eyes appear brighter and more "twinkly." See Chapter 3 for some examples of various catchlights.

Ringlight. A circular light that completely surrounds the lens, eliminating shadows on the subject but casting an interesting shadow on the background around the entire edge of the subject—when that subject is close to the background. It has been very popular with fashion photography at various times.

Hard light. A light that is not soft (ha!). Smaller, point light sources create hard light, which results in hard-edged shadows on the subject.

Diffused. A point light source that is made larger by spreading it over a larger surface area—either through a translucent material or when bounced off a larger surface. A diffused light is softer than a point light source, creating soft-edged shadows.

Reflected. Light that is bounced off another surface. The surface could reflect a lot of the bounced light—as in a mirror; or it could reflect very little—as in a dark-toned wall. Reflected light becomes diffused when bounced from a larger, nonmirrored surface.

Angles of incidence and reflection. The angle at which the light beams hit your subject is the angle of incidence. Those light beams then reflect off the subject at the same angle in the opposite direction, which is the angle of reflection. In photography, this is very useful to be aware of as it determines where to position the camera to see, or not see, a reflection of your light source in a shiny surface. It also determines where you'll position a reflector if you want to reflect light back on to your subject.

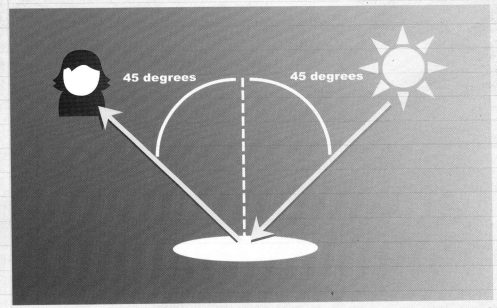

Flag. Anything used to block light from hitting the subject, background, or the camera lens. An elephant, when properly tamed, can make a very large and useful flag.

Fresnel. A type of lens used in lights to focus and intensify the beam. In photography, it is commonly used with constant light sources, or "hot" lights, to create an intense spotlight effect with very defined, hard edges.

Gobo. A commonly accepted mutation of the words "go between." In cinema and photography, a gobo is an object that is placed in front of the light to create shapes or shadows. When you make hand-puppet shadows on the wall, you are a gobo, or a goober. Although a flag is meant to completely block light, the gobo is used to create shapes or patterns from the light.

Scrim. Also referred to as silks. A translucent fabric used to soften and diffuse light shown through it.

Snoot. Someone who thinks he or she is better than you. Also a tube or cone used over a light source to direct or aim the light.

Grid. A flat, honeycomb or square patterned disc that lies over the front of a light source. It can also be made of fabric, matching the size and shape of a softbox. A grid is used to direct light in one general direction, minimizing its tendency to scatter, without reducing the relative size of the light source. This allows for larger, softer light sources to still be directional and controlled.

Chiaroscuro. I like this word. It's fun to say and represents that luminous quality of light and shadow that shapes and defines a subject. Beautiful shading and contrast that models and adds depth to your subject is good chiaroscuro. Remember, it's key-are-oh-skyoo-ro, like Chianti, only different.

Watt-seconds (Ws). This is the measure of power stored in a flash system. It can be misleading, however, to compare flash systems using this measurement because it doesn't take into account the efficiency of the electronics and flash tube, nor any modifiers that might be added to the front of the flash to focus the beam. A 600 watt-second light from one manufacturer may produce considerably more useable light than a 600 watt-second light from another. A slightly better way of comparing light apples to light apples would be with the Guide Number. See the following definition.

Guide Number (GN). The Guide Number represents the amount of light produced at a given distance, f-stop, and ISO setting. For example, a GN of 100 feet at ISO 100 means that you could get f4 at 25 feet. What? Okay, all you do is divide your GN by your f-stop to get the number of feet away your flash needs to be at for a proper exposure. Likewise, you can divide the GN by the number of feet away to get the correct f-stop to use. The GN could be expressed in meters or feet and with different ISO ratings, so make sure you compare GN ratings using similar specifications.

The Guide Number power rating is common among flash manufacturers, but is still "fudgeable" to some degree. For example, if the measurement were taken in a small, white room, a noticeable amount of light would be bouncing off the walls, helping to illuminate the subject and adding to the Guide Number. If the test was done out at a salt flat at night, it would register a lower number. It's a good starting point for comparing flash units, but the only real way to compare their power output is side-by-side, in your own controlled environment, using a flash meter. This is generally something to do when you are really bored.

Lumens. The measure of light as perceived by the human eye. Again, not a measurement that can be used to precisely compare light output from different sources, but a good starting point. A lumen rating is often used for flashlights. However, as with Guide Numbers, manufacturers have their own creative ways of measuring lumens, and I've had flashlights with the same lumen rating that are at least an f-stop different in brightness when measured with a light meter.

Now that you have some key terms under your belt, let's think about how to use them in daily practice. In the next chapter, we'll talk about some essential lighting skills and technology you'll also want to master on your way to photographic en-*light*-en-ment.

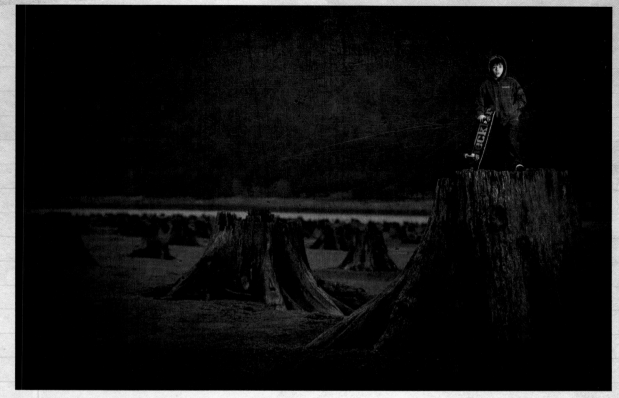

The Trees: This dramatic setting was used for one of the images in the Notebook section. I loved the unusual contrast in subject matter.

Chapter 3
Essential Lighting Skills

LEARNING TO FEEL LIGHT

The unforgettable phrase "Take time to smell the roses" rings as true as ever when we search for ways to appreciate light and how it shapes form and creates mood. I remember when my younger son was 6 or 7, watching as he crouched near our front door and pondered a bug slowly traversing the walkway. He just sat and watched. I caught myself just about to say, "Hey, let's get going…" when I decided, instead, to squat with him and observe. I watched an amazing miniature world unfold and discovered subtle, beautiful details in a colorful caterpillar and textures in the rock pathway that could have forever remained a mystery.

One of the best ways to learn to feel light is to simply pause, calm your mind, and observe. I am sitting in an airport lounge right now while my son is curled up in a ball on the chocolate leather chair across from me. A large window is behind him, and a silvery-gray concrete rooftop outside reflects light from a clear blue sky. Over the window is a pale white, translucent shade—15 feet wide and at least 5 feet high. The light bounces from the bright outdoors, through the large shade, and creates a bathing, soft light over his entire body. A crack at the bottom of the shade allows the crisp, directly reflected light to add a specular highlight just across the top of his hair. Next to him is a tall table lamp with a large, flat, eggshell-like shade that glows tungsten orange. It casts a warm wash on the side of his face in perfect, short light fashion. It's beautiful light, and I could re-create this in my studio.

Whenever I can remember to do so, I stop, look around, and just "feel" the light. When I see, or feel, something I like, I analyze it and try to figure out what is happening to make it feel the way it does. Is it reflecting off something? Warm or cool? Full of rich shadows and crisp highlights? By taking time to "reflect" upon light that you like, and then dissecting it, you learn what you need to do to emulate that feeling later with your own lighting tools. Slow down, breathe deep, and discover something you may have walked past today.

Take a moment now. Stop what you are doing and hold your hand out in front of you. Admire the light that shapes it. Is it soft, wrapping light that slims your fingers and is kind to the wrinkles? (If you don't see any wrinkles, just keep it to yourself). Are their beams of crisp sun illuminating every tiny fiber of hair, exaggerating the years of hard work in to strong, bold character lines? Are the tendons on the back of your hand deep and defined when you extend your fingers? Rotate your hand in the light and find the best, most shapely angle for the intricate piece of art you have before you. How would you re-create *this* light in a darkened room?

Studies have shown that visualizing yourself doing something—whether it's a sport, hobby, music, or most any skilled activity—can improve your performance in that skill nearly as much as physical practice. A recent study has even shown that visualizing yourself eating and chewing your favorite food will actually make you eat *less* of it when it becomes physically available.[1] The key to making visualization work for you, however, lies not in just thinking about the activity, but actively imagining yourself doing it. You must imagine the muscle movements, sounds, taste, touch, and emotion of doing that activity.

Begin to challenge yourself to be an active observer. Stop, see the light, analyze it, and then figure out how you could create it again. Practice your lighting whenever and wherever you are. Visualization is a key component to learning and success. The beauty of being a photographer is in the ability to see a scene in your mind and re-create it in an image—piece by piece, light ray by light ray. Practice seeing light, dissect how it's created, and imagine yourself building that light again with the tools you have. When you are in your studio, recall those mental notes

and physically build the light. This visualization practice can make you a better lighting master.

If you need a good starting point for lighting a scene, just think about the sun. The primary reason for the invention of artificial light was to emulate the sun, when and where it didn't shine. In cinema and photography, we strive to make light look natural, or to copy what the sun would do—either shining directly at, bounced off, or diffused through something. If you think about building your lighting scene starting with a single, primary light source, and then adding diffusion, reflection, or redirection in support of it, then you'll usually end up with a fairly natural-feeling scene. Of course, there are many reasons and ways to light a scene that will not emulate what the sun could do, especially indoors, and this is totally acceptable, too, if it suits your photographic goals. Your artistic desires are the only limit.

Learning to feel light also involves understanding how *your* selection or use of lighting tools can make the viewer feel about your image. We discussed earlier about how the intensity of light affects the mood of a photograph, but here's another subtle, and somewhat subliminal, way to affect the viewer. Psychology studies have revealed that dilation of the pupil is a subconscious indicator of attraction. It is, of course, not the only reason our pupils dilate, but we are programmed internally to feel more attracted to someone when his or her pupils are dilated. Advertisers know this little trick and often digitally enlarge the pupils of models in magazines to make that person appear more alluring.

Take a look at the following set of beautiful eyes. They were both taken within seconds of each other, with the same lighting conditions. In the second example, I simply turned the model a little bit away from the bright primary light so that the glare was not causing her pupils to constrict. Which pair of eyes seems more warm and inviting to you?

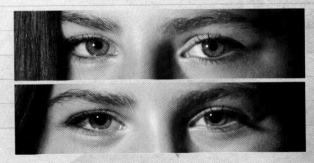

[1] Reference article in *Science* magazine, December 10, 2010

If you are a fairly normal human, your subconscious would have told you that the second set of eyes with the larger pupils is more attractive. If part of your goal in making a photograph is to make the subject appear attractive, then this is a great little trick to know! When you are setting up your lighting, consider reducing the ambient light and the modeling lights of your flash units—allowing yourself enough light to focus effectively, but keeping it low enough to allow your subject's pupils to naturally dilate. When using point source lights, especially, try to keep them from beaming directly into your subject's eyes. This is one advantage of flash lighting over constant lighting. Constant lighting generally needs to be fairly bright to allow for reasonable exposures, and this naturally causes pupils to constrict.

METERING LIGHT

At least three subjects, when brought up at gatherings of experienced photographers, cause colorful debate. RAW versus JPG, Canon versus Nikon, and the necessity—or not—of a light meter. If you take a bit of secret pleasure in provocation of the opinionated, then throw out this line casually at a party, "Who needs a light meter? I can see what the light looks like on the back of my camera." It's a great conversation starter, if nothing else. If that doesn't work, try, "Hey baby, your pupils are dilating; you must be happy to see me."

If you were to ask me whether you should go out and buy a light meter, I'd probably say, "No, save your money for other equipment." If you were to ask me whether it's helpful to have a light meter, I'd say, "Yes, definitely." I have light meters in my photo closet, but I haven't used them in years. In the days prior to digital imaging, it was essential to have one because that was the only way you could reliably predict a manual flash exposure in the studio and to determine the balance of multiple lights.

I was sharing this thought with another experienced photographer the other day—one who believes in the use of a light meter, and he had a very good point. He kindly encouraged me to remember that I have 20 years of lighting experience, and I could probably predict the amount of flash power too, and the resulting look of the light, fairly accurately without a meter. He's right, and I realized the value of a light meter to those learning the lighting ropes.

A light meter is very helpful if you want to create precise light ratios and see the effects of changing them. Later in this chapter, we'll talk about light ratios and see examples of what different ratios look like. The reality of it is, however, that rarely does a client actually request a "4 to 1 light ratio," or do we, as photographers, think about the creation of a photograph in these terms. Although it's good to know what a higher, or lower, light ratio looks like, we generally design lighting based on what just looks right—not by the numbers. Technical purists and traditionalists probably will scoff at me, but this is my experience…and it's my book, darn it.

As I mentioned before, if you have access to a light meter, then it's great practice to take it out and learn how to use it. My primary use for a light meter nowadays is for testing lighting equipment. It's very useful to compare the power output of various light sources and/or the consistency of their output. In fact, during some testing I was doing for this book, I discovered that my Nikon SB900 Speedlight is actually slightly higher in output than my Alien Bee B800 (when the Nikon is zoomed to 200mm). This was surprising to me, as I never suspected it was this powerful. It gave me reasons to reconsider taking my bulkier lights on location. I also discovered which lights are more consistent from shot to shot and which can be harder to identify without the aid of a light meter.

Your digital camera is really your most useful light meter as it shows you what the light actually looks like. When combined with a basic understanding of your in-camera histogram, it's all you need to make perfect exposures and perfectly "felt" light ratios. Here's a basic workflow for using your camera to evaluate a basic light scene with a 3:1 light ratio, or something that "feels" about there. This is assuming a studio lighting situation, or something similar, in which the strobe lighting is the only light measured.

1. Decide what f-stop you want to use on camera and set it. Set the shutter speed to your maximum flash sync speed. You always should use the maximum sync speed to minimize the effects of any ambient light in the room.
2. Place your subject and figure out the location and modifiers of your main light. Approximate the power setting and make a test exposure.

3. Look at your image in-camera and the corresponding histogram. If you plan to use a flash for fill, adjust the main light as needed so that your exposure for the main subject is approximately ½ to 1 f-stop underexposed. If you will be using a reflector instead of fill flash, then the main light should be adjusted to give closer to a normal exposure.

4. Add in your fill light and adjust until the shadow fill looks right to you. When a flash is used as fill, it will add to the exposure of the main light, raising its value, which is why you slightly underexposed it in the preceding step. A reflector fill will not necessarily add to the main light, but will open the shadows, so less underexposure (or none) will be needed.

5. Add in your hairlight and background lights as needed and adjust them to give the look you want.

6. Do a final check on your histogram to ensure important highlight and shadow detail are within range. If the highlight (mainlight) side of the subject is too bright, but the light ratio balance looks right, adjust both the main and fill down the same amount, splitting the difference between them. For example, if the highlight side of the face looks to be 2/3 f-stop too bright, lower the main and fill lights by 1/3 f-stop each.

1 stop underexposed

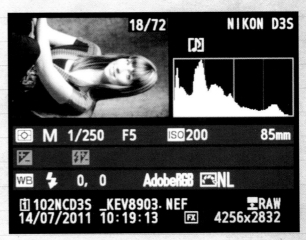
Normal exposure

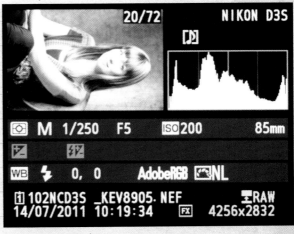
1 stop overexposed

QUALITY, QUANTITY, AND RATIOS: THE BASIC RULES

The quality of the light refers to the sum of several factors, including the size of the main light source, its distance to the subject, whether its shadows are filled or softened, and the color of the light. When we use the term *quality* to infer good or bad, it is mostly subjective—as "good" quality light is light that serves the mood and objective of the photograph—it could be hard, soft, bright, or nearly nonexistent. When I talk about the quality of the light here, I'll refer to the various elements that form the characteristics of the light, or its summative quality.

One of the key factors that determines how light shapes and shadows a subject is the size of the light source. When a light source is larger, in relation to the subject it is illuminating, it is softer, creating gentle shadow transition areas and less specular highlights. A soft light does not necessarily mean there are *less* shadows, only that the transition from light to shadow is gradual and soft edged. Remember that the operative phrase is *in relation to the subject*. The sun, for example, is the largest light source imaginable. However, in relation to the earth, as we see it, it is a speck in the sky—a point light source creating crisp shadow edges when undiffused by clouds. If the sun were just a few miles from Earth, it would require SPF one zillion, but more importantly would be the largest, *softest*, light imaginable—incredibly even and nearly shadowless.

Here's a more earthly example. A medium-sized softbox is indeed a soft light, when used up close to a single person's face. If you pulled that same softbox back farther to illuminate eight people evenly from a distance, it would no longer give the same soft quality as it did. It just became a smaller light source *in relation* to the subjects. When I want a light source to be as soft as possible, I bring that source as close as possible to my subject—just outside of the camera view, ideally. Similarly, when you are shining light through a scrim, or other translucent object, and want it to be as soft as possible, be sure to move the original light source as far back as necessary to completely cover the scrim surface. Remember that this surface becomes your new light source, and you now want it to be as large as possible.

The distance of the light source to the subject has a very direct effect on the "feeling" of the light and the dimensionality it creates on the subject. This is chiaroscuro at work. When the light source is farther away, the lit parts of the image seem to jump quickly from light to shadow—with harder edges. There is no real transition area—just light and then shadow. When the light source is closer, transitional shading occurs from light to shadow. The shadows ultimately will be the same density, but the areas of transition between light and dark are smooth and gradual. I call this effect "3D," for Distance Diminishes Depth because the feeling of depth is created by this soft transitional shading. When you want a soft, shapely subject, remember 3D and reduce the distance of your light source.

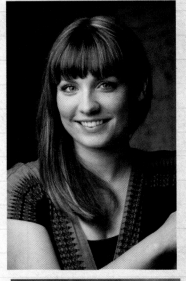

This photo was shot with a single 3-foot octogon softbox at about 2 feet from the subject. Notice the soft transition from highlight to shadow and beautiful shaping of her features.

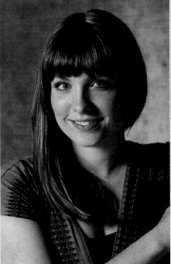

The same light box was moved about 10 feet away and adjusted to give the same exposure to the highlight side of the face. Notice how different the shadow transition is and how much less vibrant her hair looks.

When creating the lighting feel you want, it's important to consider the reflectivity of the subject as an important part of the lighting equation. Shiny, wet, or mirror-like objects tend to reflect—just like a mirror, the actual light source to the camera. (Think of the catchlights-in-the-eyes scenario discussed earlier). With this in mind, a black shiny object would be difficult to light with a point light source as you primarily would see the reflection of the point of light—with very little of that light seeming to actually illuminate the object. On the other hand, a large light source would reflect in the shiny object, showing tones of the object's color, and indicate to us that it is reflective and black.

When a person has oily skin, it is more reflective. If you use a small light source to illuminate that person, the oil reflects the small light as specular highlights, which can be distracting. When a larger light source is used, there are less "point source" reflections, and the shininess is minimized. Consider, also, if you want to light a very large reflective object like a car. The most flattering light, which would bring out the shapes and color of the body, would be a source that is large enough to cover the entire length of the car as seen in reflections in-camera. An evening sky or giant softbox would do just that. A point light source would show as a dot of specular highlight, with no reflections to shape the body or indicate its true color.

BALANCING NATURAL AND ARTIFICIAL LIGHT

If you take a Zen-like perspective, nature is perfect—everything is the way it's supposed to be. Photographers, although certainly Zen-ish on occasion, are not always satisfied with light just the way it is. We often need to supplement natural light with our own artificial lighting tools. Learning to balance the two types of light in the same scene, so that the effect is natural and convincing, is what Zen epitomized.

Typically, the need for artificial light arises when the natural light does not completely illuminate the subject or when the desired composition is incongruous with the direction of the existing light. Perhaps the natural light creates deep shadows that yearn for some fill light. As with most things in life, balance is key. When the goal is to supplement the natural light, maintaining the mood and quality, then the added artificial light should be crafted with care to complement it seamlessly without overpowering it.

Modern dSLR cameras and their mated on-camera flash systems provide accurate and automated flash balancing—such that the user rarely needs to think about how to set the flash for natural fill light. In fact, it's actually fairly difficult nowadays to make a *bad* exposure when the camera and flash are on automatic modes. Whether the exposure is creative or artistically enhancing to the mood of the image is up for debate, but, technically, they are good exposures. The day will come, fortunately, when the photographer will have to think for herself and figure out how to manually balance flash and existing light.

Light is additive. For example, imagine one side of a face that is receiving directional light from the sun and measures f/5.6. We add an on-camera flash that illuminates everything the camera sees—that by itself is also equal to f/5.6. The previously lit side of the face will now be receiving f/5.6 from the sun and f/5.6 from the flash—light totaling f/8. We have doubled the light on the lit side of the face, which is equivalent to a 1 f-stop exposure change. The new light is added to the existing light.

If the shadow side of the face was in near darkness before, now it receives f/5.6 worth of light. The brand-spanking-newly lit scene now registers f/8 on the bright side of the face and f/5.6 in the shadows, which is a 2:1 light ratio. If, instead, I were to add flash of output equal to f/4, this gives me f/5.6.5 on the bright side of the face (f/4 is half the light of f/5.6) and f/4 in the shadows—a difference of 1.5 f-stops, and a 3:1 light ratio. If it's confusing, don't worry, I'll explain light ratios a bit more in depth later in this chapter.

We also need to remember that we filled the shadows nicely, but we bumped the bright side of the face up 1 f-stop, which we may need to account for in our overall exposure.

It helps to understand that to change one f-stop requires doubling (or halving) the amount of light. In practice, this means that it takes much *more* actual light intensity to change from f/11 to f/16 than it does to change from f/2.8 to f/4, even though both are essentially 1 f-stop. What? Changing from f/2.8 to f/4 only requires 1 unit of light, whereas changing from f/11 to f/16 requires 16 units. The following chart shows this progression:

Each additional f-stop requires double the light of the previous f-stop which requires exponentially more power.

Units of Light Intensity	1	1.5	2	3	4	6	8	12	16	24	32
f-stop Value	2.8	3.5	4	4.8	5.6	6.7	8	9.5	11	13	16
f-stop Difference	0	.5	1	1.5	2	2.5	3	3.5	4	4.5	5

This also explains why it's fairly easy to make a flash that generates power up to a certain practical level, but to add just one more f-stop level of output requires exponentially more energy. Sometimes it helps to imagine a unit of light as one candle, or candlepower. If you start with one candle, doubling the light only requires adding one more candle. No problem. Doubling it again requires digging in the drawer to find and light two more candles—still not too tough. But, to double that again and again will start to create a lot of work and quite the fire hazard! Each time we double it, however, we only change 1 f-stop.

So how is this information helpful on the job? Let's say you are trying to light a scene with a speedlight, and at full power you achieve f/5.6. If you need to squeeze just one more f-stop out, you could add another speedlight, also at full power, and get f/8. But what if you needed 2 more f-stops? Would you add two more speedlights? I get confused with this, too, sometimes! Adding a third speedlight would give you only f/8 and a half, or f/9.5. You would need three more speedlights (a total of four), each at full power, to reach f/11. To get yet another f-stop, or f/16, you'd need eight total speedlights, each firing at full power.

Because of this exponential law, it's often expensive, or impossible, to have one flash that generates enough light for your f-stop needs. In this case, grouping multiple flash units together or "ganging" them up, does the trick. However, you need to know how many units you'll need to reach your goals. You can use the previous chart to help you calculate how many flash units of the same intensity will be needed for a target f-stop. Ignore the fstop Value column for now and simply associate a single flash unit to the 1, under Units of Light Intensity, then on the bottom row look for the f-stop difference (from your current f-stop) that you need. Follow that back up to the Units of Light Intensity column, and it will tell you how many total flash units, of equal power, will be required.

Here's another interesting bit of lighting information. A typical flashtube, like the one in a speedlight, only has two actual power levels—on or off. To achieve the lower output settings, the flash cuts its duration short, limiting the time that it illuminates. Just like longer exposure to the sun will burn your skin, whereas a brief sunbath will not, light from a flash unit accumulates the longer it is on. A full output blast from a flashtube may last 1/1000 second, but a lower output burst might only last a fraction of that—say 1/16,000 second. The tube illuminates at the same power level each time but is turned off sooner to achieve the lower actual output.

There are two real-world reasons why knowing this information is helpful—beyond the aforementioned benefit of making you the life of the geek party. First, you need shorter flash durations to freeze motion. Second, you have a speedlight with high-speed sync (or your particular manufacturer's term for syncing flash at faster than normal sync speeds). I'll explain both.

To freeze motion, avoiding ghost edges, you need very short shutter and/or flash durations. The appropriate duration is dependent on the speed of the moving object. Faster-moving objects require shorter flash or shutter durations. Let's say you are trying to freeze the motion of a dancer jumping through the air in your studio. You've set your lighting up and determine that a single flash unit

needs to be at full power to give you the f-stop you want. At full power, however, this flash has the longest flash duration it will ever have—possibly too long to properly freeze the motion. A few test shots can verify it. Armed with the previous knowledge, and a second flash unit, you could use two flash units—at half-power each—to achieve the same output, but with half the flash duration time. This may be just what you need to cleanly freeze the motion.

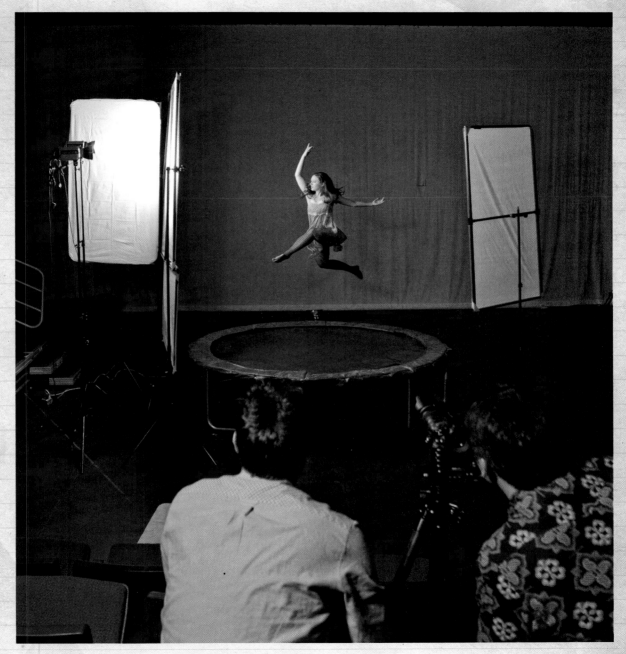

For this setup, I used two identical flash heads, each at half power, to shorten the flash duration time and freeze the dancer midair. View the final image and setup information in the Notebook section.

High-Speed Sync

High-speed sync is a term used by speedlight manufacturers to indicate the ability of their flash units to properly synchronize with the shutter at faster-than-optimal shutter sync speeds. Most cameras have an optimal sync speed of around 1/250 second. This is the fastest speed at which the shutter mechanism actually leaves the sensor completely exposed and ready for a quick burst of light.

Did someone just turn the light out? Maybe we should explain how a shutter works first. In a nutshell, a camera sensor is exposed by two curtains passing over it, one after the other, with a delay between them creating a "window" for light to expose the image. This delay is your shutter speed. At shutter speeds up to your optimal flash sync speed, the sensor is completely unobscured by these curtains for a certain amount of time during the exposure. At higher speeds, the curtains cannot physically move fast enough to leave the sensor completely exposed for any amount of time, so the window "scans" over the image, exposing it gradually. Imagine a desktop scanner or copy machine that passes its light/sensor evenly across a document.

Because the sensor is never exposed completely at higher shutter speeds, a single flash pulse at any point during the exposure would leave a dark shadow where one (or both) of the shutter curtains was still obscuring the sensor. To circumvent this, the flash unit pulses (like a strobe light) to expose the sensor in sections as the shutter window passes over it. (This all happens so rapidly we can't even see the pulses.) When you consider that a flash could be firing multiple times during a 1/2000 second exposure, it's actually mind-bogglingly fast! The reality of it is, however, that the flash couldn't possibly provide its full output *and* recycle that quickly for each pulse, so it fires repeatedly at shorter durations—exposing only part of the sensor with each burst at a much lower output.

What the photographer needs to know is that high-speed sync is great when your flash needs are modest, but don't expect the full output of your speedlight when you set that shutter speed higher than its optimal flash sync speed. Third-party flash systems—as opposed to speedlights, are not integrated by the camera manufacturer in to this complicated web of split-second magic, so they cannot function with high-speed sync.

The image area is fully exposed between first and second shutters at slower shutter speeds. Normal flash sync can occur at these speeds.

As the shutter speed increases, only a window of the image is exposed at any one moment. The two shutters "scan" across the image.

As shutter speeds get even faster, a proportionately smaller window of the image is exposed as the shutters pass over the image.

High Speed Sync flash fires in pulses as each part of the image is uncovered

Normal flash fires in sync with full image uncovered

The gray box represents the first shutter; the black box is second shutter. Typically, they move from top to bottom at the same speed, but with less and less delay between them for shorter shutter durations. Note: This illustration has been simplified for clarity and is not 100 percent technically accurate.

Rear Curtain Sync

At any speed up to your highest normal flash sync speed, the flash could fire at any point while the image is revealed completely by the shutters. This is possible because the flash duration is much shorter than the time the shutter is completely open. Typically, cameras are set for first curtain sync, which means it will fire the flash as soon as the first curtain fully clears the image. If the subject is moving during slower shutter speeds, some blur will occur, and a sharper "ghost" of the image also will be exposed when the flash fires. This can be a great way to illustrate movement; however, with first curtain sync the blurring will appear to occur in front of the moving object, which is unnatural looking to humans.

To avoid these painfully awkward moments, the camera can be set to *rear curtain sync* instead, which fires the flash just before the second shutter begins to close. This will create the ever-desirable ambient blurring behind the subject's direction of travel, creating a natural-looking artistic interpretation of movement and avoiding potential professional embarrassment. I set my camera to rear, or

HIGH-SPEED SYNC VERSUS NEUTRAL DENSITY FILTERS

An ND filter is essential when you want to shoot in full sun, at f/1.4, for example. Remember your Sunny 16 rule? On a sunny day, to achieve f/16, use 1 over the ISO rating as your shutter speed. For example, if the minimum ISO of your camera is 200, you would use a shutter speed of 1/200 second to properly expose at f/16. Doing the math, and working backward to f/1.4, means I'd need a shutter speed of 1/51,200! This is faster than any current SLR camera shutter. A 3 f-stop neutral density filter would bring my shutter speed down to 1/6400 second—within the capabilities of most modern dSLRs. An 8 f-stop ND filter would bring the shutter speed right back down to 1/200, which is within my optimal flash sync range.

When I need more effective output from my flash systems and I am working in a lighting situation that would normally require a faster than optimal shutter sync speed, I also will turn to a neutral density filter rather than using a speedlight and high-speed sync. The ND filter allows me to set my shutter speed to 1/250 second or slower, and still keep my larger aperture. I've discovered, through my own testing, that I can get more useable output from my flash systems at full power coupled with an ND filter than I would using high-speed sync at faster shutter speeds. It also allows me to use my other flash systems that otherwise wouldn't work with sync speeds over 1/250.

I keep a *Vari-ND* filter in my camera bag at all times. This is a neutral density filter that seamlessly adjusts from 2 to 8 f-stops of density with a simple twist of the filter. Buy one size for your largest lens filter size (77mm, for example) and then get some step-down rings for your smaller lenses.

The first image on the left was shot with a Lumiquest large LTP softbox on an SB900 Speedlight on full power. I needed a shutter speed of 1/8000 second to properly expose my sky and clouds *and* use an f/2.0 aperture—so high-speed sync came into play.

The second image on the left uses an ND filter adjusted to give me a matching exposure for the sky, resulting in a 1/250 second shutter speed. The same flash setup, still on full power, gave me 2 f-stops more output! This is a clear indication of the efficiency advantage of the ND filter with a speedlight.

second, curtain sync and just leave it there. I haven't found any downside to doing so, and I never have to worry about accidentally creating a front-curtain faux pas.

Let's talk about light ratios a bit more, shall we? The light ratio is the relationship between the main and fill lights. It can be explained in one of two ways, which occasionally causes confusion. First, a light ratio can be simply the output of a single light source, as measured solo at the subject compared to the second light source, also measured solo at the subject. For example, a fill light illuminates all that the camera sees and reads f5.6 at the subject. A main light illuminates one side of the subject only and also measures f5.6 at the subject. In this first method of describing ratios, or the *incident method,* you have a 1:1 ratio. It simply compares the output of each light individually. If the main light, in this same scenario, were measuring f8, then we'd have a 2:1 ratio.

In practice, however, this explanation of light ratios gives you no direct indication of how that light would look on the subject when they are both illuminated and captured by the camera. A 1:1 ratio sounds very flat and even, when in effect there would be *double* the light on the main light side of the subject—creating mildly shapely shadowing. Why double? Because light is additive,

remember? The f5.6 from the main light would be added to the f5.6 of the fill, measuring f8 when both lights illuminate together. So, the camera actually sees f8 on the main light side and f5.6 on the fill side. This is a 2:1 light ratio as described in *reflected light* terms.

Although various texts refer to these ratios as *incident versus reflected,* or *source versus additive,* I find it makes more sense to simply think of them as power ratios versus visual light ratios. The power ratio simply tells us how much output we have from the main light compared to the fill. The visual light ratio is what we actually see as the result. For most practical purposes, we really just need to know what we'll be seeing, and most photographers rarely sit and calculate ratios and numbers; instead, they just adjust lights until it looks right. Needless to say, all knowledge is good knowledge, and understanding the basics of what light ratios are and, more importantly, how they look is smart practice.

The following simple chart illustrates some common light ratios (in additive or visual light terms) and the corresponding measurements of each light source solo versus their effects combined. Note that the last row is a measurement of the main light added to the fill versus the fill alone.

Visual Light Ratio (main:fill)	2:1	3:1	4:1	5:1
f-stop difference of main and fill light *measured individually*	0	1	1.5	2
f-stop difference between main and fill *measured combined at the subject*	1	1.5	2	2.5

These images illustrate 2:1, 3:1, and 4:1 light ratios, respectively.

It is most helpful to know that generally speaking, higher light ratios, which indicate more contrast, are more appropriate for character studies, males, and dramatic lighting; whereas lower light ratios are more flattering to women and create "softer" overall feeling images. This is a broad generalization, of course—and please, take the liberty to break the rules.

THE COLOR OF LIGHT

Light has color. This probably comes as no surprise to most professional photographers, and even amateur photographers, as we've all seen the little sunny, cloudy, lightning bolt, and light bulb icons on our digital cameras for many years. These white balance settings are designed to compensate for the varying color casts that different lighting conditions create. What many photographers don't fully consider, however, is how subtle changes in the white balance can affect the mood of an image. Just as we consider how lighting style, intensity, softness, chiaroscuro, and direction influence the feeling of the image, we also must consider the impact of light color.

The ABCs of White Balance and Color Temperatures

Generally speaking, warmer (yellow to orange cast) light imparts a more comforting, romantic feeling. Think of the yellow flame of an open fire, entrancing you and calming your mind. Cooler light (blue and cyan) can be invigorating, moody, mysterious, or even foreboding. Think of the blue ice in the middle of a glacier or the expansive, unknown of the deep blue sea. Simply changing the color of your light can alter significantly the mood of the image—all other elements remaining equal. As a photographer, you always should be asking yourself, "What color of light best suits this image?"

Color temperature is expressed in Kelvin (K), with lower numbers being warmer, or more yellow, and higher numbers being cooler, or bluer. In photography, we typically deal with a range of 2700 K (for a home light bulb) to 6500 K (for overcast daylight), although numbers beyond these can be encountered. High-end digital cameras can adjust manually for temperatures from 2500 to 10,000 K. 5500 K is considered "normal" daylight and neutral, rendering colors in their true form. It is very common to confuse Kelvin for Kevin, although there is no formal relationship.

Digital cameras can be set manually to match the color temperature of prevailing light—essentially counteracting it with the necessary adjustment to make the light appear at 5500 K. They also can be set to *Auto White Balance*, whereby the camera analyzes the scene through the lens and makes the adjustments it thinks are necessary to achieve 5500 K light. Photographers need to know the limit of their cameras intelligence, however. When the camera sees a blue man in a blue shirt against a blue wall, it really doesn't know whether a preponderance of blue *light* or blue *objects* exists. It just sees blue and wants to compensate by neutralizing the scene with more yellow. The actual light illuminating this scene could have been completely neutral, but the camera wouldn't know that. You, however, could know that and could make the necessary manual WB adjustments to render the blue in all its bodacious blueness.

A color temperature scale showing approximate Kelvin numbers from warm to cool and common corresponding camera WB settings

Light also can have color tints, which normally range from green to red/magenta. Typical fluorescent lighting has a green tint that is balanced with the complementary color, magenta, to make it neutral.

One of the truly fabulous things about digital RAW files is that the color temperature and tint can be balanced later in software, with no loss in image quality. This leaves room to compensate for camera misinterpretation or your own creative interpretation. The same is *not* true if you capture JPG files; however, as significant losses in image quality will occur when large adjustments to the color are made in postproduction. Shoot RAW and be smart.

Matching Supplemental Light Color to Existing Light Color

Most electronic flash units are designed to output fairly neutral light—in the neighborhood of 5500 K. Your mileage may vary, however, and there is often noticeable variation in color temperature from unit to unit. It's a good starting point for making educated corrections when you need your flash color temperature to match warm tungsten lights in a room, for example. Matching color temperatures from various light sources (other than when purposely mismatched for artistic liberty) is the mark of a true professional photographer. When done properly, light should appear seamless—as if coming from similar sources.

One of the most common instances where the mismatch appears, and is undesirable, is at indoor events under tungsten lighting where the photographer also uses flash to help illuminate the foreground subject. The background will be warm due to the tungsten lighting, but the flash-lit areas will be neutral. The dramatic color difference makes the subject look very "detached" from the background and very much like a typical snapshot from a consumer point-and-shoot camera. The solution is to put a warm, tungsten-colored gel over the flash to make it match the tungsten lights in the background. If the background is lit by older fluorescent bulbs, then a green filter can be put on the flash to make it similar to the fluorescent. In both instances, the camera WB setting should be adjusted to match the ambient light, rendering everything nicely neutral.

Color-correction gels, or filters, are readily available for flash units, but my favorite are Sticky Filters. These are designed for speedlights in typical color-correction values, sized just right and ready to stick to the front of a flash. They incorporate a reusable sticky surface (similar to Post-It notes) that makes them a breeze to use. Each set comes with a variety of colored gels in a handy dispenser pack.

Estimating and matching color temperatures between lights is not an exact science, unless you have a color temperature meter. In practice, however, you can evaluate the differences between light sources by looking at your camera LCD and making adjustments. If the flash looks too blue compared to the background, add a warm gel to it and try another test shot. When the balance feels close, the final camera WB setting is not as critical because this can be fine-tuned later in software, as mentioned earlier. It's much harder to fix an image where the WB is different in various areas of the same scene than to fix a global WB problem. Match the light temperatures within the image and all will be well.

This shows the necessary complementary colors needed to neutralize colorcasts.

Checkout: After our photo session with these two young shoppers, they climbed up on a chair and chatted with the store clerk at the checkout counter.

Chapter 4
An Overview of Essential Lighting Tools

Most every lighting scene starts with a point source; often the bare, naked, vulnerable bulb or flash tube. Consider this your sun. Now you have to make a decision: Do you diffuse it, block it, bounce it, reflect it, or focus it? Maybe you'll use a combination of several, or all, of these. How wonderful it is to play with light! It's an art in itself, and shaping a subject with light is like creating a sculpture. To see the shapes change and evolve, and the mood transform from dull and mundane, to dramatic and edgy, is pure magic. So begin your sculpture by asking yourself one question, "Do I feel lucky?" No wait—not that one; this one, "What kind of mood do I want to convey?"

Although this might sound odd, how to light a subject is often the afterthought of a photographer. Many times photographers will plan a great scene, with a great subject and cool props, but then just throw in whatever lighting they have available—or, more likely, are most familiar with setting up. This doesn't guarantee the light will match, enhance, or even complement the subject and scene at all! Lighting is an integral part of the creative process and often is the most important aspect of defining the mood of a photograph.

CHOOSE YOUR TOOLS WISELY

So let's get back to your sun. Don't stare at it. By itself, it can be a useful and distinct lighting style, whether from the real sun or your portable version. Bare-bulb flash is commonly used to add a natural, "sun-like," crisp light. Bare-bulb is when you have no diffuser or reflector over your point light source. The flash tube on most studio-type flash units

extends out from the body of the flash and effectively throws light in all directions—just like a light bulb in a bare socket will do. Often, this is what you want. Perhaps you want to light a room, bouncing light off ceiling and walls in all directions, bathing everything in crisp, direct light and reflected fill light. Go for it, baby! Just make sure this is exactly the mood you are looking for.

The next step would be to ponder a bit. Hmm, maybe I don't want the "light everywhere scatter bomb effect." You need control and direction (much like my children, bless their little hearts). Imagine the mood you are trying to create and then choose the tools to modify your "sun" and create it. Here's an example of how to think about building your lighting sculpture.

1. Create a calm, early morning or evening mood with warm, directional light through the window. Consider slight warming gels over a partially diffused light through a window or fake window. Add slight fill light to the interior by bouncing some light off the ceiling.
2. Create a moody, pensive, or dramatic environment with directional light, similar to a single lamp or sconce. Leave deep shadows to build shapes and mystery. Use warmer gels to simulate evening lamp light.
3. Create a playful, friendly feeling with open and diffused lighting. Bounce your light source in the ceiling or walls for softer illumination. Highlight parts of the room with warm diffused light in the background to focus on interesting fixtures or textures. Reduce shadows to keep it fun and "safe" feeling.

Do you see where I'm going here? Pick your mood and then pick the tools to create it. We'll go over the various light modifiers and how they can be used to achieve the mood you want in a minute, but first I'll give you a real-world example of how I plan an image and the thought process for the lighting that supports it.

The following image was for a boudoir portrait (details on how it was created are in the Notebook section). I knew that this image would be used in a book and would be publicly shared. I wanted an image that was sexy and, obviously, complimentary

to the subject. However, I didn't want it to be overtly sexy or provocative, rather I wanted it to be fun, playful, and sassy. Yes, that's it, sassy. If I used very dramatic lighting, emphasizing her body more and creating moody shadows, it might be an image her husband would love, but I wouldn't feel comfortable sharing it in a book my kids might read! (Someday, they may actually take an interest in what dad is writing). My goal, instead, was to focus more on her lovely face, keep the light fresh and open feeling, drop hints to her body in the negligée, and elicit smiles and laughter—rather than sultry gazes. The style of lighting I chose changed the mood and feel of the image from one that may have been destined to a private collection to one more suitable for PG-13 sharing.

Using bright, open lighting creates a mood that is more approachable and a little less provocative.

To achieve this mood, I used a ringlight for the main light, which gives soft, bright, even illumination. I also used speedlights to bounce more fill light in to the surrounding walls—enhancing the airy, Sunday-morning feel.

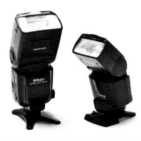

Speedlight from Nikon and Speedlite from Canon

FLASH LIGHTING EQUIPMENT

Commonly referred to as "strobes," they don't actually pulsate like disco lights at the dance club you closed last night. (Well, in some cases they *do* actually strobe). Flash lighting falls into three basic categories: speedlights, monolights, and power pack with head systems. They can be battery powered, A/C powered, or both. No matter how much you love natural light, you'll need to own and master a few basic flash systems. When you don't have great natural light, you can create the look of natural light with properly managed flash equipment.

Speedlights versus Speedlites

Speedlight and Speedlite are trade names used by Nikon and Canon, respectively. The term is generally used, however, to indicate any brand of battery-powered flash unit that mounts to the camera hot shoe. I'll use the *speedlight* version from here on as a generic term to reference these, as it grammatically makes more sense. When you buy a speedlight from the same manufacturer as your camera, you gain TTL, or *Through The Lens*, control of that flash. This means the camera makes complicated decisions and adjustments to its exposure and flash balance based on what it's seeing through the lens. Prior to TTL systems, a flash used a sensor built into its body to see the light reflected back from a subject and automatically shut itself off when it sensed enough light was there for a "normal exposure." This is usually the "A" mode, or Auto Flash, on most units. The accuracy of Auto Flash ranges from awesome to "what the heck?!" I have used it in the past, but probably never will again.

There's been an amazing flood of speedlight-specific light modifiers to hit the market in recent years, making location work for photographers faster, more efficient, and easier on the spine than ever before. One of the main limitations of using speedlights as a primary light tool is the limited power output. With the higher ISO capabilities of today's cameras and the availability of tools to hold multiple speedlights, this limitation is diminishing. Many situations still demand the power and fast recycle time of a moonlight or power pack system, so you'll probably

Table 4-1 Comparison of Power Output at Different Zoom Settings. ISO 100 at 10 ft

Nikon Speed-light	Zoom Setting	Measured Output in f-stops
SB900	200mm	11.6
SB900	35mm	8.4
SB800	105mm	8.8
SB800	35mm	8.3

want to own some of each. See the above table for an interesting power comparison of some common flash systems.

Monolights

One of the most versatile and useful inventions of the free world is the monolight. Essentially, it is a self-contained studio flash with A/C power system, flash, and controls all in one relatively compact unit. They range in power from 150 watt-seconds to 1600 watt-seconds or more. Monolights plug right into the wall socket (or a battery pack providing A/C power, covered later). Although a monolight may weigh more than the head of a power pack / head system, you gain simplicity and portability compared to all the components of the pack system. Pack systems often can offer much more power output, however, for really demanding lighting jobs. The downside to a monolight is that because all the controls are on the head itself, you may have a hard time adjusting it when it's high up on a light stand or boom. Modern remote control units solve this problem elegantly, however.

A D1 monolight from ProPhoto. It offers extensive controls and a remote to adjust the flash from camera position.

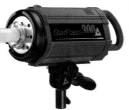

The StarFlash monolight from Photoflex is affordable and solidly built.

Wescott makes a line called PhotoBasics and this is its Strobelite monolight. It is compact and affordable in its ninja-like packaging.

The Alien Bee monolight from Paul C. Buff. These are very compact and affordable systems.

Photogenic monolight. They have been around a long time and offer a good quality to value ratio.

Power Pack and Head Systems

When the time comes to light the side of a building from 100 yards away at f/22, you need a power pack system. This is essentially a sturdy box supplying up to 3000 watts, or more, of power with one or more flash heads connected to it via cables. All adjustments are done via the pack, safely at your feet, while the heads are placed around and above your subject. When you need the power, you need the power. But, having used these extensively as a commercial photographer, I have to say they can be a pain in the butt. The cabling to the head is usually limited so that placing two heads at opposite sides of the set, while connected to one pack, can be an exercise in creative snake arranging. The packs are usually heavy, and it creates more stuff to carry and set up on location. If you don't need the additional power, consider monolights for most portrait studio and location work—especially when paired with a remote control.

The Profoto AcuteB2 AirS is unique among pack and head systems in that it has its own rechargeable battery for working off the grid. It can also be used in the studio like a normal pack system. It has a built-in radio receiver, too.

CONTINUOUS LIGHTING EQUIPMENT

Traditionally called "hot lights," today's continuous light sources are no longer necessarily hot to the touch, thanks to modern fluorescent and LED technology. So, let's just call all "always-on" light sources "constant lights." Constant lights today are generally typical tungsten bulbs, HMI, fluorescent, or LED. Other types are available, but these are most common. The main reason for using constant lights in photography is that you see what you are going to get before you take the photo. This is often much easier for beginning lighters (and experienced ones as well, of course).

Tungsten Bulb Lighting

The good old household bulb hasn't changed much since Edison brought it to light in the late 1800s. It's moderately bright, it gets hot, it's fragile, and it's cheap. Only the cheap part appeals to photographers. Tungsten bulbs are warmer in color temperature, requiring adjustments to white balance in-camera. Although knowing how and when to use tungsten bulbs to light a

scene is very valuable, they don't make a great addition to most photographers' daily lighting kit. Taking advantage of tungsten lighting that already exists in a location, on the other hand, can be very important. Tungsten lights create a certain mood and warmth that is both familiar and comforting to most people. It's important to know how to balance the intensity and color temperature of our supplemental lighting with that of existing tungsten lighting on a set or in a home.

LED Lighting

Remember when having an LED watch was really cool? Back then, a light-emitting diode didn't really put out much light—just a groovy red glow, indicating you'd been playing Space Invaders for 12 hours straight. Today, LEDs can be bright enough (when grouped together) for moderate lighting needs. They are the most efficient of our lighting options, making more light from less power. They are relatively expensive because you need multiple smaller bulbs to create useable light output. They are best used, and most common now, in compact "video light" type systems. I expect they will be more commonplace in studio lighting as the technology continues to evolve.

High-powered LED flashlights, on the other hand, are very handy to have around as a lighting tool for dramatic effects. I use a couple of high-output LED flashlights for dramatic spotlight effects when the existing light is relatively low. In full daylight, they are not quite powerful enough to generate much effect, but in shade or indoors, they can come in quite handy. If you can find one in the 300–500 lumen brightness range, and with variable, or at least 2-level, dimming, you'll have a cool tool at your disposal. I show several examples of images made with these flashlights in the Notebook section.

LED scuba light, flashlight, and Doug Gordon Torchlight.

HMI Lighting

I love HMI lights only because of the name, Hydrargyrum medium-arc iodide. Although they may be useful on movie sets, they are not really practical for portrait studios. They are very bright, daylight balanced, very hot, and somewhat unstable. Practice saying the name though; it will really impress your friends.

Fluorescent Lighting

Cool and efficient. That's the name of the game with fluorescent light bulbs. A 100-watt fluorescent bulb will put out roughly the same light as a 400-watt tungsten bulb. Even though they cost a bit more, they last nearly forever, are more stable, and can be daylight or tungsten color balanced. Most studio lighting manufacturers now offer some type of fluorescent fixture for mounting multiple bulbs as a gang together. They can be used inside of softboxes and enclosed modifiers because they build up much less heat than tungsten or HMI-type lights. Many photographers and videographers use fluorescent light setups in their studios because they are color balanced and cool for extended periods of shooting.

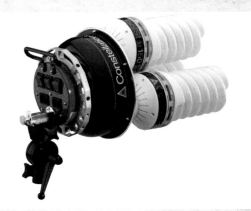

The Constellation from Photoflex holds three fluorescent bulbs for a virtual universe of light! Each bulb can be turned on independently.

Flashlights

As mentioned in the section on LED lighting, flashlights are great gadgets to keep in your lighting bag. Even a lower-powered common flashlight can be used to "light paint" during a longer exposure, adding attention and interest to key areas of an image. Most LED flashlights are bright and close to daylight color balanced. Older filament-type lights will be warm and closer to tungsten

balanced. Larger roadside spotlights can be used for dramatic lighting effects, even in relatively bright existing light. I purchased a Dorcy rechargeable LED spotlight from Sears for about $45. It's rated at 500 lumens and creates a tight, even spotlight shape—perfect for Hollywood-style drama. Even if you don't ever use a flashlight for photo lighting, it's a good idea to keep a small one in your camera bag for finding that memory card you dropped on the way back to the car at night.

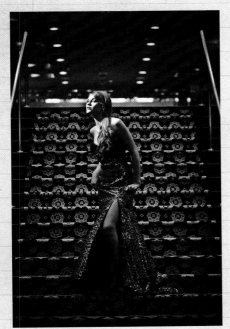

An image made with existing light and my Dorcy emergency spotlight.

Video Lights

They call them video lights because they are popular with videographers and are designed to mount in the camera hot shoe for supplemental (if not flattering) light in any situation or location. You don't have to be a videographer to use them, however, and when taken off the camera and used for effect, they become another handy trick in your pocket. Video lights, compared to flashlights, generally produce a broader light pattern, evenly illuminating a greater area with a wash of light. This can be really helpful, or really boring. The most useful ones are compact and battery powered with LED bulbs being the most efficient. Sometimes video lights come attached to a videographer, like at a wedding. In this case a little prodding and hard

candy might be necessary to convince the light to shine in your preferred direction.

DIFFUSING TOOLS

As you learned earlier, the size of the light source determines how soft it is. In my handy digital dictionary, diffuse means to *spread over a wide area*. So, in order to make the light from a small flash tube large and soft, we have to diffuse it by spreading it out across a larger object, *which then becomes the new light source*. A light can be diffused by shining it on to the back of a translucent object or by reflecting it off a larger surface. When a piece of translucent fabric, or other object, is used between the light source and the subject, it's often referred to as a scrim, or silk. When an object is used to bounce light from the source to the subject, it's called a reflector.

Scrims

I like my scrims. They are probably some of the most used and useful tools in my lighting kit. There are jillions of products available to scrim your own light. A scrim can be as simple as a bed sheet hung in front of a window, diffusing the harsh direct sunlight into something lusciously soft and shapely. My personal favorite tools for scrimming (yes, that's something me and the boys go out and do on Friday nights) are the collapsible frame and fabric kits and the pop-up discs from Photoflex. These tools have been the mainstay of my lighting style and arsenal for many years. They are extremely versatile, affordable, and durable. Good stuff. Many other manufacturers make similar products, which are functionally identical.

Photoflex LitePanels can be covered with diffusion fabric or reflective fabrics.

The 42″ Photoflex diffusion LiteDisc is my favorite size for most uses.

One of the simplest ways to get great head-and-shoulders light on location is by firing a speedlight (or any light) through a pop-up disc. One assistant can hold the disc in one hand and the speedlight in the other at arm's length away from the back of the disc. You could, of course, use a light stand and support gadgets for them instead (covered later in this section). Be sure to check the zoom setting on your flash to make sure it's covering the full diameter of the disc properly. Generally, when held at arm's length, a 50–70mm setting on the flash works well.

When combined with TTL wireless flash control, this setup is nearly foolproof. If you set your flash for a normal exposure (no + or – compensation) and set your ambient light compensation to minus 1 stop, you should get about a 3:1 light ratio on your subject.

This disc/speedlight combo creates beautiful light, and the whole package collapses and fits in your camera bag. I use a Tamrac Super Pro 13 camera bag, and it's perfect because the pocket in the back that's made for a laptop also doubles as a pop-up disc holder. The 42" disc, when collapsed, fits like it was made for it.

SCRIMMING FOR THE MASSES

Each year we do a charitable photo shoot in which we work with other local photographers to provide holiday family portraits for folks in need. We spend the day at a local park and literally photograph *hundreds* of families in a few hours. It's an amazingly rewarding endeavor.

One year when we were just getting it started, I asked the other photographers if they had scrims to diffuse the sunlight. None of them did. We couldn't afford to purchase professional kits for everyone, so we made a quick run to Home Depot and the fabric store and spent the afternoon building our own DIY scrims for everyone to use. The quality of the portraits was dramatically better that year.

The 42″ collapsible disc fits perfectly in the laptop pocket of my Tamrac bag.

Lastolite also makes a great product that is similar to the pop-up discs from other manufacturers but is teardrop shaped and has a sturdy handle on one corner. It is much easier to hold these in position when you have only one hand available. An assistant could hold one in each hand, creating butterfly lighting, or other more complex arrangements with very little setup time or fuss.

The Lastolite TriGrip is available in diffusion or reflective fabric options.

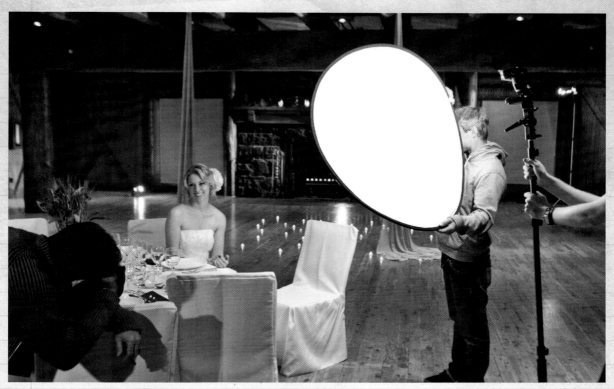

The diffusion disk and a speedlight make a great location portrait lighting setup.

Larger frames, like the Photoflex LitePanel kit, are incredibly versatile as you can put diffusion fabric, white reflective, silver/gold reflective, or black fabrics on it. The benefit of the larger scrim is the increased surface area, which translates to gorgeous, soft, diffused window-like light. You can put two or more frames together for an even larger, softer light source.

You could also make your own frame and scrim using PVC pipe from the hardware store and parachute nylon from the fabric store. I've made a few of these myself (see "Scrimming for the Masses"). Although not as elegant or quick to set up and take down, they get the job done and can save quite a bit of money. Eventually, you'll want a good one from a company like Photoflex, but if you're just getting started, don't let your budget get in the way of creating beautiful light with a large scrim.

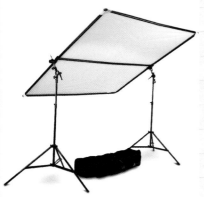

The large Photoflex LitePanel creates amazingly soft window-like light.

My DIY scrim made from PVC pipe and parachute cloth. It's not as portable or easy to set up as the manufactured versions, but it's cheap.

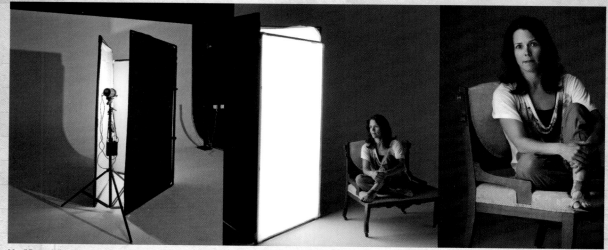

My "Panel Box" setup creates a soft, beautiful, window-like light. Use clips or gaffer's tape to hold the panel edges together. Make sure to create a triangle with the frames around the light so the light bounces forward through the diffusion face. Notice the placement of the panel box; the back edge is approximately even with the subject's ear. This allows the light to wrap forward and around the subject.

To create a beautiful, large, window-like light source, clip three large panels together to form a triangle around your light source. The facing scrim will have diffusion fabric, and the two side scrims will have white reflective fabric on the insides to bounce any stray light forward through the face. This creates a soft, directional light, similar to the look of a giant softbox that would be quite expensive, using tools you can multipurpose for other uses, too. I've used this setup for a variety of portraits—from babies sitting on the floor to full-length body shots and small groups.

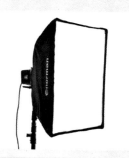

A typical rectangular softbox, which is a staple in most photography studios.

Softboxes

Although familiar to most photographers, softboxes come in so many shapes and sizes that it may be hard to determine what you need and when to use it. Just buy them all! Just kidding. I'll give you a few tips on picking your perfect softbox, or boxes. A softbox would be used instead of a scrim when you need more control over the direction or spill from the actual light source. Although a scrim softens the light on the subject, stray light from the flash itself is still being sent bouncing around the walls or is lost in space. Sometimes, this is fine, or even necessary. When you do want all of your flash power focused on the front of the diffusion surface, making you feel in control of your photographic destiny and the light you create, then a softbox is the way to go.

Another feature of a softbox is its shape. When placed close to the subject, the shape of the softbox reflects in the eyes. When the image being made is a close-up, this "catchlight" is actually very integral to the feel of the image. Larger catchlights make the eyes seem brighter and more appealing. Smaller catchlights make the eyes darker and more mysterious. The shape of the reflection, which is the shape of the box, can also be significant. A round or octagon-shaped softbox creates round catchlights, which match the shape of the iris and look very natural. Square and rectangular catchlights in the eyes give the essence of a big window light, which is also very natural and familiar to most people. Neither is right or wrong; it's really a matter of taste. Just remember that a larger catchlight, created by moving the light source closer or making it larger, will create brighter, more "twinkly" eyes, which people and animals generally find more attractive.

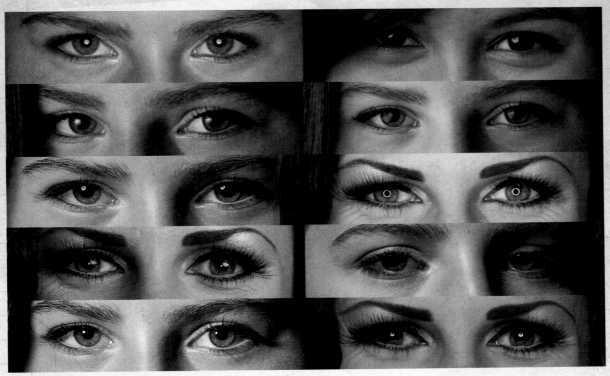

A virtual plethora of catchlights. Which one catches your eye?

Softboxes can be attached to studio monolights and/ or speedlights. In the last few years, there have been all kinds of new products for attaching speedlights to studio softboxes. Life is good. One of the sore spots for many photographers, and especially their assistants who have to do the setup, is the assembly of a softbox. Because of the inherent design, you have to bend flexible rods, while under tension, and place them in tiny pockets in the *speedring* (the device that forms the base of the softbox and attaches to the flash itself). It's usually the disassembly that causes cursing and the oft-heard profession, "If they can put a man on the moon, why can't they make a softbox that is easy to take apart!" Yes, I've cursed and broken a few fingernails in my career.

Times have changed, though, and many attempts have been made by manufacturers to make the assembly and disassembly of softboxes more agreeable. When purchasing yours, look for features like releases in the corner pockets and larger flaps near the back of the box that allow for reducing the tension on the rods when assembling and disassembling. Although nobody has actually managed to make setting up a box *fun*, one

product comes close—the Ezybox, by Lastolite. Even though it's designed only for speedlights and comes in smaller sizes, it uses the flexible wire technology used in pop-up discs. Setup or takedown literally takes seconds, and nobody gets hurt or yelled at.

The Lastolite Ezybox is the simplest and fastest softbox to set up. It is designed for speedlights.

I have softboxes of all shapes and sizes, but I tend to find that I end up using a couple of them more than most. I love the Ezybox and my OctoDome from Photoflex. I particularly like the smaller OctoDome nxt: Small.

The Photoflex OctoDome small and extra small.

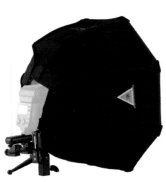

The Photoflex OctoDome NXT XSML is perfect for use with speedlights but can also mount to most monolights or heads with a standard speedring.

The small OctoDome seems to be a great size for portraits, and the fact that it is about double the size of a human head may have something to do with the "just right" lighting it achieves. If you take the diffusion face off the small OctoDome and use the white inner panels, it functions very similarly to a beauty dish, which is still soft, but a little more crisp.

Beauty Dishes

When you are really hungry, just about any dish is beautiful. For photography, however, only specialized tools will do. A beauty dish is a round dish-shaped modifier that is somewhat soft, but crisp and directional. You'll see a bit more specular highlights and deeper shadows from a beauty dish than a softbox of the same size and shape. Many photographers swear by a beauty dish for fashion photography as it seems to strike just the right balance of soft and crisp.

Although usually white inside, a beauty dish could also be silver. White creates a softer, more even light. Silver will be more specular and will preserve more light power from the flash unit.

Umbrellas

Lighting umbrellas have been around since the dawn of time (or thereabouts) and they certainly are a cheap and effective way to throw light all over the place. I've person-

A beauty dish for Paul Buff light units.

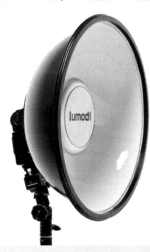

This unique dish from Lumodi is designed to mount on speedlights only and is made of plastic, so it's very lightweight.

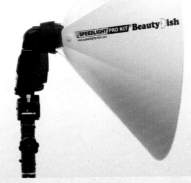

This beauty dish from Speedlight Pro Kit wins the award for most innovative accessory! It's a cross between a Japanese origami project and a doggie scratch protection collar. Despite the unusual design, it actually works great. It has nice, efficient output and folds nearly flat for transport. We use this product in many of our photo shoots.

ally never been a real fan of them because of their lack of control and character in the light. When you just want to cast light over a big area, however, they are very useful.

A variation on the classic reflective umbrella is the parabolic translucent umbrella. Several manufacturers make these, and their uses are much more varied than the standard umbrella. Light can be bounced in to them, like a traditional umbrella, or it can be used to diffuse light—like a scrim. When a light is fired through the translucent umbrella (with the top of the dome facing the subject), the resulting light is bright in the center, with a rapid fall-off at the edges due to the curved shape of the umbrella. It has a very unique look and is quite nice, especially in the larger sizes.

Light Focusing Tools

Directing light precisely where you want it, in exactly the right intensity, is the objective of the savvy photographer. Lighting starts to become a whole lot more interesting when you learn to "paint" with light by illuminating only the parts of the scene that need the most attention. (Note that the term "light painting" is also used to describe the technique of moving a constant light source over the subject during a longer exposure). The following are common tools used to narrow, focus, or direct beams of light.

In Chapter 2, "The Lingo of Lighting," we covered snoots, grids, and Fresnel lenses—all useful tools for light control. One of my favorite ways to create that perfect "beam" of light is with a speedlight and the Rogue Grid by ExpoImaging.

ExpoImaging also makes the FlashBender, which is another unique product for "bending" light where you need it. They mount to your speedlight and bend in to whatever shape you need—either to bounce or funnel the

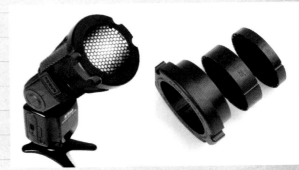

The Rogue Grid system includes two unique grid inserts to adjust the beam width from 16 to 45 degrees. I also use it without any grid insert for a slightly wider beam spread.

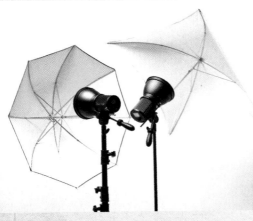

A white reflective umbrella and a silver umbrella.

light. I form mine into a snoot when I don't have enough Rogue Grids on hand.

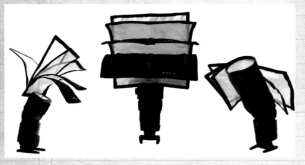

The FlashBender comes in a set with three sizes. You can bend or roll them in nearly infinite ways.

Triggering Tools

To fire a flash that is off your camera, you need a way to send it a signal. Once upon a time, the only way to do this was via a PC cable (nothing to do with personal computers) wired from camera to the flash unit. I personally feel that the design of the PC connector tip is one of the worst in history—up there with the Yugo and parachute pants. They would constantly fail, bend, or come loose. They even sold special tools just to re-align the connection tips because they got bent so often. Unfortunately, they haven't changed the design to this day. Fortunately, we have other *wireless* options.

Wireless triggers fall into three basic categories: basic manual triggers, triggers with flash power control, and triggers with power and TTL control for speedlights. Triggers range in price from fairly affordable to moderately expensive. Be careful about buying too cheap! It's really true that you get what you pay for, and although there are good, affordable triggers, there are also bad, affordable triggers. A trigger is worth less than nothing, however, if it fails to fire just when you might have had the perfect shot. Don't skimp on your flash triggers.

Here are a few options that I've used and with which I've had good results.

The RadioPopper also works manually or as a TTL repeater. It mounts to your flash to capture the IR TTL signal and convert it to a radio signal for a more reliable transmission.

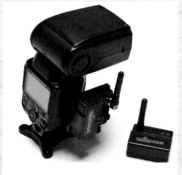

The MicroSync, from Tamrac, is very simple and reliable for use with studio strobes. It doesn't even need an on/off switch.

The PocketWizard TT5, TT1, and AC3 system allows for manual triggering, manual with power adjustments, and TTL control. It is one of the most versatile systems on the market.

The PocketWizard Multi-Max is a very robust manual trigger system with multiple coded channels. It can also be used to fire a remote camera, which we did for one of the shoots in the Notebook section.

Scott Robert Lim sells these basic manual triggers for speedlights. They have four coded channels and are very simple to use. They are some of the most affordable on the market while still being reliable.

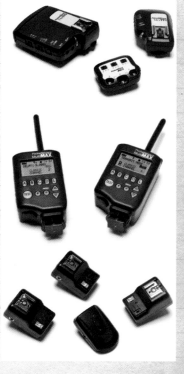

Most modern speedlights also have their own optical slave built in. An optical slave simply tells the flash to fire whenever it sees another flash fire. An optical slave is only reliable when it can clearly see another flash fire, so positioning of the unit is key. In bright daylight, they may not work at all.

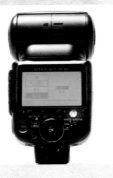

Setting the Nikon SB900 to "SU-4" mode will turn on the optical slave. I know what you're thinking, "Why the heck don't they just call it 'slave mode', huh?"

Although I love my wireless triggers, sometimes only a wire will do—like when you forgot your wireless trigger at home. It's a good idea to keep a few wires and adapters in your camera bag just in case. I keep a few old-fashioned PC cables, some hotshoe PC adapters (to connect multiple cables), and optical slaves on hand. The accessory optical slaves can be used to trigger a flash when the strobe doesn't have a built-in optical slave or it doesn't see the main light well enough to trigger. With a Wein Peanut Optical slave on a cable, I can position the slave in a more light-sensitive location.

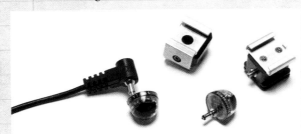

When you are on a budget, or have wireless phobia, then wires, slaves, and adapters will have to work.

You can also use the manufacturer's speedlight cable to move the flash a short distance off-camera and still maintain TTL control.

Light Powering Tools

Not all flash photography happens in the studio, and it doesn't always happen near an A/C outlet either. One of my favorite tools for bringing the studio outside is the battery-powered A/C adapter. These rechargeable battery packs allow you to plug in and power a standard studio light (or several) wherever you go. Just recently, battery technology has evolved to where the size and efficiency of these units has improved *tremendously*. Some of the batteries will even allow you to plug in a laptop for extended runtime in the field.

My favorite A/C battery pack, which will work with most studio strobes, is the Paul Buff Vagabond Mini Lithium. (Always read the instructions before plugging something in.) Considering that the previous model of this battery was the size and weight of a typical car battery, this new gem is a small miracle. If you already own Alien Bee, or other brand, monolights, then the Vagabond Mini makes a great add-on. Please check compatibility on the Paul Buff website before using with other lights, however.

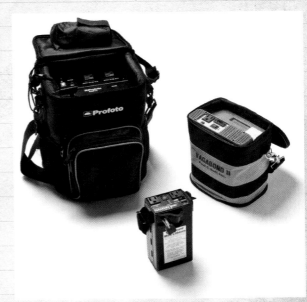

The Profoto battery, Buff Vagabond Mini, and previous model Vagabond II. All provide roughly the same power and number of flashes. Profoto lights prefer the Profoto battery pack.

Another variation on the battery-powered head are the integrated systems from companies like Norman, Quantum, Impact, and Photoflex, among others. These systems have small rechargeable battery packs and matched flash heads that function much like studio strobes. Some of these can be plugged into an A/C outlet for unlimited use in the studio and then transitioned to battery power when you move outside. My personal favorite is the Triton, from Photoflex. This system is extremely compact, well built, easy to use, and powerful.

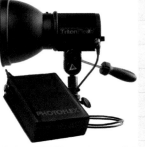

The Triton system packs a lot of features and power into a tiny, portable package.

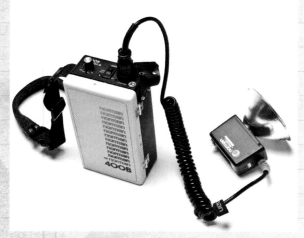

Norman has made this 400B system for a looooong time. It's not as flexible as some of the modern systems, but it's solidly built and reliable. I used these when I started shooting weddings 20 years ago!

Rechargeable Batteries versus Alkalines

No talk about batteries would be complete without a little message from Mother Earth. She told me to tell you, "Please don't use alkaline batteries in your speedlights. They are expensive, wasteful, and overly polluting to me—not to mention they recycle slower and don't last as long as a good set of rechargeable batteries." There, you heard it straight from your mother's mouth. Keep a set of alkalines on hand for emergencies, if you must, but use rechargeable batteries whenever possible. What Mother says is true; there really is no downside to using rechargeable batteries other than a few bucks more in the initial cost. After just a few uses, however, this quickly turns in to a savings.

If you tend to forget to charge your batteries before a shoot, then grab the ULSD (Ultra Low Self Discharge) type batteries. The common type of rechargeable battery will slowly lose its charge while sitting on a shelf waiting to be used. It's best to charge these within 24 hours of when you plan to use them for best results. The ULSD type can sit for much longer before losing a significant charge.

Helping Hands, Holding Tools, and Other Gadgets

A whole book could be written on gadgets, but I'll just cut to a few essentials that may not be obvious. Some of these are photo specific, and others are not. It's a great idea to have some good light stands for your lights. The operative word here is *good*. If you are on a tight budget, it's fine to get cheap light stands, they won't affect the quality of your images one bit. Cheap light stands fall apart, however, dent easier, and become harder to fold or set up. Eventually you *will* have to replace them, and you'll buy the better stands anyway.

A really great tool to have, for speedlight users, is an extending pole. This is like a monopod with a light stand head on it. We use these to mount speedlights and hold them up high where the sun doesn't shine. You'll need an assistant to carry the pole/light combo, but it's much faster than setting up and moving a light stand to just the right spot—especially if you like to scoot around a lot while you shoot.

Speedlight on a stick. This Lastolite extending handle is great for getting that light into all the right places.

Critical jobs like this require specialized equipment. A magic arm with a super clamp on each end will hold most anything.

Super Clamps and Magic Arms to the rescue! I don't know what I would do without these photo gadgets. Manfrotto makes the best ones, and they will save your bacon one day. You can do amazing things with two super clamps and a magic arm.

Make your own gobos for unique lighting patterns. Foam-core boards from the art supply store are great for use as reflectors, but they can also be used as gobos when you carve your own unique patterns in them with a chainsaw or hunting knife. Just kidding, use a utility razor and be very careful. I've cut windows, leaves, lines, and farm animals into my foam core. Your imagination is the only limit! Shine a light through them onto the background. Keep in mind that the closer the gobo is to the light source, the softer and larger the cast shadow will be. Plan accordingly.

A gobo made from foam core. I call this unique piece of art "Signal Strength." Thank you, Cindy Girroir, for your handiwork.

Following are a few more little things to make life easier.

True *gaffer's tape* from the photo supply store is relatively expensive, but it holds like crazy and is often indispensable. It's a good idea to get some black cloth duct tape from a home improvement store as well, for general use, as it's much cheaper.

Sticky Filters are reusable self-stick color-correction gels that quickly apply to the head of any speedlight. They come in standard color-correction sets. I've found these to be a huge *timesaver* over trying to tape or attach colored gels on my lights the old-fashioned way.

Instant on, instant off. Sticky Filters come with a lifetime guarantee against losing their sticky.

I depend on *neutral density (ND) filters* quite a bit to reduce the ambient light outside to a flash-syncable shutter speed. I explain more about this in several shoots in the Notebook section. You can get ND filters in set densities: 1-stop, 2-stop, and so on, or as variable ND filters that work like a polarizer. You simply rotate the front ring to change the density from 2 to 8 stops.

The Singh Ray is an expensive, but extremely high-quality variable ND filter.

Most guys need very little encouragement to go out and buy a multitool, but if you're not in touch with your inner tool-monger, then consider adding one of these to your photo tool kit. They will also save you one day—like the time I repaired the zipper on my wife's boot while at a wedding. Yah, I was the hero.

Leatherman makes some of the best multitools. I think they may come in fashion colors as well.

Keep *clips* and *pins* on hand to attach gels, hold fabrics, secure clothing, tighten backdrops, and myriad other tasks.

Don't leave home without *zip ties*. Right up there with Velcro and duct tape as one of the best inventions of all time.

Although not a lighting gadget, it is always a great idea to keep model releases on hand. If you have an iPhone or iPad, there are apps for creating *model releases*. I have it on my iPhone, so I'm never without one. Your model can sign right on the device and receive a copy via e-mail. Nice.

Chapter 5

Build Your Lighting Kit

This chapter is here simply to make your life a little easier. When I do lighting workshops, I often get asked to write down everything I use, so students can go and put together their own lighting kits. I tell them that it's probably not practical for me to write down *everything* I use, including my Dremel-Tooled, Hotshoe-Fitting, Pez Dispenser. What I want to know is what subject matter they typically photograph and what kind of budget they are working with; then I can recommend a lighting kit for them. There are ways to save money and still get great lighting tools.

When I first started out as a photographer, I made most of my own lighting tools simply because I couldn't afford to buy the good stuff. I would use foam-core boards from the art store, sheets and curtains from the thrift store, household lamps, PVC pipe from the hardware store, and lots and lots of duct tape. For the most part, it worked. They occasionally would fall apart during the shoot, and I'm sure my clients were less than impressed with the presentation, although most of them were freebies or trade-for-coffee-type arrangements, so I wasn't too worried about it.

As I began to get more actual paying clients, and the equipment started to get used on a regular basis, I started to realize the shortcomings of the tools—in efficiency, reliability, and impressibility. I then started to buy "professional" tools, but from low-end and generic manufacturers. This

was a slight step up, and it worked for a while until they inevitably broke—and they all broke. As fate would have it, my cheap equipment would always seem to break or fail the day before a really important shoot, and I found myself scrambling to rent or borrow replacement gear. I've learned, over and over again, the value of investing in good quality equipment, especially when it's used for your profession.

I've also found that *good* quality doesn't always have to be the most expensive. I don't need the best quality, but I do need good, reliable gear. I depend on it, and my clients deserve it. So there's a time and place for DIY gear, and a time to step it up. Your budget and shooting schedule will determine the right time to invest, and I do recommend investing in good equipment when it's time to buy. It costs more in the long run to buy cheap stuff that eventually *will* fail, than to buy the product you really thought you should have bought in the first place.

THE KEY COMPONENTS OF A LIGHTING KIT

At the very minimum, a lighting kit should consist of lights (duh), a way to trigger them, stands to hold them, and modifiers to diffuse or reflect them. The type of light could be constant light sources or flash. It rarely makes sense to use just constant light, as the heat or limited output will quickly rear its ugly head. If you can afford powerful enough constant lights to overcome the output problem, then you easily can afford a decent flash system. I suggest you add constant light sources later, if needed.

Triggering flash equipment, when off the camera, can be done the old-fashioned way—with a long PC cable (this reminds me of corded telephones, old school!) or with one of several available wireless systems. Honestly, neither is perfect, but I prefer to go wireless and deal with the occasional interference issues than to manage tripping over more cords and having them fall out of my camera on a regular basis. Some pro-sumer digital SLRs do not even come with PC connection ports anymore, so a hotshoe adapter would be required, which introduces more weak spots. I have cables and adapters in my lighting bag, but they are only for backup on the rare occasion that all my batteries are dead or I'm shooting in a known UFO landing spot, teaming with radio-jamming microwaves from another universe. Invest in a good wireless trigger system, and you will be a happy camper.

I've created four basic lighting kits for you to consider, starting with the least expensive and moving up. I also assume that you'll need more variety in your lighting tools as you progress. These kits are designed primarily for portrait photographers but could serve the needs of other photographers working in other genres as well. They are built from my experiences over the past 20 years and my reflection upon what specific tools I actually have used most often. Certainly, another experienced photographer may very well recommend completely different tools—and that's just fine. Just don't tell me about it. It might hurt my feelings. There are many ways to skin a cat, although I don't know any of them because I've never actually done it.

THE DIY LIGHTING KIT

You'll be amazed at the high-quality lighting you can achieve using do-it-yourself lighting tools. You'll look a little like a clown, but who cares, right? The most important thing is that your *images* will sing, and the client will be happy. Honestly, the actual *quality* of the light on your subject will be indistinguishable from that coming from tools costing hundreds, or even thousands, of dollars more. What you save in money, you give up in speed of setup, ease of use, durability, portability, consistency, flexibility, and professional appearance. For the photographer starting out, this could be a pretty fair trade-off.

The kit consists of the following:

- Two speedlights matching your camera manufacturer
- A basic wireless trigger system for two flashes (See "Basic Wireless Trigger Systems" in the Appendix.)
- Two light stands
- Diffusion frame made from PVC pipe from hardware store
- Diffusion fabric for frame made from nylon from the fabric store
- A white foam-core board (or two) from the art supply store for a reflector

The minimalism in light stands assumes that you could have an assistant to help hold the reflector or diffuser panel or that you would use only one light on one stand

and a reflector on the other. It certainly helps to have more stands and gear-holding accessories, but you can get by with this. I did for a while.

The diffusion frame is made by cutting lengths of PVC pipe to form the rectangular shape you want. I suggest 39 × 72", which matches the frame size made by Photoflex. This way you could buy just the fabrics from them and save money on the frame itself. Otherwise, go super cheap, buy parachute nylon from the fabric store, and sew a heavy piece of elastic across the corners to hook over the frame. Attach 90-degree corners to the PVC and glue only one side, so that the other frame pieces can be pressed into them, but still be pulled apart for storage. Optionally, run a long elastic cord through the pieces so that it more easily pulls together—like tent poles.

I recommend speedlights here instead of monolights because they are something that most photographers have, or need to have, anyway. They are impressively powerful (when the zoom is set to maximum) and quite versatile. The downside to using speedlights is that you don't have a modeling light, and you have to rely on batteries. A few test shots and a pocket full of rechargeable ions will help elevate that downside. Innovatronix also makes a cool A/C adapter for speedlights so you could run them indefinitely when plugged in.

The basic wireless triggers in this kit are from Scott Robert products. The set comes with three receivers and a trigger. The speedlight attaches to the shoe adapter on the receiver, and you turn it on. That's it. Well, it does have four channels you could change, but you don't need to unless you get interference from other units or spacecraft.

A GOOD BASIC PURCHASED LIGHTING KIT

This step-up kit consists of the following:

- Two speedlights matching your camera manufacturer
- An PocketWizard TT1/TT5 wireless trigger system, with TTL, for two flashes (See "Advanced Wireless Trigger Systems" in the Appendix)
- Two light stands
- Photoflex 39 × 72" aluminum LitePanel frame
- Photoflex 39 × 72" diffusion fabric
- Photoflex 42" MultiDisc pop-up reflector/diffuser with multiple surfaces
- Photoflex Extra Small OctoDome nxt for speedlights

Now things are starting to look good. We've added in some slick products, specifically made for photography, not plumbing, and spiced it up a bit. The DIY diffusion frame is replaced with a Photoflex collapsible aluminum frame. If you bought fabrics from Photoflex in the previous kit, they can still be used with this setup. The benefits

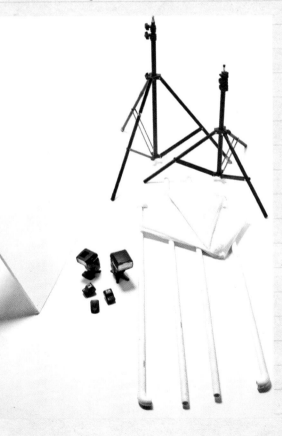

of the Photoflex aluminum frames are lighter weight, faster setup and takedown, available accessories, and fancy red corners.

The pop-up MultiDisc is an extremely versatile product allowing for diffusion or reflection—in a variety of intensities and tints. The OctoDome is a great mini light box that allows for soft, yet directional light, which is perfect for fashionable looks and edge lights.

The wireless trigger system has been upgraded to a more sophisticated unit, allowing for TTL, or manual, control of the speedlights. They also offer remote triggering of cameras and many other options.

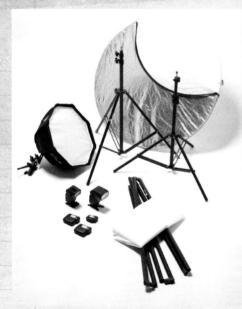

small groups of people. Fire two Tritons through this LitePanel and be amazed at the gorgeous light.

The Rogue FlashBender is a handy accessory to attach to speedlights for bouncing and softening the direct output. If you shoot events and use your flash on-camera quite a bit, this really improves the quality of that light. You can bend and twist the reflector in any direction you want, easily customizing the quality and direction of the bounced light.

The RogueGrid is another one of my favorite tools. It funnels the light into a spotlight, which is ideal for dramatic looks and highlighting specific areas.

The unique Speedlight Pro Kit Beauty Dish folds nearly flat but assembles into a light modifier that is crisper than the OctoDome and a little more efficient. This is great for fashion lighting and punchy senior portraits.

AN "I CAN LIGHT ALMOST ANYTHING ANYWHERE" LIGHTING KIT

This system forms the core of what I probably use 90 percent of the time. It's a super location lighting kit for those who travel a lot or shoot away from the studio. Most of the items are lightweight and portable. It consists of all the items in the previous kit, plus the following:

- Photoflex 77 × 77" LitePanel frame with diffusion fabric and white/gold reflective fabric
- Two more light stands
- Speedlight Pro Kit Beauty Dish
- Rogue FlashBenders for speedlights
- RogueGrid for speedlights
- Two Photoflex Triton flash systems with batteries

The addition of the Triton flash heads opens up the door to multiple light setups and adds monolight-quality lighting anywhere. The batteries last a really long time and recycle quickly. They also can be used when plugged in, so indoor use won't drain the batteries. Because they are designed primarily as battery-powered lights, the modeling light illuminates only for 10 seconds, usually long enough to check your light. I generally rely on my test shots anyway, so it's not that big a deal.

The larger LitePanel allows for some beautifully soft window-light looks and enough surface area to cover

THE STUDIO KIT

When you really start to buzz along, and you are tackling a wide variety of situations, you probably could use a few more tools in your toolbox. This is not to say that you

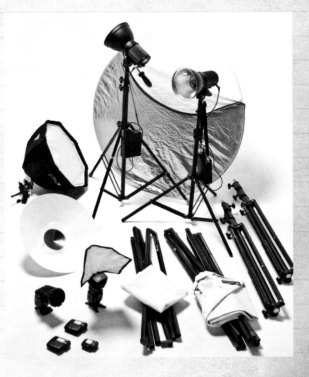

couldn't get along fine for many years with one of the previous kits, but it really is nice to have more options. This kit contains all of the previous two kits, plus the following:

- A third speedlight
- A third PocketWizard TT5 transceiver
- PocketWizard AC3 ZoneController
- A second PhotoFlex 39 × 72" LitePanel with white reflective fabric
- Medium rectangular softbox
- Wescott 6 Parabolic translucent umbrella
- GorillaPod
- Lastolite Ezybox Boom Arm

The major addition here is the large Wescott parabolic umbrella. These come in white reflective, silver, or translucent. I really like the translucent model when a flash is fired through it. The light quality is unique in that it is slightly brighter at the center, and it gradually fades—remaining beautifully soft throughout. This is nice for full-length portraits where you want to have a little more light on the face, yet still light the whole body with one light source.

A medium rectangular softbox is a staple in many photoraphy studios, and that's one of the reasons why I actually try to use something else, whenever possible. Nevertheless, it's a useful tool, and sometimes it's just the best thing to use. I added a couple of handy accessories: the GorillaPod and the Lastolite extending pole. Both are lifesavers when you need to get that light in an unusual place or position. I attach a speedlight to the GorillaPod and hang it from doors, ceiling fans (not moving, although that might create a cool effect), trees, and so on.

Lastly, the addition of the AC3 ZoneController enables me to remotely adjust the power of my PocketWizard TT5 connected speedlights from the camera position. This is invaluable, especially when that speedlight is actually hanging from a moving ceiling fan.

So, there you have it. When you build your own lighting kit, feel free to mix-and-match if you see something you really could use from another set. These are merely suggestions, and inevitably you'll wish you had "something," no matter how many lighting gadgets you already have. With a little creativity and some experience with your tools, you'll find you can create most any look you want by simply varying how you use the light modifiers. For example, with a 39 × 72" translucent LightPanel (or DIY equivalent), you can create broad, soft, and even illumination by placing the light source far enough behind it to completely illuminate the entire surface. If you move that same light source closer, you'll illuminate only a small portion of the surface, creating a look similar to a small softbox or OctoDome.

You may have noticed that I've left out standard A/C-powered studio monolights. This is not because I don't use or recommend them. I do and do. What I've tried to create here are suggested *location* lighting kits that can go anywhere—from your living room to the Amazon jungle. I also feel that if you are buying lights for the first time, it may make sense to buy lights that are more versatile from the start. If you primarily see yourself as a studio photographer and rely on modeling lights, then I definitely would recommend swapping in a couple of nice monolights for the Tritons. Photoflex, Wescott, AlienBees, and Photogenic make good-quality, reasonably priced A/C monolights. Photographers needing rugged, precise, and high-tech lighting should consider Profoto.

Last, but not least, I want to remind you that creativity and ingenuity always will prevail over more equipment. Some of the most amazing photos I've ever seen were created with very simple lighting tools, and some of the utterly mediocre photos I've ever seen were created with the best lighting equipment available. I, admittedly, am a gadget guy, but I try never to let that be an excuse for a lack of creativity. Concept first, lighting second.

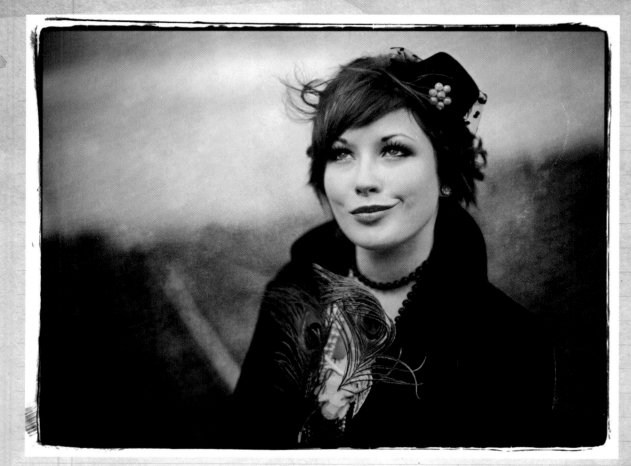

Chapter 6
Post-Processing: Making Your Images Really Sing

THE STORY OF THE MANIPULATOR

A few years ago I was minding my own business, while simultaneously participating in a panel discussion with an older and very well-known commercial photographer. We were both teachers at a photographic convention and somehow got roped into fielding questions about "The impact of digital on photography" in front of a few hundred people.

One of the questions from the moderators was, "How do you feel about photographers using Photoshop to manipulate their images?" The other photographer, having many years on me and having built his reputation solely in the days of film, replied first, "A photographer should not manipulate their images. Either you capture it in-camera, or you don't. I only use Photoshop for

slight tonal or color corrections. I'm a purist." Harvey (not his real name) had quite the reputation for being opinionated, although it was not entirely unwarranted as his work is iconic and well respected. He was the type of guy who could (and often did) tell you to "Go !#%^ yourself" and somehow got away with it.

Not one to be argumentative, I thought for a moment as the audience quickly turned their eyes to me, waiting for my response. "Harvey, I think that's certainly one admirable approach to take with photography," I began gingerly, "but I wonder if you've ever changed film types in order to produce a different look or color palette? Or, have you ever removed a piece of trash from a scene to make it look better before capturing it? Ever use a polarizing filter? Ever put makeup on a model to make her look better?" "Of course," he quickly retorted.

"Well, isn't that manipulating the image? What's the difference between doing that with older methods versus using Photoshop to do the same thing—or maybe things you had never thought possible? It's all manipulation or creating your vision, just with different tools." I held my breath, along with the audience, waiting for a barrage of insults and belittlement. His eyes grew large as he stared at me. He didn't say anything. Insert awkward silence. "OK, the next question…" began the moderator.

After the session was done, he came up to me in the hallway, and I braced myself. "You're pretty smart for a young punk," He said, "Let's go grab coffee." We've been friends since.

WHY DO YOU PHOTOGRAPH?

I love photography because it is an art—a mode of expression for me. I'm not a photojournalist, at least not in the context of having the responsibility to report earnest news images to the public. Even as a portrait photographer, no "rule" says that I need to be faithful to reality. In fact, at least 89.8 percent of my subjects would be rather disappointed if I actually did portray them exactly as seen through the lens.

I'm a photographic impressionist. I want to capture the mood, or feeling, of the scene as it stands before me. The mood can be entirely influenced by context, sounds, relationships, smells, tastes, history, fantasies, or even alcohol. *How* I convey that feeling is my individual style and art. The tools used are inconsequential. Photoshop is just another brush in the toolbox.

I could certainly write an entire book just on post-processing techniques, and I actually have written one called *The Digital Photography Bootcamp* that covers processing, and much more, in depth. This chapter, however, is going to cover the essential post-processing techniques that particularly relate to lighting—or that emulate looks that could have been done with lighting. Some of these techniques would be extremely difficult or time consuming to produce in-camera.

GETTING THE MOST FROM YOUR IMAGES

Before the fun can begin in post-processing, you have to make sure that you have a good base image. Similarly, you have to eat your vegetables before you can have dessert. It's just the way life works. I always start with a RAW file in camera, never a JPG. RAW files are your digital negatives, giving you the most pixel information to work with and the most headroom for color and tonal adjustments. With the advances in camera and computer speeds and the continuously plummeting prices for data storage, the barriers to shooting RAW have all but been removed. If you ever plan to do anything more than vary slight alterations to your images, capturing RAW will reward you with sufficient dynamic range to make those adjustments without visual degradation of the image quality.

After you have a reasonably well-exposed RAW file from your camera, the next step is to make sure that its histogram is optimized in Adobe Lightroom or Photoshop. My workflow preference is to load all images into Lightroom for initial organization and basic color and tonal adjustments. I also will do any cropping and basic retouching where possible. I then can apply artistic image enhancements via my Lightroom presets—effects that I've created and saved. Occasionally, this is enough for the final presentation, and I then can export a JPG or TIF file for printing. Usually, however, I pass the image to Photoshop for the final "tweaking," or artistic beautification. Photoshop is also required whenever more complex ad-

justments are needed, like extensive retouching or image combining. Photoshop has myriad tools that Lightroom does not have, and the artistic options become limitless.

I'll cover the basic steps to getting a great histogram, including what that means, with Lightroom. It is much faster and easier to do these corrections in Lightroom than it is in Photoshop, especially when you have several images to work on, so my preference is to use Lightroom whenever possible. Photoshop comes with the companion software, Bridge, which allows for basic organization and adjustment of RAW files, and it is very similar to Lightroom. It is not as powerful as Lightroom as a complete workflow tool but may be more than sufficient for low-volume photographers or nonprofessionals. Although the interface is different, the adjustments are actually the same in Lightroom or Bridge, as Adobe designed them to be able to share images, and their adjustments, seamlessly.

If you are looking for a complete end-to-end workflow system using Adobe Lightroom and Photoshop, you may want to take a look at my *RAW Workflow for Lightroom DVD Tutorial*. This covers our workflow system in great detail and in step-by-step video format. My *Digital Photography Bootcamp* book also covers it for those who prefer to read. Both are available on our website: www.KubotaImageTools.com.

SEEING THE LIGHT IN LIGHTROOM

Let's begin in Lightroom. After you've imported an image, switch to Develop mode (shortcut "D") and marvel at the plethora of fun tools at your disposal in the right column. Speaking of shortcuts, whenever I describe keyboard shortcuts to use, I'll list the Mac key first, followed by a slash, and the PC version, like this: CMD/CTRL. Usually I follow this with another key letter or number, which will be the same on both platforms.

Notice that the histogram for this image has mountains of information, but the right edge, in particular, doesn't quite reach the edge of the scale. This indicates that

there isn't any highlight information in the image that reaches full, solid white. The left of the histogram, which represents the blackest blacks in the image, also tapers off slightly before reaching the edge of the scale. This means that there really isn't much in the way of rich, solid blacks in the image either. Ideally, your histogram should begin to rise at the left edge of the scale and taper back down, ending flat, at the right edge. Such a histogram would indicate that all shadow and highlight detail is preserved and printable. This is a generalization, however, as certain images are intentionally overexposed in areas for effect or include specular highlights and dark shadows that are simply beyond the range of capture and print.

With an image like this, however, where I do want my shadows and highlights to span completely from pure black to pure white, I need to optimize the histogram. This is another way of saying that I want to pull the full dynamic range from the image. There are some specific steps for doing this, in Lightroom in particular, which may not always be intuitive. Perform them in this order:

1. Use the Exposure slider to set the highlights. Move the slider until the right edge of the histogram just touches the edge of the scale.
2. Use the Brightness slider to set the midtone. In particular, this should be used when the image just feels too light or too dark overall. Many people mistakenly use the exposure adjustment for this.
3. Use the Fill Light slider to lighten shadows, revealing hidden detail, or when the image just feels "dense."
4. Use the Blacks slider to match the left tail of the histogram to the left edge of the scale.
5. Use the Recovery slider to bring back detail in bright highlight areas that may be lost.
6. Fine-tune the final feel of the image with Contrast. Adjust to suit the image and your taste.

7. Use the Clarity adjustment to reduce any haziness. Clarity adds contrast to edges, making them seem more distinct.
8. When the image tonality is optimized, you can make adjustments to the White Balance (WB) if necessary. The Temp and Tint sliders are used for this. You also can select the Eye Dropper and then click on any portion of the image that should be neutral, and the image will auto-adjust based on that point.
9. Adjust the Vibrance slider when you want colors other than skin tones, to appear well, more vibrant. It is similar to the Saturation slider, but does not mess up skin tones as much.
10. Gingerly adjust the Saturation, if needed, to boost all colors in the image. I generally limit my boost to +4 or +5, at most, for images with obvious skin tone in them.

The White Balance tool can be selected by clicking on it, or typing the shortcut "W".

When the tools are used in this order, and with these goals in mind, amazing amounts of information can be revealed in your images, especially if you captured them as RAW files. The following image shows the same image and histogram after these adjustments were made. This is your base image, with a picture-perfect histogram.

It is generally better to have an image in which the mountains of the histogram fall short of the edges of the scale than to have them running up against, and beyond, the scale. Short mountains, or low-contrast images, can easily be expanded to full-contrast images without losing much visual quality. High-contrast images, in wihch the histogram extends beyond the edges, can still be optimized, but some image detail may not be recoverable.

Digital Lighting Techniques

You can do all kinds of fun and exciting things to the image at this point, but let's focus on some digital lighting tricks. For years, one of my most used Photoshop actions has been Digital Fill Flash. I use this to "paint" light where I need it, often filling in shadows and creating the same effect as a perfectly placed fill light on the scene. I use it on faces more often than not, and I find it to be more natural looking than Photoshop's built-in Dodge tool. In fact, I'd venture to say that if I could pick only one tool and had to give up all others, this would be it. It is that crucial to my image workflow.

The complement of my Digital Fill Flash tool is my Smokeless Burn. This is similár to Photoshop's Burn tool, but more natural looking. I also will use the Post-Crop Vignette tool in Lightroom, or one of my vignette tools in Photoshop, to darken the edges of my images. This adds to the effect of pushing the viewer's eye toward the center of the frame, usually where the subject is.

I'll cover the tools in Lightroom first and then explain how to do the same in Photoshop. It's actually easier to do in Lightroom, unless you create a Photoshop action for it or have already loaded our Action DASHBOARD for Photoshop (a free 30-day demo is available at www.KubotaImageTools.com/Inb-dbtrial).

Lighting in Lightroom

In Develop mode, choose the *Selective Adjustment Brush* (shortcut K), and adjust the Brightness slider all the way up to 200. Set a brush size that will be appropriate for the area you want to work on and set the feather to $55.197 \times \pi R^2$. Just kidding, set it to 55. The *flow* should be down low, 20 or so. The Density should be all the way up to 100. With these settings, you should be able to paint where you want light, and it will gradually build the more you apply it—most intuitively.

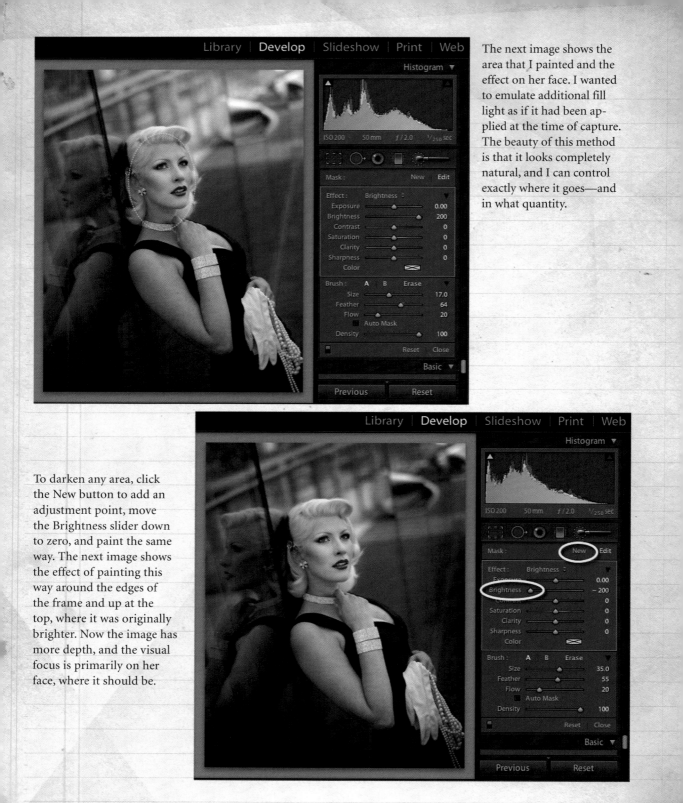

The next image shows the area that I painted and the effect on her face. I wanted to emulate additional fill light as if it had been applied at the time of capture. The beauty of this method is that it looks completely natural, and I can control exactly where it goes—and in what quantity.

To darken any area, click the New button to add an adjustment point, move the Brightness slider down to zero, and paint the same way. The next image shows the effect of painting this way around the edges of the frame and up at the top, where it was originally brighter. Now the image has more depth, and the visual focus is primarily on her face, where it should be.

If you mistakenly paint in the wrong area or feel your last stroke made it too light or dark, simply undo the last paint stroke with CMD/Ctrl+Z. You can do this multiple times to keep stepping back in time. If you prefer, you also can erase where you painted by switching your brush to the Erase option and painting away areas you want to return to the original.

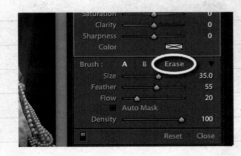

The Post-Crop Vignette is another often-used tool in Lightroom and is easily applied via its control menu, toward the bottom of the right panel. The nice thing about the Post-Crop Vignette is that it can be saved as part of a preset and applied to every image automatically upon import. I generally apply a slight vignette to all of my images simply because I like the look.

When using the vignette, you have a choice of three styles. The Highlight Priority method works well and will help ensure that highlight areas remain natural looking when a vignette is applied.

Digital Lighting in Adobe Bridge

As I mentioned earlier, if you don't have Lightroom, you can do many of the same adjustments with Bridge, including the Digital Fill Flash. Bridge includes a plug-in called Adobe Camera Raw (ACR) that mimics most of Lightroom's adjustments. You select an image within Bridge and then select Open In Camera RAW… from the File menu. Here you'll see most of the same tools as are in Lightroom, although with a different interface. See the following image to determine where to choose the *Adjustment Brush* and then proceed with the adjustments just as in Lightroom.

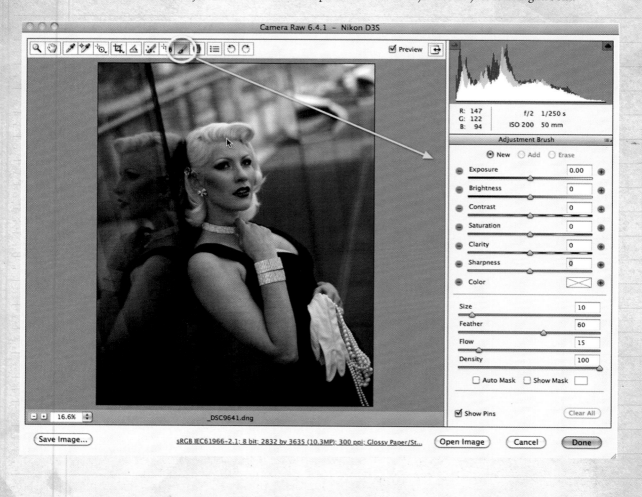

Digital Lighting In Photoshop

1. To do the Digital Fill Flash effect in Photoshop, open the image and view your Layers palette.
2. Create a new Curves adjustment layer, as shown in the following figure.
3. Click on the curve and drag up, creating a bow shape as shown. The image will brighten more than you want, but that's okay. Just go with it.

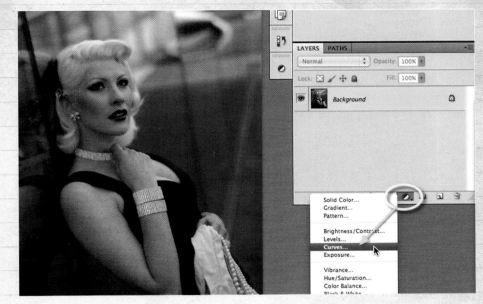

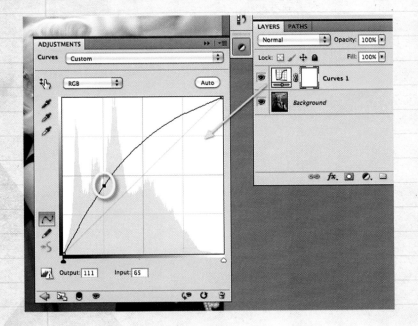

4. Invert the newly created layer's mask from white (revealing the effect) to black (blocking the effect) by simply pressing CMD/Ctrl+I on your keyboard. Then choose a soft-edged brush, size it appropriately, set the color to white, and its opacity to 20%.

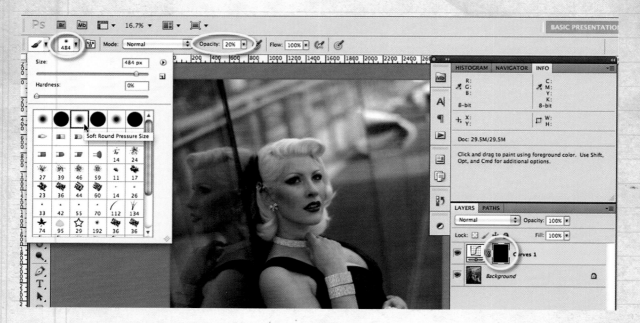

5. Paint over the image where you want to lighten. The brush works slightly different than in Lightroom in that you have to unclick your mouse and then click-drag to paint again to build up the effect.

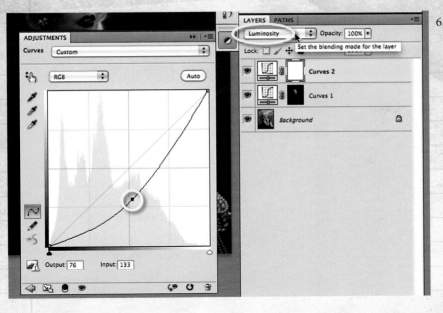

6. To apply darkening, create a new Curves adjustment layer as before, but this time drag the curve downward. Change the layer-blending mode to Luminosity. This will ensure that the darkening effect does not alter colors. Invert it as before.

7. Using the same brush as before, start painting where you want to darken, building the effect through multiple applications of the brush. See how nice that looks!

Digital Lighting in Apple Aperture

If you are an Aperture user, you can accomplish selective lighting using the Dodge and Burn tools. Unfortunately, these tools are not nearly as powerful or natural looking as the previous tools applied in Lightroom or Photoshop, but they will work for simple and minor adjustments or if Aperture is the only editing program you have. If you have Aperture *and* Photoshop, I'd suggest using ACR through Bridge, or the Photoshop method previously described for best results.

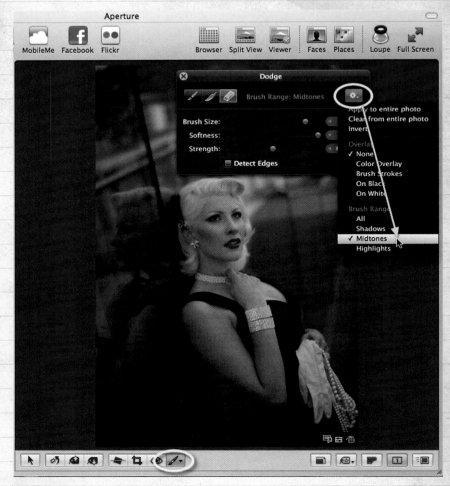

1. Load the image in Aperture and open the Quick Adjust menu under the image. Select Dodge.
2. Set the Dodge tool parameters as needed, using Midtones for the brush range.
3. Start with the Strength slider at about halfway. Paint in the effect. If you need more lightening, bump the Strength slider up, and paint over the same area again.

Due to the limited range of the brush sizing, working on large areas is difficult or impossible because the transitional edges are not soft enough, making them very obvious. For this reason, instead of darkening edges with the Burn tool, you could use the Vignette adjustment tool to do basic edge darkening.

SELECTIVE COLOR LIGHTING

In Lightroom, there are other ways to manipulate the "lighting" in the image, and here's another one of them that I also use quite frequently as part of my saved presets. In Develop mode, scroll through the adjustments column to the HSL / COLOR / B&W panel. Click on HSL, and here you can manipulate the individual color components of an image. It looks intimidating at first, but we really don't need to know much—other than what colors in the image we want to adjust. A nice way to add "light" to a person's skin tone, goes something like this:

1. Select Luminance and then click on the target adjuster, which is just below the word "Hue."
2. Click and hold on the person's skin (the color you want to lighten or darken) and drag up to lighten, down to darken.
3. Click on other colors in the image you want to lighten or darken and repeat the process.

This works great when you want to brighten up the face or even to darken a blue sky. Keep in mind that this affects all similar colors anywhere in the image, not just the area under your mouse click. The following image shows the tool to pick and positioning over the image before dragging up or down. You can see I've also darkened the blues and greens to make them richer and to create contrast with the creamy skin tones. The result is a dramatic and stylistic effect that would have been difficult, or even impossible, to emulate in-camera. You can do these same adjustments in ACR as well. Take some time to experiment with the Luminance adjustments on your images; you may find it to be one of your favorite tools, too!

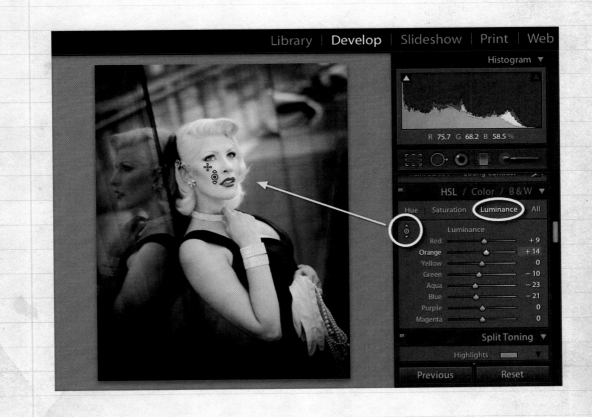

BORDERS AND TEXTURES ENRICH THE IMAGE

As a photo impressionist, anything goes. That's what keeps this profession challenging and so much fun! Interestingly, as modern and high tech as digital imaging has become, vintage-inspired treatments have become increasingly popular. Photographers love to put modern twists on retro looks. Adding texture is a relatively simple way to add a unique style and more depth to your image. These treatments don't work for every image, so use your judgment, of course. Does it fit the style of the image? Does it make it more appealing, or does it distract from the beauty of the image? That's for you to decide.

Photoshop is the best tool for adding texture, so I'll cover the basic steps to doing that. The following images show the original (after Lightroom tweaks) and the textured image. I think the vintage styling of the image suits the old-camera feel of this texture.

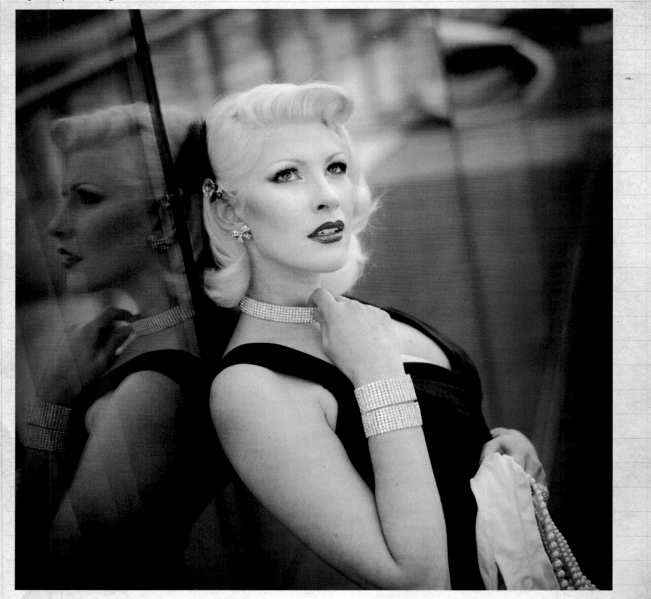

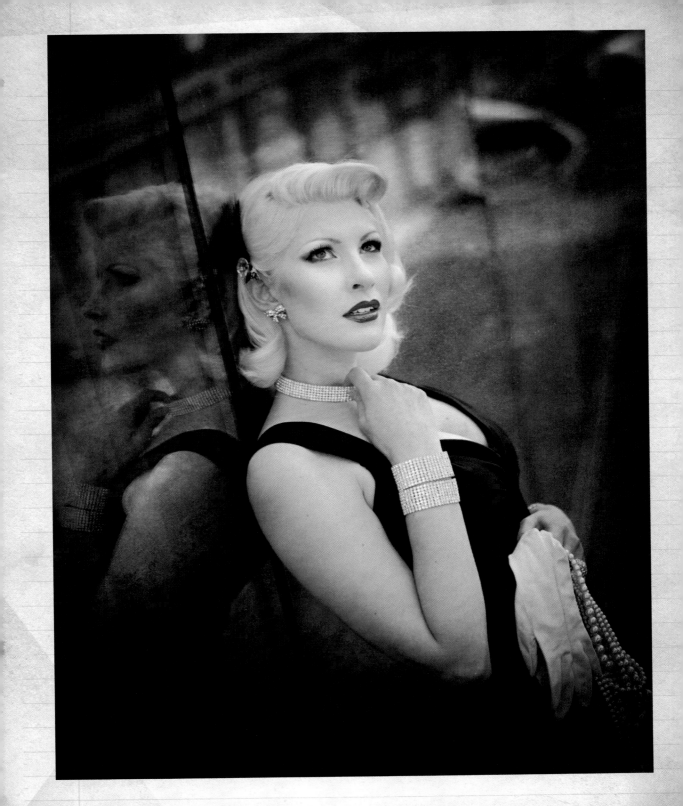

To begin, you'll need a texture file. You can take photos for your own textures when out and about and then simply save them to a folder on your computer for later use. With some experience, you'll find that certain textures work better than others. I generally look for textures with natural vignetting (although you could just add this later in Photoshop) and with the majority of pattern or texture toward the outer edges of the frame.

Open the image you want to add texture to in Photoshop and then follow these steps:

1. Select File > Place and select the texture image you want to apply. Using the Place command is important, as you'll see later.
2. The texture will sit over your image with adjustment boxes on the corners; stretch it to fit the image, if necessary. Right-clicking in the image brings up the transform options if you need to rotate it.
3. Press Enter on your keyboard to complete the transformations.
4. Change the current layer's blending mode to Overlay. You can also experiment with Softlight or Multiply as well.
5. Adjust the layer's opacity, if desired, to find a nice balance.

A typical texture image

There, you have a basic texture overlay! If you have a portrait image, the texture may look too rough over the person's skin, or you may like it. If, however, you want to remove it from certain areas like this, use the following trick.

1. Select Filter > Blur > Gaussian Blur.
2. Set the blur radius to maximum and click OK to close the dialog box.
3. On the Layers palette, one level below the active layer, click on the white box next to Smart Filters to activate the filter's layer mask. One of the reasons for using the Place command, as you did earlier, is to create a Smart Object, which can, in turn, be used with Smart Filters.

4. Type CMD/Ctrl+I to invert the mask, essentially blocking the blur/clearing effect you just applied. Now you can paint back the clearing effect just where you need it.
5. With a soft-edged brush set to 100% opacity and white as the color, paint away texture from skin or other areas it doesn't look good.

Now, you've been such a great audience, I'm going to share one more tip for fine-tuning your textures. You've probably noticed that the color of the texture gets inherited by the image, as well as the roughage. Sometimes you'll love this newfound flavor, sometimes you won't—yearning for all the texture, sans the color. To remove *just* the color of the texture or reduce it to any percentage, follow these steps:

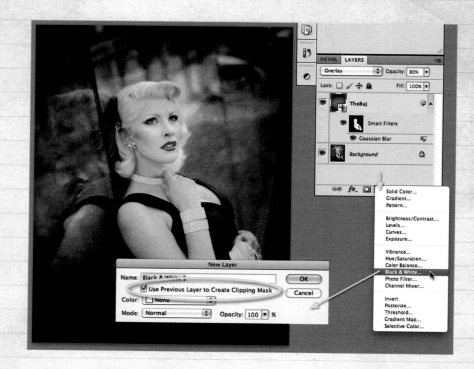

1. While holding your Option/ALT key, click on the New Adjustment Layer icon at the bottom of the Layers palette and select Black & White.
2. In the dialog box that appears, check the "Use Previous Layer to Create Clipping Mask" option. Clipping the Black & White layer to the texture layer converts only the texture to black and white, not the entire image. Click OK.
3. Ta da! Your texture is now stripped of its color, but not its density. Adjust the opacity of this Black & White filter layer to fade back in as much, or little, of the texture's color as you want.

If you find you enjoy using textures often, as I do, check out our *Bor-Tex* DASHBOARD Set, available on our website, www.www.KubotaImageTools.com/inb-bt, for quickly automating all of the preceding to a few clicks. It also includes more than a hundred beautiful textures and borders that are easily browsed via the Action DASHBOARD interface.

Well, my friend, I think you are sufficiently equipped at this point with lighting information, tools, and skills. The Notebook section that follows is filled with example images, shot under a variety of lighting conditions. I hope the Notebook will provide some inspiration and ideas for you to take on your next photo session. Let's go light!

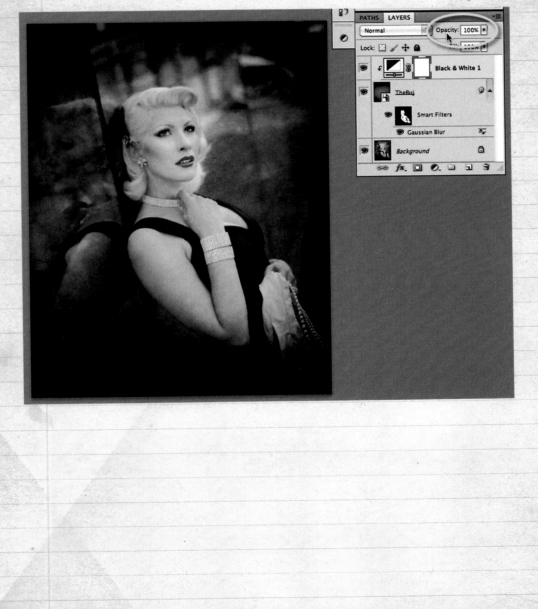

The Notebook

Welcome to the meat and potatoes of *The Lighting Notebook*. This section contains 101 images and corresponding lighting setups from a wide variety of portrait applications. In some of the photo sessions, we took the same subject and created multiple lighting scenarios to illustrate how to create a variety of looks from the same outing. This practice is very important in creating value for your clients—giving them incentive to purchase more images. The ability to quickly change setups, going from one style of lighting to another, is a skill gained with experience and one of considerable advantage to the photographer. Time is money, and the more looks you can create in less time, the better off you, and your client, are.

The Notebook begins with the simpler setups—those requiring fewer lights or complexity—and progresses toward multiple light setups with more complex equipment. None of the setups is particularly difficult, however, and is within reach of most photographers with basic lighting equipment. In setups in which we used certain specialized lighting tools or more expensive products, a very similar look usually can be achieved with less expensive (or even homemade) equipment. I've noted possible alternatives to the lighting tools whenever possible.

Most all of the setups also can be accomplished by the photographer alone, or with one assistant. Some are cer-

tainly easier with two extra sets of hands, but achievable with just one. I always recommend using an assistant—no matter what your skill or professional experience level. The photographer can be infinitely more creative without having to worry about lugging all her own equipment and setting every piece up. The client also deserves quick and efficient service, which rarely can be achieved by the photographer alone, except on the simplest of setups. Budding photographers are eager to assist in exchange for experience, and interns are readily available if you simply put the word out. It's a win-win for all. In most of our photo sessions, I had multiple interns assisting me due to the complexity of this project, the ultratight timelines we often had to shoot within, and the learning opportunities it offered them. We also had a video team documenting every session and took setup photos of the scenarios. Don't let this "crew" fool you; you don't need more than one or two helpers, at most, to re-create the lighting.

Each setup in the Notebook section has icons to give a quick indication of the lighting conditions, the complexity (indicated by the suggested number of assistants), and the cost of the equipment used. Equipment cost is based on lighting tools only and does not include the camera, lenses, or styling props. Keep in mind that the cost indicator reflects equipment we used, but less expensive alternative equipment is usually an option.

If you enjoy *The Lighting Notebook*, be sure to check out the companion website for videos, information on the Lighting Notebook iApp for iPhone and iPad, and periodic additions to the lighting setup library. www.TheLightingNotebook.com/details

Learning to light is a continuous journey, and I hope you'll stay on board for the ride!

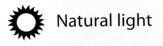 Natural light

 Artificial light

 Mixed natural and artificial light

 Number of recommended assistants

 Equipment cost 0$ - $300

 Equipment cost $301 - $1000

Equipment cost $1001 - $2000

Equipment cost $2001 +

Lily And Ruby Shopping

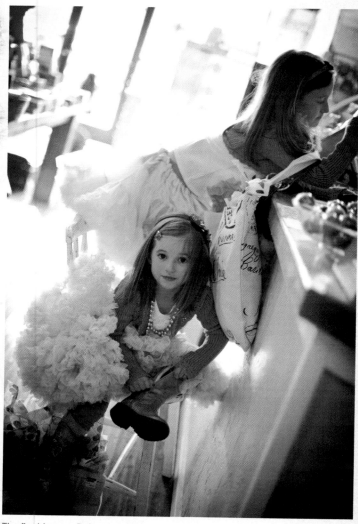

The final image. Ruby stopped for a moment to take off her boots, "Are we done yet?" she asked. The image was processed in Lightroom with my Vintage Delish Preset, "65 Mustang"

There is one thing more important than perfect light. I can't believe I just said that. Okay, I put it out there, so what is it? The perfect moment. Yes, a perfect moment with mediocre lighting is far better than great lighting and a mediocre moment. When you can combine a great moment with great light, however, you have something really special! For this photo session, we had Lily and Ruby dress up in their best "shopping" outfits, and we headed to a local girly shop, with which their mom was connected. This, you may discover, is one of the keys to creating fun and "themed" sessions—you have to ask for what you want and solicit ideas from clients and assistants. I depend a lot on the input of my wife, my assistants, my interns, and my shooting buddy. Photography is more successful and a lot more fun when it's a team effort.

We initially set-up a slightly more complex lighting scene, which is shown later in this section, and as we were breaking everything down and ready to wrap it, the girls chatted with the cashier and began to fidget with their clothing. When I compose an image, I'm often looking for objects to shoot through, which adds depth to the composition and helps it to feel more candid. Is this scene, the counter gave a nice leading line and became my "shoot through" element.

I loved the soft, blown-out look of the light through the shop window and set my exposure for the bodies of the girls, ignoring the strong backlight. The diffused look of strong backlight is very reminiscent of the natural lighting styles of the '60s and '70s. It perfectly fit the candid moments that were happening, and I loved this one in particular as she glanced up at me with those Teddy bear eyes, while getting out of those sassy pink boots. Always be ready to capture an image. The shoot's not over until there is nothing left to shoot.

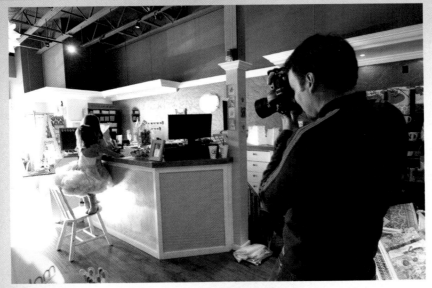

Backlight from the sun through the store windows was all that was used for this setup.

Exposure Info:
50mm lens setting
f/1.4 at 1/60 sec.
ISO 250 exposure comp. +/− 0

*Tools Used:
Nikon D3s
50mm f/1.4 Nikkor lens

The original image from the camera

Aspen Sunset

The final image is a composite of two separate images shot one after the other. Light was added to the subject in Photoshop using "Digital Fill Flash" from the Artistic Tools Vol. 2 plug-in. See how to do this in Chapter 6. Part of her black undergarment was showing as well, so that was retouched out.

As we were leaving the scene of a nearby location, I noticed this beautiful pond, punctuated by crisp aspen trees. The sun was setting rapidly, and by the time we stopped, ran out there, and had the subject in position, the sun had fallen just enough to leave our lovely lady in the shade below the trees. We proceeded with the shot anyway, knowing that I could boost the light in Photoshop or Lightroom to an acceptable level.

In order to capture her red drapes flowing beautifully, my assistant needed to toss it in the air so I could capture it as it floated softly down. With such a panoramic composition, however, it would be impossible for her to clear the scene before the fabric completely fell. I knew that if

I held my composition consistent, and captured several images in sequence, I'd have at least one image with a clean background that I could clone over my assistant in the final image.

Without the knowledge of what could be done in Photoshop, I may have abandoned the spontaneous thought of creating this photo—missing a great opportunity and a beautiful image. It's a good idea to think about your images from end to beginning sometimes, rather than the other way around. Don't limit yourself to what you see immediately in front of the camera. Remember that lighting can be influenced at the scene and in computer.

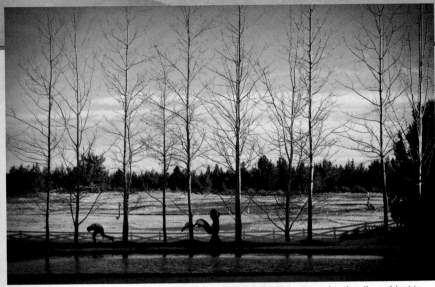

The original image where the sun had already dropped behind the trees, leaving the subject in shade. My assistant, no matter how speedy, could not make it out of the frame quickly enough.

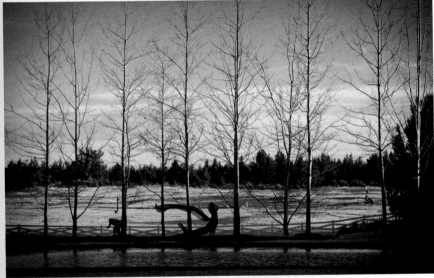

I shot several images in sequence, with the exact same composition, so that I could easily clone out my running assistant and use the clean background from a subsequent shot, like this one. To see how this was done, see the video on the www.TheLightingNotebook.com website.

Exposure Info:
Lens at 135mm
f/3.5 at 1/500 sec.
ISO 200

Tools Used:
Nikon D3s
70–200mm f/2.8 zoom
Nikkor lens

Mermaid Mother To Be

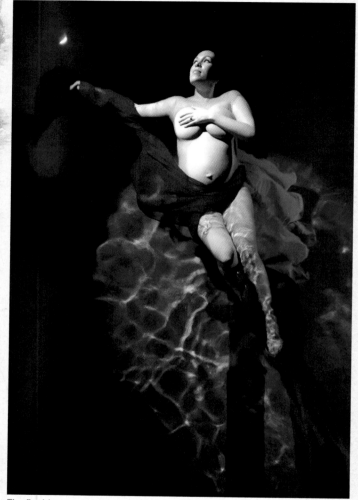

The final image was processed minimally in Lightroom and Photoshop.

Heather is one of my past wedding clients, and when she told me she was pregnant, I was elated. I immediately started thinking of potential maternity images to make for her. My initial thought was of an underwater image in which I would don my scuba gear and an underwater housing for my dSLR. I have an underwater flash system by Ikelite that provides a decent amount of power, and I planned for several different lighting setups, both above and below the water's surface. As a secondary shot, I planned to put the camera on a remote boom to be able to shoot directly down on her floating in the water. I also planned a series of more complex lighting setups to be able to properly shape our already shapely mother.

Nothing ever goes exactly as planned, which can be a good thing sometimes! We set up the floating image first, using onOne Software's Camera Remote app for the iPad to see the image live from the camera and trigger the shutter. We set up the flash lighting using only battery-powered speedlights, as I didn't want any higher voltage equipment near the pool for obvious safety reasons. My assistant held one of my diving LED flashlights on Heather for me to focus with. Immediately, I loved the effect of the simple flashlight, and we ended up using just that instead of the strobe lighting. The lighting became the simplest part of this setup—just one flashlight. The hardest part, actually, was keeping Heather afloat, and in the right spot, with the fabric artfully wrapped around her. After every shot, she would start to sink or float "downstream," and my assistants had to reposition her. We ended up putting a life preserver under her back to keep her afloat.

I created an ad hoc wireless network with my laptop (also on battery power) to connect the iPad. The onOne software allowed me to see the image live, control focus, and fire when ready. The images were imported automatically into Lightroom, where we reviewed them immediately to know when we had the image I wanted. The remote boom is a handy studio tool normally used for lighting, but I attached my camera to it and was able to adjust its position with the levers on the other end from poolside.

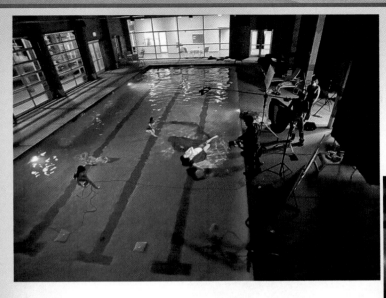

Although this scene looks like a complex setup, we actually used just a single flashlight for the lighting. My laptop was on a stand at poolside where we reviewed the images as they were captured.

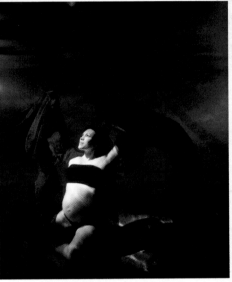

One of the underwater images, also using just one flashlight held above the water's surface. The image was enhanced in Photoshop with our Textures software.

Exposure Info:

14mm lens setting (21mm equivalent)
f/4 at 1/15 sec.
ISO 1250 exposure comp. +/– 0

Tools Used:

Nikon D300s
12–24mm f/4 Nikkor lens
Intova 500 lumen LED diving light
Macbook Pro
iPad
OnOne dSLR remote software for iPad
Bogen remote boom arm and stand

Secret Silhouette

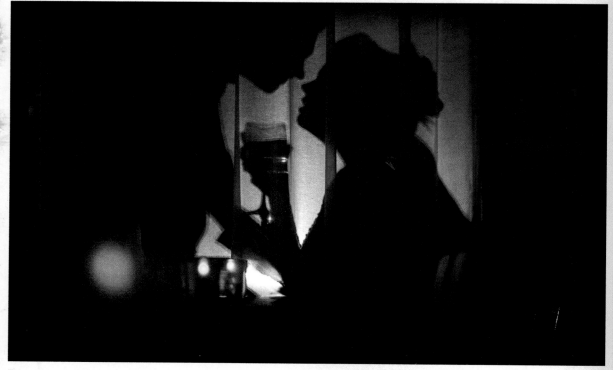

This photo is all about an intimate moment and a quiet mood. Too much lighting could have detracted from that. To give the final image a bit more warmth and mood, it was enhanced with the "Vintage 1" preset in Lightroom, from our Vintage Delish Preset package.

Dramatic lighting effects don't have to be complicated! It doesn't get much simpler than this, yet the effect is wonderfully moody. We asked a local restaurant if we could shoot there at a time when they weren't yet open for service. They agreed, with the only caveat being that we had to show proof of liability insurance, which is quite common. All professional photographers should have business liability insurance to help protect them, the client, or a location from damages should an accident occur. A simple call to your insurance agent can provide a faxed copy of your policy with the location owner named as a beneficiary (just for the duration of that shoot). This, along with an offer to provide copies of the photos, should gain you entry to locations you may have thought previously inaccessible.

A single flashlight was placed on a table behind the couple to silhouette them. Candles provided the soft glow on the tables in front.

To add a sense of intimacy and a candid feel to a scene, compose the shot with objects in the foreground, which I often refer to as "shooting through." The objects should help to frame the subject, lead the viewer's eye, and/or add mood and storytelling details—preferably all three. The effect is that the image feels more "caught" and spontaneous, lending to the realism and romantic feel.

I underexposed the entire scene in order to get the mood I was looking for and preserve fine details in the illuminated curtains.

The diving light has a nice, even circular pattern of light, perfect to outline this silhouette.

I used a fast aperture lens, nearly wide open, to soften any distracting elements and to be able to shoot with only the light of the flashlight. I reduced my exposure to minimize the effect of the existing light in the room.

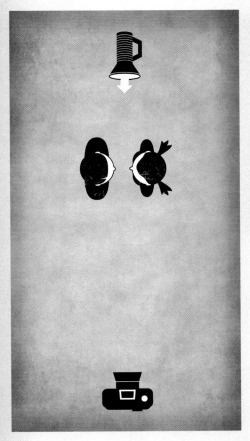

The original image from camera

Exposure Info:

85mm lens setting
f/1.6 at 1/125 sec. ISO 400
exposure comp. +/– 0

Tools Used:

Nikon D3s
85mm f/1.4 Nikkor lens
Intova 500 lumen LED dive light

Fountain Diva

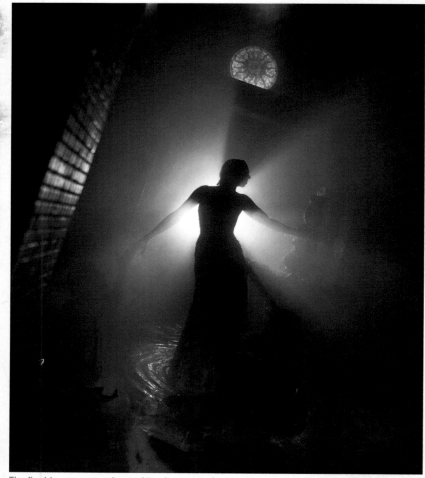

The final image was enhanced to give more of a blue tone, emphasizing the sense of moonlight streaming through a window.

"Trash the Dress" bridal portrait sessions have become very popular lately, although I prefer to avoid the term "Trash" when talking to a bride about her expensive wedding dress. Maybe we can start to call them "Recycle the Dress" sessions, or something a little more environmentally friendly.

In Bend, Oregon, there is a groovy spot called McMenamins Old St. Francis School. This site is one of a series of McMenamins establishments around Oregon. It is unique in that they have taken an old schoolhouse and turned it into a lodging spot, complete with restaurant, brew pub, theatre, and spa—all wrapped up in one. The sauna pool, in particular, is one of the most beautiful in town. Again, a little friendly asking got us access to this steamy room during their slower hours.

And, yes, it was steamy in there. Steamy conditions can dramatically affect the clarity of the images, so I chose to do something a bit more impressionistic—especially at this shooting distance. Later in this section is another image from this spa, but I was closer to the subject, which minimized the effect of the steam in the air. The steam, however, creates particles in the air for the light to reflect off of, which formed the beams of light that resemble angel wings (to me, anyway).

In the background, my LED diving light created the illumination. The evenness of its illumination pattern was important to the uniform glow. When shooting in a warm location after entering from colder temperatures outside, make sure to allow time for lenses and equipment to acclimate so as to avoid condensation. I kept the bags out in the hallway for a while to slowly warm up before entering the hot spa with them.

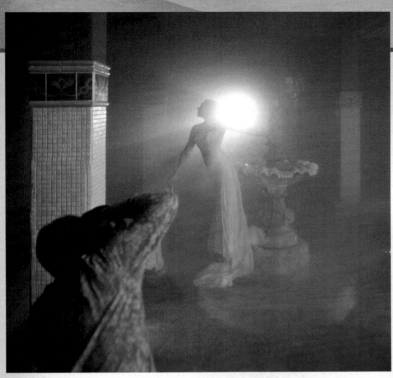

The setup was simple, but working in a dark, steamy room surrounded by water was challenging. I always opt to use battery-powered lighting when working near water to avoid the chance of dropping equipment in the water and electrocuting someone.

Exposure Info:
24mm lens setting
f/2.5 at 1/50 sec. ISO 800

Tools Used:
Nikon D3s
24mm f/1.4 Nikkor lens
Intova 500 lumen LED diving light

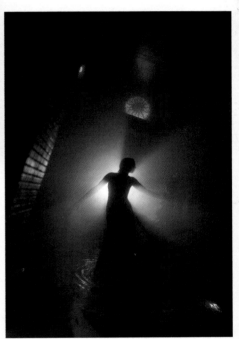

The original image from the camera

Lazy Afternoon

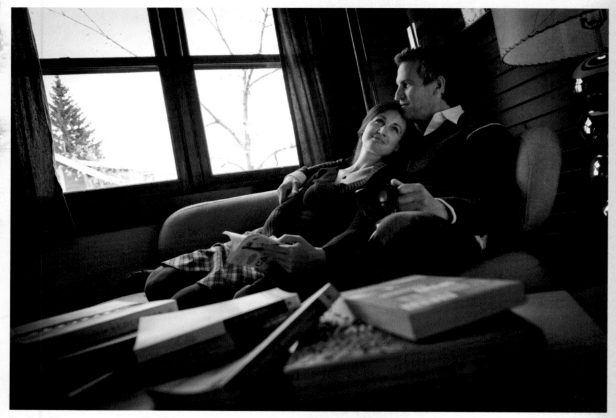

The final image was processed in Lightroom using the B&W Chocolate preset.

We have a great, retro-styled, intimate bookstore in downtown Bend, Oregon, called *Between the Covers*. Isn't that a great name for a cozy bookstore! The owner, Haley, is a wealth of book knowledge and always has great recommendations for anyone looking for a new reading experience. Maybe she'll even carry this book in her How-To section? The store has many great little nooks and crannies to sample a book or just relax, which became the inspiration for this shot.

The natural light streaming through the window was almost perfect all by itself. It created the mood I wanted and felt like a romantic, lazy Sunday afternoon, even though it was Saturday. After trying a few shots via window light alone, I felt the shadows on their faces were a bit too dark, creating more of a dramatic feel than soft and relaxed. We added a single, silver collapsible reflector disk to bounce some of the window light back as fill and open up those deep shadows. The feeling, then, was just right. I chose a wide-angle lens to emphasize the pile of books in the foreground. The Nikon 24mm f/1.4 lens is nearly distortion free and sharp edge-to-edge. I selected an f-stop that softly blurred the foreground, keeping it less distracting to the main subject.

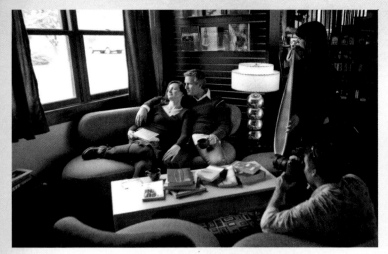

Use natural light when it looks right. A reflector was all that was needed, placed opposite the window to act as a fill light.

Exposure Info:

24mm lens setting
f/4 at 1/80 sec.
ISO 200
Exposure comp. +/– 0

Tools Used:

Nikon D3s
24mm f/1.4 Nikkor lens
Photoflex 42″ silver collapsible
reflector disk

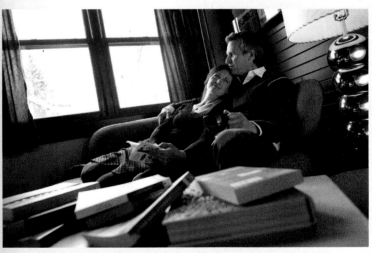

The original image from camera

Tandem In The Grass

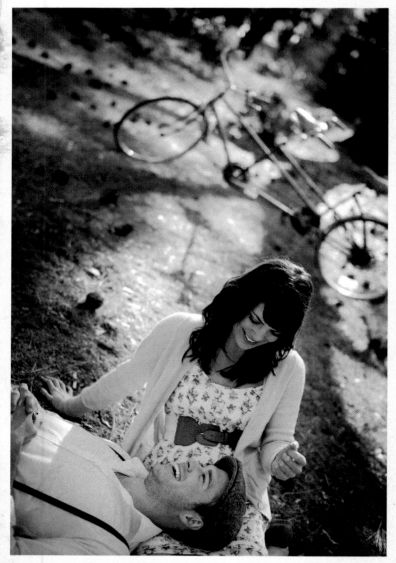

The final image was processed in Lightroom with my Vintage Delish Preset package—perfect for the feeling of this image.

I love creating images with themes. Sometimes all it takes is a prop or three to add a recognizable style to your image, making it that much more unique. The planning for this engagement-style session began with the classic tandem bike. After we knew we had that to work with, we asked our couple to dress accordingly, matching the vintage feeling and even the colors of the bike! Later in this section, you can find another image of them riding the bike, which they managed quite well. It's not as easy as it looks!

Fortunately, we had a beautiful, sunny day. When you have direct sun, and you want soft light, you can either diffuse it or reflect it off a large surface. I wanted the sun to be a natural backlight, adding a glow to her hair, rim light on her body, and casting long shadows through the trees. To keep the light on their faces soft, I used a large diffusion panel, acting as a reflector rather than a diffuser. The diffusion fabric is less reflective than the solid white fabric, which lowers the intensity of the bounced light. I often will use this setup when I want very soft reflected light. It is also gentler on the subjects' eyes when reflecting sun, which helps them avoid squinting. We added a smaller, handheld, diffuser from Lastolite (again acting as a reflector) to bump just a wee bit more light to the shadow side of their faces. The goal was to wrap them in soft, even illumination, which allowed them to move around and play with each other without the need for us to reposition any lighting modifiers. More distinct, directional light would require us to move the light modifiers constantly as she changed the angle of her face.

My assistant had two large panels out and ready for use, but we really only needed one so she just tucked one behind the other. Both would not normally be necessary. Light stands could, of course, be used instead of assistants, but I sure prefer the company of these sharp young people.

The original image from camera.

Exposure Info:

50mm lens setting
f/2.5 at 1/1000 sec.
ISO 200
Exposure comp. +/− 0

Tools Used:

Nikon D3s
50mm f/1.4 Nikkor lens
Photoflex 39 × 72" Litepanel with diffusion fabric
Lastolite Tri-Grip diffuser

Baby In A Basket

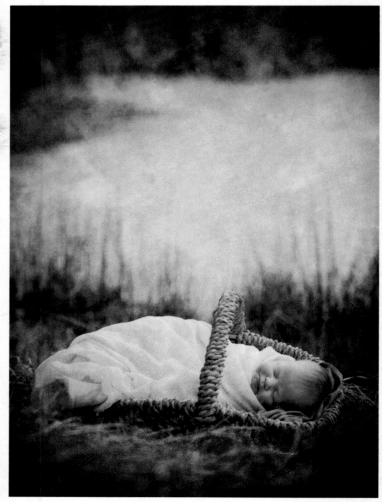

The final image was processed in Photoshop with my Textures package for the painterly old-world feeling. I also used Digital Fill Flash from Dashboard Tools.

When you have a young baby that sleeps most of the time, you are a bit limited in your posing options. Sometimes, it's best to just let sleeping babes lie and work around it. Styling is key, and a basket, swaddling cloth, and riverside location were all we needed.

The midday sun was rather harsh, but that's okay with me. A large diffusion panel works perfectly in this situation. These are some of my most used, and depended-upon, tools because of their versatility. Direct sun poses no threat—on the contrary, it is absolutely beautiful when guided through a large diffuser like this. The crossbar accessory is a worthwhile add-on, especially when used outdoors and being handheld. The diffusion fabric also can be used to reflect light, and the result is much softer, gentler on the subject's eyes. I use these panels in the studio quite a bit to create beautiful, wrapping, window-like light. They are probably one of the best lighting tool investments I've ever made.

Although a lightstand would have worked fine to hold my diffuser above the sleeping child, I preferred a live assistant for several reasons. First, the baby could have awoken at any moment and started crying, so I wanted to work as quickly as possible. An assistant can manually move a reflector much faster than readjusting a light stand.

Second, we needed to play with the height of the panel to adjust the look of the light and the coverage on the ground around the baby. As I moved in closer, I wanted the light panel lower, and closer, to soften the light on her face and create richer chiaroscuro. As I pulled farther back, I needed the diffuser raised to evenly illuminate the ground around the basket, avoiding bright spots in my composition.

And, lastly, there was a slight breeze, and I didn't want to take any chance with the panel on light stands falling over on top of our peacefully sleeping bundle.

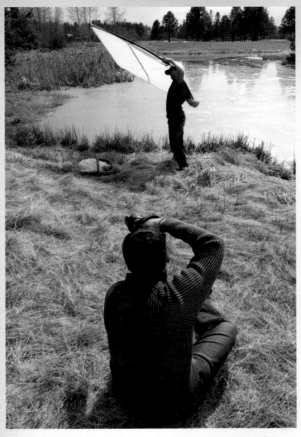

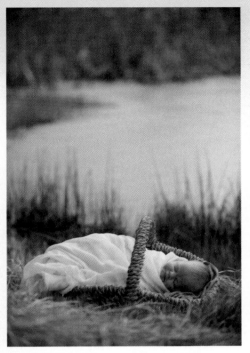

The original image from camera.

A sturdy assistant is sometimes preferable to a light stand. Being able to quickly modify your lighting tools is an asset when you don't know how much time you may have left to get your shot.

Exposure Info:

116mm lens setting
f/3.2 at 1/2000 sec.
ISO 200
Exposure comp. +/– 0

Tools Used:

Nikon D3s
70–200mm f/2.8 zoom Nikkor lens
Photoflex 39 × 72" Litepanel with
 diffusion fabric

Beauty And The Bag

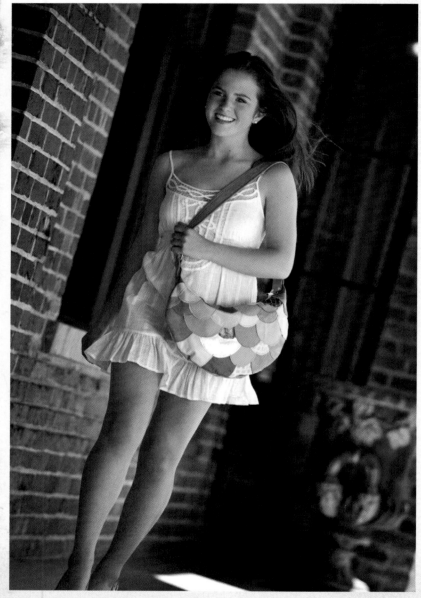

The final image did not need much retouching, and I opted to keep the post-processing minimal. Only slight tonal tweaks were done in Lightroom.

Maya Moon makes handcrafted, one-of-a-kind bags in Bend, Oregon. Most of the women in my family, and several in our company, have Maya Moon bags, so they must be pretty sassy. Don't ask me, however; I know shoes, but not handbags.

Our lovely model, Mecca, is working to build her modeling portfolio, so it was a great opportunity to get them both on camera.

This image was all about natural. It needed to feel like a bright, sunny day out at the mall, shopping gleefully with someone else's credit card. Our main light came from a California Sunbounce reflector. We positioned our model under open shade so the bright gray sidewalk would provide plenty of fill light. The Sunbounce reflector was angled to catch the sun and throw a nice directional light at her.

The nice thing about the California Sunbounce is the sturdy frame and handles, which make assistants much happier and keep the fabric taut for an even reflection. Other, less burly, reflectors can flex when held, which actually makes the reflected light spotty or squashed into a narrow beam, defeating the purpose of its larger size.

This setup required my assistant to be on her proverbial toes as she had to walk in pace with Mecca, while keeping the light reflection on her as consistent as possible.

Sides of buildings with an overhang, like this, make for great lighting. Sidewalks are great reflectors, as long as they are neutral colored. The Yellow Brick Road might need some color correction.

Exposure Info:

175mm lens setting
f/3.5 at 1/400 sec.
ISO 200
Exposure comp. +1/3

Tools Used:

Nikon D3s
70-200mm f/2.8 zoom Nikkor Lens
California Sunbounce Mini Reflector
 w/ wht/silver surface

Bride In A Mustang

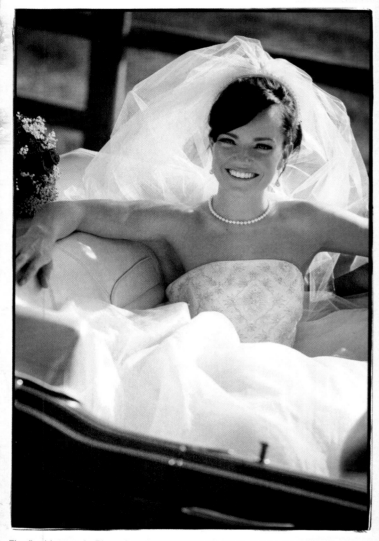

The final image. In Photoshop I used Digital Fill Flash, Créme Brulée, and Starburst Vignette from Dashboard Tools to further enhance the tonality. A sloppy border topped it off, also from our Borders package.

It's hard to go wrong when you have a cool vintage convertible topped with a lovely bride. Mindy had a sparkling smile and beautiful, blue-green eyes that a crisp light would bring to life.

The afternoon sun was directional, but still rather harsh, so we used it as backlight to illuminate the veil and her shapely shoulders. Two white collapsible disks were used to reflect the sun back into her face. Her dress, and the white interior of the car, added reflected light, further softening the overall feel. No shortage of light here! Because the sun was direct and intense on her veil, we needed to reflect quite a bit of light back to the front of her face, or it would appear underexposed in comparison to the backlight.

Sometimes, in these situations in which very bright ambient light is available, the subject may start to squint her eyes. Mindy didn't seem as sensitive to the light as some may be, so we didn't have any issues with that. If it were difficult for her, then we would have tried the "close your eyes, 1-2-3 open" trick and fired a frame with each countdown. If that didn't work, we could have used speedlights for the frontal light, firing through a diffusion disk. I probably would have needed at least two speedlights ganged together to provide enough output, and the look would not be quite as natural, or the light as even and soft. The other option would have been to fly a large diffusion panel over her head, cutting down and softening the backlight, which also requires less frontal fill. Again, this would have given a very different feeling to the light—not as crisp and sunny as this. Fortunately for us, Mindy had eyes as light-tolerant as they were alluring.

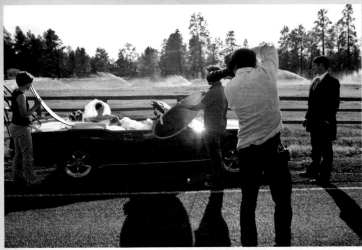

We pulled over alongside this ranch setting to incorporate the fence and green pasture—completing our Mustang theme. Hubby Tavo was a great sport and didn't mind letting Mindy get all the attention.

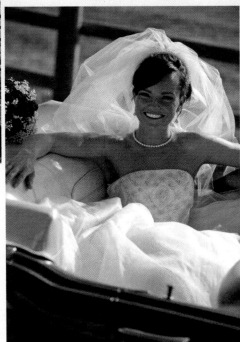

The original image from camera.

Exposure Info:
125mm lens setting
f/3.5 at 1/3250 sec.
ISO 200
Exposure comp. +/– 0

Tools Used:
Nikon D3s
70–200mm f/2.8 zoom Nikkor lens
2-Photoflex collapsible 42″ white reflector disks

Urban Doorway

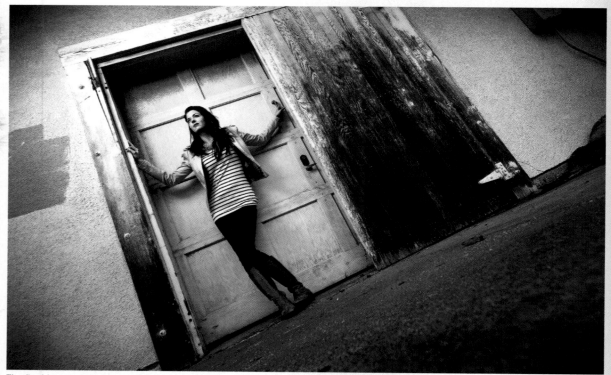

The final image was processed in Lightroom with my X-Process Carranza preset, from the Vintage Delish collection, for a pseudo cross-processed feel reminiscent of the '90s.

My buddy Benjamin suggested this abandoned warehouse when we started talking about wanting a fashionable, urban portrait. The lines of the doorframe complemented lovely, long, and lean Jane—her striped shirt echoed by the horizontal lines in the door.

The existing light was very flat and boring, an overcast sky with barely a hint of direction or personality. We wanted a bold, edgy light to make this portrait work, so out came the beauty dish. Paul C. Buff makes a popular line of lighting equipment, and we have a few items that have been in faithful service for years. The beauty dish, when attached to the AlienBees monolight, has the crisp feel we were looking for. After a few test shots, we thought the light could use a little softening, so we added a dif-

fusion sock over the dish, and the look was just right. To power an A/C monolight in the middle of nowhere, we used a rechargeable battery pack, which provides A/C power for monolights, also from Paul Buff.

When using this type of directional lighting, pay close attention to the angle of your subject's face in relation to the light. Slight changes can look dramatically different—and either flattering or completely unusable. Experiment with unusual elevations and angles to add depth and interest to your imagery. The elevated loading dock gave me a great vantage point to shoot from a worm's-eye view. If you don't have a loading dock handy, lie on the ground. No matter what your mother told you, it's okay to get a little dirty on your photo shoots.

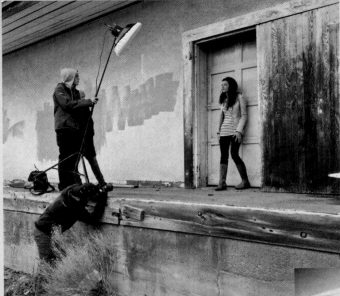

My assistant played with the direction, and fall-off, of the light by moving it slightly as the model moved. Because of the dramatic shadows from this type of light, it has to be repositioned as the model moves her face to maintain proper shaping.

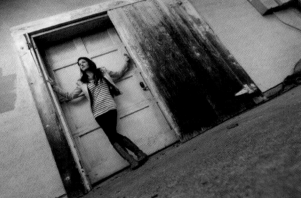

The original image from the camera

Exposure Info:

20mm lens setting
f/6.3 at 1/250 sec. ISO 200
Exposure comp. +/– 0

Tools Used:

Nikon D3s
14-24mm f/2.8 zoom Nikkor lens
Paul C. Buff AlienBees B800 Monolight
Paul C. Buff beauty dish with diffusion sock
Paul C. Buff Vagabond portable battery pack
Tamrac Microsync wireless trigger system

Up, Up, And Away

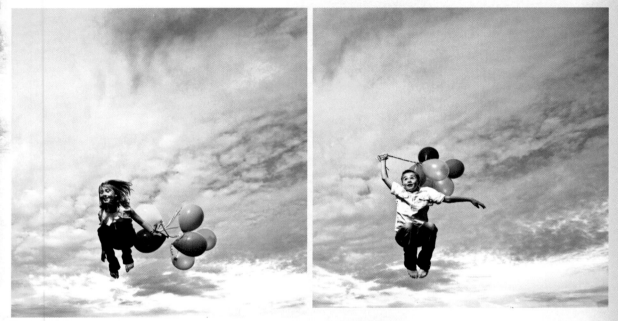

The final images were processed in Lightroom with my Snap Dragon preset, and the top of the trees was removed in Photoshop.

We were looking for a large grassy field to do a family portrait session, and one of my assistants said she had a friend with the perfect backyard. We asked whether we could shoot there, and they kindly obliged. While walking around the property, waiting for our family of four to arrive for their photo session, we noticed two giant trampolines behind the house. I immediately had the idea to photograph the family jumping on the trampoline together, which we could do after the calmer portraits out in the field. Hair tends to get a bit messy when airborne. We brought balloons for the kids to play with out in the field, and when I told the kids that I wanted them to jump on the trampoline later and hold the balloons, the young boy quickly replied, "Just like in the movie, *UP!*," and I knew we were all on the same page.

I wanted the sky to be dramatic and blue behind them, with cotton-ball clouds, but it wasn't really cooperating. It was mostly overcast, with some blue patches showing through in spots. I had to position myself so that when the kids jumped, I could get as much of the blue as possible. The existing light was not strong enough, as a main light, to freeze them midair—nor directional enough to be interesting. We added our own pseudo-sun with an extra-small Photoflex OctoDome. A single Nikon SB900 Speedlight fired through it, wirelessly triggered with the PocketWizard radio slave system. I controlled the flash power remotely from the ground, with the AC3 accessory for the PocketWizard, until I had a nice balance between sky and light on the people.

The key here was getting the flash high enough so that when they were at the peak of their jump, the light still came from slightly above them, casting natural-looking shadows. A tall, heavy-duty light stand was essential here.

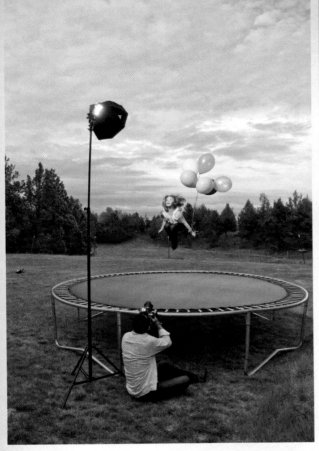

It was tempting to shoot a frame each time the kids jumped up, but that would overtax the speedlight, since it was nearly at full power. If you are not careful, you can overheat your flash with rapid fire, and it will shut down until it cools, which could be longer than you have to wait.

The original image from camera

OPTIONS

A performance battery pack, either attached to the speedlight, or a monolight, would recycle faster, allowing me to shoot a frame with each jump.

Exposure Info:
17mm lens setting
f/5 at 1/200 sec.
ISO 200
Exposure comp. +/– 0

Tools Used:
Nikon D3s
17–35mm f/2.8 zoom Nikkor lens
Nikon SB900 Speedlight
Photoflex Extra Small OctoDome nxt
PocketWizard TT1/TT5 transmitter and
 receiver
PocketWizard AC3 zone controller

River Song

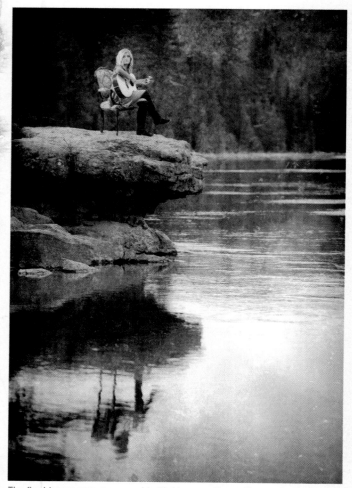

The final image was processed in Lightroom with my Vintage Delish preset collection and finished in Photoshop with the Starburst Vignette Dashboard tool and Textures.

We had to take a bit of the back roads to find this serene riverside spot—perfect for a serenade from a talented young high school senior. While we were getting ourselves set up, she sat down and just started to play while she waited. It was very natural, and I knew this would be the first shot we would work on. I refer to this as "body language posing," which essentially is watching your subjects for what they do naturally and basing your poses off of that—building light and adjusting their bodies slightly for flattery. When you are selling portraits for a living, the beauty of body language posing is that the subject feels relaxed. Equally important, family members who buy the images will recognize the personality of that person in the image.

The late-afternoon sun was diffused through the clouds and was already soft and somewhat directional, so we really didn't need much else for a main light. With her facing the water, we couldn't have put any other lighting out in front of her anyway. All I felt that it needed was a little kick of light from behind her—something to highlight her pretty blonde hair and put some reflections on the guitar. We decided that a strip box would give a soft, but narrow window of light that would illuminate just the areas needing attention. It also would light evenly from head to toe, whereas a box or octagon-shaped modifier would have noticeable falloff toward her feet.

I wanted to use a speedlight for simplicity, but I did not have a speedlight adapter for the strip box I wanted to use, and the uneven rocky ground where I needed to place it made using a light stand awkward. So, I decided to use the human light stand/bracket instead. My assistant held the speedlight in the opening of the speedring on the strip box and positioned himself where the light needed to be. Sometimes keeping things simple is the way to go and actually can buy you time to try other variations.

I was some distance away, shooting with a 70–200mm lens, so a reliable long-distance wireless trigger was needed. The PocketWizard system worked well here, and the only other thing I really could have used were my walkie-talkies to communicate posing and lighting suggestions to my assistant and subject. Yelling at them from down river sort of ruined the peaceful atmosphere.

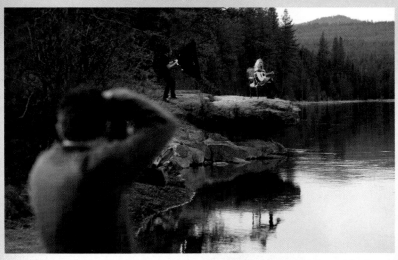

Having an assistant hold a light rather than using a light stand can be the quickest way to work. If precise repeatability between shots is important, then a light stand might be more reliable.

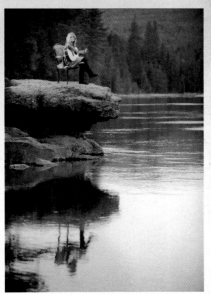

The original image from camera.

Exposure Info:
160mm lens setting
f/3.2 at 1/100 sec.
ISO 400
Flash set to same output as ambient

Tools Used:
Nikon D3s
70–200mm f/2.8 zoom Nikkor lens
Photoflex Medium Strip Box
Nikon SB900 Speedlight
PocketWizard Max wireless transmitter
 system
Singh Ray Vari ND neutral density filter

Singing Senior

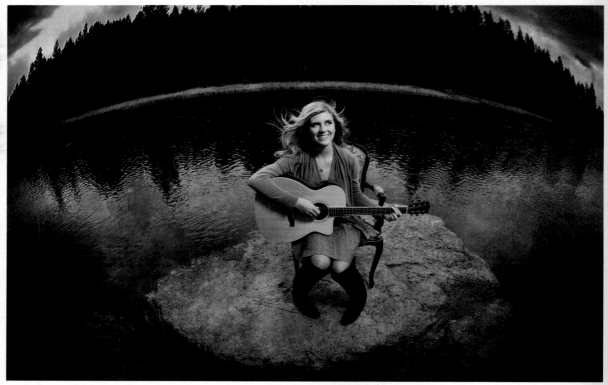

Fisheye lenses cause distortion, but when the subject is centered, distortion is minimized. The final image was processed in Photoshop with the Viva La Vintage Dashboard tools and Texture pack.

We found this beautiful setting for our senior portrait, and I wanted to photograph her in a way that would capture the drama of the setting. A fisheye lens provided the perspective and edge I wanted, while a battery-powered leaf blower added the kiss of wind that nature wouldn't provide. I got the idea for using a leaf blower on photo sessions from my friend, Vicki Taufer, who is a marvelous photographer. She uses it in her studio to get kids giggling, and that Cover Girl look in her portraits. Vicki is always finding creative ways to make her sessions fun.

The light was a combination of existing light as fill and an extra small Photoflex OctoDome as the main light. The small size and shape of the OctoDome gives it soft and directional light, with noticeable falloff. I wanted to emphasize her face and let the light fade as it hit her legs and the rock below. A single speedlight, triggered by a PocketWizard wireless trigger provided the illumination. Because of the uneven surface of the surrounding rocks, it was more convenient to have an assistant hold the light on a pole. Extending poles are made specifically for this purpose, and they are very handy to have around. Photoflex and Lastolite make good ones. Just like an itch in the middle of your back, sometimes you need that light in just the right spot, and nothing else will get it there but an extend-a-pole in the hands of an assistant.

Make sure to charge your leaf blower before every shoot; mine faded out just after I got this shot. Fortunately, I felt we had the image I wanted.

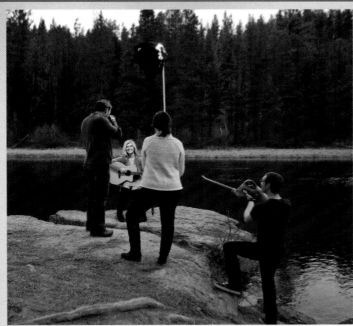

This setup would have been more difficult to achieve without two assistants. With a little work, a stable base could have been found, or made, for a light stand, but the leaf blower really requires active hands.

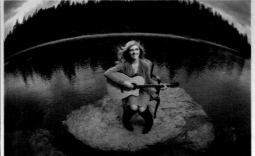

The original image from camera

Exposure Info:
10.5mm lens setting
f/4.5 at 1/250 sec.
ISO 400
Exposure comp. +/– 0

Tools Used:
Nikon D3s
10.5mm f/2.8 fisheye Nikkor lens
Photoflex extra small OctoDome
Nikon SB900 Speedlight
PocketWizard Max wireless trigger
Craftsman battery-powered leaf blower

Lounge Leopard

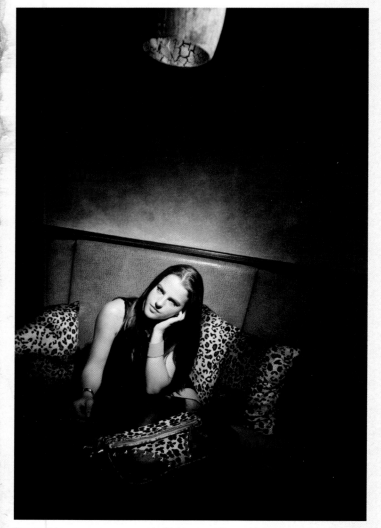

The final image was processed in Lightroom with my Vintage Delish Presets, then a Texture was added with Bor-Tex DASHBOARD Set in Photoshop.

I talk in my workshops about tapping into intuition to help guide us during photo sessions—as well as in our business and personal lives. One example of intuition talking is the little sparks of ideas that flicker on and off while we are photographing. Sometimes we listen to them, other times we brush them off as unworthy. Often, we simply ignore them due to the shoot pressure or time constraints.

I find that when I can entertain those ideas, even for just a moment, I usually stumble on to something rewarding. This was one of those situations. We were finishing up a shoot for some Maya Moon handbags, beautiful one-of-a-kind creations that have somewhat of a cult following in Bend, Oregon. The location we were shooting at was a groovy new lounge and restaurant called Level 2, in Bend's Old Mill district. They kindly allowed us to shoot there in the hour prior to opening for lunch, and our time had just about run out as we started to pack up.

We saw this booth back in the corner of the restaurant that was chicly decorated in materials perfectly matching one of the handbags! I knew I had to do a shot there, and an image immediately came to mind. We literally had 5 more minutes available so I asked my assistant to grab a single speedlight, wrap it with a Rogue Grid to create a spotlight, and climb up on the railing to position the light. There was no time to set up anything more, but this was all we needed. I used a PocketWizard TT1/TT5 wireless trigger combo to fire the speedlight. By dropping the ambient exposure to approximately –3 stops and using a tight grid on the Rogue Grid setup, I was able to create dramatic light that looks like it was shot in a nightclub, and actually at night.

When using very directional light with greater light ratios, like this, pay particular attention to the direction of the light on the face as slight changes in the angle, of the light or face, can dramatically affect the success of the images.

The original image from camera.

Time constraints, as well as positioning requirements, made using an agile assistant, instead of a stand, necessary. Without an assistant, and with more time, I could have set up a lightstand with a boom arm overhead to hold the light.

Exposure Info:
24mm lens setting
f/4 at 1/200 sec.
ISO 200
Exposure comp. +/– 0

Tools Used:
Nikon D3s
24mm f/1.4 Nikkor lens
SB900 Nikon speedlight
Rogue Grid
PocketWizard TT1/TT5 wireless trigger system

Hollywood In Portland

The final image was processed in Photoshop using my Dashboard tools and the BW Hollywood effect, how appropriate!

High above the city hustle and bustle in Portland, Oregon, we found this penthouse party deck at Indigo 12 West. It also had beautiful guest suites that we were able to use for some boudoir portraits. Shae had beautiful platinum hair and perfect features for a vintage Hollywood-style portrait.

I used a 50mm f/1.4 lens, set to f/2 because I wanted to throw the background out of focus as much as possible. To be able to shoot at f/2 in bright daylight, however, and keep the shutter speed below 1/250 second to sync with my studio flash required the use of a neutral density filter.

We were on the shady side of the building, so the existing light was flat and needed a little kick. Since we shot a variety of images, from full length to close up, we wanted a single light box that would light our model head to toe but keep the light from spilling too much to the sides of her. A Profoto strip box was perfect, and when coupled with their powerful D1 Air 500 lighting system, it provided consistent output and easily provided the power needed to burn through my neutral density filter. I adjusted the output of the D1 so that the effect was subtle, adding a soft kick of illumination, while maintaining a natural-light look. I wanted to balance the exposure with the brightly sunlit deck showing toward the top of the reflection. Fill light was provided by the existing open shade illumination.

The Profoto system has a proprietary remote control for the flash heads so that you can adjust every parameter, of multiple heads, from the camera position. It's extremely convenient and a significant timesaver on busy shoots. The build quality of the covetable Profoto system is exquisite; it's made to last and is one of the most precise flash systems I've ever tested.

I shot images from various distances with my 50mm lens, but ultimately liked the closer-up versions that felt more intimate. The background was softened by the large f/2 aperture.

OPTIONS

A less expensive monolight and strip box could be used. Photoflex, AlienBees, and Wescott make good quality systems for less. The wireless controller is very helpful, but not necessary.

Exposure Info:

50mm lens setting
f/2 at 1/250 sec.
ISO 200
Exposure comp. +/− 0

Tools Used:

Nikon D3s
50mm f/1.4 Nikkor lens
Profoto D1 Air 500 Monolight
Profoto 1 × 4 Strip Softbox
Profoto wireless flash trigger and
 controller
Singh Ray Vari ND neutral density filter

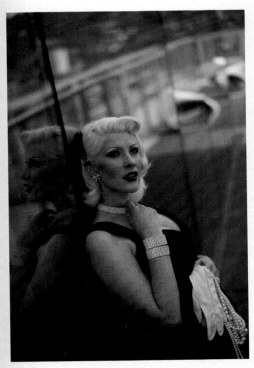

The original image from camera.

Boudoir On A Balcony

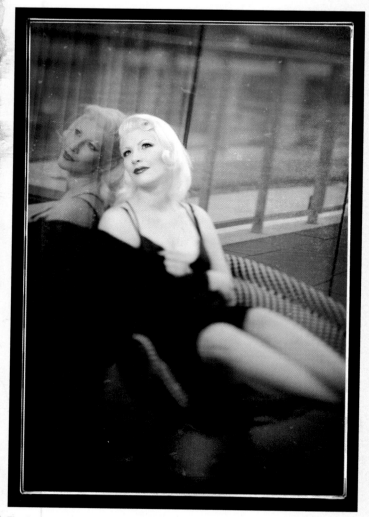

The final image was processed in Lightroom and Photoshop to create a semi-cross-processed look, and then texture and a sloppy border were added to further enhance the vintage styling.

What's the first thing you think about doing on a crisp, cool, spring day on the windy balcony of a luxury hotel? Exactly! You want to strip down to your negligee. As all photographers know, the weather doesn't always cooperate, and although our hopes for a warm, sunny day were dashed, our persistence was not. The trick was to make the lighting *look* like it was a warm (or, at least not freezing) morning.

We used the Profoto D1 Air monolight with a grid spot attachment to create a crisp and directional light. The existing light from the overcast sky was fine for fill light, but not interesting enough for the dramatic look we wanted. The Profoto grid has a beautiful, even pattern of light, with smooth falloff. An alternative, which would have worked similarly, is a speedlight with a Rogue Grid attachment. The power of the Profoto monolight gave us a bit more working distance and very fast recycle times, which was nice since we wanted to get the shots done as quickly as possible without missing a beat. Yes, the model was cold.

The grid spot gives a slightly harder light, which is very focused. It closely resembles the Hollywood lighting of days gone by, as well as a sun—low in the sky. When the exposure is matched carefully to the existing light, you get facial shaping, specular highlights on the lips, and twinkles in the eyes, without undue harshness.

I used a Nikon 85mm tilt-shift lens to throw the lower half of the frame out of focus. This is a really fun lens to use for portraiture, although it takes some practice to master the various adjustments. I also used a neutral density filter to allow for 1/250 second shutter speed at f/2.8.

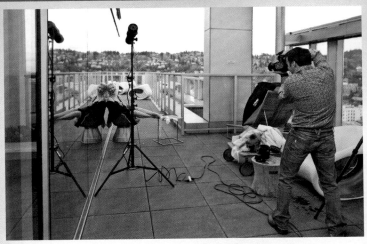

After you have a normal exposure for the ambient light determined, adjust the flash and check the camera until the balance between ambient and artificial feels right. I find this much more intuitive, and quicker, than measuring each with a light meter.

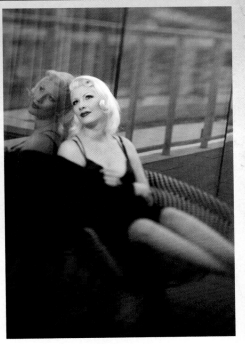

The original image from camera.

Exposure Info:

85mm lens setting
f/2.8 at 1/250 sec.
ISO 200
Exposure comp. +/− 0

OPTIONS

A speedlight with a Rogue Grid could have been used for similar effect. At this distance and with an ND filter in use, near full-power probably would be necessary, increasing recycle times.

Tools Used:

Nikon D3s
85mm f/2.8 tilt-shift Nikkor lens
Profoto D1 Air 500 Monolight
Profoto grid spot attachment
Profoto wireless flash trigger and
 controller
Singh Ray Vari ND neutral density filter

Beautiful Bride, Ugly Hallway

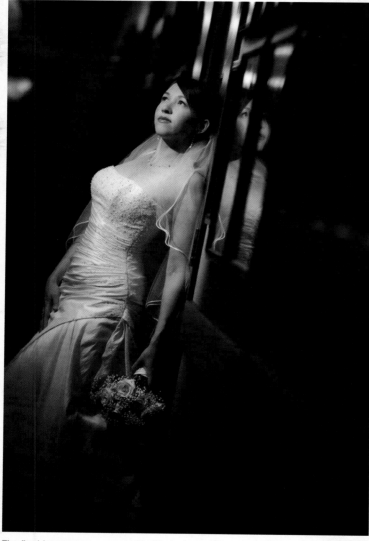

The final image was processed in Photoshop with our Dashboard tools—Creamsickle, Doll Face, and Edge Blur, adding to the drama and glamour. B&W Interactor effect was used for the monochrome conversion.

Sometimes you just don't have much to work with. I'm not talking about the bride, of course; I'm talking about the location. The adage is true: Almost anyone can make a beautiful photo under beautiful conditions, but it takes experience to make a nice photo in an ugly location. The right choice in lens, composition, and lighting literally can create something out of nothing.

The walls of this hallway were decorated with "interesting" framed prints, hardly conducive to the romantic mood we wanted to convey. The overhead lighting was less than flattering, with an unusual colorcast that was hard to match with colored gels on a flash.

To add to the excitement, guests and hotel staff were constantly walking through the hall, making a clean shot down the middle challenging. Our solution was to disguise the prints by shooting at an extreme angle, use black and white to bypass the color issues, and reduce the ambient exposure to hide other distracting details and bystanders. In the end, the effect is a dramatic portrait that focuses on the lovely subject rather than the distracting background.

A single speedlight was used with a Rogue Grid accessory to funnel the light into a dramatic beam on her face. The grid kept the light off the wall as much as possible while allowing the light to fade as it moved down away from her face.

A PocketWizard wireless trigger system allowed my assistant with the light to be around the corner, out of sight, and still receive the flash signal. I set my exposure to the flash and allowed the ambient to be about two stops darker, to create more dramatic lighting and to hide the distracting hallway as much as possible.

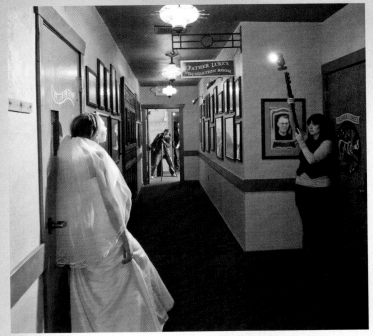

I knew when I shot this image that I would make it a black and white. If I had intended to keep it in color, a Sticky Filter colored gel over the flash would have helped to match the flash to the ambient light colors, although perfect matching was difficult.

The original image from camera.

Exposure Info:
190mm lens setting
f/2.8 at 1/125 sec.
ISO 1250
Exposure comp. +/– 0

Tools Used:
Nikon D3s
70–200mm f/2.8 zoom Nikkor lens
PocketWizard TT1/TT5 wireless trigger
 system
Nikon SB900 Speedlight
Rogue Grid for speedlights
Lastolite Ezybox Extending Handle

Breezy

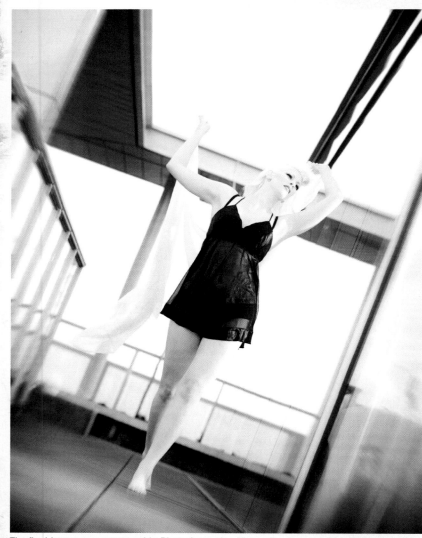

The final image was processed in Photoshop using VintageTen from our Viva La Vintage Pak. I also used Doll Face to smooth her skin a bit and hide the goosebumps!

This elegant image wasn't created on a warm, sunny day. It was cold, and she was on the shady side of the building. I wanted to emulate the look of crisp sunlight reflecting off the glass walls to her left, but nature wasn't going to cooperate. So, instead we placed a monolight inside the building, but shining outward through the windows. I drew the sheer curtains closed to slightly soften and diffuse the otherwise crisp light from the bare flash head.

Shae was, obviously, the other successful element of this image. She maintained her lovely composure, despite being barefoot and barely dressed.

The position of the light inside gave me a relatively small "window" of opportunity in which Shae would be receiving the light at just the right angle. I had her walk up and down the path several times to get her body position, the scarf, and lighting all in sync.

I knew that much of the success of the image would be in the post-processing, as it needed a vintage feeling to match her styling and the "Marilyn Monroe" vibe I got from the whole scene. I also wanted to give it more of a dreamy feeling, so I used my Edge Blur Modified Dashboard Action to gradually soften the edges of the frame. I felt the strong architectural lines were a bit too harsh, and distracting, for the softness we needed to convey.

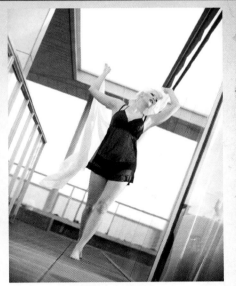

My assistant played with the direction, and fall-off, of the light by moving it slightly as the model moved. Because of the dramatic shadows from this type of light, it has to be repositioned as the model moves her face to maintain proper shaping.

The original image from camera. Clean, but it needs some vintage feeling!

OPTIONS

A less expensive monolight could have been used, although a speedlight probably would not provide the power or recycle times I needed.

Exposure Info:

82mm lens setting
f/3.2 at 1/250 sec.
ISO 200
Exposure comp. +/– 0

Tools Used:

Nikon D3s
70–200mm f/2.8 zoom Nikkor lens
Profoto D1 Air 500 monolight
Profoto wireless remote
Singh Ray Vari ND neutral density filter

Going To School

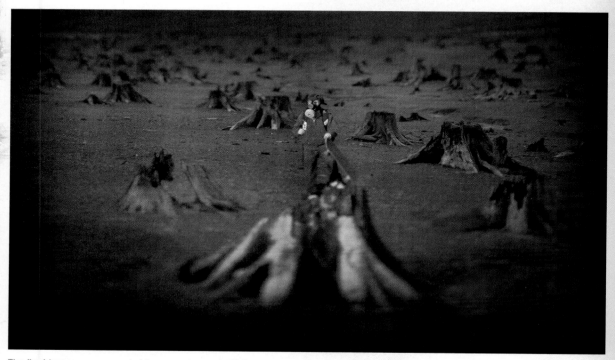

The final image was converted to monochrome in Lightroom, and then two layers of texture were applied in Photoshop with texture tools from our Bor-Tex DASHBOARD Set package. The result is an antique look that is at the same time quite timeless.

Benjamin Edwards, my good friend and photo buddy, worked with me on the *Lighting Notebook,* and this was one of the images he wanted to create. He had seen this location many times while driving through and imagined it would make an amazing location for a portrait—this one, in particular, a statement about the future of our environment and the impact it could have on our children.

The challenge here was to capture enough of the environment to show the desolation, while also keeping the subject relatively small in the composition to emphasize the vastness and solitude. Somewhere in there, we'd also need to get a small light box, up close to the subject, to bathe him in the directional light Ben envisioned. The solution was to capture two frames—one lighting the subject (and

revealing the assistant) and another with the assistant out. He used the same technique that I illustrated earlier in this section (Aspen Sunset) to clone out the assistant with information from the clean, second photo. If the assistant had been farther out of frame to allow a single capture, the lighting quality would be very different and not the look he was going for.

A single Photoflex small OctoDome was attached to a Nikon Speedlight, and our assistant held the complete setup above the subject's eye level using a Lastolite extension pole. The small light box, when used up close, illuminates just the subject and tree stump. It added shaping and definition to the subject that the existing overcast sky could not provide. An 85mm Nikon Perspective Control lens was used for the unusual depth-of-field effect.

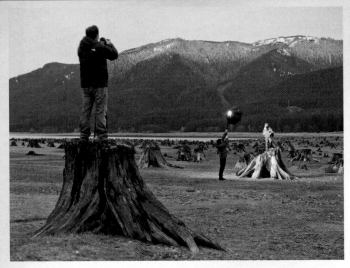

The original image from camera, sans assistant. The 85mm Perspective Control Lens enabled him to move and control the plane of focus, creating the "miniature camera" look.

After Ben found his perfect vantage point, he shot one image with the assistant in the frame, and, without moving the camera, shot another frame with the assistant out. He then combined and masked the images in Photoshop.

Exposure Info:
85mm lens setting
f/2.8 at 1/320 sec.
ISO 200
Exposure comp. +/– 0

Tools Used:
Nikon D700
85mm f/2.8 PC Nikkor lens
Nikon SB800 Speedlight
Photoflex small OctoDome
PocketWizard Max wireless
 trigger system
Lastolite extension pole

I'm On Track

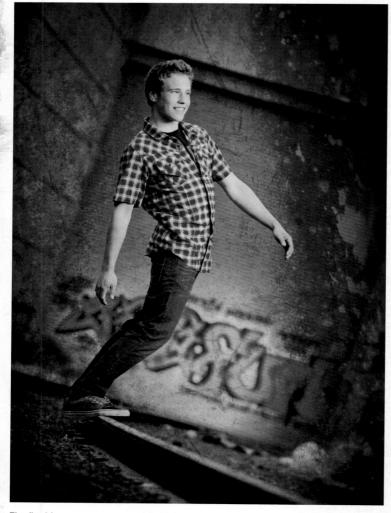

The final image was processed in Lightroom with my Vintage Delish preset collection and then retouched in Photoshop. The Dubnium texture was applied using our Bor-Tex Software.

We found this grungy back alley at the end of unused train tracks. The graffiti and industrial surroundings made a perfect urban backdrop for this senior portrait. The artwork-covered wall just happened to match the colors of our young man's shirt, too, which, of course, we totally planned…cough, cough.

It was an overcast evening with very little in the way of exciting existing light, so we created our own drama. A smaller light box gives us crisp and directional light, while still being somewhat soft—with nice transitions from highlight to shadow. We mounted a small Photoflex Octo-Dome on an AlienBees monolight and powered it with a Paul C. Buff Vagabond battery pack. Although we could have used a speedlight instead, the AlienBees on the Vagabond recycles faster at near full power and won't as easily shut down from rapid-fire overheating.

A speedlight was placed in the background to create a spotlight on the graffiti. This was fitted with a Rogue Grid to shape a smooth pool of light. The light and light stand were removed from the image in Photoshop. I used a neutral density filter to allow me to shoot at f/3.2 and still darken the background enough to create drama and hit a shutter speed that would sync with my monolight.

Laying on train tracks in trash and broken glass is not something I normally recommend, but I really loved the perspective and the leading line of the track as he precariously balanced on it. I feel it helped to create a more dynamic image, complemented by the edgy environment and post-processing. I asked the guy to balance and arch himself until he started to fall at which point I would capture a frame. Images feel more energetic when you can freeze movement at the peak of motion, as sports photographers do so well. It adds dynamics and anticipation, which we all need a bit more of in our lives.

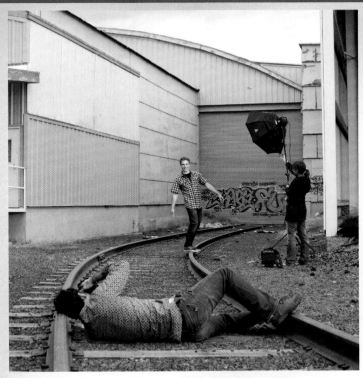

The main light was set up on a light stand, but my assistant would move the light slightly as our youngster moved, tracking his position for best light coverage.

The original image from camera. You can see the additional light in the background, spotlighting the graffiti. It was later cloned out.

Exposure Info:
125mm lens setting
f/3.2 at 1/250 sec.
ISO 800
Exposure comp. +/– 0

Tools Used:
Nikon D3s
70–200mm f/2.8 zoom Nikkor lens
Paul C. Buff AlienBees B800 Monolight
Paul C. Buff Vagabond portable battery
 pack
Nikon SB900 Speedlight
Rogue Grid for speedlights
PocketWizard Max wireless trigger
 system
Singh Ray Vari ND neutral density filter

OPTIONS
A speedlight could have been used with the OctoDome instead of the monolight and battery pack. Less expensive neutral density filters are available as well.

Baby In The Window

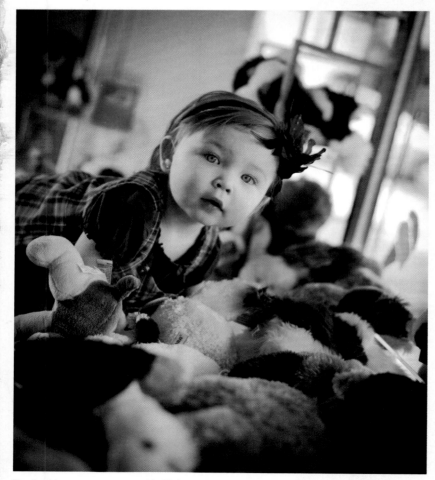

The final image was processed in Lightroom with Rolling Stone Wash preset, from the Vintage Delish collection. This gave me the soft, creamy color palette. The image was cropped to remove distracting elements.

Every child that walks by this local sweet shop window pauses, little hands and noses pressed to the glass, to drool over the candies and stuffed toys within. It's a cornerstone in our local community, and an obvious location for a child's portrait. The entire window has a shelf filled with furry fake animals, and our little lady loved crawling among them—this would be our image!

Natural light poured through the window, reflected off the concrete sidewalk outside. It provided an abundance of soft, wrapping light, but needed some additional light from inside the shop. I set up a Lastolite Ezybox on a speedlight, because it was, well, Ezy. The softbox literally pops up and snaps to a speedlight support ring. It takes seconds and creates a really beautiful light. I used this to create an edge light, coming from slightly behind the little girl, shaping her face and cute baby cheeks. Although moving the light closer to camera position would have created more typical fill light, it wouldn't have been as interesting nor created extra separation from the background.

When working with young children, I try to keep my lighting as simple and portable as possible because kids rarely sit in one spot for very long and certainly won't hold a certain head position for any longer than you can say "Lollipop." Larger light sources, like the shop window, allow the subject to move around more without there being a large change in exposure or light quality. Using the stationary flash as a rim light, rather than a main light, meant that its positioning was slightly less critical and would enhance the image even if she moved around a bit within the stuffed stuff.

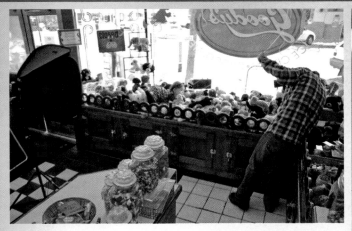

The local shop owner was happy to let us photograph there during the opening hour, when they were slowest. We, of course, bought ice cream for everyone when done and the little girl got to pick out a stuffed toy to take home.

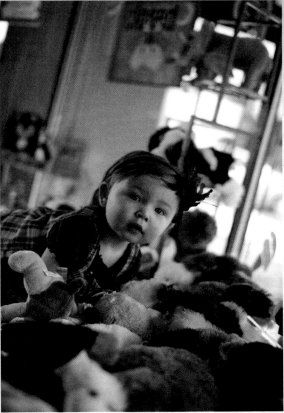

The original image from camera.

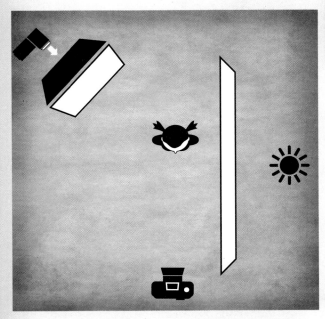

Exposure Info:
50mm lens setting
f/2 at 1/1000 sec.
ISO 200
Exposure comp. +/− 0

Tools Used:
Nikon D3s
50mm f/1.4 Nikkor lens
Nikon SB900 Speedlight
Lastolite Ezybox
PocketWizard TT1/TT5 wireless trigger system

Kid In A Candystore

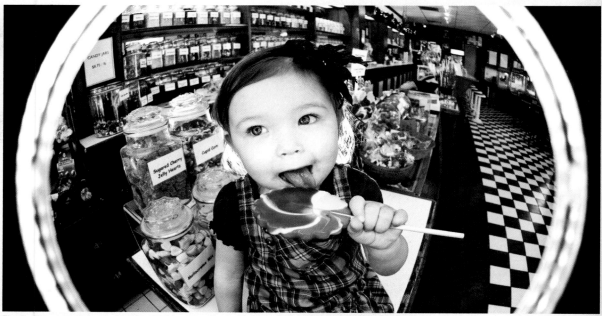

The final image was processed in Lightroom with my Vintage 2 preset, from the Vintage Delish collection. I like the added warmth in the shadows, which feels like chocolate!

One of the best ways to get children to cooperate on a photo shoot is with good, old-fashioned bribes. Candy works really well, so why not do the entire session in a candy store and save a trip! The image I had in my mind was of this little girl sitting on the counter licking a giant lollipop. When we got there, however, the lollipops they had were not actually very giant. I knew I needed a wide-angle lens to exaggerate the perspective and make the lollipop look larger than life.

The RayFlash ringlight attachment is an innovative photo tool. It fits to the front of any camera speedlight and encircles the lens. Unlike most other ringlight setups, the RayFlash is completely portable, allowing you to move about and try different angles. It also allows for normal TTL flash operation, so you don't have to worry about adjusting the light manually. Normally, the RayFlash is used with semiwide to normal perspective lenses, but I decided

to use it with a 10.5mm fisheye lens, which has such a wide angle of view that it actually shows the edges of the ringlight. I loved the effect as it felt like looking through a portal to a fantasy world of delectable treats.

A portable speedlight was placed behind the subject to add an edge light and separation from the background. A PowerSnoot from Gary Fong was used to constrain the light to a narrow beam. I balanced my flash exposure with the existing light in the shop using TTL mode on the on-camera flash and manually for the backlight. The second speedlight was triggered by the built-in optical slave, which works fairly well when in close proximity and indoors.

After taking a few images of our little lady delightfully devouring the lollipop, the candy smeared all over her face and an even better image came to light than I originally imagined. Can you say "sugar rush"?

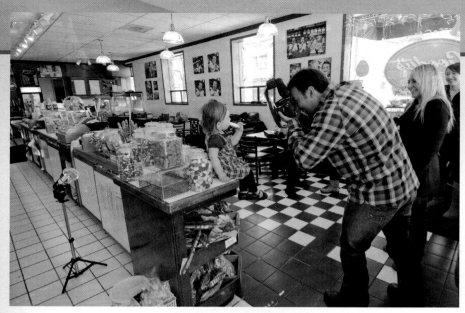

I asked Mom to stand very close and keep an eye on her daughter in case she started to scoot off the edge of the counter. Fortunately, she wasn't going anywhere—as long as the lollipop lasted.

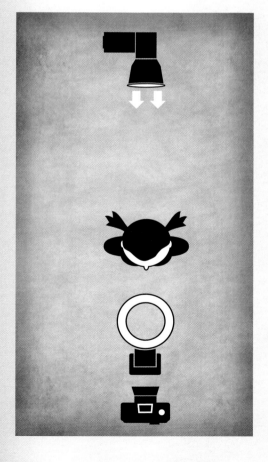

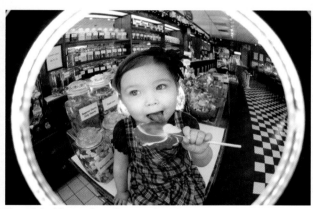

The original image from the camera

Exposure Info:

10.5mm lens setting
f/4.0 at 1/160 sec. ISO 500
Exposure comp. +/– 0

Tools Used:

Nikon D300s
10.5mm f/2.8 fisheye Nikkor lens
RayFlash ringlight from Rogue Imaging
Nikon SB800 Speedlight
Gary Fong PowerSnoot

Angel Bride

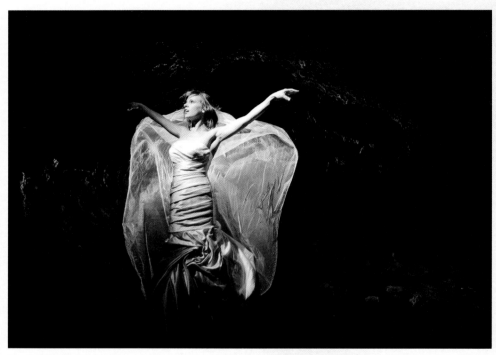

The final image was processed in Photoshop with my Ten60's Dashboard effect along with retouching to remove the visible trampoline. Additional tonal adjustments were made with my Digital Fill Flash and Smoke-less Burn tools.

Normally, when I think of underground caves, I think of bats. Fortunately, "Bat Bride" doesn't have quite the same ring as "Angel Bride," so I decided to work the angel theme instead. This became obvious to me when we started shooting this image, and the floating veil formed beautiful shapes resembling angel wings.

Benjamin suggested the location for this shoot, and I imagined the cool lighting we could create along the cave walls—rich with texture and mystery. I brought along my mini-trampoline that I've used in several other shoots, which is a great prop to have when a slight aerial dimension is needed. It's also a great way to get kids giggling.

The main light comes from a speedlight with a RogueGrid attached to create the heavenly beam she ascends to. My assistant held the light as high as he could so that it would still fall downward on her when she jumped up on the trampoline. A second speedlight was placed farther back in the cave to backlight her and edge light the walls of the cave. Both lights were triggered by PocketWizard radio slaves.

The key to this image was timing and a bit of luck. I knew what I wanted to see in the veil and in Katie's facial expression, but getting them both in the same shot required several attempts, although it took far fewer than I anticipated. Maybe somebody upstairs was cooperating to get his angel home for dinner on time.

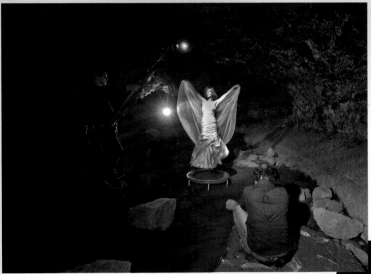

We brought a couple of tarps to lay down on the cave floor to keep ourselves, and equipment, clean.

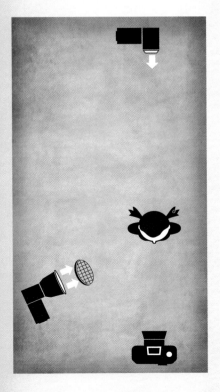

The original image from camera. Because of the perspective I wanted, and the length of the dress, we were unable to get Katie high enough to clear the trampoline. It would have to be removed in Photoshop.

Exposure Info:

16mm lens setting
f/3.5 at 1/320 sec. ISO 200
Exposure comp. +/– 0

Tools Used:

Nikon D700
14–24mm f/2.8 zoom Nikkor lens
Nikon SB900 Speedlight
Nikon SB800 Speedlight
RogueGrid for speedlights
PocketWizard TT1/TT5 wireless trigger system

Studio Senior

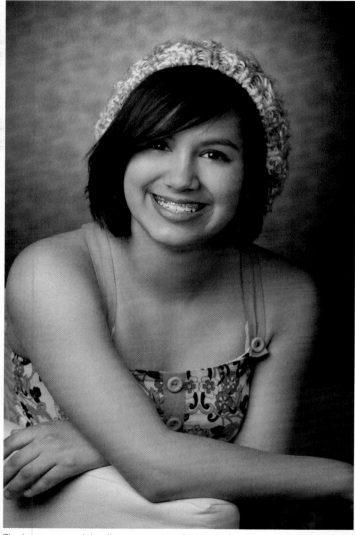

The image was minimally processed and retouched in Photoshop. We opted not to remove her braces in Photoshop as she was quite proud of them.

Sometimes you just need a great, classic headshot. Although flattering lighting is essential to a headshot, capturing a natural, convincing expression is probably paramount. Give your clients some time to loosen up and become comfortable. It inevitably seems the best image comes when I think we're finished, and I say, "Okay, we're done! Just one more shot for good luck… ."

Headshots require nice catchlights in the eyes. Remember that discussion from Chapter 4? Eyes should twinkle and be expressive. The octagon-shaped softbox used here creates a catchlight that matches the shape of the iris, making it complement the eyes nicely. The size of the softbox used here is perfect for headshots as it is large enough to be soft, when used up close, and still small enough to create great shaping and soft, transitional shadows. This particular box, from Profoto, is 3 across.

I used a white 42" reflector disc for fill and a Profoto beauty dish for a hair light. Using a beauty dish allowed for light to spill over the subject and hit the fill reflector, too, adding to its output. It's important to think about how a single light can serve multiple functions—whether that is your intention or not, it's good to be aware of it. Sometimes I'll turn my main light slightly toward the background, feathering it from the subject and utilizing some of the light as a background light. In this way, one light can act as two—or even three. By feathering the mainlight carefully toward, or away from, your fill reflector, you can create exactly the light ratio you want.

An AlienBees monolight was placed on the floor behind the subject with a grid spot adapter to create a small glowing spot behind my subject's head. The beautiful backdrop is a custom-printed product from White House Custom Color. Their backdrop options are vast, beautiful, and affordable. You can even have your own design printed for a one-of-a-kind look.

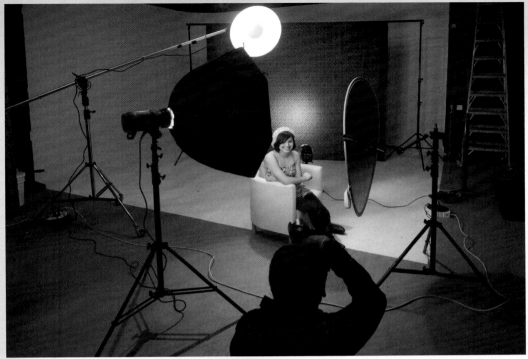

A Bogen Magic Arm holds my reflector disc. This is a valuable studio accessory and much cheaper than hiring an assistant. Assistants are generally smarter, however. The background light was triggered by the built-in light slave.

OPTIONS

The Profoto equipment used could be swapped for less expensive monolights, or even speedlights. Alien-Bees make a nice beauty dish, and most lighting manufacturers have octagon-shaped boxes to fit a variety of lights.

Exposure Info:

110mm lens setting
f/4.5 at 1/250 sec.
ISO 200
Exposure comp. +/– 0

Tools Used:

Nikon D3s
70–200mm f/2.8 zoom Nikkor lens
2 Profoto D1 Air monolights
Profoto wireless remote
Profoto beauty dish
Profoto 3 Octobox
Paul C. Buff AlienBees B800 monolight
Paul C. Buff grid spot attachment
Photoflex 42″ white/silver LiteDisc
WHCC custom backdrop

Beauty Light Beauty

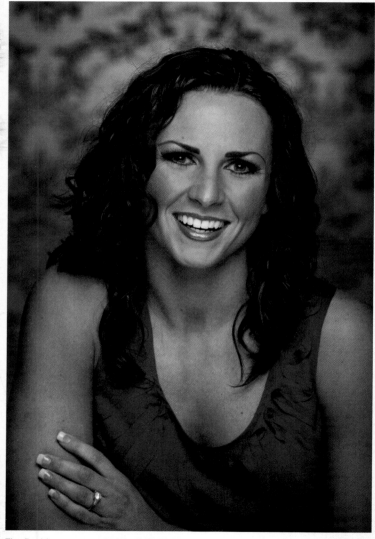

The final image was retouched slightly in Photoshop, but otherwise remains fairly true to the original capture. Kacy is blessed with lovely features and skin, so little was needed.

Classic "beauty lighting" can be created in many different ways, but essentially it is a nearly shadowless light that usually comes from directly in front of, and above, the model's face. The light source can be soft or crisp and generally is filled in with lights or reflectors directly below the face. This variation here maintains a bit more shadow for nice shaping, and the telltale catchlight from the lower reflector in the bottom of the iris is common to beauty lighting.

Although used commonly for fashion or makeup advertising, beauty lighting is not flattering to all types of faces. The subject should have a thin to normal-shaped face, otherwise it could appear unnecessarily heavy due to the flattening effect of direct frontal lighting. If you have a subject with great skin and thinner features, you might give it a try; it has a fresh and vibrant feeling that really works, when it works.

The lower reflector, or fill light, should be positioned as close to the subject's face as possible, just out of camera view. If you use a fill light, be sure to keep the power a bit lower than the main light, or you'll create up-lighting, which is generally reserved for vampires.

The backdrop used for this image was made from wallpaper attached to a sheet of plywood. It can easily be moved around the studio and can be used to hang other backdrops. A trip to the fabric store could reveal all kinds of interesting backgrounds. You might even experiment with painting your own backdrop if you are feeling bored on a Sunday afternoon. Almost anything looks good when slightly out of focus.

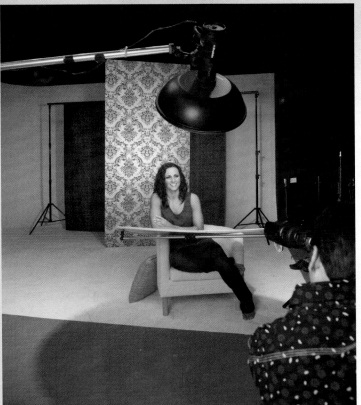

Position the lower reflector just out of camera view and it creates a beautiful catchlight in the eyes—twinkling like ophthalmic diamonds

OPTIONS

A less expensive monolight and beauty dish could replace the Profoto setup here. AlienBees makes a very nice dish o' beauty that fits its monolights. A speedlight with the Pro Kit collapsible dish could also work but would not provide quite as even a light pattern.

Exposure Info:

155mm lens setting
f/4.5 at 1/250 sec.
ISO 200
Exposure comp. +/– 0

Tools Used:

Nikon D3s
70–200mm f/2.8 zoom Nikkor lens
Profoto D1 Air monolight
Profoto beauty dish
Profoto wireless trigger system
Photoflex 42″ white pop-up Litedisc

Lord Of The Ringlight

The ringlight is known for the unique catchlight and a soft shadow that surrounds the subject. Here, the shadow is not obvious because of the distance from the subject and subject to background. Experiment to find a look you like.

The ringlight often was used for fashion and makeup advertisements through the 1990s and still has an allure that is distinctly its own. It creates the quintessential beauty lighting—shadowless and all-revealing. You really need a confident face for a close-up with this baby. It is fun, fresh, and funky, with signature circular catchlights that make your subjects' eyes jump out and grab you.

This unique ringlight is a constant-light fluorescent model from Personal Touch Portrait Studios. It's incredibly simple to use, and the large size makes shooting through it easier than most. Experiment with moving your light closer and farther from the subject as the look changes

quite a bit. The output is high enough that I could shoot at 1/125 and f/3.2, although I needed ISO 500 to do that. If you are not comfortable shooting at that wide an aperture, you'll need to crank up that ISO or bring the light a bit closer to the subject. It would be risky to shoot at a slower shutter speed and expect crisp images.

The backdrop used here was another custom print from White House Custom Color. The patterns take on very different looks depending on how much they are in, or out, of focus.

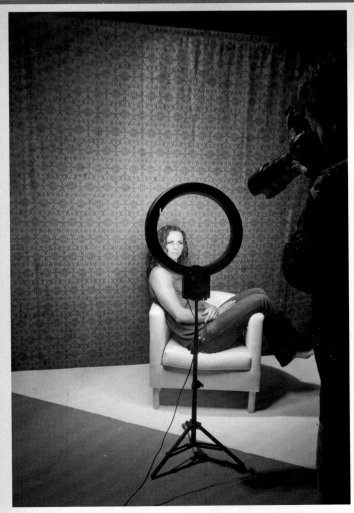

The large aperture of this particular ringlight allows me to move about a bit more freely than other ringlights.

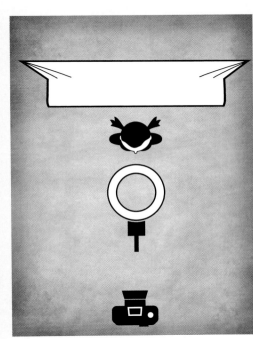

 OPTIONS

If you prefer a flash-type ringlight, AlienBees makes an affordable unit that also takes a variety of modifiers to soften the output, or convert it for use as a standard octagon-shaped softbox.

Exposure Info:

175mm lens setting
f/3.2 at 1/125 sec.
ISO 500
Exposure comp. +/– 0

Tools Used:

Nikon D3s
70–200mm f/2.8 zoom Nikkor lens
Personal Touch Portrait Studios ringlight
WHCC custom backdrop

Lyible. The Band

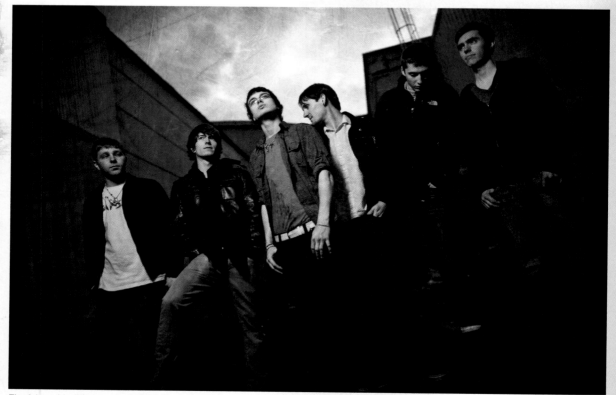

The feigned indifference look is all the rage right now. Although they look casually arranged, we did have to do some positioning to ensure they wouldn't cast shadows on each other's faces. The image was enhanced with my Vitamin K preset in Lightroom and a texture from our Bor-Tex plugin in Photoshop.

Lyible is a young, energetic local rock band, and we set out to do some promotional shots of them in action, and just hangin' as a group. It was getting late, and the light was fading fast. It was a rather gray, overcast day, so there wasn't a dramatic sunset to take advantage of, but we needed drama, one way or another. I decided to do two things. First, I whipped out the beauty dish. This gives the punchy light we wanted, and the shape provides nice falloff from head to toe. Next, I wanted a dramatic blue sky, so I set my camera white balance to tungsten and added a warm amber gel to my flash unit. By matching the flash to the tungsten setting, the subjects illuminated by the flash appear normal, while the sky in the background turns extra blue.

Using the monolight on the portable battery allowed me to shoot rather quickly as we had little time before the sky went too dark and we would lose that perfect balance between ambient and flash. When you are lighting a group, and the main light is on one side, aim it so the center is pointing at the person farthest away. This allows the brightest portion of the flash to travel the farthest distance, which in turn creates more even illumination across the group as it feathers. If we aimed it at the center, the person on the left, closest to the light, would be much brighter than the others.

My assistant had the flash on a light stand, but we found it easier to get in the correct position quickly if he just held it.

OPTIONS

A speedlight with a beauty dish or a small octagon-shaped light box would give a similar quality light. The beauty dish makes efficient use of the flash power.

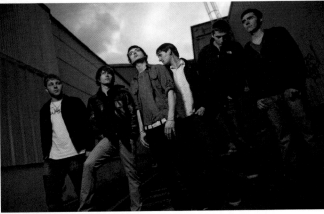

The original image from camera.

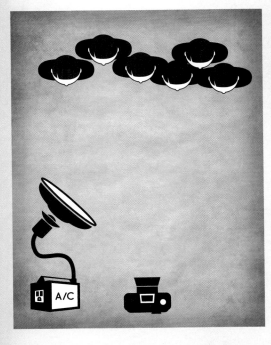

Exposure Info:
24mm lens setting
f/1.6 at 1/40 sec.
ISO 200
Exposure comp. +/− 0

Tools Used:
Nikon D3s
24mm f/1.4 Nikkor lens
AlienBees B800 monolight
Vagabond battery
PocketWizard Max wireless trigger
 system

Hot and Steamy

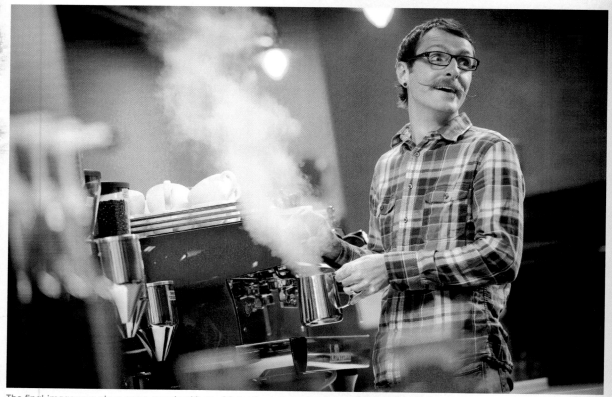

The final image was given some punch with my 65 Fastback Lightroom preset. I also removed a green exit sign from the background in Photoshop.

Bend, Oregon, is full of great local coffee shops and breweries. In fact, we pride ourselves on being coffee and microbrew snobs. One of the best in town is Backporch Coffee Roasters, and Dave, the owner, is quite the coffee aficionado. You'll often find him behind the racy red La Marzocco, pulling shots for customers with a smile and a perfectly tuned mustache. I wanted to capture a bit of Dave's quirky side, while keeping the image candid feeling and fun.

The front of the shop is a giant glass garage door, so there was an abundance of natural light streaming in. When the light is good, use it! All I wanted was a little kicker over his shoulder to help make him pop from the background and emphasize the character in his expressive face. An extra small OctoDome from Photoflex, mounted with a speedlight, did the trick. I adjusted my flash to balance with the natural light, and we were good to go. Notice the foreground objects. They were placed strategically to add depth and a candid feel to the image. It took a few shots to get the steam eruption and Dave's expression to coordinate, but it actually came together pretty quickly with the simple setup and Dave's easygoing manner.

Later in the Notebook, we create another, very different, image of Dave with a slightly more involved lighting setup.

The original image. I removed the green exit sign and the reflection on the wall later in Photoshop.

Tight composition kept the good stuff in frame: artsy painted wall, beautiful red espresso machine, and colorful personality.

Exposure Info:
130mm lens setting
f/2.8 at 1/60 sec.
ISO 640
Exposure comp. +/– 0

Tools Used:
Nikon D3s
70–200mm f/2.8 zoom Nikkor lens
Nikon SB900 Speedlight
Photoflex extra small OctoDome
PocketWizard Max wireless trigger system

Blue Steel, Eat Your Heart Out

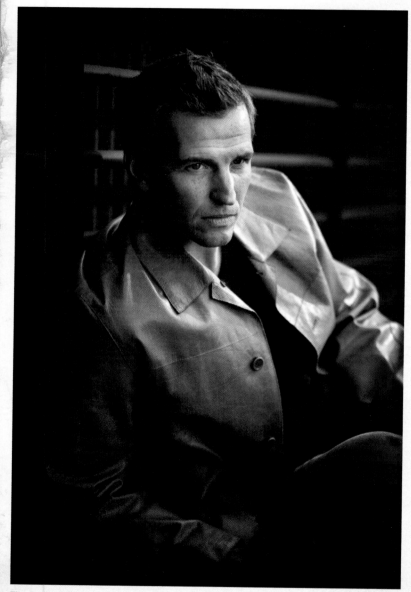

The final image was enhanced with my Old N Warm Lightroom preset. It's a nearly monochromatic look that still preserves some color and adds a toasty warm tone.

Markus was in need of some updated headshots for his active modeling work, and we had just the spot in mind. This modern industrial backdrop gave his rugged looks the edge it needed. The natural light was almost enough to make this setting work, but it needed some "pop." Remember the kicker light from Chapter 2? That's what this portrait needed, so we set up a speedlight with a Rogue Grid attachment to create a narrow beam. I wanted the light to skim the highlight side of his face and clothing, while also adding some interesting patterns to the wall behind him.

The overcast sky and gray reflective sidewalk create a soft, yet directional light that needs very little to make it just right. Usually a reflector or kicker light will be all that is lacking. Buildings with overhangs that block the direct sun, but still allow an abundance of reflected light, are great "mobile studios" to have in your database.

My assistant attached the speedlight and grid to an extending pole so he could hold it up high, in the exact spot we needed. It's important that they hold it consistent, however, after the light is properly placed.

This particular angle works really well for male portraits as it allows the closer shoulder to drop, and the head has a natural masculine tilt to the rear shoulder. The leading lines of the handrail add dynamics to the image and draw the viewer to the model.

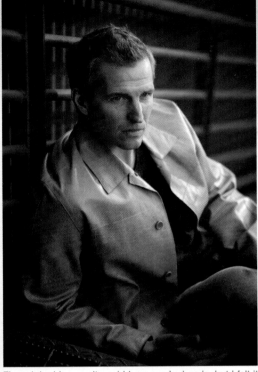

The original image. It could have worked as-is, but I felt it needed a bit more drama and style.

Oops! I did a few test shots, thinking, "Why is that flash just not firing!" Then I realized I hadn't attached my transmitter yet. Yah, I meant to do that.

Exposure Info:

120mm lens setting
f/2.8 at 1/640 sec.
ISO 250
Exposure comp. +/− 0

Tools Used:

Nikon D3s
70–200mm f/2.8 zoom Nikkor lens
Nikon SB900 Speedlight
Rogue Grid for speedlights
PocketWizard wireless trigger system
Lastolite Ezybox extension pole

Smokeless Marlboro Man

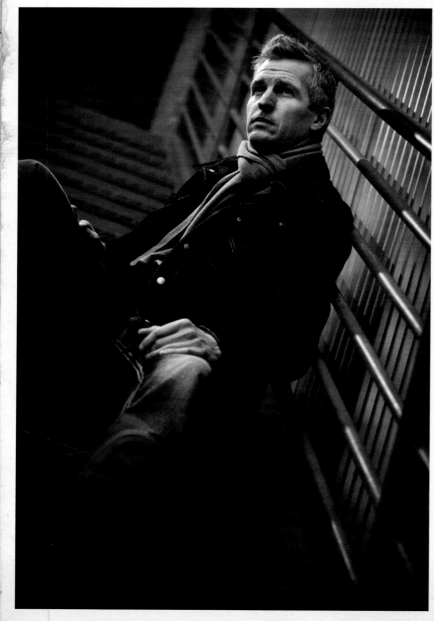

The final image needed some character, so I applied my 60s Film Lightroom preset and some vignette.

This image used a similar setup to the previous shot of Markus; however, some cloud cover started to move in, and the directional light from the sky started to fade. I decided to add my own directional light via a small Lastolite Ezybox. We also kept the grid spot as a kicker light, coming from his right side.

The Ezybox is very handy to have if you use speedlights a lot. It sets up quickly, and the light quality is impressive. The smallish size of the box and the distance from the subject create a directional beam that has nice feature shaping without being too harsh. The Ezybox has interchangeable face panels, too, so you can change the size and shape of the light.

The kicker light should be about an f-stop brighter than the main light for that crisp highlight edge. It also casts great highlights on the corrugated wall behind him, adding much more depth and interest.

In certain public places, like this mall/theatre complex where we were shooting, they get suspicious if you set up tripods and light stands. They may think you are doing a large commercial project and want you to pay for a permit. We always check first to see what their rules are. They were fine with us shooting here as long as we kept our equipment "mobile."

I kept my equipment mobile so we could move to a variety of locations easily and keep the mall management happy.

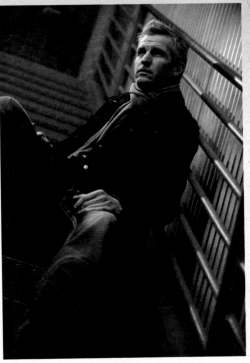

The kicker light does double-duty as an edge on the model and a background light. The Ezybox mainl ight adds nice facial shaping.

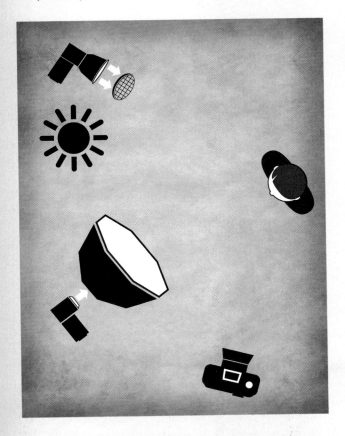

Exposure Info:
90mm lens setting
f/3.2 at 1/800 sec.
ISO 250
Exposure comp. −1

Tools Used:
Nikon D3s
70–200mm f/2.8 zoom Nikkor lens
Nikon SB900 Speedlight
Nikon SB800 Speedlight
Rogue Grid for speedlights
PocketWizard wireless trigger system
Lastolite Ezybox
Lastolite Ezybox extension pole

Dream Bride

I love the dreamy feel of this image. What groom wouldn't love to see his bride appear for him like this—bathed in glowing light, ready to take control of the checkbook?

While I was working on another photo outside, Benjamin set up this shot for us with two simple lights—a main light in an extra small OctoDome, and a un-modified speedlight for a backlight. The fill light comes from the existing light in the reception hall.

The drama and impact of the image really come from the backlight, and this is a great trick to keep in mind. A

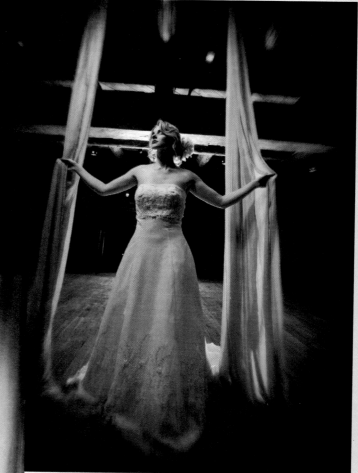

In Lightroom, I applied my Old Is New Again preset before taking it to Photoshop to apply my Edge Blur Dashboard tool.

simple, unadulterated speedlight can be placed behind your subject, almost anytime, for slight separation, or dramatic impact. All you need is a good wireless trigger system.

The second image shows a variation in the pose, using the same lighting setup. You could do your full-length, three-quarter, and close-up poses all at one time.

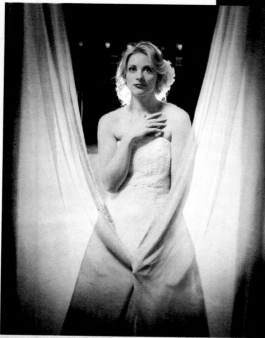

The image was processed in Photoshop with our Holgish texture from the Bor-Tex collection and the Edge Blur tool.

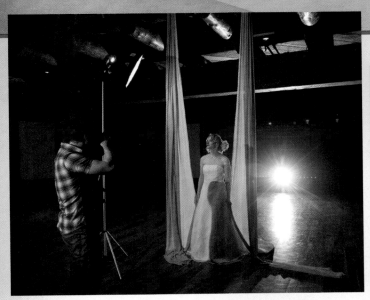

Ben got this beautiful shot all set up for us, and it gave us a few different options for posing—from full-length to close-up. When shooting the close-ups, bring the light box closer to soften it on her face.

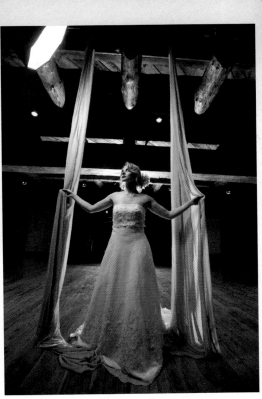

The original image. I used a wide-angle lens and wanted minimal distortion to her face, which meant keeping it centered. This revealed the light box, but I knew I could crop that out.

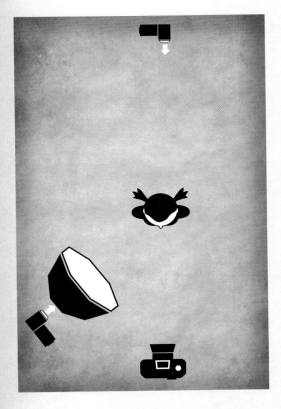

Exposure Info:
17mm lens setting
f/4 at 1/125 sec.
ISO 320
Exposure comp. −1

Tools Used:
Nikon D3s
17-35mm f/2.8 zoom Nikkor lens
Nikon SB900 Speedlight
Nikon SB800 Speedlight
PocketWizard wireless trigger system
Photoflex extra small OctoDome

Bride With A View

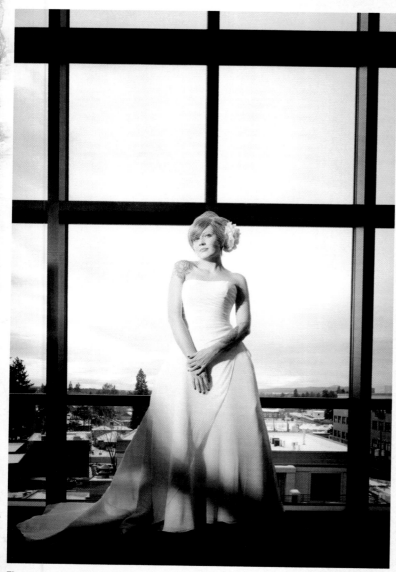

The converging vertical lines of the image were straightened in Lightroom using the Lens Correction tool. It then was processed in Photoshop with the Orange Juice texture and the Pow Wow and Starburst Vignette Dashboard effects.

Ben captured this beautiful image on the top floor of a local hotel. It was actually the hotel's workout room, but it had an amazing window wall with a view of the town below.

We wanted very crisp, and directional, light that would be a tight beam focused primarily on the bride's face. We also wanted to use the workout equipment to cast shadows on the bride, enhancing the windowpane feeling of the shot. And, lastly, because of the expansive windows and the wide-angle shots we wanted to do, the flash had to be placed quite far away, or the reflection would show in the glass. The solution was to use a grid spot on the flash, placed far enough away to cast the shadow we wanted, and remain unseen in the window.

However, one flash unit did output enough to match the exposure Ben wanted for the sky outside. It was one f-stop short of what we needed. We didn't have any flash units more powerful with us, but we did have another duplicate flash head, so we doubled them up—both fitted with grid spot attachments to funnel the light. Now we had one f-stop more; just right.

Remember, when using bold, directional light, that the angle of your subject's face is very important. Turning it toward the light creates nice short-light shaping. This pose, with the bride's head tilted toward her raised shoulder, is very feminine and sexy, with a nice S-curve in her hip.

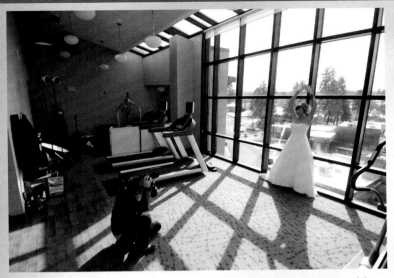

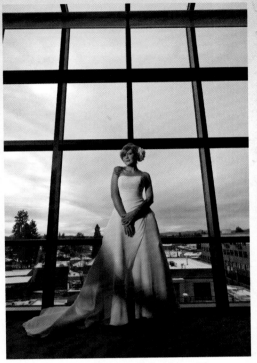

A lot of glass and wide-angle lenses dictate moving light sources out of the reflection zone. This then dictated needing more power to balance with the exposure for the outside.

OPTIONS

Three speedlights may have worked instead of the two moonlights—if fitted with RogueGrids and zoomed to their maximum setting.

The original image. The converging lines of the window could be kept as-is for a dramatic effect, and some of the images were kept this way. This one was corrected in Lightroom.

Exposure Info:
22mm lens setting
f/10 at 1/200 sec.
ISO 200
Exposure comp. −1

Tools Used:
Nikon D700
14–24mm f/2.8 zoom Nikkor lens
2 AlieBees B800 monolights
2 AlienBees grid spot attachments
Tamrac MicroSync wireless trigger system

Business As Usual

The image was kept fairly clean and needed only slight adjustments to the tone and color in Lightroom.

The Oxford Hotel in Bend, Oregon, is boutique at its best, and it's also the perfect setting for a business meet-up. This stock-type image shows off the luxurious hotel lobby and yet is generic enough to be used for a variety of business marketing needs.

The natural light from the windows was fairly diffused and bright, but it didn't quite illuminate our subjects as much as we wanted—they just didn't "pop." I wanted to keep the feeling of the existing light, but just give it more oomph. The solution was to set up a large diffusion panel and beam a flash through it. This mimicked the broad, soft feel of the window lighting, but with the extra boost we needed.

A speedlight provided enough power and was a bit quicker to set up. We wanted to be respectful of the hotel guests and get our shot done—and out of the way—as soon as possible. It was also important to have as few cords running across the floors for safety sake. Speedlights to the rescue!

I also needed something to separate my female model from the background and give her a beautifying hair light. We used a speedlight, hidden back by the elevators, fitted with a Gary Fong PowerSnoot and the grid attachment. This also creates a nice edge on the side of our male model's face.

The large scrim emulated the look of the existing window light but allowed us to boost it with a flash. Camera crews sometimes appear out of nowhere to record what I'm thinking.

There was a small light leak from the snoot that was visible on the wall. The simple solution was to toss a beany cap over the back of it. Pretty high-tech, huh?

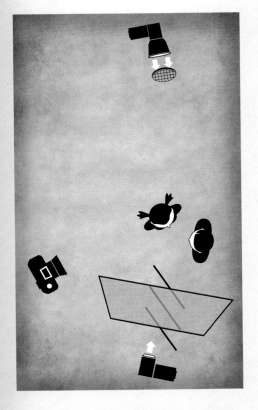

Exposure Info:
14mm lens setting
f/4 at 1/50 sec.
ISO 800
Exposure comp. −1

Tools Used:
Nikon D3s
14–24mm f/2.8 zoom Nikkor lens
Nikon SB900 Speedlight
Nikon SB800 Speedlight
Calumet Diffusion frame & fabric
Gary Fong PowerSnoot
PocketWizard TT1/TT5 wireless trigger system

Shaken, Not Stirred

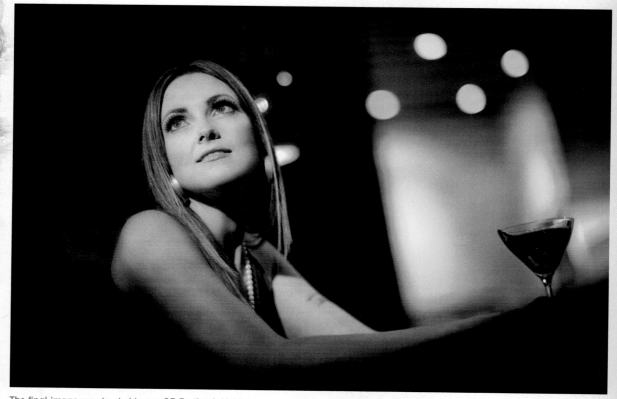

The final image was treated to our 65 Fastback Lightroom preset. Then, in Photoshop, I smoothed and softened the red blotchiness on her arm. A little softening was done to the face with our Doll Face Dashboard tool.

Typhoon, in Bend, Oregon, is a great Thai restaurant with an elegant, lounge feel. The existing lighting was low and moody, but with a slightly higher ISO and a wide aperture lens, we could make use of it and capture the natural lighting design as part of our images. I needed a directional main light, so we used a Doug Gordon Torchlight for its beautiful, even light pattern and power adjustability. The Torchlight is a battery-powered LED light. It has a dimmer switch for fine-tuning the output.

A speedlight also was used behind the divider panel to cast some shadows through it and add to the moodiness of the scene. We were careful to cast the shadows on her body, but not her face. The image could have been made without the speedlight, but it does add subtle touches that enhance the scene.

I put a tungsten gel over the speedlight, and the tungsten filter cap (that comes with it) over the Torchlight. This brought the color temperature of my add-on lights closer to matching the tungsten of the existing lights. The lamps used in the lounge were very warm, however, so they still rendered warmer than my tungsten-balanced lights. This was fine, however, as I wanted the room to feel cozy and inviting.

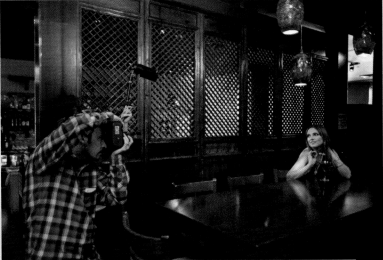

The Torchlight was wrapped with a Rogue FlashBender shaped into a snoot to create a more focused beam. The Torchlight gave more than enough output to balance with the existing lights in the restaurant.

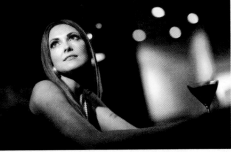

The original image.

Exposure Info:
85mm lens setting
f/1.4 at 1/100 sec.
ISO 1250
Exposure comp. +/– 0

Tools Used:
Nikon D3s
85mm f/1.4 Nikkor lens
Doug Gordon Torchlight
Rogue FlashBender
Nikon SB900 Speedlight
PocketWizard TT1/TT5 wireless trigger system
StickyFilter white balance gels

Sassy Like Sunday Morning

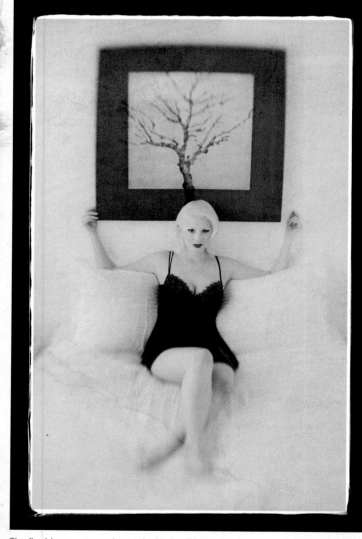

The final image was enhanced with the 58 Vette Lightroom preset. This gave the image the creamy skin tones. Then, in Photoshop, I did some slight skin retouching using our Doll Face Dashboard tool. I then added a subtle texture and a vintage sloppy border with the Bor-Tex plug-in.

The white walls and natural daylight gave this bedroom a soft, comforting feeling—like a lazy Sunday morning, when the kids had a sleepover at someone else's house.

The setting was perfect for a boudoir portrait, but the lighting needed a little more direction. The bed was surrounded by close, white walls, so it bounced and diffused the sunlight into a fairly nondescript, even illumination. I wanted just a bit of direction, maybe a 2:1 or 3:1 light ratio that looked like window light from the left.

The solution was to aim a speedlight in to the white wall on the left so that it would reflect off it, creating the effect of a big, soft window. Because the room was so small, I had to place the speedlight on the opposite side of the room, so that it fired across the scene to hit the wall. I added a RogueGrid snoot to the speedlight to keep it contained to just the wall and avoid hitting the model with hard, direct light as it passed over her.

I used the daylight-balanced fluorescent ringlight for just a bit more fill and an extra twinkling catchlight in her eye.

I'd love to take full credit for the beautiful, dreamlike look of the image, but I have to give some credit to my Lensbaby. This selective focus lens is always in my camera bag. The front of the lens swivels, placing the point of focus anywhere you want and gradually blurring the edges proportionally to the f-stop you use. It's great when you need a creative jolt.

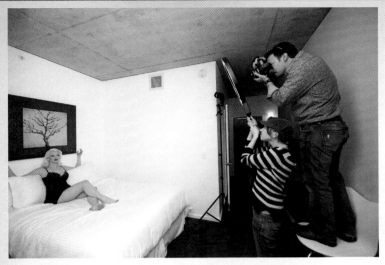

The speedlight was directed at the opposite wall to create soft, directional, bounced light. The ambient light and my ringlight provided fill.

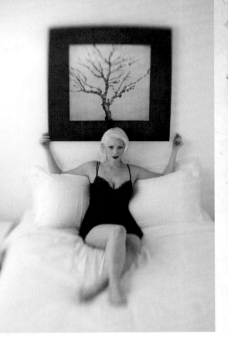

The original image. The Lensbaby gave the image the distinctive dreamy look

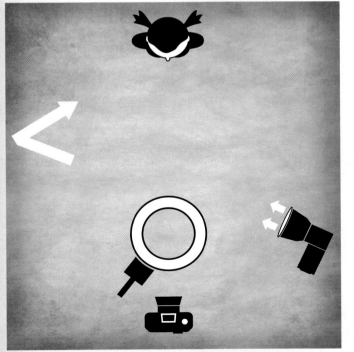

Exposure Info:

50mm lens setting
f/4 at 1/125 sec. ISO 200
Exposure comp. +/– 0

Tools Used:

Nikon D3s
Lensbaby Composer w/ glass optic
Personal Touch Portrait Studios ringlight
Nikon SB900 Speedlight
Rogue Grid
Scott Robert wireless flash trigger

Ruby Red

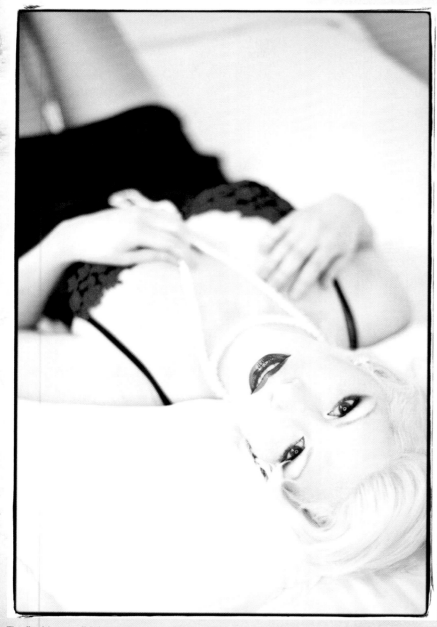

The final image didn't need much, but I used my Skin Bright Lightroom preset and added a vintage sloppy border with the Bor-Tex plug-in in Photoshop.

This image uses a modified version of the previous setup. The speedlight is still bouncing into the opposite wall for some directional light, but the main light on her face now comes from the ringlight. I adjusted my speedlight fill to be slightly less than the output of the ringlight, so there would be some natural light fall-off on her body and legs, keeping the emphasis on her face.

Moving the ringlight up closer now makes it the primary light source, and it's a glamorous light, with signature circular catchlights in the eyes.

The great thing about a ringlight is that it is shadowless, since the camera is placed directly in the middle of the light. This allows your subject to move and turn her face, without worrying about unflattering cast shadows. It also makes lips glisten and hearts flutter. Jewelry will have an extra-special twinkle as well.

If you do much boudoir portraiture, it may be worth investing in a ringlight, but keep in mind that the flat, direct nature of the light is not as flattering on rounder, or heavier faces.

A ringlight is designed for you to shoot through it, although you could experiment with placing it off to the side, like a normal light. You'd lose some of its signature look, however.

The ringlight does mount on a light stand, but because I like to move around a lot, it was quicker to have an assistant hold it and move with me.

Exposure Info:

50mm lens setting
f/1.4 at 1/250 sec.
ISO 200
Exposure comp. +/– 0

Tools Used:

Nikon D3s
50mm f/1.4 Nikkor Lens
Personal Touch Portrait Studios ringlight
Nikon SB900 Speedlight
RogueGrid
Scott Robert wireless flash trigger

It's Curtain Time

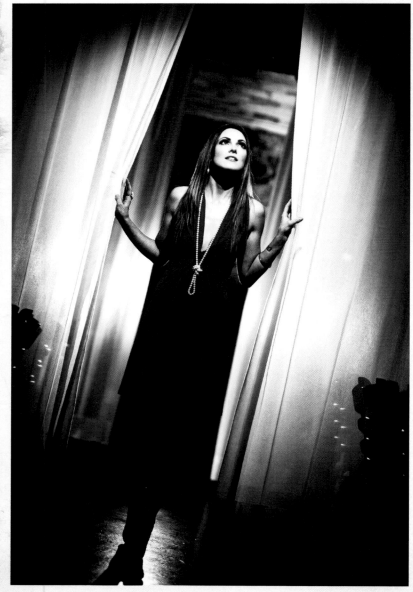

The final image needed a lot of drama, so I employed my X Process Gone Wild preset in Lightroom. This gave the image a funky color palette and the increased contrast it needed.

It was very difficult to work on this photo shoot, in one of my favorite restaurants, while employees prepared to open for lunch. Not because they were rushing me (they were very relaxed about it), but because the smells wafting from the kitchen were making me drool!

Typhoon graciously allowed us to shoot during its preopening hour. The backdrop of curtains and textures was wonderful, giving us a perfect canvas with which to play.

I imagined this beautiful woman, emerging from behind the curtain—glowing with a dramatic amber spotlight, as she asks in her sultry voice, "Is this seat taken?"

We needed only two lights to make this work, a Torchlight held up high and aimed at her face, for the main light. I wanted dramtic fall-off from head to foot, so the light source had to be high and feathered slightly upward.

To add to the glow on the curtains and to create the reflection in the ground behind her legs, I placed an LED diving light on the table directly behind her. The key feature of this particular light is the bright, even circular light pattern it makes. Most flashlights have hot spots or dark rings. Ready to dine?

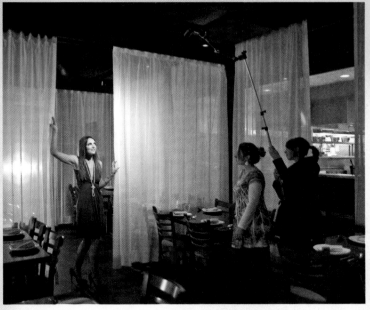

A magic arm attached to an extension pole put that Torchlight in just the right position.

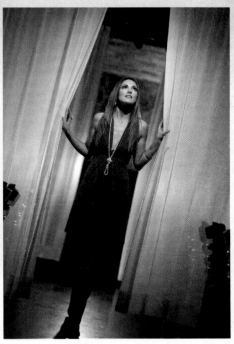

The original image is nice, but my vivid imagination demanded more. It needed the surrealism that only Lightroom or Photoshop could give.

Exposure Info:

85mm lens setting
f/1.8 at 1/80 sec.
ISO 800
Exposure comp. −1/3

Tools Used:

Nikon D3s
85mm f/1.4 Nikkor Lens
Doug Gordon Torchlight
Intova 500 lumen LED dive light

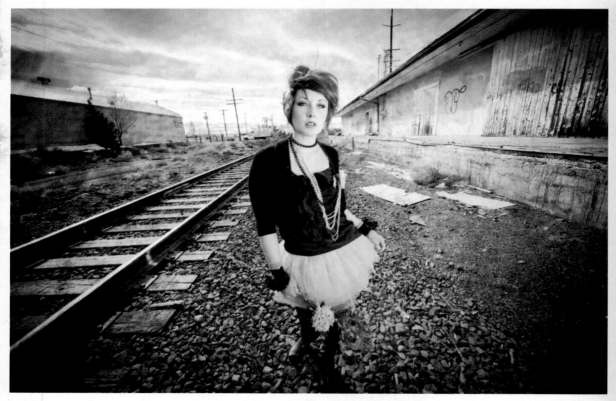

Pretty In Punk

Not one to be satisfied with "straight," I applied my Acid Wash Lightroom preset for the creamy skin and Steam Punk color palette. I then added texture with my Bor-Tex Dashboard plug-in in Photoshop.

At first glance, this dirty old abandoned railway station didn't look like much. At second glance, it still didn't look like much. You really had to squint your eyes to see the possibilities, but then it all became clear. It was the perfect backdrop for this fun and funky senior portrait. I loved the rugged textures (which I would later complement with my Photoshop textures), and the leading lines of the railway and buildings draw you right to our lovely star. A wide-angle lens gave the image more drama and included the story-telling surroundings.

The sky was spotted with clouds, creating moments of bright sun mixed with diffused, soft light. I needed something more predictable, and even from head-to-toe, so I set up our large panel diffuser and fired two speedlights through it on the opposite side of the falling sun. The diffused sunlight made a nice hairlight and backlight and provided fill light for my panel main. I needed two speedlights to give me the power I needed to match the sun and recycle times to match my trigger finger.

I also placed a third speedlight, without any modifiers, on the ground behind her to add a subtle boost to the rim light, especially down her arms and legs.

There was enough of a breeze to warrant a sturdy assistant on the parachute-like diffusion panel. The Lastolite TriFlash adapter holds up to three speedlights on a single stand.

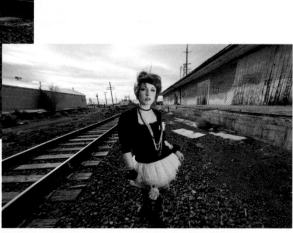

The original image. Cool, but not edgy enough for this unique young lady. I'll finish the image in Photoshop.

Exposure Info:
14mm lens setting
f/13 at 1/250 sec.
ISO 200
Exposure comp. +/– 0

Tools Used:
Nikon D3s
12–24mm f/2.8 zoom Nikkor Lens
Nikon SB900 Speedlight
Nikon SB800 Speedlight
Calumet frame panel with diffusion fabric
PocketWizard TT1/TT5 wireless trigger system
Lastolite Triflash Sync adapter

Twilight

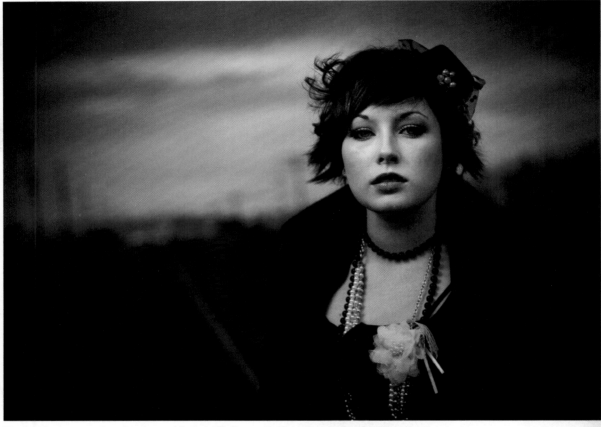

The final image was given its otherworldly feel with the application of my Twilight preset in Lightroom.

There's something hauntingly beautiful about this image. I knew as soon as I captured it that the mood I wanted could be completed easily with a dose of the right post-process magic. The painterly quality of the image is created by the very shallow depth of field—made possible by an f/2 aperture and a variable neutral density filter. The existing light was too bright for me to shoot at f/2 and use a 1/250 second shutter speed, allowing for full power from my flash. The ND filter did the trick. The background became beautifully blurred, and I maximized my speedlight output.

A small OctoDome, which incidentally is not really very small, is the perfect size for soft, yet directional lighting. I had my assistant hold it just outside of camera view, as close as possible, for maximum softness and depth. A large diffusion frame cut any spotty sunbeams from messing with my lighting and provided a soft, reflected fill. I placed a second speedlight on the ground behind her for a subtle separation light along her dark coat.

This shot could have been done without assistants, but the occasional breezes and uneven ground made it more convenient to use warm bodies.

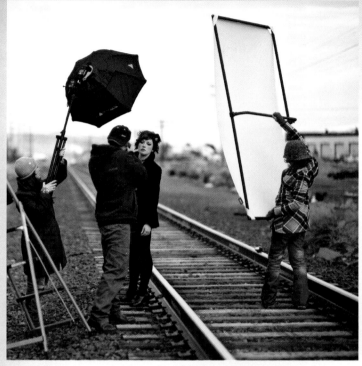

These train tracks were not in use. No assistants were harmed in the making of this photograph, although their arms did get tired.

The original image. The lighting was just right, and the mysterious expression perfect; I just need more drama in the post-process.

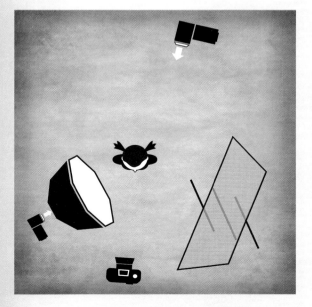

Exposure Info:

50mm lens setting
f/2 at 1/250 sec.
ISO 200
Exposure comp. +/− 0

Tools Used:

Nikon D3s
50mm f/1.4 Nikkor Lens
Nikon SB900 Speedlight
Calumet frame panel with diffusion fabric
PocketWizard TT1/TT5 wireless trigger system
Photoflex small OctoDome
Genus variable neutral density filter

The Best Balloon Ever

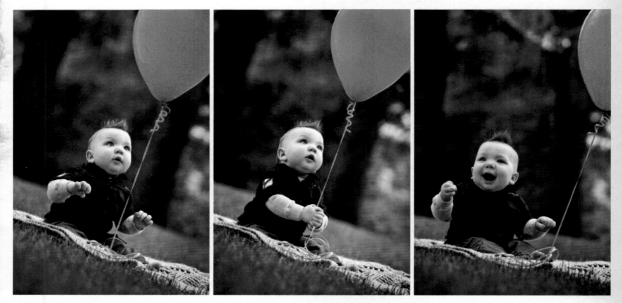

The final images were shown as a series and received very little post-processing. I softened some ruddy skin in Photoshop and darkened the edges with my Smokeless Burn Dashboard tool.

This young man not only had the cutest hairdo in town, he had little pinchable cheeks that were about as round as the balloon he captured. When we originally sat him down in the grass, he wasn't too happy about the whole scenario and started to fuss a bit. In our scramble to find something to appease him, we remembered we had a few balloons left in the car from our shoot the day before. It was the perfect pacifier, and his eyes changed from sadness to wonder!

With young children, I try to keep the light as simple as possible, because they rarely stay in one spot or facing the same direction. Larger light sources allow for more subject movement with less change in the quality of the light, so I try to use large diffusers or reflectors—if there is something to reflect. On this day, we had a thinly overcast sky, which provided adequate light for a reflector. If the sun had been harsh and directly overhead, I would have used a large diffusion panel hovered above him.

I added a speedlight with a snoot on it for a little extra rim light/kicker. It was more of a "bonus" light, and I didn't worry too much about him moving out of its beam.

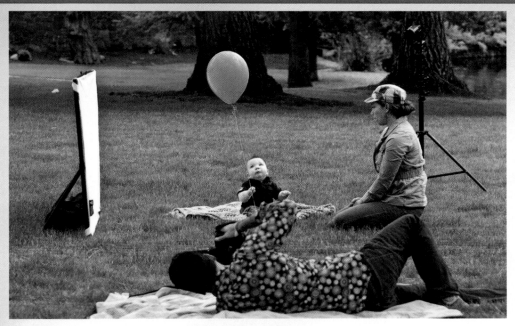

Keeping it simple is the name of the game when working with young kids. You often have a very small window of opportunity with their moods or attention. Work fast, and you'll capture everything you need in a few minutes!

OPTIONS

Sessions like this can be done very inexpensively with a single diffusion or reflector panel. The speedlight adds a nice edge light but is not totally necessary for a great natural-light portrait.

Exposure Info:

125mm lens setting
f/3.5 at 1/1250 sec.
ISO 800
Exposure comp. −1/3

Tools Used:

Nikon D3s
70–200mm f/2.8 zoom Nikkor Lens
Nikon SB900 Speedlight
RogueGrid without inner grid attachments
PocketWizard TT1/TT5 wireless trigger system
Photoflex 39 × 72″ LitePanel with white reflective fabric

We're On A Dock

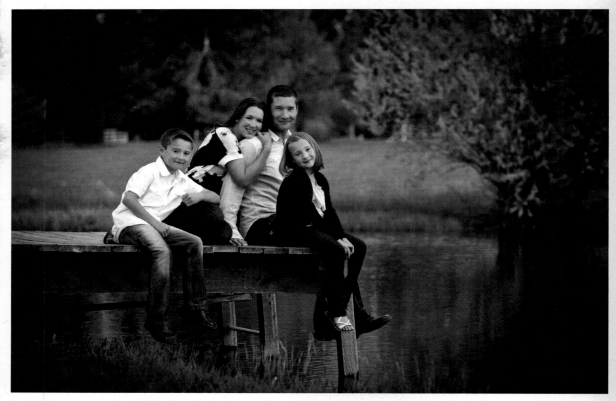

The final image was retouched slightly in Photoshop, and the edges of the frame were darkened. It didn't need much, and there's no reason to go overboard when you have a beautiful, classic family portrait. (Did you catch my pun? Pretty funny, huh.)

The setting sun on this beautiful property was nearly perfect. We had only a few minutes to take advantage of the great light, so I tried to keep things simple to allow us time to try a few pose variations. The main light is the setting sun, diffused slightly by some puffy clouds. I added a large, white reflector panel to kick some fill light back on them. It was placed just out of camera view on the left bank.

I also added a speedlight with a snoot on it to cast just a little bit of hair light. Sometimes, I would fire too quickly, trying to capture expressions, and the speedlight wouldn't recycle in time. I wanted to double up the speedlight, to be able to shorten the recycle time, but didn't feel it was worth stopping to set up—and missing my setting sun. I feel the trade-off was worth it.

I love to pose people as naturally as possible. I asked them to just sit on the edge of the dock and watched where they instinctively placed themselves. I then made small posing suggestions and adjustments but tried to keep them as close to their natural arrangement as possible. I refer to this as "body language posing," and I find it helps personalize the portraits.

I used a long lens to compress and soften the background. Being at this distance from your subjects can either relax them, by giving them space to be themselves, or it can hinder your interaction with them, making them uncomfortable. "Read" your subjects to determine what works best. If you can interact from a distance, all the better!

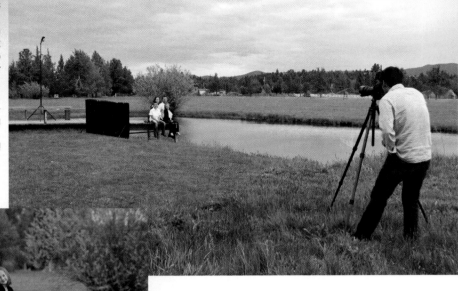

The original image.

Exposure Info:

160mm lens setting
f/4 at 1/320 sec.
ISO 250
Exposure comp. −1/3

Tools Used:

Nikon D3s
70–200mm f/2.8 zoom Nikkor Lens
Nikon SB900 Speedlight
RogueGrid without inner grid attachments
PocketWizard TT1/TT5 wireless trigger system
Photoflex 39 × 72" LitePanel with white reflective fabric

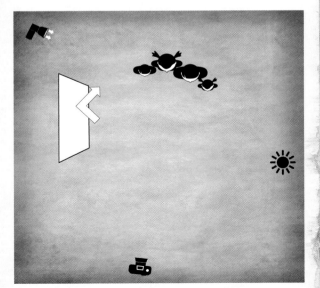

Time-Traveling Senior

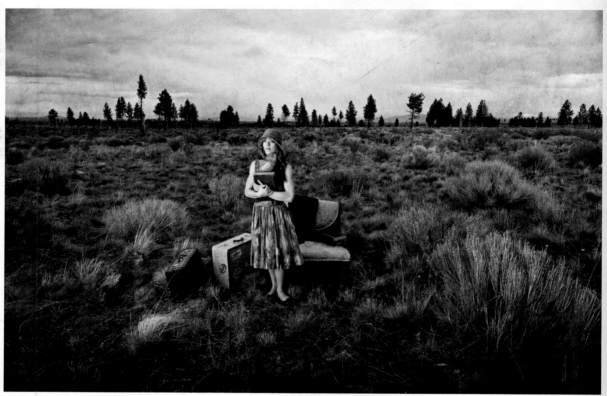

The final image was enhanced in Lightroom with my Pop Rocks and Snap Dragon presets, then I applied a texture in Photoshop using Bor-Tex, and finally it was sharpened with Sharpen KPD Magic Sharp, which gives a crisp and punchy image.

This expansive high-desert setting formed the perfect backdrop for our time-traveling senior. I imagined that her love for reading classic novels made her dream of time travel—where she could step back through the years and follow the footsteps of the characters that fascinated her. Here, she waits for the magic time-machine bus. The sky was a stormy gray. It had rained a bit earlier and was threatening to do so again. It was perfect. What I wanted was a soft, glowing light on her—as if coming from the approaching, luminescent vehicle.

We set up a double-sized 77 × 77" Photoflex LitePanel with diffusion fabric, and fired two Photoflex Triton flash units through it. The Tritons are battery-powered flash units that are surprisingly compact and powerful. This "wall of light" was beautifully soft and directional, illuminating our traveler as well as the nearby props and foliage. The fill light came from the cloud-diffused sky.

The same lighting setup also was used for some close-up shots, without any modifications. It was easy to get a variety of looks without having to change anything, other than the lens and posing.

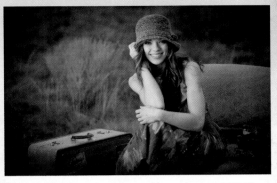

The same lighting setup was used for a close-up pose as well. This was taken with a 70–200mm f/2.8 lens set to f/4 and 130mm.

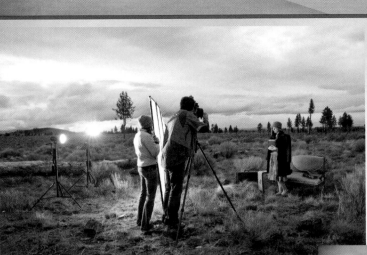

Two Triton flash units were needed to provide even coverage to the diffusion panel. I wanted to use every inch of that fabric for the largest, softest possible light.

 OPTIONS

Three speedlights may have worked instead of the two Tritons, although recycle time would be slightly slower. It would be a less expensive option.

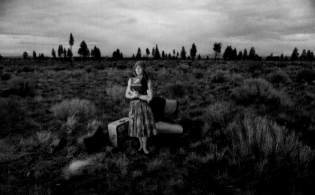

The original image.

Exposure Info:

24mm lens setting
f/5 at 1/250 sec.
ISO 200
Exposure comp. +/–0

Tools Used:

Nikon D3s
24mm f/1.4 Nikkor Lens
2 - Photoflex Triton Flash systems
PocketWizard TT1/TT5 wireless trigger system
Photoflex 77 × 77″ LitePanel with white
 diffusion fabric

Baby With A Lensbaby

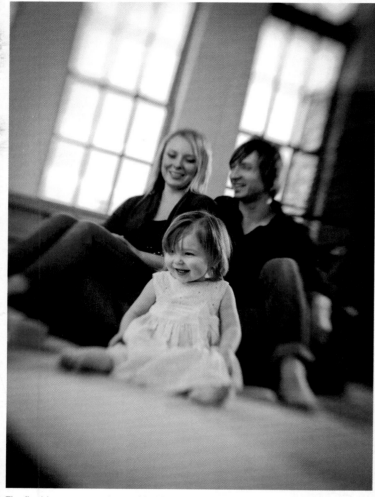

The final image was enhanced in Lightroom with my Warm Shadows and 65 Mustang presets.

Do you ever have flashbacks to memories of yourself as a child? What is it that you remember? Is it from your perspective, or as a third person watching yourself? What "lens" would you see yourself through? My friend, Craig Strong, poses questions like these when he is a guest speaker at my Digital Photography Bootcamp Workshops. He talks about creativity and how your life experiences shape your personal vision. Craig is the inventor of the Lensbaby selective focus lens.

To me, the Lensbaby simulates the way I see images and memories in my imagination; they are usually very clear in one area, but the peripheral information is mysterious, or fuzzy. I occasionally wonder whether the memories are real or a confabulation. (Isn't that a fun word! I just learned it recently).

I wanted to re-create or rekindle that childhood memory or feeling, and the Lensbaby was the perfect tool. The lighting needed to be simple and broad, allowing room for the baby to wriggle and roam. There was a white wall on the side, so I simply fired two speedlights, grouped together, into the wall from across the set. This created a beautiful, soft light that was large enough to allow the subjects to move freely without changing the light significantly. I then added a second speedlight, with a Rogue Grid attachment, as a rim light. This gave me the crisp edge on their hair and shoulders that simulated sun streaming through a window. I set my main flash exposure to one f-stop above the existing light, to allow the ambient light in the room to serve as the fill.

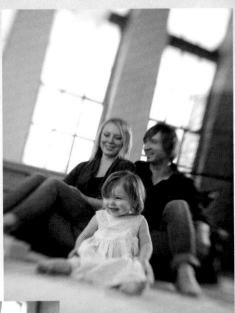

Two Triton flash units were needed to provide even coverage to the diffusion panel. I wanted to use every inch of that fabric for the largest, softest possible light.

The original image.

The rim light was wrapped with a Rogue FlashBender to form a snoot.

Exposure Info:
50mm lens setting
f/4 at 1/60 sec.
ISO 800
Exposure comp. +/–0

Tools Used:
Nikon D3s
Lensbaby Composer with glass optic
Nikon SB900 Speedlight
2 Nikon SB800 Speedlights
PocketWizard TT1/TT5 wireless trigger system
Rogue FlashBender

Bookstore Chic Geek

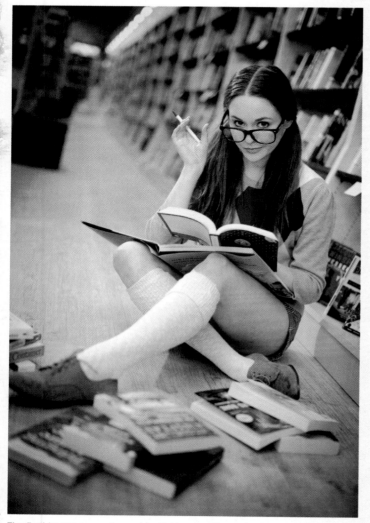

The final image was enhanced in Lightroom with my 65 Mustang preset to complement the retro styling.

This image could be a great senior (graduate) photograph, or it could be a commercial image, used by a bookstore. The Chic Geek look is hot, and we wanted a cute image to play off that. Paulina Springs Bookstore, in Sisters, Oregon, is a local shop with just the space we needed. It had fluorescent lighting in the ceiling, combined with overcast daylight streaming in through the large front windows. It presented an interesting challenge, from a white balance perspective, as the fluorescent lights read slightly green on camera compared to natural daylight.

Our solution was to use a large black panel to block the direct daylight that originally illuminated our bookworm. We then used an EzyBox small softbox with a speedlight as our main light source. We covered the daylight-balanced speedlight with a fluorescent-balanced Sticky Filter to match the color temperature of the flash with the existing fluorescent light in the background. We used a second speedlight, with the same color StickyFilter and no light modifier, behind the subject to act as a rim/hair light. We used the PocketWizard in TTL mode as a wireless trigger for both flash units.

When mixing flash with existing light, it's important to determine the color temperature of the ambient light and then you can gel (put a color filter on) your flash to match the color temperatures. This gives a much more natural and balanced look to the image. Sticky Filters come as a set of standard color-balancing, reusable self-stick gels. You simply peel the desired filter from the holder and apply it to the front of your portable flash. It removes easily without leaving a gooey mess. Stick them to your eyes, and you won't need rose-colored glasses anymore.

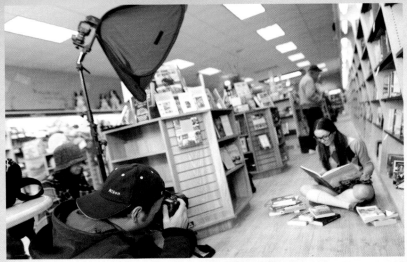

The bookstore was open, so we had to grab our shots in between customers browsing the shelves. The EzyBox is quick to set up and provides controlled, directional light.

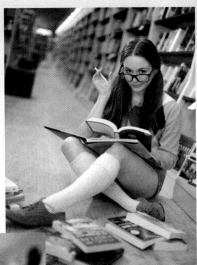

The original image.

The rim light was covered with a greenish Sticky Filter gel to match the color of the existing fluorescent lighting. It was placed on the shelves slightly behind and to the right of the model.

Exposure Info:

50mm lens setting
f/1.8 at 1/60 sec.
ISO 100
Exposure comp. +/–0

Tools Used:
Nikon D3s
50mm f/1.4 Nikkor Lens
Nikon SB900 Speedlight
Nikon SB800 Speedlight
PocketWizard TT1/TT5 wireless trigger system
Lastolite EzyBox
Sticky Filters

She's On Fire

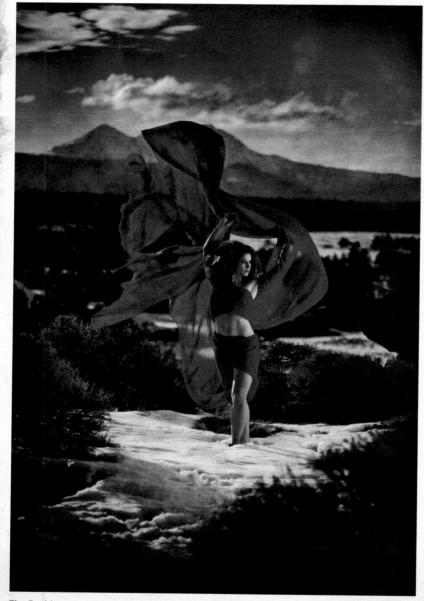

The final image was enhanced in Lightroom with my Pop Rocks preset, and it was sent to Photoshop where I applied the Dragon Princess effect from our Dashboard and the Buj texture from Bor-Tex.

The cover image for this book was created on a crisp winter day. The sun was still fairly bright, but I envisioned a more moody, dramatically lit image. I wanted to shoot wide open, with my 70–200mm lens at or near f/2.8. I also needed to synchronize with my monolights, which would require 1/250 second or slower shutter speeds.

Normally, with this much ambient light, I would get a shutter speed of 1/1000 or higher, so I placed a neutral density filter over the lens to reduce the daylight down to a synchronize-able 1/60 second. Two AlienBees B800 lights, powered by a portable battery pack, were used behind a wall of diffusion material held by two PhotoFlex medium LitePanels, side-by-side. This gave a wonderfully soft, window-like light from the right side, balanced with the afternoon sunlight creating the rim light on the left.

I wanted the feel of her floating underwater—without having to be underwater—so my assistant tossed the fabric repeatedly in the air. Using 1/60 second allowed for some soft movement blur in the fabric, adding to the effect. I was very excited about the finished image as it captured beautiful shapes in the fabric, beautiful light, and an otherworldly feel that takes me to another place, and I like being taken to other places.

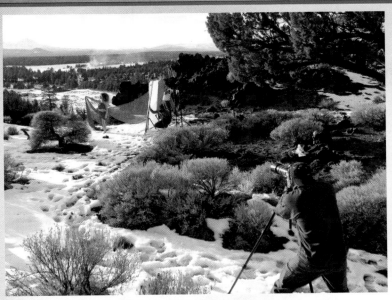

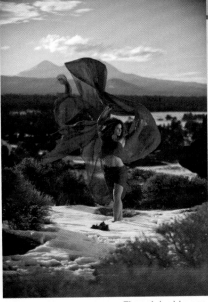

The original image.

Yes, it was cold! An assistant was needed to hold on to our panels when the wind blew. Sandbags and sturdy light stands would do the trick, but I preferred not to haul the extra gear in to this spot, and the hands were available.

Two flash heads were used to evenly cover the scrim and provide enough output to match the sun. Recycle times were relatively short, too, which was important to enable me to grab the moment of perfect flowing fabric.

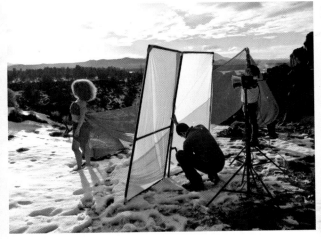

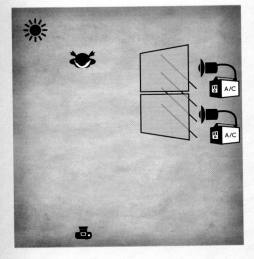

Exposure Info:

102mm lens setting
f/3.2 at 1/60 sec.
ISO 250
Exposure comp. +/–0

Tools Used:

Nikon D3s
70–200mm f/2.8 zoom Nikkor Lens
2 AlienBees B800 monolights
Tamrac MicroSync wireless trigger
 system
2 large Calumet frames with diffusion
 fabric

I Thought I Saw A Bride

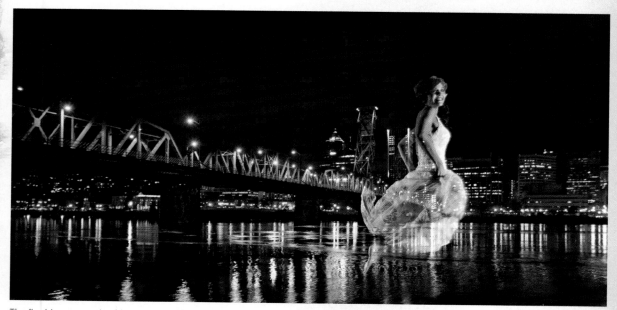

The final image received basic tonal adjustments in Lightroom, but was otherwise unaltered.

I wanted to create an unusual bridal portrait, using the Portland city skyline at night as a backdrop. This image was made by "dragging" the shutter, or holding the shutter open for a longer exposure while popping my main subject with flash. The cityscape exposure required a 2.5-second shutter speed, and I matched that exposure with my flash, so that the bride's face would be properly exposed. The translucence of the bride's dress comes from a combination of the city exposure and the flash. Her face is clear because she jumped high enough to clear the bright buildings—where the dark sky did not affect the facial exposure noticeably.

I used a Photoflex Starflash monolight attached to a Paul C. Buff Vagabond mini battery pack. A Photoflex strip bank was used to modify the light into a thin, soft beam of light. I also added a speedlight with a RogueGrid on it as a backlight for the bride, helping to separate her from the background.

We were having a hard time getting the bride to jump high enough to clear the skyline with her face, so my assistant suggested we have her jump off our equipment case. It worked great, and our bride got big air! After we got all set up, we had another small snafu. We forgot the adapter cable to trigger our Starflash with the Pocket-Wizard. Rather than running back to our truck to find it, keeping the bride freezing even longer, I attached the PocketWizard to a spare speedlight instead, set it to its lowest power, and just pointed it directly at the optical slave on the Starflash. The speedlight functioned only as a trigger for the Starflash and did not produce enough light to affect the scene.

I often try to find quick solutions, rather than "proper" solutions, especially when a client is waiting patiently in a cold breeze at night.

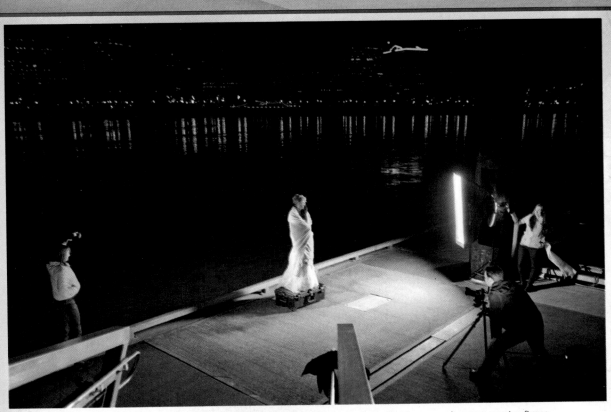

When a light source is used farther away from your subject, it is less soft. Use a larger light source when you want softness at a distance.

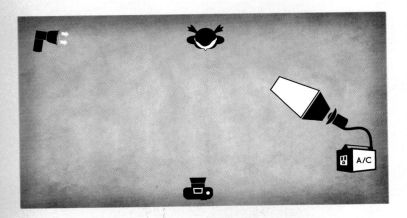

Exposure Info:

24mm lens setting
f/5.6 at 2.5 sec.
ISO 200
Exposure comp. +/−0

Tools Used:

Nikon D3s
17–35mm f/2.8 zoom Nikkor Lens
Photoflex Starflash monolight
Photoflex Strip Box
Nikon SB900 Speedlight
Nikon SB800 Speedlight (for triggering
 the Starflash)
Rogue Grid for speedlights
PocketWizard TT1/TT5 wireless trigger
 system

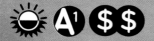

A Bicycle Built For Two

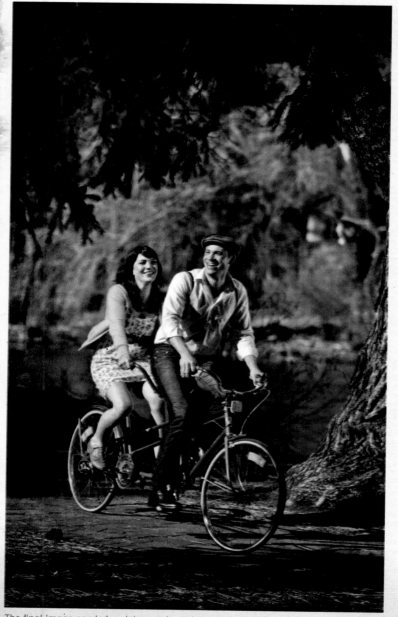

The final image needed a vintage color palette, so I applied my Nostalgia Dashboard effect and then aged it a bit with the Lava texture from Bor-Tex.

I wanted to create an engagement portrait that was timeless, with a little bit of a Norman Rockwell feel to it. The light needed to be reminiscent of the day—crisp and detail revealing. The tandem bike and clothing were coordinated and appropriate, so all that was left was to light it up and hope the couple actually knew how to ride tandem!

The main light was the crisp afternoon sun, coming through the trees to their right. You can see by the shadows on the ground that our window of opportunity was very small. I had to catch them when they hit the sun patch through the trees and hope their expressions and body position also worked! It did take several passes to get it just right.

With the bright sun came dark shadows on the opposite side of the subject. I opened that up by using a large diffusion panel with a speedlight firing through it. The panel reflected some of the sunlight, and my flash kicked in the rest of what it needed.

We kept our diffusion frame hand-held so that it could be moved quickly if innocent bystanders came walking or zooming around the corner.

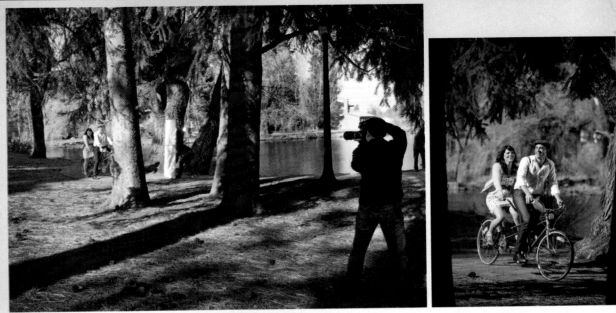

I didn't have much wiggle room with the composition I wanted and the area where my light was just right. The couple had to be riding through the exact spot, with their best expressions on. Fortunately, they were awesome, and we got the shot in just a few takes.

The original image.

Exposure Info:
135mm lens setting
f/3.2 at 1/250 sec.
ISO 200
Exposure comp. −1/3

Tools Used:
Nikon D3s
70–200mm f/2.8 zoom Nikkor Lens
Nikon SB900 Speedlight
Photoflex 39 × 72″ LitePanel frame with
 diffusion fabric
PocketWizard TT1/TT5 wireless trigger
 system

For The Love Of Golf

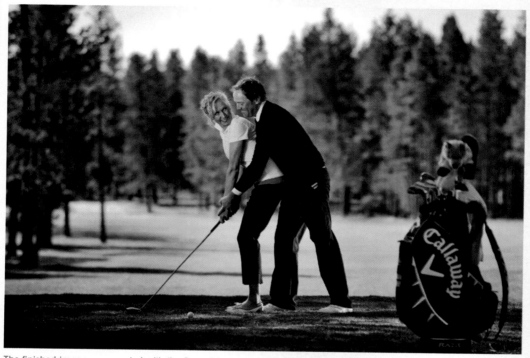

The finished image was created with the Snap Dragon and 65 Mustang presets in Lightroom.

We created this playful portrait of a couple of golf lovers at Sunriver Resort's golf course in central Oregon. It's a beautiful setting for a little "fling." The spot we wanted to use was shaded, so we added our own simulated sunlight. I chose a large Wescott parabolic umbrella with a white translucent cover. These are designed to diffuse the sun or to fire a flash through them. The parabolic shape gives an interesting light pattern on in which the light is broad and soft, but the center is noticeably brighter than the edges. This looks really nice when you want to highlight the face but allows the light to darken slightly as it falls toward their feet, which was exactly what we wanted.

A monolight was used with the parabolic to provide enough power to shoot through the diffuser and still balance with the sunny background. A portable A/C battery pack was used since the nearest outlet was at least two holes away. I also used a neutral density filter to keep my shutter speed at 1/200, to sync with the monolight, while maintaining the f/3.5 aperture.

We used a gold reflector panel from Photoflex on the opposite side to bounce some of the flash and sun back onto the couple, forming a rim light for more snap. An assistant was used here instead of a light stand because we needed to adjust the angle of the reflector constantly as the couple moved and changed poses.

It's a good idea to have a full-time guard on your parabolic umbrella when outside. The slightest breeze will send it to its death on the ground—like ours experienced. My assistant only took his hand off it for a few seconds to grab something for me, and it blew over.

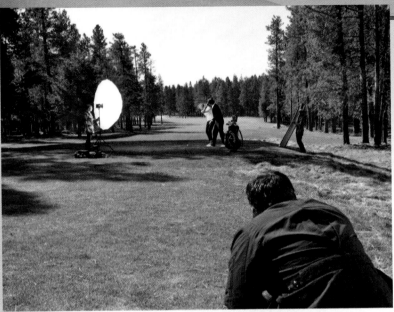

I kept my distance to avoid being whacked with a golf ball. Just kidding. The long lens compressed the long fairway in the background into a soft wall of green.

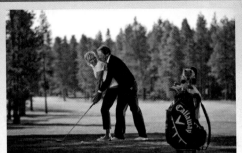

The original image.

Exposure Info:
190mm lens setting
f/3.5 at 1/200 sec.
ISO 220
Exposure comp. +/–0

Tools Used:
Nikon D3s
70–200mm f/2.8 zoom Nikkor Lens
AlienBees B800 monolight
Wescott 7 parabolic umbrella
Photoflex 39 × 72″ LitePanel with gold
 reflective fabric
PocketWizard TT1/TT5 wireless trigger
 system
Paul C. Buff Vagabond portable battery
Genus variable neutral density filter

Fore!

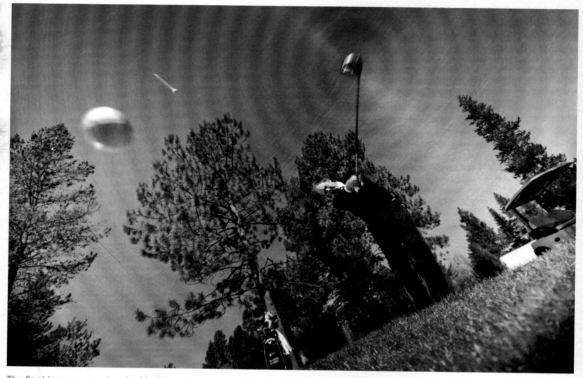

The final image was retouched in Photoshop to combine images and remove the line holding the ball. A texture with the circle pattern was added from our Bor-Tex plug-in.

I have to admit, I'm not a golfer. There are some amazing golf courses in central Oregon, like this one at Sunriver Resort, but my dance card for outdoor activities is already pretty full. I also have a thing for adrenaline sports, which golf doesn't normally satisfy, although it might if the game were more like this!

I wanted to create a fun image of, perhaps, the gopher's point of view—without losing an eye. There was an abundance of bright sunlight already, so we just needed to position our model accordingly and then add an edge light to fill the side of his face and the edge of the flying ball. We used an AlienBees monolight for that fill, which, in turn, necessitated the use of a neutral density filter to reduce my shutter speed to 1/250 second so it would synchronize.

The image is actually a composite of three separate images, one of the golfer, one of the ball in the perfect position, and one of the flying tee. We attached a fishing line to the ball and held it in place and then Photoshopped out the line. I took several shots to get each component just right and then pieced them together. The golfer actually did swing that club, creating the blur on the head, which was also dangerously close to my head. Well, I got my adrenaline rush.

In Photoshop, I added the texture of the concentric circles to give the feeling of the air pulsating after the "crack" of the ball. The image is supposed to be fun and a bit whimsical, so I felt it worked.

Sometimes I just get tired and need to take a little nap. The monolight was used with just the standard reflector, to keep the light crisp and sun-like.

One of the original images. The final is made up of three separate pieces. The vignette comes from the ND filter, which is slightly thick for such a wide lens. Thinner (more expensive) models are available.

OPTIONS

A speedlight, or two, may have worked instead of the monolight, if zoomed to the maximum setting.

Exposure Info:

19mm lens setting
f/5 at 1/250 sec.
ISO 1400
Exposure comp. +/–0

Tools Used:

Nikon D3s
17–35mm f/2.8 zoom Nikkor Lens
AlienBees B800 monolight
PocketWizard TT1/TT5 wireless
 trigger system
Paul C. Buff Vagabond portable
 battery
Genus variable neutral density filter

Family Riverside

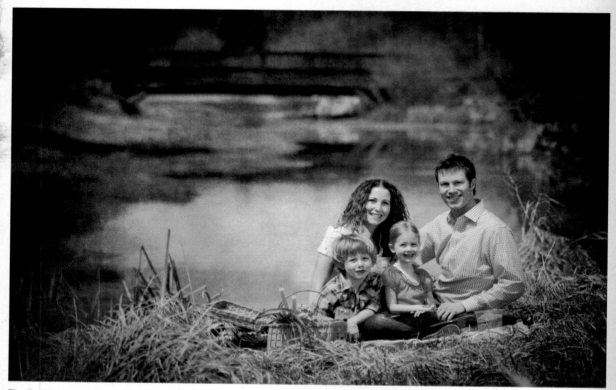

The final image was enhanced with my Bor-Tex texture plug-in in Photoshop.

One of the joys of being a portrait photographer is following a lovely family as they grow. I photographed the engagement photos and wedding for this couple, and here they are with kids! We planned to do a picnic scene, and I had this location in mind that is normally lush with green grass by the river. When we got there, it looked like a desert. I decided to go with the "roll in the hay" look anyway and make the best of it. It looks like a fall day at the pumpkin patch!

The sun was ducking in and out of the clouds, so I set up two large panels with diffusion fabric through which to fire two monolights. If the sun was out, I'd use these for fill. If the sun disappeared, I'd make them my main light. In this particular shot, the sun was out, so the flash became soft fill. I just needed to adjust my camera exposure accordingly. I also added a neutral density filter to drop my shutter speed to 1/250 second and synchronize with my monolights.

Props can make such a big difference in your portraits. Not only does it add personality and interest, but it makes the image more unique. It also gives your subjects something to do or hold, which can ease nervousness. My assistants are awesome at helping me plan and gather props for our sessions. If you don't normally use props in your sessions, try it on the next one and see how it works for you. You may see a big difference! I try to use props that are lifestyle things, or relevant to the subject—preferring to avoid cheesy props—unless I'm shooting a portrait of someone who makes cheese.

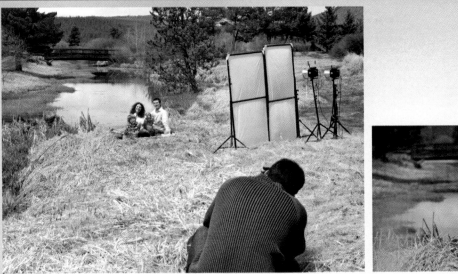

It would be a good idea to have an assistant on hand in case the panels blow over. It is really helpful to grab the kid's attention, too.

The original image.

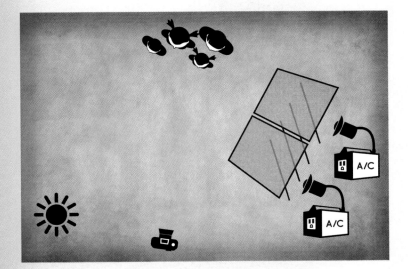

Exposure Info:
160mm lens setting
f/4 at 1/250 sec.
ISO 200
Exposure comp. +/–0

Tools Used:
Nikon D3s
70–200mm f/2.8 zoom Nikkor Lens
2 AlienBees B800 monolights
Paul C. Buff Vagabond mini battery
 pack
2 Photoflex 39 × 72″ LitePanel frames
 w/ diffusion fabric
PocketWizard TT1/TT5 wireless trigger
 system

Picnic Party

This adorable family had one thing in common—they could levitate oranges. Just kidding. We set up this picnic scene to give them some fun props to play with, and to stylize the shot beyond the typical family portrait. The oranges instantly became playthings for the kids, and I wasn't going to mess with a happy youngster by taking them away. Many parents instinctively try to remove anything from their children's hands, fearing it will ruin the photograph. I urge them to let the kids be themselves and let me worry about capturing nice expressions. Fortunately, these parents were relaxed and playful as well, making for a series of great moments.

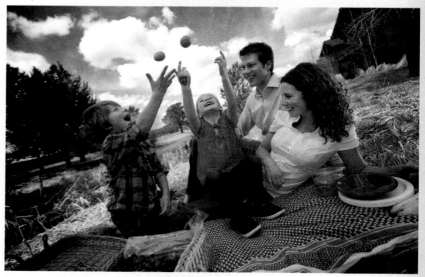

Both of these images were processed in Lightroom with my Vintage Delish presets and then passed to Photoshop for texture with Bor-Tex.

I used a wide-angle lens to create a dynamic and intimate perspective. I wanted viewers to feel they were right there, sitting on the picnic blanket with the family. The lighting comes from diffused and reflected sunlight. I asked my assistants to hold a doubled-up diffusion panel in front of the sun. This created a wonderfully soft and flattering light, allowing the kids and parents to move around freely without adversely affecting the lighting patterns.

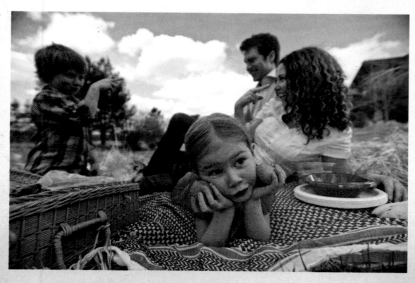

A large silver reflector was used behind them to harness the sun in to a beautiful edge light. Mom's hair receives a nice Hollywood glow, and dad gets the crisp edge normally reserved for a quadruple-bladed shaving razor.

Light stands could have been used instead of assistants to hold the panels, but even a slight wind would be a factor with such a large scrim, and the assistant can adjust the reflector as the subjects move about.

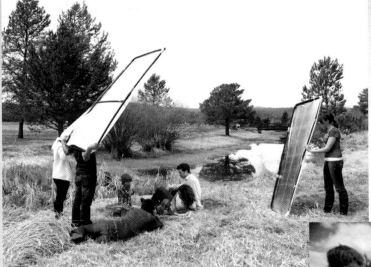

Being this close to my subjects allowed for fun perspectives and allowed me to interact with them much more intimately.

The original image.

Exposure Info:

19mm lens setting
f/5.0 at 1/800 sec.
ISO 200
Exposure comp. +1/3

Tools Used:

Nikon D3s
17–35 f/2.8 zoom Nikkor Lens
Calumet 77″ double panel with diffusion fabric
Calumet 39 × 72″ silver reflector panel

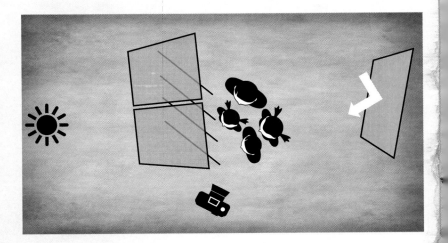

Quick Bridal Portrait

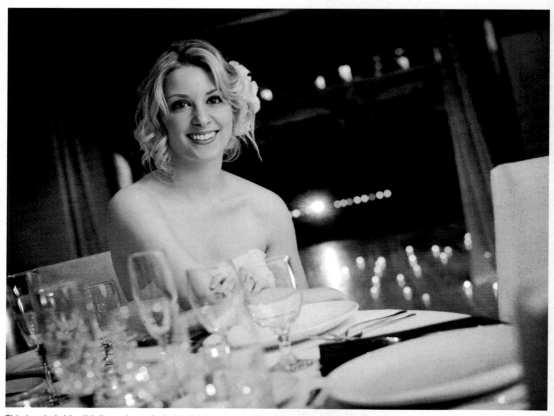

This lovely bride didn't need much, but I did do some light retouching and added a subtle, warming texture with Bor-Tex

One of favorite techniques for a quick portrait, just about anywhere, is to use a 42" pop-up diffusion disc and shoot a speedlight through it. The quality of the light is amazing and it can be very quickly set up. The key is to move the disc as close as possible to your subject—just out of camera view. It's also important to completely cover the back of the disc with the speedlight flash. I usually find that a zoom setting of 75mm works pretty well when the flash is held at arm's length from the back of the disc. Normally one assistant can hold the disc in one hand and the flash in the other.

For this scene, I wanted to use the existing ambient light as fill light, but it was very warm in color temperature.

The solution was to put an amber Sticky Filter gel on my speedlight, matching it to the room lights. Then I set my camera to tungsten WB, and everything blends nicely.

I placed a second speedlight in the fireplace in the background. It's primary function was as a mood light, although it also adds highlights to her hair. Sometimes I'll have a light in the background actually visible and flaring in to the camera. The star-like glow is a nice element that adds mood and depth. Speedlights tend to have a nice star-shaped light burst. This light was also covered with a warm Sticky Filter gel.

The original image.

Two assistants aren't necessary for this setup, but they were available so I put them to work. The flash should be about an arm's length from the disc.

Exposure Info:

50mm lens setting
f/3.2 at 1/150 sec. ISO 800
Exposure comp. +/– 0

Tools Used:

Nikon D3s
50mm f/1.4 Nikkor Lens
Nikon SB900 Speedlight
Photoflex 42″ LiteDisc with
 diffusion fabric
PocketWizard TT1/TT5 wireless
 trigger system

After The Guests Have Gone

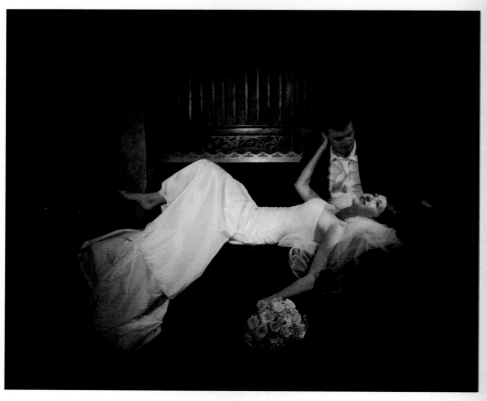

The final image was treated to a lovely application of my Buj Texture from the Bor-Tex DASHBOARD Set. It really enhances the antique feel of the image.

I'm sure every bride feels like doing this after the wedding but, alas, so many guests and so little time. This entryway, at McMenamins Old St. Francis in Bend, Oregon, had a small area with a rich backdrop of velvet and old wood. I wanted to see this in the background of my image, but not much else. Using a very focused spotlight kept the attention on the good stuff and less on the distracting surroundings.

A TorchLight was used as the main light on the bride's face. We covered it first with an amber Sticky Filter gel to make it match the color temperature of the tungsten lights in the room. I also wrapped the light with a Rogue Grid to snoot and focus the beam a bit more. The Rogue Grid is made for speedlights, but it fits perfectly on my TorchLight, too. A second flashlight was used to illuminate the lower portion of her dress. It was also covered with an amber gel since the flashlight is naturally closer to daylight balanced. If you use a flashlight with LED bulbs, they will be much closer to daylight than traditional flashlight bulbs.

The position of the main light is important to properly shape and flatter her face. It was positioned to create butterfly lighting on her face when her head was tilted to the desired position.

Both of these lights could have been put on light stands if you didn't have assistants handy. When I'm shooting in a busy public place, however, I prefer to stay as mobile and unobtrusive as possible.

The original image. We had people walking through this lobby while we were shooting, so I opted to keep my lights mobile instead of setting up light stands.

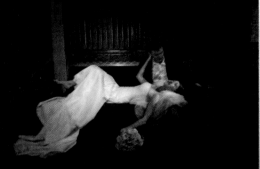

I exposed for the flashlights and underexposed the ambient light by about two f-stops to keep it moody.

Exposure Info:

24mm lens setting
f/1.8 at 1/20 sec.
ISO 1000
Exposure comp. +/– 0

Tools Used:

Nikon D3s
24mm f/1.4 Nikkor Lens
Doug Gordon TorchLight
Intova 500 Lumen LED dive light

Sleeping Beauty

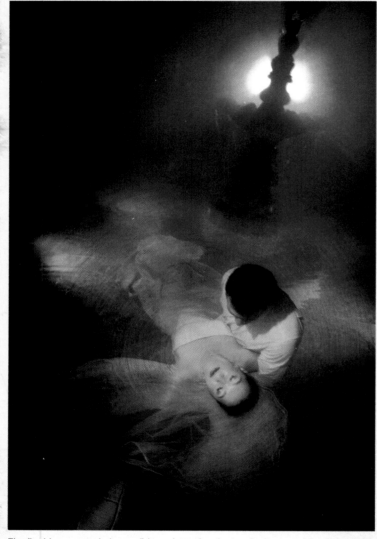

The final image needed more "dreaminess," so I retouched some of the distracting hot spots out and added a texture with Bor-Tex DASHBOARD Set.

"Trash the Dress" bridal portraits have become very popular in the past few years. I love doing them, but I really don't like the idea of telling the bride we're going to "trash" her dress. I prefer to call them "Recycle the Dress" sessions, since we're actually putting it to another good use—rather than delegating it to a box in the closet.

At McMenamins Old St. Francis in Bend, Oregon, they have a beautiful soaking pool and spa that they graciously allowed us to shoot in during their slower hours. The most difficult thing to deal with was the abundance of hot and steamy. I'm not talking about between the bride and groom either. The steam diffuses everything, so it's important to shoot as close as possible to your subject if you want to preserve clarity or details.

My main light was a TorchLight with its included tungsten filter cap. The second light was a high-powered flashlight that I left unfiltered so it would render blue when I then set my camera to tungsten WB.

Keeping the main light on a pole, like this Lastolite Ezybox extension pole, is really handy. It's much quicker to adjust when subjects move their faces this way or that. With softer light sources, this is not as important since the light is more forgiving, but with direct light, the position of the light source is much more critical.

It's important, when working near water, to use battery-powered lights for obvious reasons. Speaking of liability, you all have business liability insurance, don't you? Every photographer in business should have at least $1 million in coverage, which is fairly standard. We carry $2 million as some places we shoot at require proof of it before they will even let us in. You'll find it's easier to get people to let you shoot in their cool locations if you assure them you have coverage.

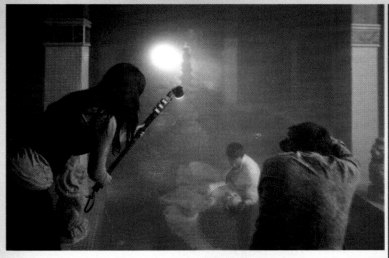

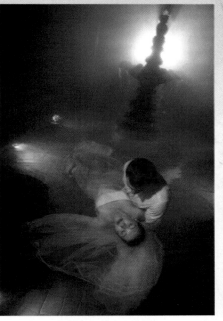

I was actually knee deep in the water while shooting in order to get close enough to my subjects.

The original image

Exposure Info:

24mm lens setting
f/2.5 at 1/50 sec. ISO 800
Exposure comp. +/– 0

Tools Used:

Nikon D3s
24mm f/1.4 Nikkor Lens
Doug Gordon TorchLight with Tungsten filter
Intova 500 lumen LED dive light

This Could Be A Shampoo Ad

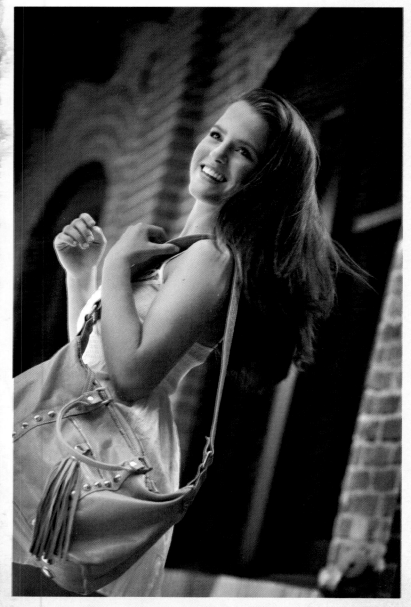

Mecca would stand in one spot and repeatedly turn, giving us her glowing expressions. Good models will know how to stay in one spot but appear as if moving. Teach your non-model clients how to do this, too, and you'll get great, natural feeling images from them.

This was another image for Maya Moon handbags, but Mecca's hair indubitably upstaged the purse. I loved the fun and spontaneous feeling in the image, and all of the warm tones worked together nicely.

We positioned our model just under an awning, where she would receive fill light reflecting from the sidewalk, yet be protected from direct sun. The open sky provided the soft main light, and we added more fill light with a California Sunbounce Mini Reflector. We used the gold side of the reflector to keep everything sunny and warm.

The real punch for this image, however, comes from the golden hair light, created with a gold reflector disk on the staircase above, and behind, her. This disk caught the direct sun, making it a virtual mirror of solar radiation. We did not apply sunscreen.

When I was just starting out in photography and had a very limited budget (actually, NO budget), I made my own gold reflectors from foamcore boards. I bought gold foil from the craft store and spray glued it to the foam core. I did the same with silver aluminum foil. I also would buy dulling spray and spray it over the foil to take some of the edge off of it, making it a bit softer reflection. You can buy big sheets of thin cardboard with gold and silver surfaces, which are a bit less reflective and smoother than the foil.

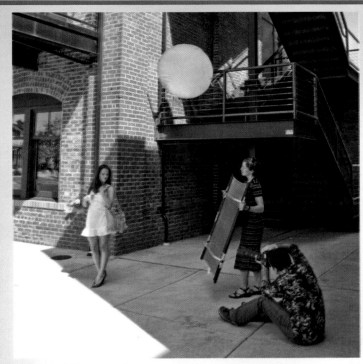

Use your environment by looking for natural reflectors and places to put reflectors.

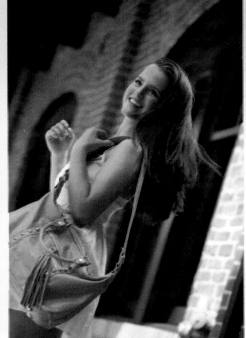

The original image.

Exposure Info:
110mm lens setting
f/3.5 at 1/400 sec.
ISO 200
Exposure comp. +1/3

Tools Used:
Nikon D3s
70-200mm f/2.8 zoom Nikkor Lens
California Sunbounce 3 × 4 Mini
 Reflector w/gold fabric
42" Photoflex LiteDisc Gold Reflector

Black And White And Red All Over

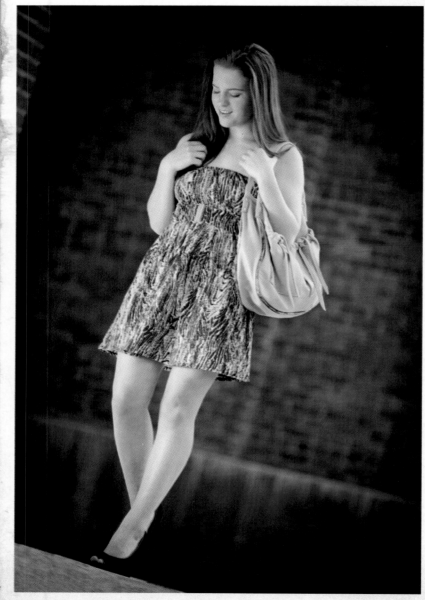

The image was processed with my Vintage 78 Lightroom preset.

This was another image for our handbag company, Maya Moon. Our goal here was to create soft, but directional light to flatter both our model and the stylish bags.

The main light was created from a California Sunbounce reflector, catching direct sunlight in its gold fabric and throwing it back to Mecca like a warm afternoon glow. Raking the main light across the bag helps to define the texture and details, while facing the model toward it creates short lighting on her face.

The fill light comes from both the gray sidewalk and the large diffuser softening the direct sun. The effect here is gorgeous light—shapely, yet soft and feminine. This setup is great to use anywhere you have direct sun to deal with. We could be out at the beach and achieve similarly beautiful results.

Many photographers, myself included, will often just use the large diffuser as the main light in bright sun. However, by turning it in to a fill light, and using reflected light as the main, you gain a bit more edge to the light—and additional compositional options.

The final image needed just a bit of cleanup work in Photoshop—specifically, I removed the white thingy from the dark balcony in the background and filled in the slight hot spot on the bottom-left corner. See the original image for reference.

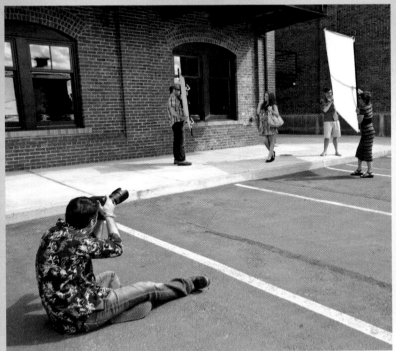

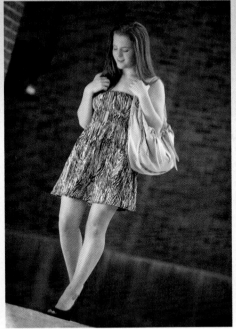

The original image.

I suggest bringing orange cones with you if you plan to sit in the road to photograph. I prefer to live on the edge. Keep your diffusers and reflectors as close to the model as possible for maximum softness.

Exposure Info:
170mm lens setting
f/3.2 at 1/1000 sec.
ISO 200
Exposure comp. +/– 0

Tools Used:
Nikon D3s
70-200mm f/2.8 zoom Nikkor Lens
Photoflex 77 × 77" double panel with
 diffusion
California Sunbounce Mini Reflector with
 gold fabric

Shop 'Til You Drop

Girls just wanna have fun—and fun usually means going shopping. When we talked to mom about the photo session, she said she had a friend that owned this great little boutique gift store in Bend's Old Mill District. It would make the perfect setting for a "Day At The Mall" photo session, so we gathered some props and coordinated some outfits.

The shop had a decent amount of natural light streaming in through the generous windows, but it didn't give me enough for a main light, although it would provide decent

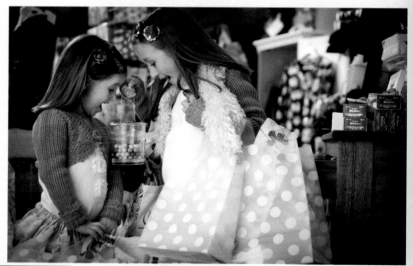

The final images were treated to my Cotton Candy Lightroom preset for a soft, timeless color palette

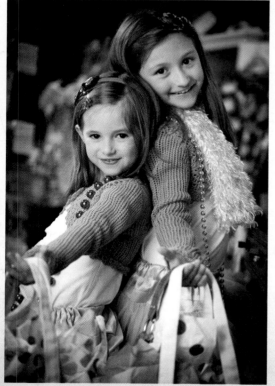

fill. I set up a large diffusion panel, with a speedlight shining through it. I used the larger panel to create very soft light, but also to give myself more lighting area to work with. Little girls don't stand still too long and I wanted to let them play with their poses without having to reset the lighting each time.

After setting up the main light, I still felt the background was too blah, so I added a Wescott Apollo softbox in the back corner of the store. I took the front face off the soft box, so that it would function more like an umbrella, casting a broader, crisper light over the room. It created a great hair light and separation light in the background. I set the output to be about the same as the ambient reading, so combined it was a stop brighter.

These little ladies were all about playing it up for me and all I had to do was suggest, "Let's pretend that…" and they did the rest.

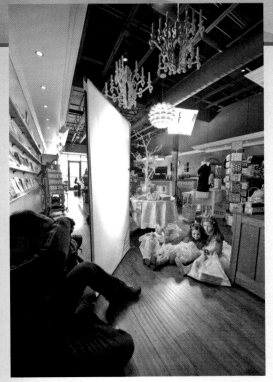

The store was very empty at the time of the shoot, so I wasn't too worried about blocking other shoppers. As luck would have it, the one customer that did come in wanted the greeting card right behind my head.

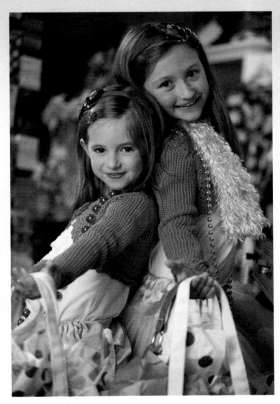

The original image.

Exposure Info for both images:

50mm lens setting
f/2.8 at 1/60 sec.
ISO 320
Exposure comp. +/– 0

Tools Used:

Nikon D3s
50mm f/1.4 Nikkor Lens
Nikon SB900 Speedlight
Nikon SB800 Speedlight
Westcott Apollo Softbox
Photoflex 77 × 77" LitePanel frame with diffusion fabric
PocketWizard TT1/TT5 wireless trigger system

Runaway Love

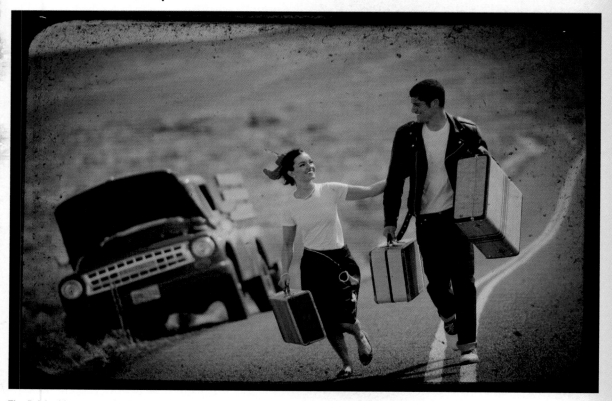

The finished image received a dose of my 58 Vette Lightroom preset—perfect for the style we were creating

The concept for this shoot started with the vintage pickup truck. It belongs to a friend of mine and I told him I'd love to use it for a shoot someday; he kindly obliged. When I met Mindy and Tavo, I imagined a story of two young lovers, forbidden by their parents to wed, so they decide to run away together. The getaway truck breaks down in the middle of nowhere, but they are so excited to be together they gleefully grab their bags and continue running. Romantic, isn't it?! None of it was true, of course, except the part about them being in love.

To complete the 1950s styling, I found some luggage at a vintage store and asked if I could borrow it. They said "Sure!" We got a poodle skirt for Mindy, and Tavo did up the Greased Lightning look.

My first priority was to find the right spot on this quiet road. I loved the way it rolled and snaked behind them— leading from far, far away. The sun was coming from over their shoulders, which was great; it formed a natural edgelight. I needed fill for the other side, however, so a group of three speedlights on a Lastolite TriFlash adapter was used. Three units were needed to give me the output necessary to fill the sun, and to recycle fast enough to allow me to shoot repeatedly while they ran. My assistant kept the lights pointed at them and ran in pace ahead of them to keep the lighting consistent.

To finish off the final image with the vintage touch, I added a custom border/texture that I made from the actual viewfinder of my antique twin-lens reflex camera.

I used a PocketWizard wireless trigger to ensure flash synchronization at this distance. I also used a neutral density filter to keep my shutter speed at 1/250.

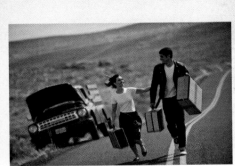

The original image.

Exposure Info:

200mm lens setting
f/3.2 at 1/250 sec.
ISO 200
Exposure comp. +/– 0

Tools Used:

Nikon D3s
70–200mm f/2.8 zoom Nikkor lens
Nikon SB800 Speedlight
2 Nikon SB900 Speedlights
Lastolite Ezybox extension boom pole
Genus variable neutral density filter

No Time Like The Present

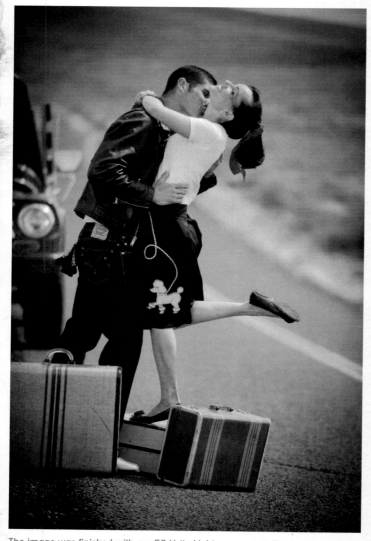

The image was finished with my 58 Vette Lightroom preset. The luggage came out unscathed, which is more than I can say for Mindy's neck.

Our love story continues…as our young runaways can no longer contain their excitement in being together, and drop everything for a little light afternoon necking.

The lighting was similar to our previous image; with the sun casting its smile over their shoulders. Since I was cropping in closer, however, I wanted a softer main light to flatter their faces a bit more—not that they needed help in that department.

A large diffusion panel was placed in front of the same three-speedlight setup we had previously used. The output had to be kicked up a bit to overcome the blast through the diffusion, but the three together held more than enough power.

Many photographers worry about shooting in full sun, but it can be easily managed when you have complementary lighting to balance it out. I especially like using sun as a backlight or rim light; it has a beautiful and romantic quality to it.

While we shot alongside this desolate road, only two cars passed us by—and one of them was a state trooper. He pulled over and started to walk toward us, "thank you notes" in hand. I immediately greeted him and asked diffidently, "Officer, are we blocking the road too much? We've been very careful to keep an eye out for cars in both directions." He thought for a moment, and then asked, "What are you shooting?" "This couple's in love" I said, "and I'm shooting a love story." He paused another moment, then smiled and replied, "Next time it might be a good idea to bring some safety cones for the road." And with a puff of smoke, he was gone—like John Wayne into the sunset.

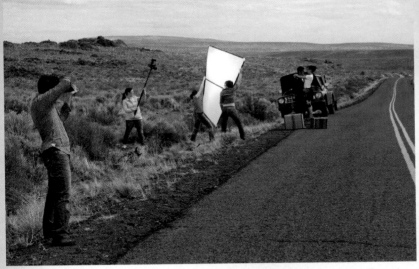

A neutral density filter was used to lower my shutter speed. The wind eventually sent my assistants sailing into the bushes.

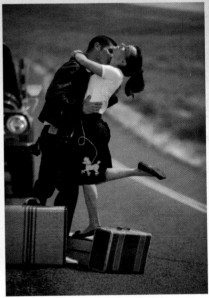

The original image.

Exposure Info:
200mm lens setting
f/2.8 at 1/250 sec.
ISO 200
Exposure comp. −1/3

Tools Used:
Nikon D3s
70–200mm f/2.8 zoom Nikkor Lens
Nikon SB900 Speedlight
2 Nikon SB800 Speedlights
Photoflex 77 × 77″ LitePanel frame with
 diffusion fabric
PocketWizard TT1/TT5 wireless trigger
 system
Genus variable neutral density filter

That Pickup Line Worked

Overcome with passion, our young lovers decide to return to the privacy of their immobilized pickup, where they can melt into each others arms—and hope that roadside assistance is a longtime coming.

For this scene, the direct sun was almost where I needed it for a main light, but not quite. It was also a chameleon of light patterns as the clouds quickly wandered in and out—changing the light from flat to harsh every few seconds.

I decided to take control of the situation and create my own ideal sunlight. A beauty dish fitted to a speedlight was the perfect source as it's crisp and directional, but ever so slightly soft. I positioned it so that it was as close as possible to the natural direction of the sun, so any other shadows cast by the sun would match mine. A California Sunbounce panel

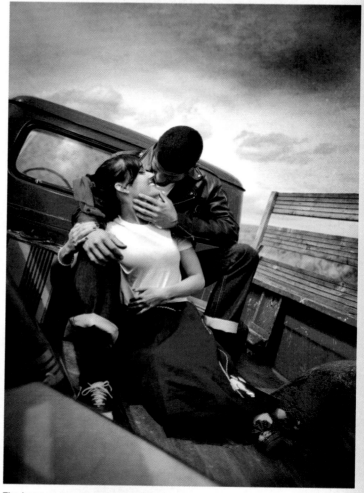

The image was retouched in Photoshop to minimize the reflection in the window and a tasty texture was applied with Bor-Tex

was handy, so we used it as a blocker to keep the sun from interfering with my perfect light, when it did shine through.

This lighting was beautiful, and lent itself to several interesting poses, some of which are not suitable for this PG-13 rated publication! I did create some nice close-up images, however, as Mindy's adorable face and twinkling eyes simply beckoned for a kiss from my portable sunshine.

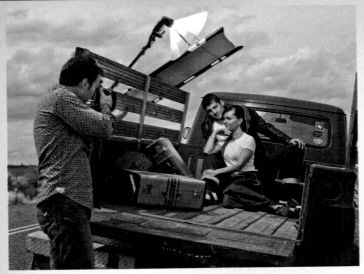

When in doubt, block it out. I couldn't get the sun to behave, so I blocked it and created my own simulated sunlight.

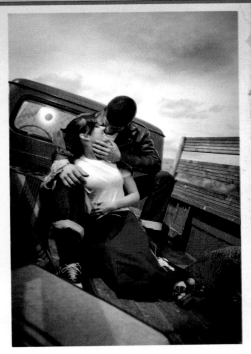

The original image.

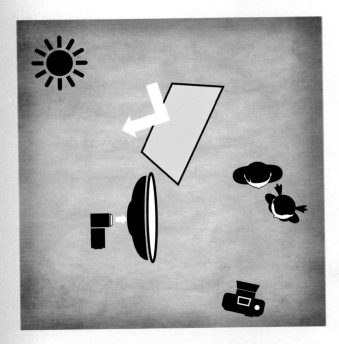

Exposure Info for Both Images:
First Image: 30mm lens setting
Second Image: 95mm lens setting
f/2.8 at 1/250 sec.
ISO 200
Exposure comp. +/– 0

Tools Used:
Nikon D3s
First Image 17–35mm f/2.8 zoom Nikkor lens
Second image 70–200mm f/2.8 zoom Nikkor Lens
Nikon SB900 Speedlight
Speedlight Pro Kit beauty dish
California Sunbounce Mini as a blocker
PocketWizard TT1/TT5 wireless trigger system

Hop A Train

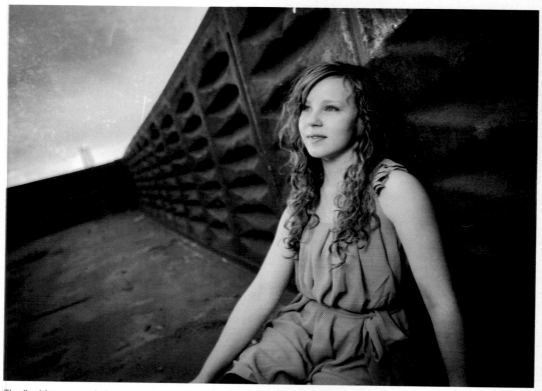

The final image needed some grunge, so I first used my 68 Beetle Lightroom preset and then applied a rough texture with Bor-Tex in Photoshop. I removed the texture from her face and skin.

Industrial settings can make a great backdrop for senior photo sessions. We decided to get out of Dodge and hopped aboard this (abandoned) train car, only to find a plethora of texture and patterns—perfect for a photo shoot. The backdrop made an interesting juxtaposition with our lovely young lady's soft curls and dress. I wanted dramatic light, but the sky was not going to provide that. Instead I set up a speedlight with a small OctoDome, for its tight light pattern and soft, directional output. I wanted something that would light my subject only, but not much else.

A second speedlight was set up with a Rogue Grid to cast a beam of light on her hair and side of her face. Both of these lights were covered with amber Sticky Filter gels to give them a tungsten white balance. By setting my camera to tungsten also, the gray sky turned a bit more blue while the skin stayed fairly neutral.

I chose a wide-angle lens to dramatize the lines of the cargo car and kept my subject close to center of the frame to minimize distortion to her face from the wide angle.

Working with wireless radio flash triggers in a metal structure like this could cause interference problems, so I set my PocketWizards to transmit on standard channels, instead of using TTL, just to avoid any potential issues.

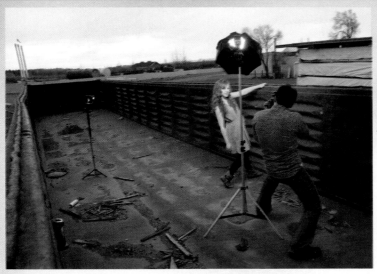

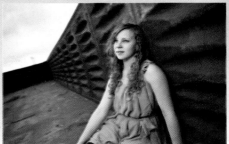

The original image.

Check that shooting stance! I think we could make a whole book with the funny poses photographers assume while working it. All those years of karate paid off.

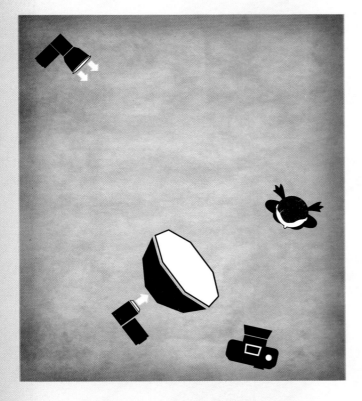

Exposure Info:
30mm lens setting
f/2.8 at 1/160 sec.
ISO 200
Exposure comp. +/– 0

Tools Used:
Nikon D3s
17–35mm f/2.8 zoom Nikkor lens
Nikon SB900 Speedlight
Nikon SB800 Speedlights
Photoflex extra small OctoDome
Rogue Grid for speedlights
PocketWizard TT1/TT5 wireless trigger system
Sticky Filter color gels

Ballerina

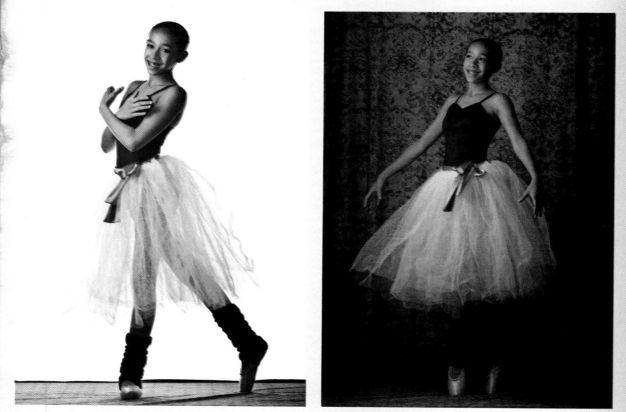

The final images received slight tonal adjustments and retouching, but were left otherwise unaltered.

Here's a way to get two very different looks quickly for an event—like a ballerina school, sports teams, or other group. The main lighting for this setup is a large Photoflex HalfDome strip box. We chose the strip box to keep the light contained as much as possible to the model, allowing the backdrop to naturally darken. The box was angled so that it feathered across the ballerina, and also illuminated the fill reflector. See the lighting diagram for more specifics. The result is a very soft, flattering light, with rich shadows that shape their hard-earned physiques.

The white background is a unique product from Lastolite, called the HiLite Background. It is essentially a rectangu-

lar box made with spring wire (like the pop-up reflector disks), and translucent fabric. It sets up easily in less than a minute. You simply place a light in its side opening and fire it through. Amazingly, that one light creates a completely even, glowing white backdrop. If you do high-key portraits, this is the cat's meow.

For the second look, we simply turned off the background light and draped a White House Custom Color custom-printed backdrop over it. The backdrops are lightweight, soft, and drape beautifully. I still can't get over how they can stand on their tippy-toes like that.

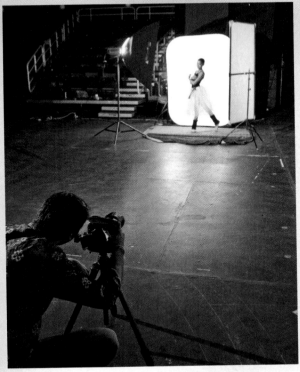

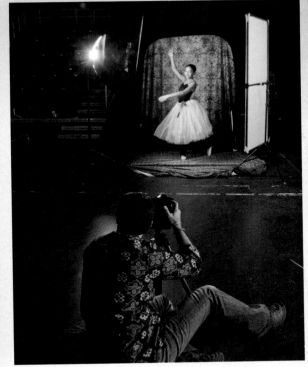

A single light inserted into the side opening of the HiLite is all that's needed to evenly illuminate it. A custom WHCC backdrop was laid on the floor across a slightly elevated board.

We laid another WHCC backdrop across the HiLite for our second look. The lighting remained the same.

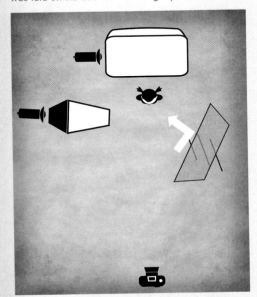

Exposure Info:

120mm lens setting
f/5.0 at 1/200 sec. ISO 250
Exposure comp. +/– 0

Tools Used:

Nikon D3s
70–200mm f/2.8 zoom Nikkor Lens
2 Photoflex Starflash monolights
Photoflex HalfDome
Photoflex FlashFire wireless triggers
Photoflex 39″ × 72″ LightPanel with
 diffusion fabric
Lastolite HiLite Background
2 WHCC custom fabric backdrops

Sunshine In The Rain

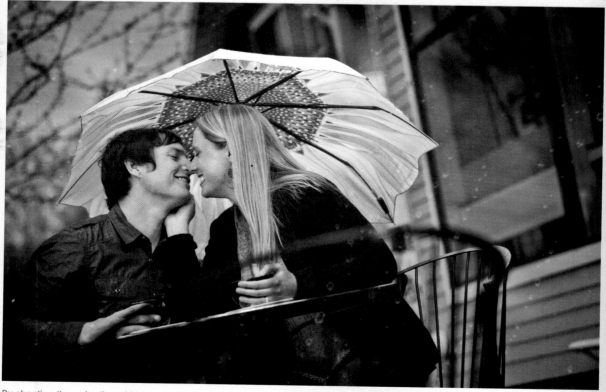

By shooting through other objects, you create an illusion of spontaneity and the image feels more candid. I often look for, or arrange, things to shoot through. The edges of the image were darkened in Photoshop with my Starburst Vignette Dashboard tool.

Love knows no bounds. And apparently it defies common sense too. When you have sunshine in your heart, it's never raining, right? That's the idea, anyway, that I wanted to portray with this image. We planned for a sunny afternoon at a coffee shop, sipping lattes together—laughing and smiling, but it started to rain on our parade, just a little bit. I decided to use the rain, and create my own sunshine that would break through the clouds and illuminate my couple.

The main light came from a 39 × 72" diffusion frame with two speedlights firing through it. This gave the soft, natural-looking light on their faces. There was enough ambient light to serve as fill. We then placed a third speedlight on an extension pole and held it above, and behind, the umbrella. This cast a ray of sunshine down on them and helped to make the umbrella glow.

It was only slightly raining—on and off, but I really liked the idea of the rain once I had a taste of it. There were some raindrops captured in the final image, but I thought it would be nice to see even more rain, so I took an image of just raindrops on black, from my stock, and overlaid it on the image in Photoshop. By fading the transparency, and using the *screen* layer blending mode, the backdrop of black disappeared, leaving only the raindrops on the image.

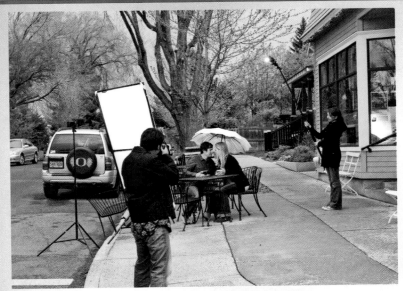

Two speedlights behind the scrim gave me faster recycling times and the power to light that panel in daylight.

The original image. Small raindrops are visible, but I wanted more!

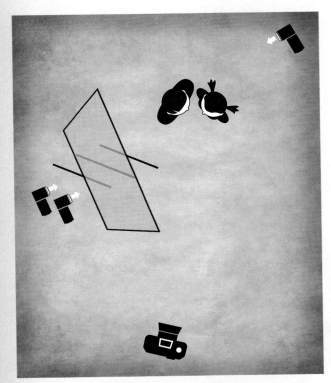

Exposure Info:

116mm lens setting
f/3.5 at 1/200 sec.
ISO 400
Exposure comp. +/− 0

Tools Used:

Nikon D3s
70–200mm f/2.8 zoom Nikkor Lens
Nikon SB900 Speedlight
2 Nikon SB800 Speedlights
Photoflex 39 × 72" LitePanel frame with diffusion
 fabric
PocketWizard TT1/TT5 wireless trigger system

Goddess of Motherhood

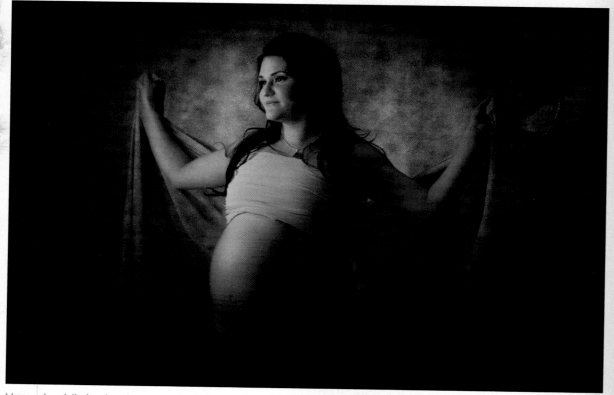

I keep a bag full of various fabrics in long strips. They are perfect for pregnancy portraits as they are more timeless than clothing and infinitely more romantic and dreamy.

For a pregnancy portrait, it's hard to beat the soft, shapely light from my custom three-panel light box. I use this setup quite often when I need the most chiaroscuro and I don't have time to travel to Italy. One nice thing about this setup is that you can repurpose tools you may already have—like the LitePanels. It's also less expensive than buying a dedicated softbox of this size. To form the three-panel box, create a triangle around your light source. The front face is translucent and the two sides are white on the inside. The light should have a wide reflector or be bare bulb.

We used a white reflector panel for fill light, and a monolight on the floor behind her with a grid spot on it for a background light. The grid created the spotlight effect on the backdrop. The backdrop was a custom-printed design from White House Custom Color. The beautiful rusty texture and color matched perfectly with the tones of the fabric and warm light. I also enhanced the image further in Photoshop with my Buj Texture from Bor-Tex to make it painterly.

Cara is a professional roller derby queen and you can see the completely different type of pregnancy portrait we did for her later in the notebook section.

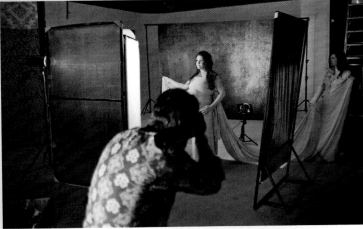

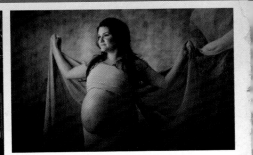

The original image

The three-panel box at left is made from three LitePanels clipped together. This setup creates exquisite light. My assistant threw the tails of fabric in the air while I captured.

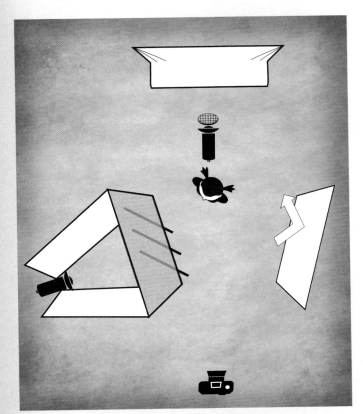

Exposure Info:

85mm lens setting
f/2.0 at 1/250 sec.
ISO 200
Exposure comp. +/– 0

Tools Used:

Nikon D3s
85mm f/1.4 Nikkor Lens
2 Photoflex StarFlash monolights
Photoflex 39 × 72″ LitePanel frame with diffusion fabric
Two 42″ × 78″ Calumet panel with white fabric
42″ × 78″ Calumet white reflector
Warm gel for the StarFlash background light
30-degree grid spot on background light
White House Custom Color Backdrop
Photoflex FlashFire wireless trigger system

Special Delivery

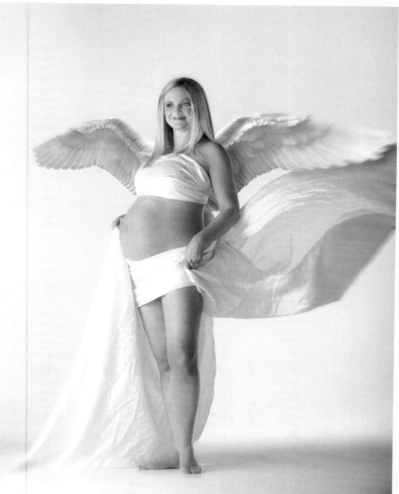

The final image was retouched slightly in Photoshop and combined with the wings image. Extensive masking was used to realistically match the two.

Is she an angel? A messenger with a little gift? The cutest stork ever? Any way you look at it, mothers-to-be are something special, and I love creating maternity portraits for them. I had already envisioned and planned for the winged body-builder portrait you'll see later in the notebook section, so I also started to imagine how they would look on a pregnancy image.

I've always held expectant mothers up there on a pedestal—just a few steps down from angels—so the symbolism worked for me. I got the image of the wings from a stock photo site. I paid particular attention to the style of the wings, and the original lighting used—so that I could closely emulate the quality and direction of it on my subject.

I needed soft and directional light that was fairly even from head to toe. A double-sized Photoflex 77 × 77" LitePanel with diffusion fabric was perfect when lit with a monolight from behind. We adjusted the distance of the LitePanel to my model until the quality of the shadows matched the shadows on the wings image. I then lit the background with two additional monolights to create an even white wash. I didn't want a pure white, blown-out looking background. I felt it would have more depth with very soft shadows and near-white tones. The light bouncing off the white background provided sufficient fill in the shadows on the model, so no additional fill light or reflectors were needed.

It took a fair bit of Photoshop work to size, angle, and shadow the wings to make them look realistically attached. I also blurred the edges of the image to further enhance the dream-like feeling of the image and give a sense of motion—like wings riding on the wind.

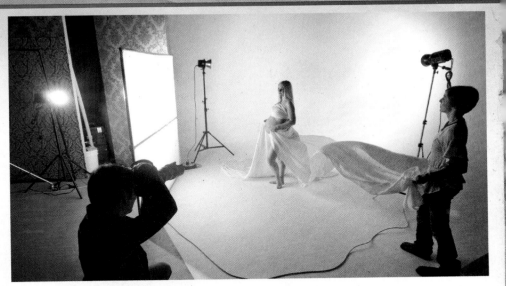

Our studio has a seamless cove background, making whiteout backdrops easier. White seamless paper could also have been used.

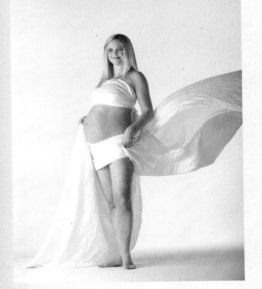

The original image.

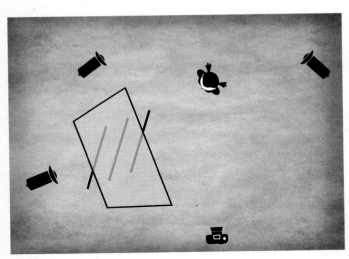

Exposure Info:

95mm lens setting
f/9.0 at 1/200 sec.
ISO 200
Exposure comp. +/– 0

Tools Used:

Nikon D3s
70–200mm f/2.8 zoom Nikkor Lens
2 Photoflex StarFlash monolights
AlienBees B800
Photoflex 77 × 77" LitePanel frame with
 diffusion fabric
Photoflex FlashFire wireless trigger system

A Girl And Her Dog

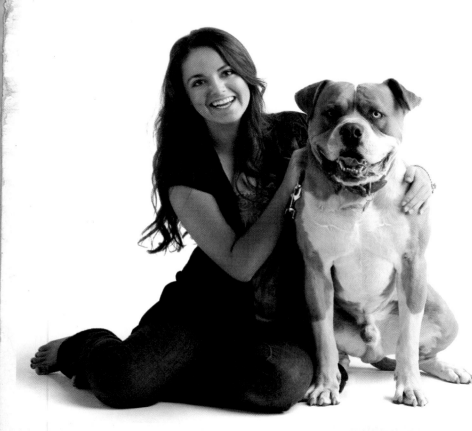

Mariah's beautiful smile helps to offset her dog's menacing gaze. I think that was actually his smile, however. The image was cleaned up in Photoshop to whiten whites.

When Mariah brought her dog into the studio, my assistant—a tall young guy—said tentatively, "Hi, puppy." The dog let out a blood-curdling growl and lunged at him briefly, nearly shocking him off his feet. Heart pounding, he moved to the opposite side of the studio. "That's a frickin' big dog!" he proclaimed. Goliath was polite to us the rest of the session, but we all kept our distance anyway.

For a beautiful high-key look in the studio, we used a Wescott 7 Octobank, which is an incredibly soft and even light. I brought a white reflector up as close as possible on the opposite side to keep shadows light. Large, even light sources are great when subjects may be moving around a bit, like dogs tend to do. It's especially important when you don't want to try to go over and move your drooling subjects either.

The background was washed white by a single monolight, set to measure one-half f-stop more than the base exposure.

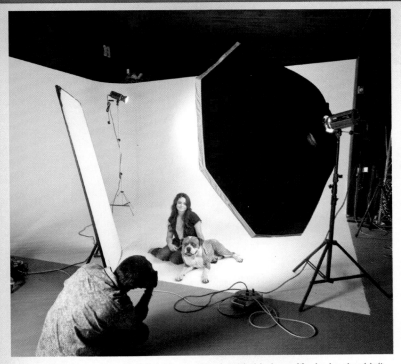

The original image. It just needed a bit of cleaning up in Photoshop.

Can you spot my assistant? He's hiding in the closet behind me. Maybe he shouldn't have worn the Sassy Kitty cologne that day.

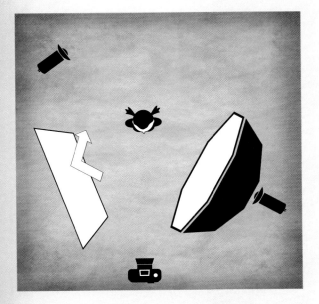

Exposure Info:
78mm lens setting
f/8.0 at 1/160 sec.
ISO 200
Exposure comp. +/– 0

Tools Used:
Nikon D3s
70–200mm f/2.8 zoom Nikkor Lens
2 Photoflex StarFlash moonlights
Calumet 42 × 78″ lite panel with white
 reflective fabric
Westcott 7 Octobank softbox
Scott Robert wireless trigger system

Headshot And Shadows

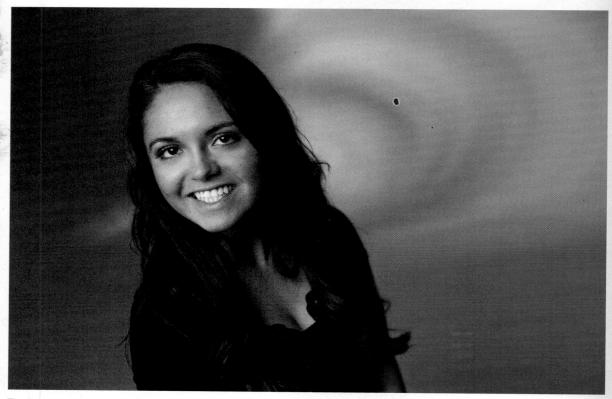

The final image was retouched slightly in Photoshop to soften skin a bit.

To spice up this simple headshot, we cast some interesting shadow patterns on the background by using a gobo cut from Foamcore board. You can create a gobo from just about anything— window frames, a plant, body parts— whatever is handy. When casting light on the background, consider having the brighter areas in the background behind the darker side of your subject—and vice versa. This can help to create more visual separation and depth.

The main light was a large rectangular softbox—a long-time standard for headshots. The light is soft, reasonably directional, and easy to control. If you position the box so that the back edge of it is approximately aligned with your subject's ear, and let it come forward from there, the light will wrap—creating its own fill light. Usually a reflector is not needed for additional fill.

A second monolight was set to shine through the gobo, casting the shadows on the background. Keep in mind that if you want crisper edges in your shadow pattern, move the light farther away from the gobo—and/or the gobo closer to the background (which also moves it farther from the light source).

Two additional light panels were used to block any stray light from hitting the background. Black Foamcore boards could also be used.

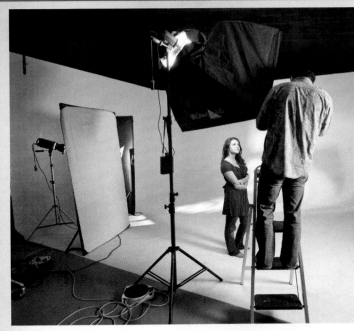

A stepladder is nice to have around when you are looking for a fresh angle.

My super-duper custom handmade gobo by famous artist/photographer Cindy Girroir—on loan from the Museum of Modern Art.

Exposure Info:
50mm lens setting
f/2.8 at 1/160 sec.
ISO 200
Exposure comp. +/– 0

Tools Used:
Nikon D3s
50mm f/1.4 Nikkor Lens
Photoflex StarFlash 300
Photoflex Triton flash
Two 42 × 78″ Calumet Panels to flag
 light
Photoflex medium LiteDome softbox
Photoflex Flashfire wireless trigger
 system
Gobo made from Foamcore board

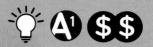

Vintage Hollywood

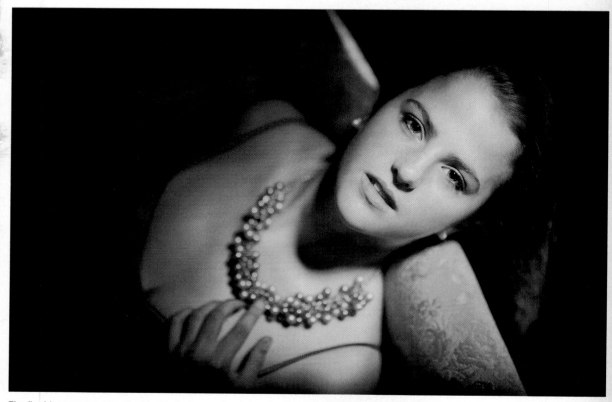

The final image was retouched in Photoshop and enhanced with my Doll Face and Eyes & Teeth Enhance from the Action DASHBOARD.

Lovely Mecca reminded me of a glamorous Hollywood actress from the days of George Hurrell and nickel pops. I wanted to do a portrait of her, reminiscent of this period, but with a modern twist. True to vintage Hollywood form, the main light was a crisp, directional beam, positioned to create a classic butterfly lighting pattern. I used an AlienBees monolight with a 20-degree grid spot attached. The tight grid pattern kept the light brightest on her face, with rapid falloff into darkness.

A second light, also with a 20-degree grid, was aimed at her hair, cascading over the back of the chaise. A warm amber gel was added to this light to complement her red hair and tones in the image.

Subtle details help to make this portrait more Hurrell-esque. Look for wispy shadows cast from the eyelashes, dilated pupils, the butterfly shadow under the nose, the position of the hand, and the reclined pose—all characteristic of the beautiful portraits he made of Hollywood's most famous sirens.

Post-processing is also very important, as images of this era were heavily retouched to show flawless skin with a creamy surface, bordering on the verge of overexposure. I used Photoshop, of course, to smooth and polish the skin, using my Doll Face Action. The result is a classic-style portrait with a modern, edgy color palette.

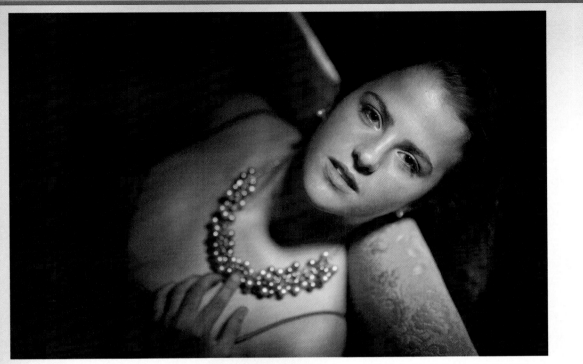

The original image. It feels like a good start, but it's not how you feel, it's how you look. And in Hollywood, baby, you have to look Maaaarvelous! Let's visit Photoshop.

Yes! There is no setup photo for this image. We did not originally intend to include this image in the Notebook section, but I decided the image and background information were worth sharing. The graphic diagram and shadows on the image should give you a pretty good idea for where lights were placed. It's great practice to look at images and reconstruct the lighting in your mind, and then run to the studio and re-create it!

Exposure Info:
85mm lens setting
f/1.6 at 1/160 sec.
ISO 200
Exposure comp. +/– 0

Tools Used:
Nikon D3s
85mm f/1.4 Nikkor Lens
2 AlienBees B800 monolights with
 20-degree grid spots
Warm amber gel
PocketWizard TT1/TT5 wireless
 trigger system

Surfer Girl

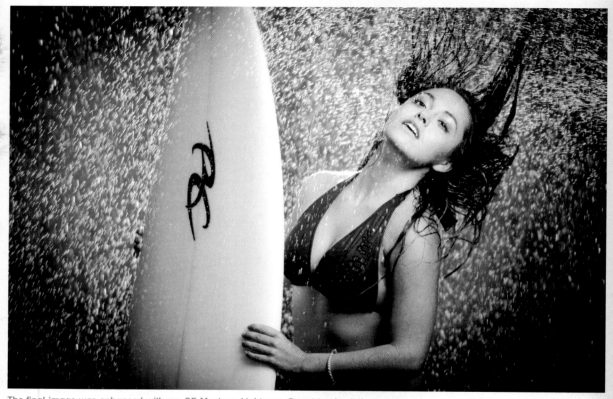

The final image was enhanced with my 65 Mustang Lightroom Preset to give it the creamy skin tones and rich color palette.

I would have loved to head down to Malibu to create our surfer girl photo, but it wasn't in our budget. This was a senior photo for a local lady, and the closest thing we had to a beach was some sand paper in the utility closet. We decided, instead, to emulate the spray of the ocean, the spritz of a cool shower, right outside the studio.

The lighting was actually fairly simple. A Photoflex small OctoDome was used as the main light, with a Photoflex Triton battery-powered monolight within. A second Triton, fitted with a 40-degree grid spot, was placed behind the subject and the wall of rain to backlight it, making it sparkle. A White House Custom Color custom backdrop was used, as it simulated a worn and textured

wall. Remember to use battery-powered lights whenever working around water.

To create the rain, we bought a cheap garden hose and drilled tiny holes across a 7-foot section of it. We plugged the end of it and then strung it up between two light stands. Open faucet, enter rain!

I used a neutral density filter to lower my shutter speed to 1/200 second so my flash units could synchronize. I set the ambient exposure for an f-stop less than the flash, to provide fill and allow the flash to command attention as the main light.

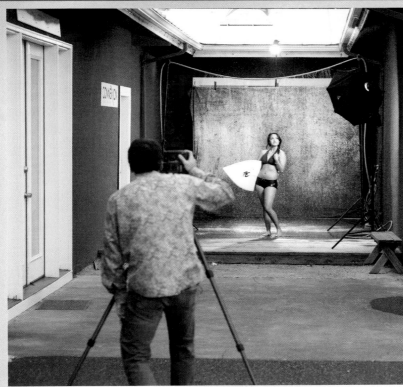

The original image

Our young lady was quite the trooper, considering it was in the 60s and raining cold water on her!

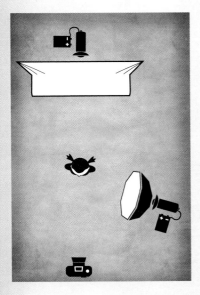

Exposure Info:

200mm lens setting
f/2.8 at 1/200 sec.
ISO 200
Exposure comp. +/– 0

Tools Used:

Nikon D3s
70–200mm f/2.8 zoom Nikkor lens
2 Photoflex Triton Flash systems
Photoflex Medium OctoDome
PocketWizard TT1/TT5 wireless
 trigger system
WHCC custom backdrop

 OPTIONS

Two speedlights would have worked in place of the Triton flash units, although the Tritons have slightly higher output and faster recycling times

Date Night

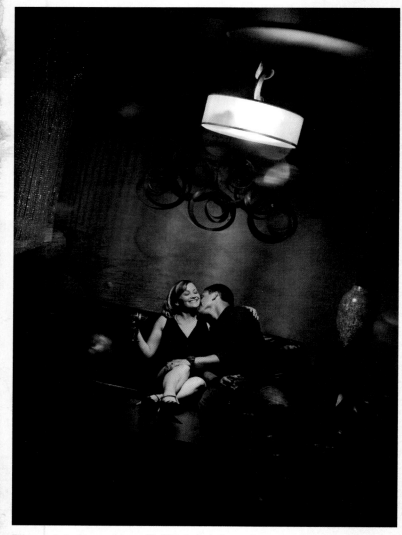

This couple had no problem with PDA, in fact, the gentleman asked if we could extend the photo shoot a little longer. The final image received love from my Rolling Stone Wash Lightroom preset.

Every couple should have a scheduled date night—whether you've been dating for a month or married for 40 years. This image is my personal testament to saving the world via citizens with happier love lives! Not really, it's just a cool engagement photo taken in a groovy lounge in downtown Bend, Oregon. Fox's Billiards is a modern pool hall with multiple tables, a luxurious lounge, and surprisingly good food. The perfect spot for a photo shoot and lunch.

The image was taken in the middle of the day, but we pulled the shades and overpowered the existing window light with our strategically placed flash units. The main light comes from the hanging lamp above them, but the bulb in it was not bright enough, so we hid a speedlight inside of the lamp to emulate its effect.

We placed another speedlight to the left, shining through the crystal curtains with a blue gel over it. This cast amazing shadows on the wall behind them and made the glass sparkle like diamonds.

The diffused shapes in the foreground come from another set of glass bead curtains that I'm shooting through. They reflected some of the window light behind me, and added to the dreamy feel of the image.

I love to contrast colors—for example, warm light and cool light. It gives the image vibrancy. Notice the strategically colored drinks in their hands too, mimicking the colors in the lighting.

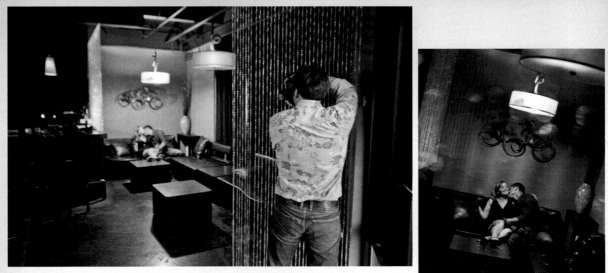

Maybe they won't notice me if I hide behind this curtain? Notice the brighter lamp over the couple; it has a speedlight hidden within.

The original image.

Exposure Info:
50mm lens setting
f/2.8 at 1/160 sec.
ISO 200
Exposure comp. +/− 0

Tools Used:
Nikon D3s
50mm Nikkor Lens
Nikon SB900 Speedlight
Nikon SB800 Speedlight
Rogue Grid for speedlights (without grid
 baffles)
PocketWizard TT1/TT5 wireless trigger system
Sticky Filter blue gel

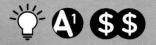

What Was In That Drink?

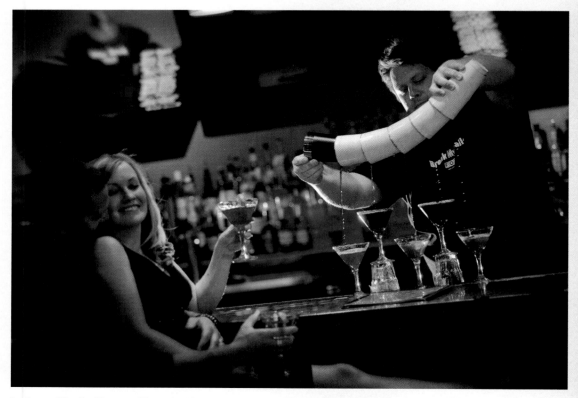

I enhanced the final image with my Acid Wash preset in Lightroom and softened the edges of the image with my Edge Blur Dashboard tool in Photoshop

Bartenders are such show-offs. This one, from Fox's Billiards in Bend, Oregon, had bragging rights. We had taken several other images here at the lounge during the hour before it opened and, as usual, we were packing up when I had one more idea for an image. The bartender/owner said he could make a drink tower, and I wanted proof. I imagined a scene where the couple was cozied up to the bar, so infatuated with each other that they don't even notice this amazing feat happening right before them. The doors to the bar were opening, however, and people started to wander in.

To make those colorful drinks glow, they needed to be backlit. My assistant held a speedlight with a snoot on it back in the corner of the bar, aiming at the drinks. We could have used a light stand, but time was running out and it was faster to just hold it. We quickly set up another speedlight with an extra small Photflex OctoDome over it as our main light. My intention here was to create more mood light than portrait lighting. I wanted the amazing drink tower to glow, with the couple subtly making out on the fringes.

We literally shot for two minutes before the customers were lining up for drinks, and the bartender had to wrap up his magic show.

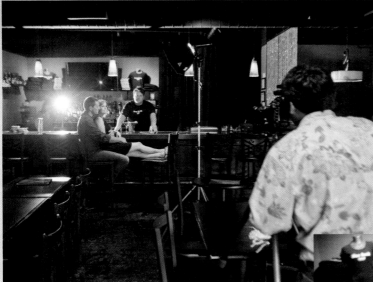

The ability to work quickly sometimes determines whether you get the shot or not. Use an assistant to make your life easier. Keeping your lighting simple and portable also helps considerably.

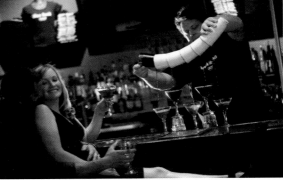

The original image.

Exposure Info:
110mm lens setting
f/2.8 at 1/8 sec.
ISO 200
Exposure comp. +/– 0

Tools Used:
Nikon D3s
70–200mm f/2.8 zoom Nikkor lens
Nikon SB900 Speedlight
Nikon SB800 Speedlight
Photoflex extra small OctoDome
PocketWizard TT1/TT5 wireless trigger system

iSpy Love

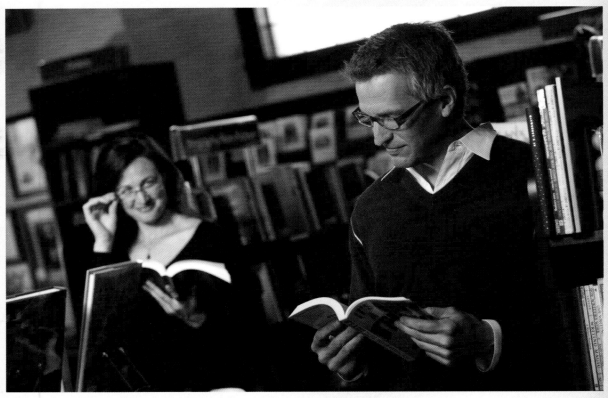

The final image was kept close to the original, but just didn't feel healthy enough without my Vitamin K preset in Lightroom.

What better place to meet the man of your dreams than a bookstore—especially when that bookstore is Between the Covers, in Bend, Oregon. This cozy and eclectic hangout is teaming with the best, hand-picked books by Haley, the shop's particular proprietor. It was also the setting for our little bookstore love story, starting with this first glance.

The shop had some nice natural light streaming through antique windows. I needed more snap though, so we pulled out the "his and her" beauty dishes for our speedlights. I wanted the same directional lighting, as if coming from a large overhead lamp, to fall on both subjects. I didn't want a large light source that would wash out the entire space around them; it had to be contained. A

beauty dish on each of them individually worked great. The unit on the temporarily disinterested male was from Lumodi. This lightweight, hard plastic dish straps to the head of your speedlight. The second dish on our seductive female was from Speedlight Pro Kit. It folds nearly flat and assembles quickly.

A third speedlight was placed in the background, with a RogueGrid snoot, to cast some edge lighting on the wall and bookshelves behind them.

Stay tuned for the next episode, and find out whether the cat catches her mouse, or the mouse turns out to be a man.

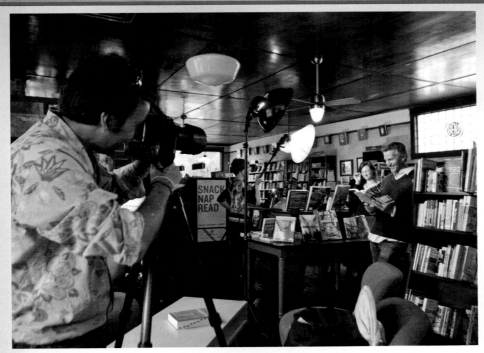

Both beauty dishes were placed at the same relative distance and direction to their subjects. They emulate perfectly placed lamplight.

Exposure Info:
105mm lens setting
f/4.0 at 1/50 sec.
ISO 200
Exposure comp. +/– 0

Tools Used:
Nikon D3s
70–200mm f/2.8 zoom Nikkor lens
Nikon SB900 Speedlight
2 Nikon SB800 Speedlights
Rogue Grid
Speedlight Pro Kit Beauty Dish
Lumodi Beauty Dish model 40
PocketWizard TT1/TT5 wireless trigger
 system

Meet Me In The Romance Section

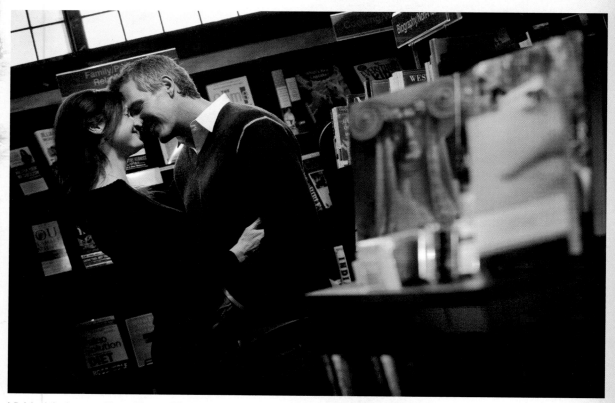

I finished the image with my Vintage 78 Lightroom preset. I also selectively darkened the edges.

In our last episode, the two bookworms discovered their common interest at Between the Covers bookstore while casually browsing the aisles. Now they've decided to get together and discuss their findings in the romance section.

I wanted this image to have a bit more dramatic and romantic lighting—you know, like when you meet the person of your dreams and the world just stops, lights seem to dim around you, and birds start singing. Exactly. To create this, I used a single beauty dish hovering above their heads as if it were the only light in the bookstore. Placement of your main light is important with more than one person. The general rule is always make the woman look good. Guys are secondary. This means placing the light so that it's flattering to the woman's face and features. For this image, I placed it above and to the right, so that it would fall down across her face at a pleasing angle. I then asked him to make sure to lean his face toward her left cheek, so as not to block the light on her face. Turns out, he was a natural right-side-head-tilt kisser anyway, so it all worked great. Which way do you tilt?

There was a second speedlight, with a grid spot, beaming at the bookshelf in the foreground to add depth and illuminating my strategically placed prop. Do you see it?

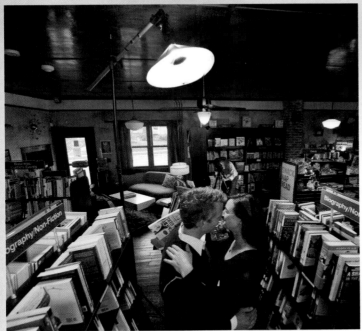

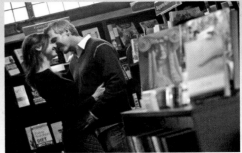

The original image.

The second speedlight with the Rogue Grid is camouflaged in front of the candy shelf on the right.

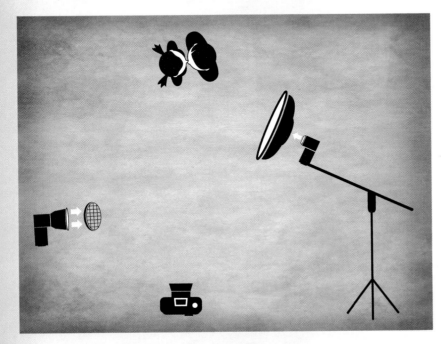

Exposure Info:
86mm lens setting
f/4.0 at 1/50 sec.
ISO 200
Exposure comp. +/– 0

Tools Used:
Nikon D3s
70–200mm f/2.8 zoom Nikkor Lens
Nikon SB900 Speedlight
Nikon SB800 Speedlight
Speedlight Pro Kit Beauty Dish
Rogue Grid for speedlights
PocketWizard TT1/TT5 wireless trigger system

Burning Boudoir

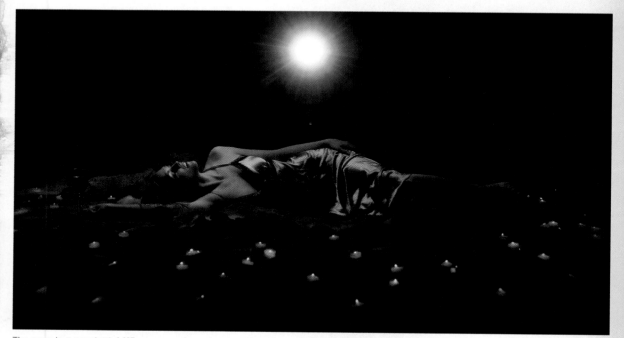

The cave is a constant 44°F year-round, so she wasn't nearly as cozy as she looks. The final image was processed in Photoshop with my Lord Of The Rings and Edge Blur Dashboard tools.

Although an ancient underground lava tube cave may be the obvious and cliché spot for a sexy boudoir portrait, I decided to do it anyway. We did a bridal portrait in here previously, and we just loved the location! I think the juxtaposition of this soft and lovely form, in the rough and rugged environment, just works. Is she Juliet, having taken her last sip of poisoned wine? Is she waiting patiently for her husband who is a miner, away on assignment for way too long? One can only wonder.

Lighting all those little emergency candles took some time, but they actually contributed to the illumination slightly—warming things up a bit. The main light, however, needed to be ultrasoft and moody. I floated a 39 × 72" diffusion panel over her and illuminated it with a speedlight. This created the gorgeous, soft light that wraps her. I had my assistant hold the speedlight toward her head-side of the back of the diffusion so that it would be the brightest, letting it naturally darken toward her feet.

We added a second, unadulterated, speedlight in the back of the cave, pointing directly into the camera. This created the star-like light and added a bit of boost to the main illumination, highlighting the edge of her body. Both speedlights were covered with amber Sticky Filter gels to match the color of the candlelight.

As we were photographing this, a family of cave-hikers came through, flashlights in hand. We smiled and said, "hello" and giggled to ourselves as they passed, wondering what must be going through their minds; were we having some kind of sacrificial ceremony down here? One can only wonder.

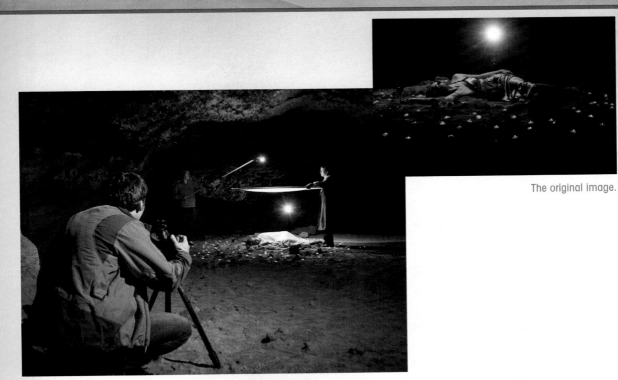

The original image.

Holding the lighting tools was much more convenient than setting up stands.

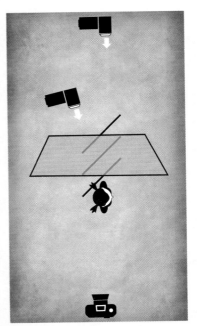

Exposure Info:

98mm lens setting
f/6.3 at 1/25 sec.
ISO 200
Exposure comp. +/– 0

Tools Used:

Nikon D3s
70–200mm f/2.8 zoom Nikkor Lens
Nikon SB900 Speedlight
Nikon SB800 Speedlight
Photoflex 39 × 72″ LitePanel frame with
 diffusion fabric
2 Tungsten Sticky Filter gels
PocketWizard TT1/TT5 wireless trigger system

Wild Mustang Ride

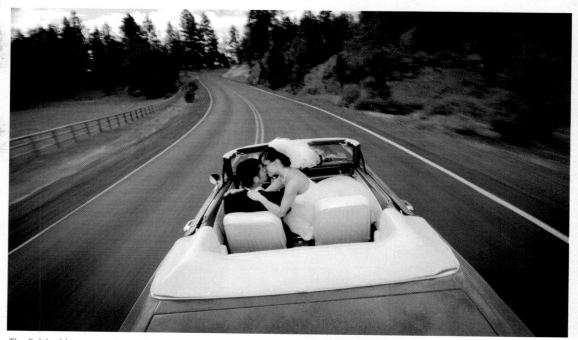

The finished image was treated with; you guessed it, my 65 Mustang Lightroom preset.

Many years ago, I did a wedding photo of a bride and groom riding in a red convertible mustang, like this. It became one of my favorite images because I just loved the raw, imperfect, fleeting, spontaneous feeling of it. I entered it in a print competition and it didn't fair nearly as well as I thought it would. One judge commented, "A professional photographer should know how to take a sharp picture." I agreed. A pro should know *how* to take a sharp picture—but more importantly, *when* to take a sharp picture. This was not the time. I hung that photo in my studio, and bride after bride commented that they *loved* that image—and many booked me because of it. I've taken many similar images since.

The images I've taken previously were done with me sitting up on the trunk, one foot hooked under a seatbelt, going 40 MPH, and trying to focus my camera while simultaneously trying to avoid noticing that I was not being very safe. I didn't want to encourage anyone else to do that, so here's a better way! I also like that you see more of the car from farther back—which makes the image all the more dynamic.

I attached my camera and speedlight to a tripod and strapped it to the car. Normally I try to avoid flash-on-camera, but here it was the best solution for keeping it simple, and still adding a kiss of fill light to the image, which would primarily be lit from the sun and sky. I set the flash to TTL mode, and minus one f-stop of flash compensation. I triggered both with the PocketWizard MultiMAX wireless system. I had to set the remotes to the special "long distance mode" to get reliable firing, but then it worked great.

I used a combination of a Fat Gecko suction cup mount, and my own creative rigging, to keep the tripod firmly attached. This included old flip-flops, but you'll have to watch the video to see that.

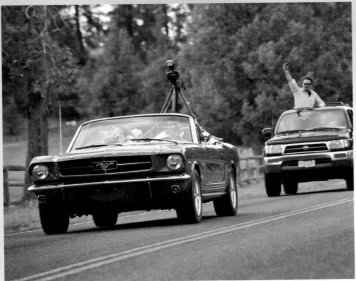

The original image.

It's not a parade; I'm triggering the camera from the pace vehicle. I got better reception when holding the transmitter up high.

Tie-down straps were used to secure the tripod. A Fat Gecko suction cup mount holds the forward-most leg to the trunk lid.

Exposure Info:
12mm lens setting
f/5.0 at 1/25 sec. ISO 200
Exposure comp. +/– 0

Tools Used:
Nikon D300s
12–24mm f/4 zoom Nikkor Lens
Nikon SB800 Speedlight
PocketWizard MultiMAX wireless trigger
 system
Fat Gecko suction cup mount

Girls Day Out

The final images were kept relatively normal and assembled in to this collage in Photoshop. Lightroom has a timesaving feature, "Open as Layers In Photoshop," which automatically opens selected images as layers in a single file.

This fun series of images came from a portrait session with two teenage sisters, who obviously love to shop. Their mom owns this fashionable boutique, Hot Box Betty, in downtown Bend, Oregon. I decided to set up a scene in the store and just let them play, try on clothes, and do what girls do.

There was window light, but it was not consistent or of the quality I wanted. I placed a large diffusion scrim just outside the shop window and fired two speedlights through it. This would simulate soft, diffused light—as if naturally coming through the window.

I put a third speedlight in the back of the store, pointing down at the girls, to create a hair/separation light. It was fitted with a RogueGrid to contain the light to the area just around them.

Once the lighting was dialed in, I let them play! My assistants would grab items from around the store and feed them to the girls as they tried things on, talked on their cell phones, and teased each other. Having the double speedlights outside helped the keep the recycle times fast enough to keep up with my rapid capture.

An assistant stayed outside to warn passersby and keep an eye on the gear. A good wireless trigger system is a necessity for setups like this.

Exposure Info:
30mm lens setting
f/4.5 at 1/200 sec.
ISO 400
Exposure comp. +/− 0

Tools Used:
Nikon D3s
17–35mm f/2.8 zoom Nikkor Lens
Nikon SB900 Speedlight
2 Nikon SB800 Speedlights
Rogue Grid
Photoflex 77 × 77" LitePanel frame
 with diffusion fabric
PocketWizard TT1/TT5 wireless trigger
 system

The hair/rim light was focused just on the backs of the girls and fitted with a Rogue Grid.

Dos Sisters

Slight retouching and a helping of my Lord Of The Rings effect in Photoshop finished up the images. This is a great effect for female portraits.

After these young ladies finished their "shopping spree" we wanted to make some traditional portraits, in addition to the playful images we had just done. I thought to use the shop environment as a backdrop, rather than a studio-type backdrop. This helped to personalize the images more and kept them in a comfortable environment. By using a long lens and wide aperture, I could blur the distracting details of the boutique in the background, while still keeping a hint of it with the interesting soft shapes.

We set up a 77 × 77" diffusion frame with a speedlight behind it. This gave me soft, shapely light that needed nothing extra for fill light. With large light sources, if you position them so that they come forward of your subject a bit, the light will wrap the face and body and additional fill lights are often unnecessary.

We placed a hair light upstairs in the balcony behind them because I wanted it to shine directly down on them as much as possible, and I didn't want to place the light stand anywhere it would be visible in the background. This hair light had a Rogue Grid attached to it to help contain the light to the back of the girls. It was also covered with an amber gel to warm the light color up.

I started shooting fairly rapidly, keeping an eye on the recycle time of the speedlight closest to me. Since it was at medium power, it recycled fairly quickly, and I thought all was good. I forgot, however, that my speedlight upstairs was firing at nearly full power—since it was farther away. It also had the grid and a gel over it, which cuts the output quite a bit. My assistant said she smelled something burning, and sure enough, the speedlight had shut down from overheating. We had used cheap, old recyclable batteries in it that weren't up to the amperage drain, and they fried. We had to switch to a new speedlight and slow down the shooting for the rest of the session. The problem speedlight eventually recovered, but the batteries were toast.

Shooting from a distance, with a long lens and wide aperture, allowed me to blur the background enough to where it wasn't distracting, but became beautiful soft shapes.

The original image.

Exposure Info:
200mm lens setting
f/3.2 at 1/160 sec.
ISO 400
Exposure comp. +/– 0

Tools Used:
Nikon D3s
70–200mm f/2.8 zoom Nikkor Lens
Nikon SB900 Speedlight
Nikon SB800 Speedlight
Photoflex 77" LitePanel frame with diffusion fabric
PocketWizard TT1/TT5 wireless trigger system
Rogue Grid
Tungsten Sticky Filter

Feeling Dirty

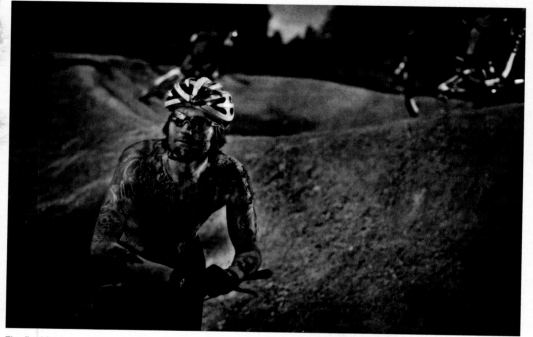

The final image was a composite of four images. I used my Fudgesicle Dashboard tool and applied the Buj texture from Bor-Tex

Ever have the urge to take your shirt off, splash cold wet mud on yourself, and sit out in the forest on a cool spring day? Me neither, but I knew we could get somebody to do it. I envisioned this portrait of a muddy mountain biker hanging out with other riders zipping by behind him. On paper, it seemed easy enough, but in reality it was a nightmare to get them all synchronized to be in the right place at the right time. So I decided to worry about each piece separately and composite the images in Photoshop.

The location we were at made it tricky to set up lights. The ground was not level anywhere, and I really, really wanted my main light right where a pile of rocks and scrub brush were. Sturdy assistants to the rescue! I think when you handhold lights and equipment, the image becomes more of a "handmade, one-of-a-kind" piece of artwork. That's my excuse, anyway.

The main light was a double-sized diffusion panel with an AlienBees monolight illuminating it. I needed a large panel to be able to cover the rider and his bike, remain clear of my framing, and provide the shapely directional light I imagined. I positioned the panel so that the light would emulate the direction of the sun, to match with the background.

We added a second light on the opposite side for a crisp edge light—helping to define the rider and separate him from the background a bit more. We used a HalfDome strip box, but removed the front diffuser to gain a crisper, more directional light. The strip box kept the highlight long and lean, with no hot spots in between.

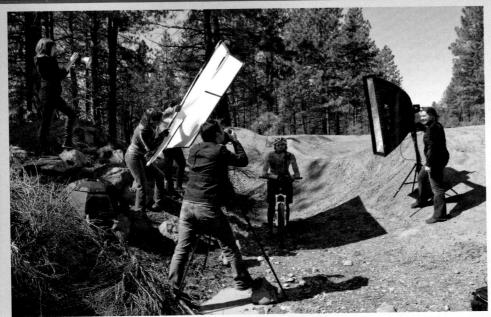

I always try to position myself over sharp objects or mud holes to make the shoot more interesting. All monolights were battery powered.

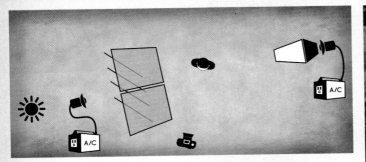

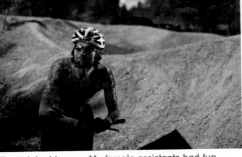

The original image. My female assistants had fun giving him a mud bath.

Exposure Info:

50mm lens setting
f/2.2 at 1/250 sec.
ISO 400
Exposure comp. +/– 0

Tools Used:

Nikon D3s
50mm f/1.4 Nikkor Lens
2 AlienBees B800 monolights
Photoflex HalfDome
Calumet 42 × 78″ Panel with diffusion
 fabric
Photoflex 39 × 72″ LightPanel with dif-
 fusion fabric
Paul C. Buff Vagabond II and Vagabond
 Mini
Tamrac MicroSync wireless trigger
 system

One of the original background biker images

Big Air

The final image didn't need much except for some color punch and cropping

Jamie Goldman is a pro Freeride mountain biker in Bend, Oregon, so I knew we would get some great action shots out of him at the bike jump park. He did not disappoint.

I wanted to get him framed against the deep blue sky—ideally backlit from the sun. If that were to happen, we'd also need strong enough lights in front to balance the backlight and keep his face from going completely dark. I set up two monolights—one toward the front of him, and another on the side, to create edge lighting. Both needed to be up high to match the level of his big air jumps.

We placed one light on a light stand, raised to its maximum height. The ground underneath was a bit elevated, so it was just high enough. My assistant held it steady. A stand wasn't tall enough for the second light, so we climbed up a tree and clamped the light to a branch instead. All those years of living with the apes in the jungle paid off.

Both lights needed full power to balance with the sun. They were powered by portable A/C battery packs. I also used a neutral density filter to lower my shutter speed.

I had heard that Jamie could do a backflip in the air, and I asked him about doing this for the camera. "Uh, I don't know," he said. "The conditions are not great today and it could be pretty dangerous." I, of course, was not going to argue with that. We got a ton of great images and were happily packing up when I saw him roll on over to the takeoff ramp for one more run. I instinctively turned to watch as he quietly rolled in and threw down a back flip! I grabbed a shot of it, but I was not in the right position anymore so the image wasn't what I really wanted, although it was awesome to see.

The backflip grab shot.

I could feel dirt spray and the thump of his tires as he landed right next to me. It was a good thing he was so precise with his jumps.

The original image.

Exposure Info:
17mm lens setting
f/4.5 at 1/250 sec.
ISO 200
Exposure comp. +/– 0

Tools Used:
Nikon D3s
17–35mm f/2.8 zoom Nikkor Lens
2 AlienBees B800 monolights
Paul C. Buff Vagabond II power pack
Paul C. Buff Vagabond Mini power pack
Genus variable neutral density filter
Tamrac MicroSync wireless trigger system

The Dance

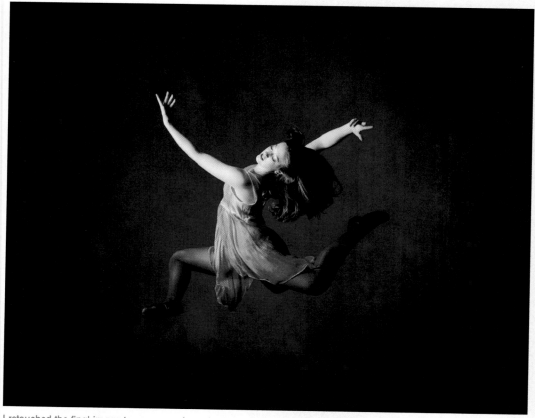

I retouched the final image to remove a rip and seams in the backdrop. I enhanced the color with my Creamsickle Dashboard tool.

We visited the theatre department of the local college to create this portrait of one of its lead dancers. This was one of those sessions in which I could have photographed all day; it was so amazing to watch her in the air, and each shot was uniquely beautiful. I'm sure she didn't feel the same way, however, as I know how tiring jumping on a trampoline can be. I took a couple jumps and had to rest for a while.

I needed a very large main light, as I needed to have wiggle room—not knowing exactly where she would be at the moment of capture. I also needed something soft, but with rich shadows to define her form. Shadows are very important to images like this; they give depth and feeling. I used two Photoflex StarFlash monolights behind a group of three diffusion panels. In order to freeze motion, you need short flash durations. And, as you know from previous chapters, using a lower power setting on your flash shortens the flash duration; hence, the reason for two monolights instead of one. It also gave me quicker recycle times, so I never missed the perfect moment.

A single white panel was used for some reflected fill, and a third monolight was placed on the floor, with a grid spot and blue gel, to illuminate the backdrop.

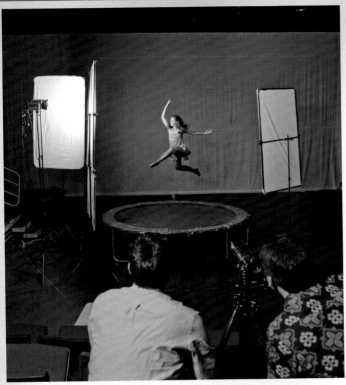

Three translucent panels together formed a large wall of diffused light. A fourth panel, with solid fabric, was used to block stray light from hitting the background.

Exposure Info:

70mm lens setting
f/5.0 at 1/200 sec.
ISO 250
Exposure comp. +/− 0

Tools Used:

Nikon D3s
70–200mm f/2.8 zoom Nikkor Lens
2 Photoflex StarFlash monolights
AlienBees B800 with grid spot and blue gel
Photoflex 39 × 72″ LitePanel frame with
 diffusion fabric
3 Calumet 42 × 78″ frames with diffusion
 fabric
Calumet 42 × 78″ frame with white/black
 fabric
Photoflex FlashFire wireless trigger system

The original image.

Star Of The Show

The final image received very little post processing. The colors were already very rich and vibrant.

For the star of the show, we put her front and center. This dramatic starlet portrait was the product of several lighting tools working together in perfect harmony—just like a finely choreographed dance. The main light was a Wescott 7 parabolic silver umbrella. This creates a fairly crisp and directional light. I kept the output relatively low, however, as I wanted to create more of a spotlight on her face—just like a theatrical spotlight, and that required another light tool.

I supplemented the umbrella with a speedlight wrapped in a RogueGrid fitted with the tightest grid pattern it offers (you can adjust it from 16 degreees to approximately 60 degrees) to form a beam for her face. I held this directly over my camera so that it wouldn't create conflicting shadows with the umbrella. A white reflector panel was used for some fill light on the opposite side of the umbrella.

I placed another speedlight on the steps just behind her to create the angelic glow. It was bare, without any modifiers. Lastly, another speedlight was placed far up in the back-right corner of the chairs, covered with a blue gel, and skimmed across the chairs. This made their natural blue color glow even more.

I synchronized the flash systems with the FlashFire wireless triggers, but I didn't have one for my speedlight over the camera. To solve that I turned on the visual slave (SU-4 mode) in the Nikon SB900, and aimed the body toward the umbrella so it could "see" that flash and fire in sync.

The final look mimics theatrical stage lighting, but with the control and facial flattery I needed.

I can shoot, hold a flash, balance on a ladder, and crack lame jokes—all at the same time.

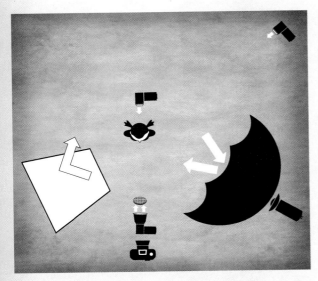

Exposure Info:
30mm lens setting
f/2.8 at 1/200 sec.
ISO 250
Exposure comp. +/– 0

Tools Used:
Nikon D3s
17–35mm f/2.8 zoom Nikkor Lens
Nikon S9800 Speedlight with Rogue Grid
Nikon SB800 Speedlight with blue gel
Nikon SB800 Speedlight
Westcott 7 Parabolic Umbrella silver
Photoflex 39 × 72" LitePanel frame with
 white fabric
Photoflex FlashFire wireless trigger system

Senior On A Red Truck

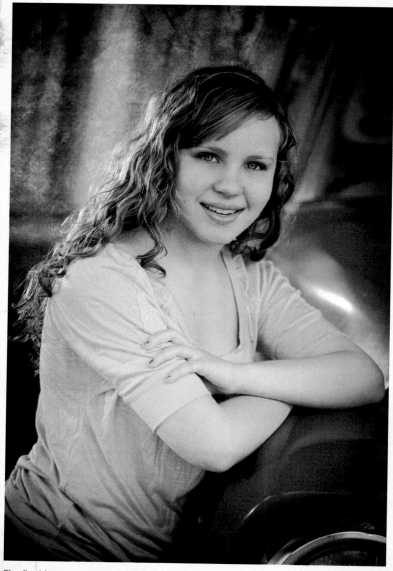

The final image was enhanced in Photoshop with my PowWow Action and Gold, a rich texture from Bor-Tex DASHBOARD Set.

When you have a vintage red pickup truck for a prop, life is good. A friend let us borrow his ride for a photo shoot with this lovely young graduate.

We were under the shade of a large outdoor warehouse awning. It had been raining off and on all day, so we decided not to take any chances and worked somewhere covered. This also meant creating our own sunlight.

The small Photoflex OctoDome is an extremely versatile light modifier. It's just about the right size for most anything if you really needed to work with just a few tools. The light can be very soft and flattering when used up close—or broad and even when pulled back. We use it with a speedlight, and it is worth its weight in fresh coconut ice cream.

With the OctoDome as our main light, I wanted her eyes to really twinkle. She had beautiful blue peepers, and they needed a lower reflector to make them really glow. We placed our California Sunbounce reflector directly underneath her face and the main light—just outside of camera view. We used the silver side of the reflector, instead of gold, to avoid having warm-colored fill that wouldn't match the color of the main light.

To light up her curly hair, and the bitchin' ride, we placed a speedlight in the background without any modifiers. I adjusted both flash systems so that they were one f-stop above the ambient light and then set the camera exposure accordingly.

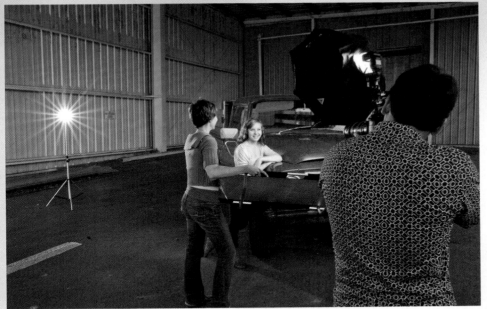

The under-eye reflector adds a beautiful lower catchlight to the eyes. It's especially valuable on close-up images.

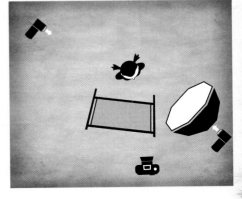

Exposure Info:
95mm lens setting
f/3.2 at 1/250 sec.
ISO 200
Exposure comp. +/– 0

Tools Used:
Nikon D3s
70–200mm f/2.8 zoom Nikkor Lens
Nikon SB900 Speedlight
Nikon SB800 Speedlight
Photoflex Small OctoDome
California Sunbounce Mini silver reflector
PocketWizard TT1/TT5 wireless trigger system

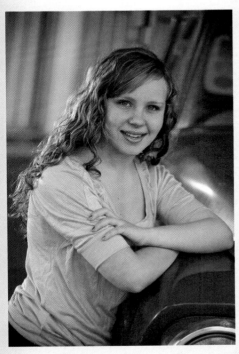

The original image.

Love In A Laundromat

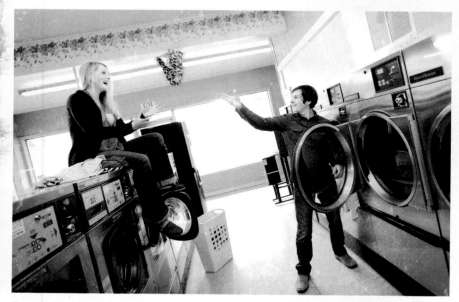

The main image was treated in Lightroom with, wait for it...my Acid Wash Preset. I then threw a little Texture in the wash via Bor-Tex DASHBOARD Set in Photoshop.

I wanted to do some playful and romantic photos for this couple, but we needed to keep it clean, so we headed to the laundromat.

I wanted a really bright, fresh, almost overexposed feeling in the images. Outside the main window of the laundromat was a busy street, which I didn't want to show, so I raised my ambient exposure just enough to blow that out. I then positioned my speedlights around the interior to bring my light level up to where it needed to be.

One speedlight was placed to my right, fitted with a Rogue FlashBender, to bounce light forward on to them, and also into the ceiling. Another light was placed on the washer to my left to bounce in to the ceiling for overall fill. The third light in the back left was aimed directly at my couple for an edge light that would look like sun through the window. Lastly, I put a speedlight outside the window behind them to backlight them and add some flare.

We did this shoot in the middle of the day, amidst active laundry doers, so I tried to keep my lighting as unobtrusive as possible, using small stands and placing them on top of things kept them out of the way.

We found a pair of underwear in one of the dryers; so if anyone is missing some, please shoot us a call.

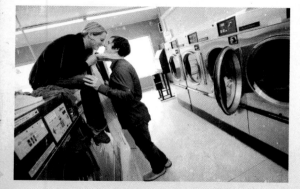

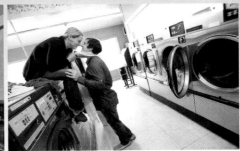

The original image.

The laundromat was quite a bit uglier than it looked in the final images. Bright light makes everything look better!

A GorillaPod is invaluable for attaching lights to awkward places. This one hangs outside the window.

Exposure Info for Top Image:
20mm lens setting
f/4.5 at 1/60 sec.
ISO 800
Exposure comp. +/– 0

Tools Used:
Nikon D3s
17–35mm f/2.8 zoom Nikkor Lens
Nikon SB900 Speedlight with Rogue Flash-
 Benders
Nikon SB800 Speedlight with Rogue Grid
Nikon SB800 Speedlight
Nikon SB600 Speedlight
JOBY GorillaPod
PocketWizard TT1/TT5 wireless trigger
 system

I Could Dance All Night

The final image was enhanced with my Hawaiianize Lightroom preset and then textured with Bor-Tex.

This romantic wedding portrait was created at the Great Hall in Sunriver, Oregon. Wedding photographers in the area affectionately refer to it as the "Great Hole" because of its lack of natural lighting and tricky-to-manage spotlights. It's a beautiful location, regardless, and it just takes a bit of planning to create great images there.

I wanted to create the idyllic, perfect first-dance moment—no gawking guests, no distractions, no time limit, and no inappropriate songs by the D.J. I positioned myself far away and shot with a long lens, using the table as a foreground element. This all contributed to the illusion of solitude.

The main light falling on the bride's face is from a speedlight hung from the rafters above her. It was wrapped with a Rogue Grid, and a warm Sticky Filter gel, to contain the light to a small pool of amber light. Two other speedlights were used—one aimed at the groom's back, the other at the bride's. The groom's light was covered with a Rogue FlashBender, shaped into a snoot, and warmed with a gel. It helped separate him from the dark background and added more detail to his dark tux. The bride's light was also wrapped in a FlashBender, but covered with a blue gel. It was aimed to skim across the fireplace. We used blue to contrast with the warm lights and to simulate blue moonlight streaming through a window.

The finishing touch was the candles strewn about the floor in front of them. Romantic, isn't it?

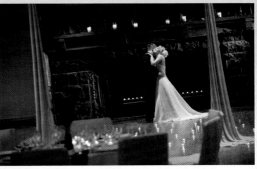
The original image

The main light was hung with a GorillaPod just above the couple.

Shooting from this distance added to the feeling of solitude in the image. It also allowed me to pass gas without being noticed.

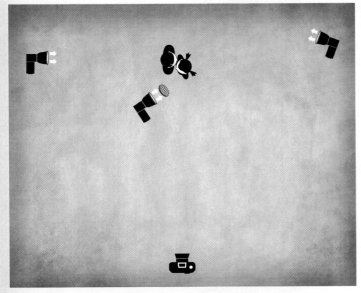

Exposure Info:
116mm lens setting
f/3.2 at 1/25 sec.
ISO 1600
Exposure comp. −1

Tools Used:
Nikon D3s
70–200mm f/2.8 zoom Nikkor Lens
Nikon SB900 Speedlight with Rogue Grid
2 Nikon SB800 Speedlights with Rogue
 FlashBenders
PocketWizard TT1/TT5 wireless trigger
 system
Joby GorillaPod

Roller Derby Queen

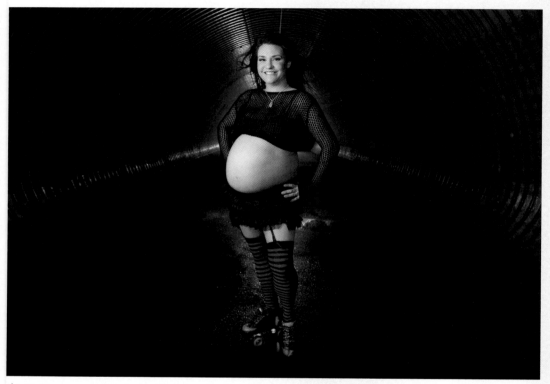

The final image was retouched in Photoshop to soften skin with my Doll Face Dashboard tool.

When we found out that our mother-to-be was also a roller derby queen, well, hello! She wasn't getting away without bringing her skates to the shoot. She did more than that, however; she brought her entire skating outfit! My original thought was to do the shoot in the actual rink where she skates. We drove by to check it out and it was being set up for an ultimate fighting event that night. Not exactly the backdrop we wanted. Benjamin suggested this walkway tunnel nearby that didn't get much use, so we headed over, and it was perfect!

We set up a strip box for the main light to keep the light confined to Cara, and off the tunnel walls. The large size kept it soft and flattering. I used a small OctoDome for a fill light, creating a beautiful 4:1 light ratio and shapely

shadowing. A speedlight was placed far in the back of the tunnel, covered with a blue gel, to light up the walls and ground.

The ground, which I wanted glowing with blue light, would only do that if wet, so I asked my assistant to run to the nearby grocery store for a couple gallons of water while I continued to set up lights. When she returned, we drenched the ground and the glistening blue I wanted came forth. All water was picked up and returned to the jugs when we were finished. We never litter.

To complete the image, we needed Cara to look like she just blew in to town on those sassy skates, so we used our battery-operated leaf blower to toss her hair back for her.

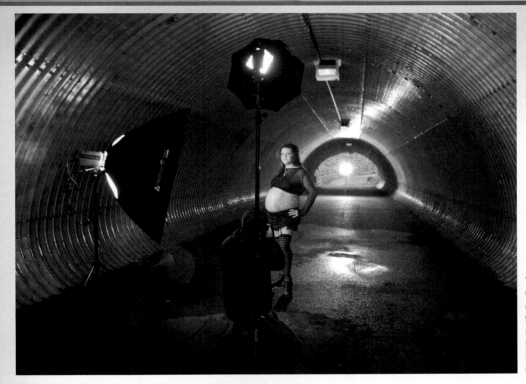

The metal tunnel was ripe for interference with our radio transmitters. We used the basic Scott Robert wireless system, and it worked fine.

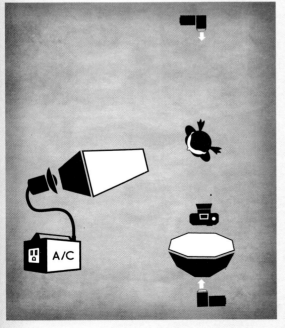

Exposure Info:

22mm lens setting
f/3.5 at 1/250 sec.
ISO 320
Exposure comp. +/− 0

Tools Used:

Nikon D3s
17–35mm f/2.8 zoom Nikkor Lens
Nikon SB900 Speedlight
Nikon SB800 Speedlight with blue gel
Photoflex StarFlash monolight
Photoflex HalfDome
Photoflex small OctoDome
Paul C. Buff Vagabond Mini battery pack
Scott Robert wireless trigger system

Coffee Guru

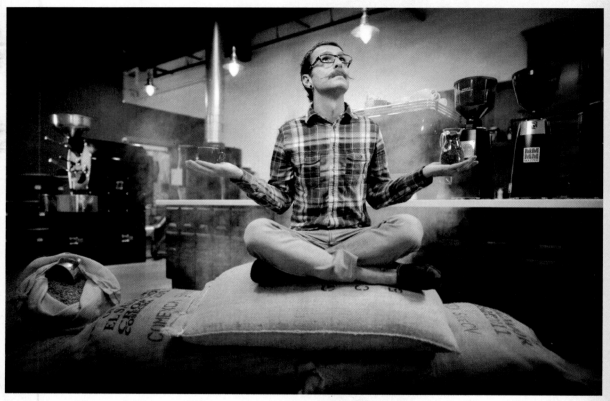

The final image was topped with a steaming helping of my Chocolate Shadows Dashboard tool in Photoshop. Some distracting spots on the walls were removed as well.

Some people take their coffee very seriously. Dave is one of them. He is the owner of Back Porch Coffee Roasters in Bend, Oregon. It's one of those hometown cafés where you can walk in and find the owner furiously brewing up espressos for his customers with precision and a smile. I think of Dave as the Coffee Guru, and that's what I wanted to portray in this quirky portrait.

The hardest part of this shoot was hauling those 150 lb coffee bags around to create his throne. The rest was easy. The main light comes from a speedlight in a Photoflex OctoDome. There was some decent natural light coming in from the large windows to the right of the image, so that provided the fill. I placed another speedlight with a

grid on it to highlight the grinders, and the Ferrari-red La Marzocco espresso machine, behind him.

A third speedlight with a Rogue Grid on it was placed in back to throw a highlight on the beautiful roasting machine. Now that the lighting was in place all we needed was a giant cloud of steam around Dave! How the heck were we going to do that? As luck would have it, my assistant had a miniature smoke machine in his car that he picked up at a discount store for 10 bucks! He got it the day after Halloween when everything went on sale. I guess he just carries it around with him all the time. Derek thinks of everything.

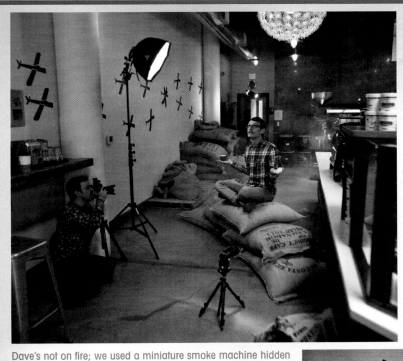

Exposure Info:
24mm lens setting
f/1.4 at 1/60 sec.
ISO 640
Exposure comp. +/− 0

Tools Used:
Nikon D3s
24mm f/1.4 Nikkor Lens
Nikon SB900 Speedlight
Nikon SB800 Speedlight with Rogue
 FlashBender
Nikon SB800 Speedlight with
 Rogue Grid
Photoflex extra small OctoDome
PocketWizard TT1/TT5 wireless trigger
 system

Dave's not on fire; we used a miniature smoke machine hidden behind the coffee bean bags.

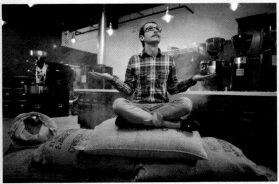

The original image.

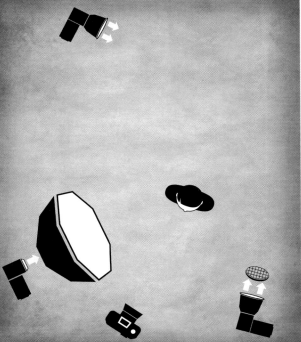

Ascending

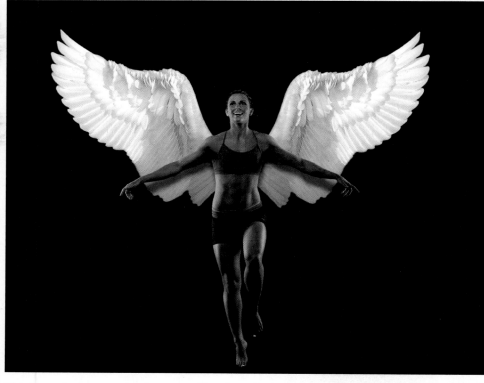

The final image was merged with the wings in Photoshop. I also changed the color of her outfit to make it more "powerful" feeling.

This image is about personal progress. Kacy is a winning, competitive body-builder. A year ago she barely worked out. I remember her telling me that she was going to start some kind of new workout program, but I had no idea she was this serious! It's amazing what you can do when you put your mind to it. Kacy is inspiring. I wanted to create an image that exemplified her newfound strength, freedom, and beauty.

I used a classic lighting technique for flattering the muscular form—commonly used for athletes and bodybuilders. My twist was to add the wings from a stock photo, completing the message that she can now go anywhere and do anything. When combining images from different sources, it's important to try to match the lighting style as closely as possible. The wings had fairly crisp, direct light—similar to sunlight.

I used two Photoflex HalfDome strip boxes, one on each side and slightly behind Kacy. These put the long, thin highlights on the sides of her body and help to define the muscles. The farther back you move the lights, the thinner the highlights become. I used a Profoto octagon softbox for the main light on her face, keeping it up high and directly in front to match the lighting on the wings. Lastly, a monolight with a grid spot was placed above and behind Kacy to provide a hair light, helping to separate her from the black background.

Kacy's going to reach the stars, if she keeps shooting for the moon!

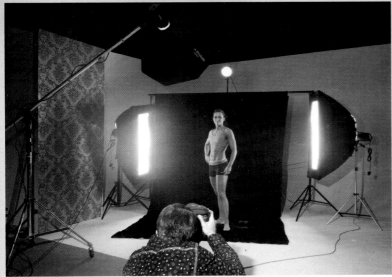

The original image.

The placement of the strip boxes is critical to the look of the highlights along both sides of her body. If they are too far forward, you lose the edge and definition in the muscles.

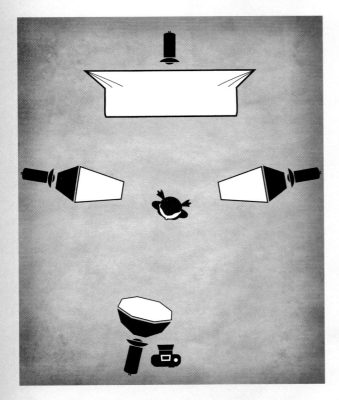

Exposure Info:
80mm lens setting
f/5 at 1/250 sec.
ISO 200
Exposure comp. +/– 0

Tools Used:
Nikon D3s
70–200mm f/2.8 zoom Nikkor Lens
2 Photoflex StarFlash monolightds
2 Photoflex HalfDome strip boxes
AlienBees B800 monolight with 30-degree grid spot
Profoto D1 monolight
Profoto octagon Softbox 3'
Scott Robert wireless trigger system
Profoto wireless trigger system

Babies And Strawberries

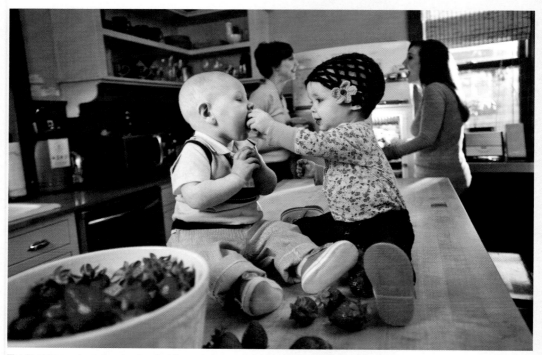

The final image had strawberries, but it needed chocolate! So, I added my Chocolate Pudding Preset in Lightroom to warm up those shadows with a sprinkle of cocoa.

We had several lights to set up for this image, and when we were close to done, I did some test shots—concluding that we needed to tweak the lights a little bit more. One of the moms put the little girl down on the counter for a moment and she immediately power-crawled toward the bowl of strawberries. We were starting now, ready or not! Her excited expressions and interest in those delectable strawberries was genuine, and I had to start shooting. Once we put her little friend on the counter, it was a free-for-all!

The main light was a Wescott Apollo softbox with a speedlight inside. We chose this particular box because it works really well in tight quarters. The light stand was about as far back as it could go, and the Apollo, because of its unique center-mount system, makes good use of the space. A normal speedlight mounted at the back of a softbox would have placed the light at least a foot or more closer, and that was not what I wanted. The light quality from this box is very crisp and even.

A second speedlight was bounced into the ceiling to provide soft fill. I wrapped it with a Rogue FlashBender to keep any direct light from spilling onto my subjects. We placed one more speedlight in the refrigerator to cast a bit of light on the mom as she held the door open talking.

Two AlienBees monolights were placed outside the house, pointing in the windows—just like crisp sunlight streaming in. All of these lights were fired in sync with our PocketWizard wireless system. I had moms sit on each side of the counter, just out of view, in case either babe started to wander off. Fortunately, squishing strawberries in each other's face was way more interesting..

The original image.

It was a fairly tight space to work in, making the Apollo softbox all the more valuable.

Honey, can you grab more milk and a speedlight while you're at the grocery store?

Exposure Info:

26mm lens setting
f/3.2 at 1/200 sec.
ISO 200
Exposure comp. +/− 0

Tools Used:

Nikon D3s
17–35mm f/2.8 zoom Nikkor Lens
2 AlienBees B800 monolights
Paul C. Buff Vagabond II battery pack
Paul C. Buff Vagabond Mini battery pack
Nikon SB900 Speedlight
2 Nikon SB800 Speedlights
Rogue FlashBender
Westcott Apollo Softbox
PocketWizard TT1/TT5 wireless trigger system

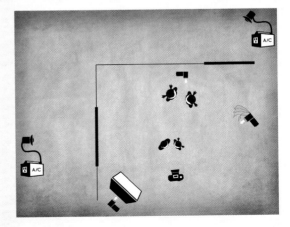

Queen Of The Universe

What would the Queen of The Universe be doing on any given Saturday night? That's the question we asked ourselves, and her, when coming up for an idea for this photo. We had this great location in an underground cave, which I talked about in an earlier shoot, and we wanted to do something with light painting. All of a sudden, it became crystal clear—of course! The Queen of The Universe would be lying on the ground, at the center of her power source, eating grapes whilst her minions made her look beautiful!

The equipment requirements for this image are fairly minimal—two flashlights. However, getting set up and light-painting an image just right took us some time, and trial-and-error. Fortunately, is was a balmy 44°F in the cave so our model had no problem just relaxing, without moving a muscle, while we light-painted in 30-second intervals.

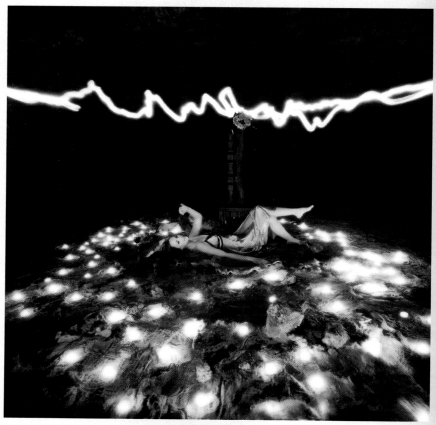

The final image was enhanced in Photoshop with my universe famous Dashboard tool, Lord Of The Rings. It adds a romantic softness without obscuring details or looking hazy.

Light-painting can be done a few ways. Sometimes, the subject is in complete darkness and all light is "painted" on with the flashlights. In our case, we wanted to use the candlelight, so I set a base exposure for the candles, pegging my shutter speed at 30 seconds to give us time to move around in the scene and paint. Then we had to experiment with just how much we could paint with the flashlights for an equal exposure on the Queen. There is no real formula here; it all depends on the power of your flashlight. Try and try again.

I used my flashlight to paint the Queen, while my assistant created the energy bolts in the background. The key for me was to avoid blocking the subject or light with my body while I painted, and to avoid pointing the light toward the camera, creating a hot spot. I found that I only needed to paint the Queen for about half the exposure time to properly illuminate her. The key for my assistant was to keep the light pointing toward the camera, and to move in a consistent and predictable pattern.

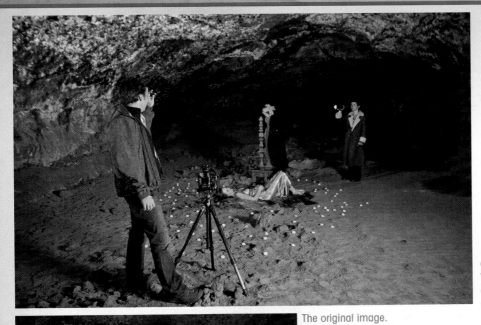

Okay, this just looks weird. We procured the throne and crown from our local theatre group.

The original image.

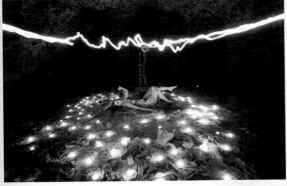

Exposure Info:

17mm lens setting
f/6.3 at 30 sec.
ISO 200
Exposure comp. +/– 0

Tools Used:

Nikon D3s
17–35mm f/2.8 zoom Nikkor Lens
2 flashlights

Hold It Like This

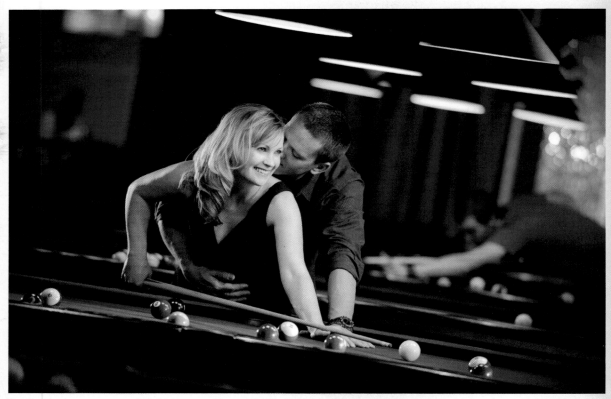

The final image was processed in Lightroom with my Acid Wash and Vitamin K presets. I also darkened the edges a bit.

We did this engagement session at Fox's Billiards in Bend, Oregon. It's a pretty swanky place—for a pool hall. And, what better opportunity to snuggle up to your gal than at a pool table. The owner of the place kindly let us come in early, before they opened for lunch. The existing lighting was challenging. There was a mix of daylight, streaming through oddly colored tinted windows, and overhead lights on the tables. I needed a bit more drama and control, so we set our exposure to minimize the ambient light and added back what we needed with our flash systems.

The main light was an extra small OctoDome powered by a Triton flash system. The light quality from this combo is amazing, and the battery-powered portability gives it legs to go anywhere with you. We added another speedlight,

wrapped with a Rogue FlashBender to form a snoot, to skim light across the pool table, casting long shadows from the balls. They needed a backlight, so we placed another speedlight on a table, hiding behind some crystal curtains for diffusion and shadow patterns.

This was all looking pretty good, but the very back of the room seemed too dark. So, we added another speedlight, covered in a blue gel for contrast, to skim across the dark curtains.

Nothing says you love him like pretending to lose at eight ball.

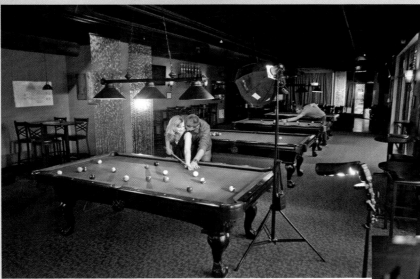

Lowering my ambient exposure allowed me to control the look of the image with the flash systems, using the ambient for slight fill and ambiance.

The original image.

The backlight was aimed through the beads.

Exposure Info:
200mm lens setting
f/3.2 at 1/60 sec.
ISO 640
Exposure comp. +/− 0

OPTIONS
A speedlight could have been used in place of the Triton flash, with slightly reduced power and longer recycle times.

Tools Used:
Nikon D3s
70–200mm f/2.8 zoom Nikkor Lens
Nikon SB900 Speedlight with blue gel
Nikon SB800 Speedlight with Rogue FlashBender
Nikon SB800 Speedlight with Rogue Grid
Photoflex Triton Flash with battery pack
Photoflex OctoDome extra small softbox
PocketWizard TT1/TT5 wireless trigger system
JOBY GorillaPod

Keep Your Eye On The Ball

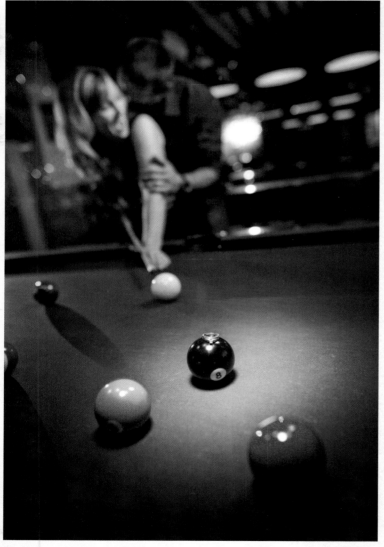

The final image got a slight color boost with my Daily Multi-Vitamin Dashboard tool.

What would you do if you approached the eight ball to take your winning shot, and discovered a diamond ring waiting for you on its crest? Exactly, call a foul! You can't touch the eight ball while a game is in play. He should have known better.

Forgiveness is the key to a happy relationship, however, and she managed to let this one slide. We weren't going to let the lighting slide though, and set up a dramatic scene for them.

We used the extra small OctoDome as the main light on her face, but this time we had another key player—the eight ball. I wanted a dramatic spotlight to fall on it, drawing your eye there right away. A Triton flash, with a 10-degree grid spot and warming gel, formed the pool of light—pun intended.

We again used the backlight through the beads, but needed to move it forward a bit to cast long forward shadows on the balls as well. This made the scene feel more dramatic. A warm gel was added to the speedlight.

I wanted the room behind them to glow with blue, so we positioned two more speedlights, covered with blue gel, to illuminate the walls and ceiling.

I used a 24mm f/1.4 lens to get up close and personal. The large aperture on the wide-angle lens gives beautifully shallow depth of field, which you normally don't see on average wide-angle lenses. I love, love this lens.

Come to think of it, I can't remember whether we ever picked up that ring when we were done shooting. Hmm.

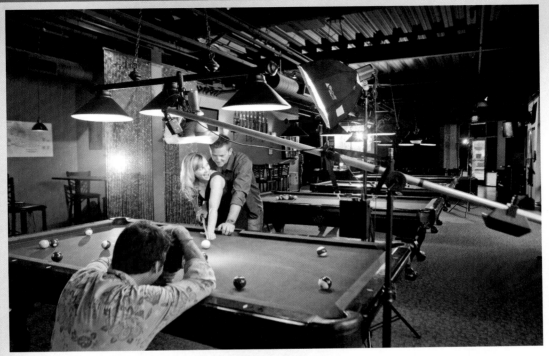

There's a lot going on here! And I'm not just talking about the lighting. Every light has a gel on it, either amber or blue.

Exposure Info:
24mm lens setting
f/2.0 at 1/200 sec.
ISO 100
Exposure comp. +/− 0

Tools Used:
Nikon D3s
24mm f/1.4 Nikkor Lens
Nikon SB900 Speedlight with blue gel
Nikon SB800 Speedlight with tungsten gel
 and Rogue FlashBender as snoot
Nikon SB800 Speedlight with blue gel and
 Rogue Grid
2 Photoflex Triton Flash monolights with
 battery pack and tungsten gel
Photoflex OctoDome extra small softbox
PocketWizard TT1/TT5 and Max wireless
 trigger system
Bogen boom arm

What's In The Bag?

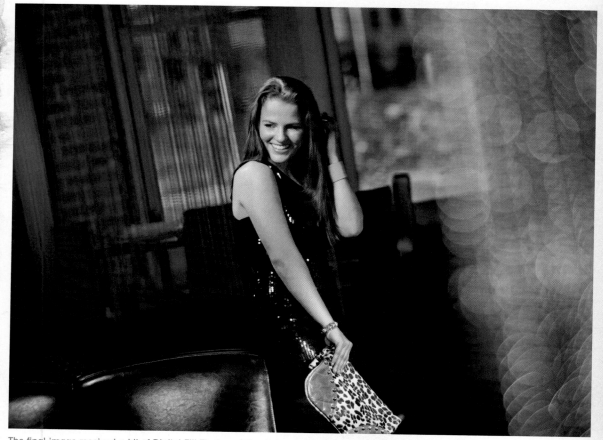

The final image received a bit of Digital Fill Flash and Smokeless Burn in Photoshop, via my Dashboard tools.

This image was part of our shoot for Maya Moon handbags. Our location, the lush and loungy Level 2 in Bend's Old Mill district, was the perfect backdrop. I wanted something evening-ish, or more moody than this location actually was—in the middle of the day. I really loved this angle, shooting through a silver beaded curtain with the stylish chairs and lounge in the background. It was really, really bright outside, however, and we didn't have time (or enough flags) to block up the windows. I decided to use a neutral density filter to lower my ambient exposure as much as I could and fill in the blanks with flash.

The main light was an extra small OctoDome, selected for its soft, yet dramatic light and natural falloff. We had to put two speedlights together in the OctoDome in order to have enough power to overcome the ND filter. Another speedlight was hung from the rafters for a hair light, with a warm gel. A Photoflex Triton monolight was fitted with a 10-degree grid spot and aimed at the handbag.

For the background we added another Triton with a blue gel, and to get the beads in the foreground to glow with beautiful shapes, I placed a speedlight on the bar and aimed it back at the camera.

The original image,

My neutral density filter was dialed down so dark that I could barely see what I was shooting, and the camera had a hard time autofocusing. I opened it up to focus and then closed it down and shot without looking through the camera.

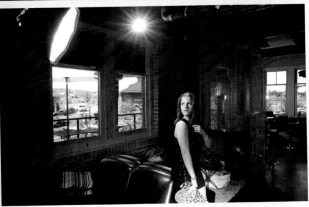

Exposure Info:

175mm lens setting
f/4 at 1/200 sec.
ISO 200
Exposure comp. +/– 0

Tools Used:

Nikon D3s
70–200mm f/2.8 Nikkor Lens
Nikon SB900 Speedlight
Nikon SB800 Speedlight with Rogue Grid
Nikon SB800 Speedlight
Nikon SB700 Speedlight
2 Photoflex Triton monolights with blue & amber gel
Photoflex OctoDome extra small softbox
PocketWizard TT1/TT5 wireless trigger system
Genus variable neutral density filter

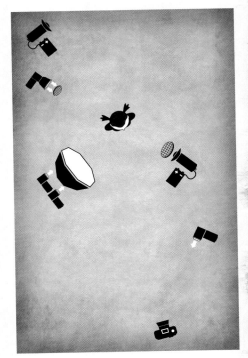

The Lensdaddy

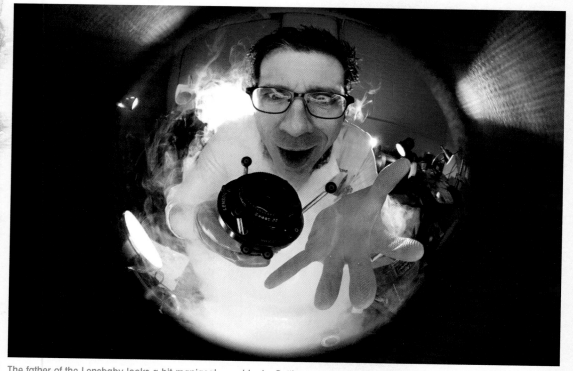

The father of the Lensbaby looks a bit maniacal—and he is. Getting great expressions was easy; getting great smoke was not.

One of my best friends, Craig Strong, invented the Lensbaby—a groovy, twisty lens that allows you to selectively keep a center point of sharp focus while blurring the edges. They are really fun lenses, and I keep one handy in my camera bag at all times. The lens elements are interchangeable, too, with one of the options being the fisheye optic, which I used to shoot this image. Outside the image circle, you actually see the inner barrel of the lens. It's completely unique. I think of Craig as a mad scientist, so that's our theme today.

The main light was our fluorescent ringlight, selected for the amazing light quality when used up very close, which is where I needed to be. It would also give me the cool reflections in the lens and eyeglasses. Behind Craig, we positioned a Profoto globe light to cast a diffused light in all directions, providing general illumination to the room.

To highlight the various tools and work areas in the room, we used speedlights covered with Rogue Flash-Benders or Grids. We also put a speedlight under the bowl of dry ice to make it glow. To increase the drama, and our stress levels, we placed two more speedlights behind Craig's shoulders to create the edge light and flare into the lens. We had a total of six speedlights, one monolight, and the ringlight—all working in cahoots.

To synchronize all of the lights, I used the Profoto trigger in my camera hot shoe, to fire the globe. This provided enough light to trigger the built-in slaves on the speedlights—except for the one under the dry ice, which couldn't "see" enough light to fire. To trigger this, I attached a PocketWizard Max transceiver to the PC port on my camera and the other transceiver to the flash.

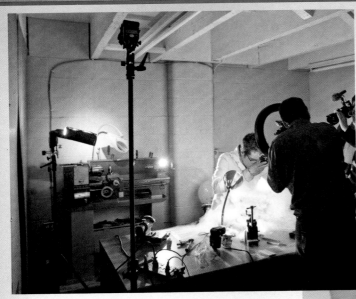

It took a multitude of speedlights to pinpoint the important details of the workshop

The large aperture ringflash gave me sufficient room to move around and compose. The orange bowl was filled with dry ice and warm water.

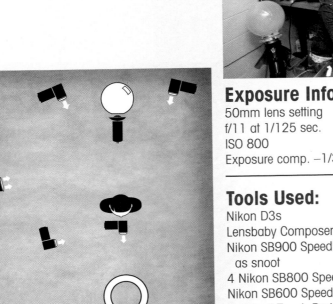

Exposure Info:

50mm lens setting
f/11 at 1/125 sec.
ISO 800
Exposure comp. −1/3

Tools Used:

Nikon D3s
Lensbaby Composer with fisheye optic
Nikon SB900 Speedlight with Rogue FlashBender
 as snoot
4 Nikon SB800 Speedlights with tungsten gels
Nikon SB600 Speedlight with Rogue Grid
Personal Touch Portrait Studios ring light
Profoto D1 monolight with Profoto Pro Globe
Profoto wireless trigger system
PocketWizard MultiMax wireless trigger system

A Bride And Her Man-sion

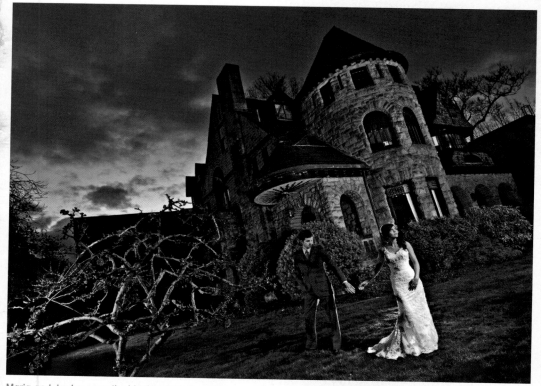

Maria and Jordan were the ideal models; beautiful, easy to work with, and impervious to frostbite. The final image received a visit from my Enter The Dragon Dashboard tool in Photoshop. This gave it the edginess and detail pop.

This is not really her mansion, but it is her man. And this little bungalow makes the perfect backdrop for a dramatic bridal portrait. This was not their wedding day, so we had plenty of time to create something special. I wanted a dramatic sky and surrealistic lighting, with a pose to match. It needed to match the period of the mansion, vintage and elegantly posed—as if suspended in a time capsule.

We scrambled to get our lighting set up as dusk approached. I set my base exposure for a rich sky. A Profoto D1 Air with a beauty dish created the main light, with its crisp, fashion-like light and efficient output. An Alien-Bees monolight, with standard reflector, was aimed at the mansion on the right, and another AlienBees and

a Photoflex StarFlash were aimed at it on the left. A speedlight was aimed at the red flowering tree in the foreground to liven it up too.

Finally, a speedlight was placed behind the couple to create a rim light, helping to visually separate them from the background and add more pizazz. That's funny; I've never used that word in writing before.

We had to work frantically as we were finalizing the setup; the sky was just right and fading fast. Instead of taking the time to setup light stands for a couple of our lights, my helpers just held them. Remember, handheld is more handmade. That's my story, and I'm sticking to it.

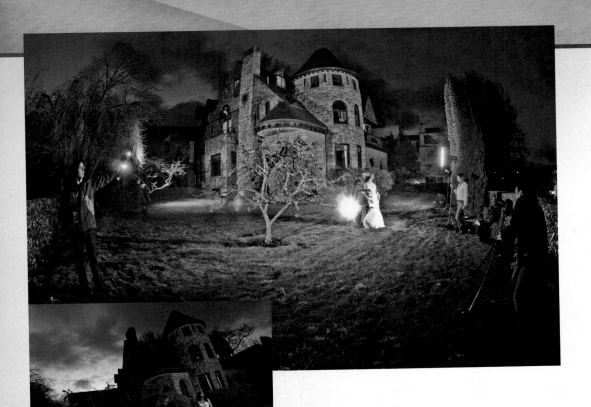

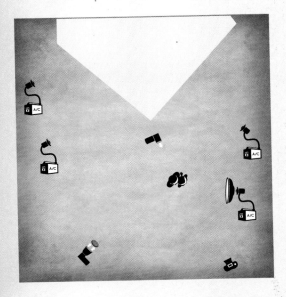

The original image.

Exposure Info:

22mm lens setting
f/11 at 1/8 sec.
ISO 100
Exposure comp. +/– 0

Tools Used:

Nikon D3s
17–35mm f/2.8 zoom Nikkor Lens
Nikon SB900 Speedlight
Nikon SB800 Speedlight
Photoflex StarFlash monolight
2 AlienBees B800 monolights
Profoto D1 monolight
Profoto Soflight beauty dish
Profoto BatPack battery
Paul C. Buff Vagabond II and Mini batteries
Profoto wireless trigger system
PocketWizard TT1/TT5 wireless trigger system

Lyible Rocks

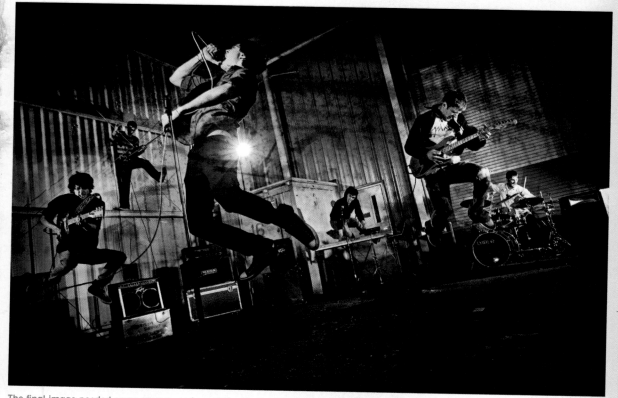

The final image needed some grunge, so I applied a Vintage 78 Lightroom preset and a heavy texture from Bor-Tex in Photoshop.

Lyible is a local rock band with energy to spare. In fact, I think they power their amplifiers from wires plugged directly in to their…well, you get the idea. We created this portrait in an abandoned warehouse space that was open on two sides to the street. There was a decent amount of ambient light, but it was boring. We needed exciting!

A small OctoDome was used for the main light on the lead singer. I wanted something soft-ish, but just large enough to light his upper body when he jumped in the air. I also wanted each band member to have a separate spotlight so speedlights and monolights, modified with snoots and grids, were poised to give each player his own limelight. One of those lights had to be clamped to

a beam, high enough to skim the wall and light the bass player up on a ledge.

A couple of speedlights were set to illuminate the amplifiers and drum set. Finally, the most important light, actually, a speedlight was placed up on the rear ledge to glisten into the lens. The way the light rays partially overlap his body is quite fortuitous. I love the effect.

The image was really about timing—after we had the lights all dialed in and balanced. They backed their gig truck up behind us and cranked up their CD. They cranked up the energy while we cranked up the light.

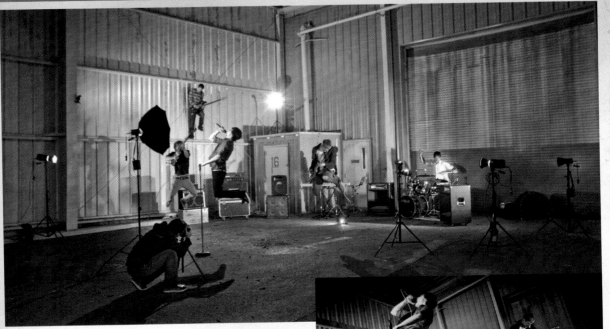

The setup took some time to get dialed in, but once we did, the images came quickly—and loudly.

Exposure Info:

24mm lens setting
f/4.5 at 1/125 sec.
ISO 200
Exposure comp. +/– 0

Tools Used:

Nikon D3s
24mm f/1.4 Nikkor lens
Nikon SB900 Speedlight
3 Nikon SB800 Speedlights
Nikon SB700
Rogue FlashBenders as snoots
Rogue Grid
2 Photoflex StarFlash monolights
2 Photoflex Triton monolights
Photoflex OctoDome small
Paul C. Buff Vagabond II
Paul C. Buff Vagabond Mini
Photoflex FlashFire wireless trigger system

The original image, after Vintage 78 was applied.

Face Your Fears

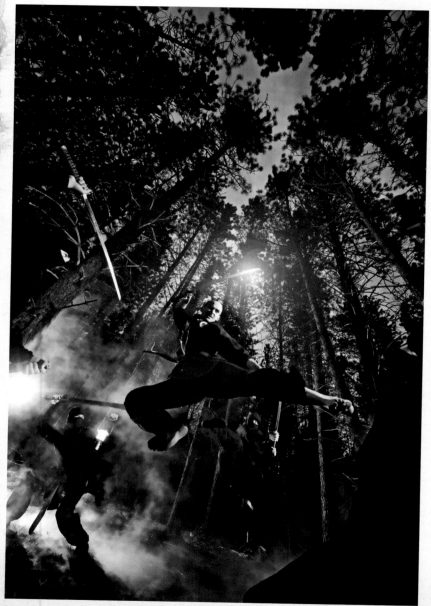

I envisioned an anime-like surreality for this photo—like in a Japanese comic or movie poster. So, since I have an action for everything in Photoshop, I used my Anime Bold Dashboard tool and topped his sword with a kiss of light.

This is the final image, of mine, that I am going to share with you, and it is one of my all-time favorites. It has a lot of significance to me, on several levels. The amazing "ninja" here is my own karate teacher, sensei Brian Sortor, from Sortor Karate in Bend, Oregon. He is a kind and gentle man, with a fierce passion for his art. He inspires many of us, young and old. The other warriors were also from our dojo (school); including his amazing wife, Kristina, holding the lantern. She is nearing her black belt, and holds that school together like Superglue.

The image is about *facing your fears*—attacking them head-on, despite the odds. I've found that some of the biggest barriers to growth in my life simply have been fears that I hesitated to face—and challenge. When I push myself to do so, I win—even if it may temporarily seem that I have lost. I always win when I face my fears.

Creating the image was a miracle in itself. As we were packing up my truck at the studio, getting ready to head out to the forest that night, it began to rain and then pour and thunder. We had rented a professional smoke machine with explicit instructions that it MUST NOT GET WET. My assistants started texting me: "R we still on?!"

Yes, we would persist. I armed everyone with rain jackets and tarps and continued loading.

We pulled off onto the dirt road through the forest and stopped at the site I had scoped out earlier that day. The trees were tall and ominous, just like I remembered them. The rain came to a stop. We jumped out, smiled at the clearing blue sky, and began to quickly set up—knowing it could start raining again at any moment. We had a small exercise trampoline for sensei Brian to jump on, although he really didn't need it. I set up my main light, a Triton with a grid on a remote boom, high enough so that it would light his face properly when he jumped. Another Triton was placed farther back in the forest to backlight our fog and cast long shadows through the trees. Our ninjas were arriving, in full costume and with a pile of *real* weapons.

A speedlight with a warm gel was taped to the back of a lantern, which the leader of the bad guys would carry, to guide them through the dark forest in search of their prey. A large diffusion panel was set up to add some fill light and to serve as a reflector for the sword blades, rendering them silver instead of dark like the forest. A grid spot was aimed at the ninja closest to my right, and another set up to light the one in the back, doing a flying kick toward our hero.

When all the lights were tested, we cued the fog machine, and the fight began. Sensei Brian and his students were amazing. Can I say frickin' amazing here? They pulled off moves with such precision and enthusiasm that the only real problem was that I didn't want to stop shooting! It was just so much fun to watch.

The fog, however, was not behaving. Instead of the wispy fog creeping through the forest that I imagined, we got puffs—

like from a magic dragon hiding behind a tree. My assistant ran to the truck and got our handy leaf blower and began to disperse the fog. It helped a little. At this point we began to worry that the forest service would see the large puffs of smoke that were now gathering and rising through the trees and send the fire department in to hose us off. We continued to shoot.

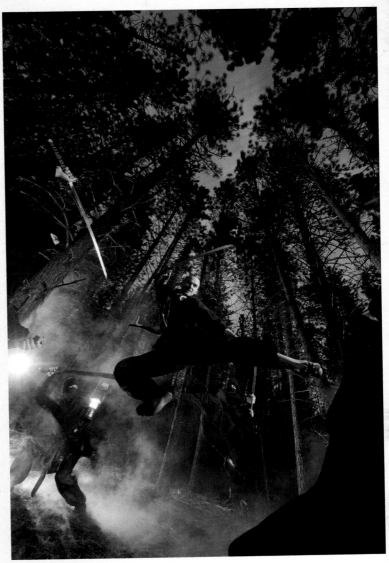

The original image.

The sky became rich with the blue that comes before darkness, the fog started to soften and behave, and my ninjas pulled off their last amazing moves. There were my shots.

A gentle sprinkle from the heavens signaled to us that it was done waiting; it was time to pack up and allow it to finish cleansing the forest. We complied, hurriedly packing up our gear with quiet smiles on our faces, knowing we had been blessed. Everything worked out.

That, my friends, was the last image and the end of my journey with light—for now, anyway. I created this project to challenge myself and to share my experiences, both old and new, with you. I could not have done any of it without the undying support of my great friend, Benja-min, and the tireless hands, and minds, of my interns and assistants. As they say in marriage, this is not the end; it's just the beginning.

Screeech! "Wait!, hold on!" you say. "That was only 97 images and setups. You promised us 101! Foul play, Foul, I cry!"

Okay, I saved the best for last. I challenged my interns to take what they'd learned on the project and concept a shoot of their very own. Benjamin and I would help them make it happen and light it up—if they needed our help. We would be their slaves for the day. So, the last four images and setups are the beautiful and creative projects from my awesome interns. Enjoy!

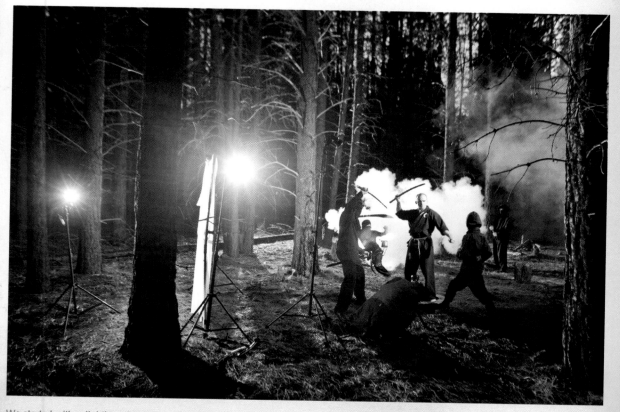

We started with a lighting plan but had to build and improvise as our ninjas took their places.

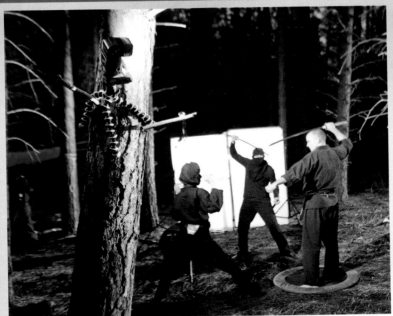

We used a boom to hold the main light up high enough for my flying ninja.

Exposure Info:

14mm lens setting
f/4.0 at 1/125 sec.
ISO 200
Exposure comp. +/– 0

Tools Used:

Nikon D3s
14–24mm f/2.8 zoom Nikkor lens
Nikon SB900 Speedlight
2 Nikon SB800 Speedlights
Nikon SB600 Speedlight in lantern
2 Photoflex Triton monolights, grid spot
2 Photoflex 39 × 72" LitePanel frames with
 diffusion
Rogue Grid for speedlights
PocketWizard TT1/TT5 wireless trigger
 system
Bogen remote boom
JOBY GorillaPod
Fog machine

Releasing From The Thoughts That Tie Her Down

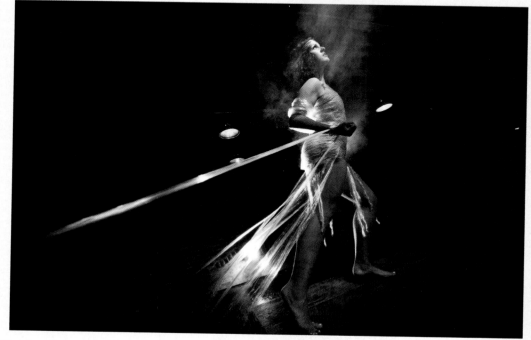

Cindy Girroir was a past wedding client of mine, turned photographer. She is amazingly positive, friendly, and warm. She's also a talented photographer! Here's what she had to say about her image titled "Releasing From The Thoughts That Tie Her Down."

"With this particular photo, I chose to work with plastic textiles. Plastics symbolize things that we create in life, of which we have a tough time ridding ourselves. They end up binding us more than metals. This happens because we are forced to acknowledge harder, more apparent substances. Plastic ideologies appear translucent as they insidiously accumulate in our lives and inhibit future growth. Our perceptions become our reality. They become our ultimate hang-ups until we find ways to dispose of them.

I wanted to emphasize the textures and bubbles of air in the plastics so the viewer would be forced to acknowledge them. I hope this prompts people to confront their personal inhibitions. I also chose to bathe the model in a passage of light to represent hope; to signify the opportunities that await when she frees herself. The model needed to be strong and capable of mind, body, and spirit so that she would *fight* to "get there." She cannot give in to the constant strain of plastic boundaries. Ideally, I would like my image to help people participate in the struggle; to identify and reinvent negative perceptions. The photograph stages the painful human process of growth. It features the intense moment of self-awareness, detachment from a toxic dependency, transition toward resilience, and willful transformation that will result in freedom. Most importantly, it reminds each one of us that the things holding us back are in *our* own minds."

We photographed in a cool loft above Stuart's Jewelry, in Bend, Oregon. At night it turned in to a mini nightclub!

Exposure Info:

14mm lens setting
f/3.2 at 1/250 sec.
ISO 1600
Exposure comp. +/− 0

Tools Used:

Nikon D700
14–24mm f/2.8 zoom Nikkor lens
Nikon SB900 Speedlight with Rogue Grid
Nikon SB900 Speedlight with Rogue
 FlashBender as snoot
PocketWizard TT1/TT5 wireless trigger
 system
Mini fog machine

The Aviator

Marina Koslow is a local photographer with a quiet nature that belies her amazing ability to get things done. She was invaluable in helping to gather props, models, and just about anything else. She is talented and a pleasure to have on our team. Here's what she shared about her image.

"I have always been inspired by the story of Amelia Earhart and really enjoy watching movies about it, so for my concept I decided to drive out to a local airport and do a shoot with an aviator theme. My beautiful model Kelly has gorgeous eyes and pretty long hair, I outfitted her with a pair of goggles, an aviator cap, a cute jacket, and a vintage suitcase. A sweet airplane in the background completed the picture. My idea was to have it look like the girl just landed somewhere new and was very excited about adventures ahead. I also wanted to have some movement in her hair and scarf and having her skip as she walked produced the desired effect. She looks free, happy, and excited—exactly what I was looking to get in this photo."

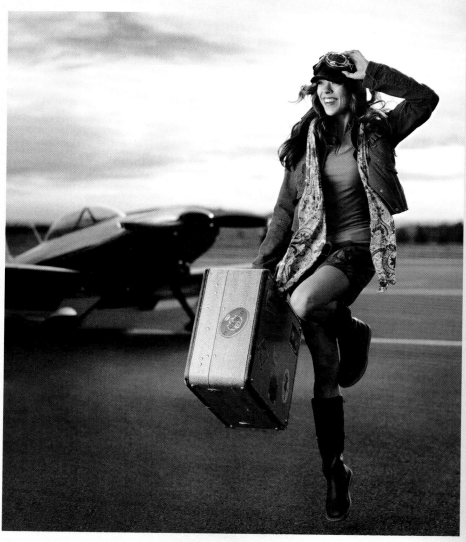

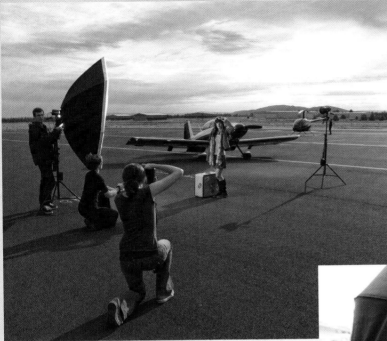

The Octabank is an amazing light source! It's giant size allows for soft, even lighting—even from a considerable distance.

We held two additional speedlights inside the Octabank for extra output.

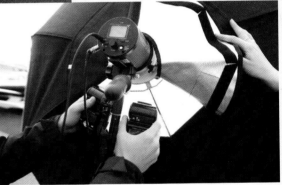

Exposure Info:
50mm lens setting
f/2 at 1/250 sec.
ISO 200
Exposure comp. +/– 0

Tools Used:
Nikon D7000
50mm f/1.4 Nikkor lens
2 Nikon SB800 Speedlights
2 Photoflex Triton Flash monolights with
 battery packs
Westcott 7′ Octabank Softbox
PocketWizard TT1/TT5 wireless trigger system

Once In A Lifetime

Alycia was the first to respond to my intern position notice and quickly earned herself a position on my permanent team. She is creative, hard working, and has a heart of gold. This is what she shared about her image:

How do you name an image? How do you begin to find the words to describe such a specific thought, emotion, or feeling? I believe it is a difficult task to try to formulate into mere words the emotion one invests into a photograph. A very difficult task...

Kevin gave each of us interns the opportunity to concept our very own shoots for the book saying that he would help us with whatever ideas we wanted to capture. "WHAT!" I thought. What does one do with this opportunity? Do you plan something flashy and impressive? Do you say, "Oh, golly, thanks for the opportunity, but I think I'll pass at risk of royally embarrassing myself in front of Kevin Kubota and the entire photography community." Um...no....you don't. So I thought long and hard about what kind of image I wanted to put before the world as a representation of who I am and I discovered that I didn't need to try to impress anyone. I didn't need to concept some kind of flashy image that, simply, is just not me. I knew I needed to be myself—a clean and simple photographer. I like romance, I like beauty, I like open space, and I like mood.

So I took all of those personality traits and tried my best to capture them in my image. Kevin was kind enough to let me borrow his '65 Mustang

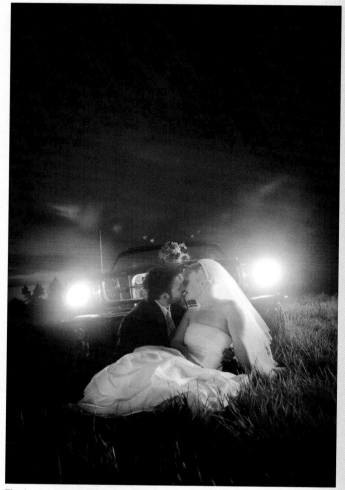

The image was created using car headlights, a reflector, and love. She used my 65 Mustang Lightroom preset.

convertible for the shoot, and I knew an open field with luscious green grass would be perfect for what I had in my mind. The shoot came together marvelously with beautiful weather and a very-much-in-love bride and groom! I can't even express to you how much I enjoyed this evening with Kevin and the crew. I learned so much and after I saw the final images, I knew that the decision to "be myself" in the process of this opportunity was definitely the right one.

So, how why did I chose the name "Once in a Lifetime" as the title of my image? I chose this title not for what might make sense to most people when they look at the photograph but for what it means to me and, for me, this opportunity was truly once in a lifetime.

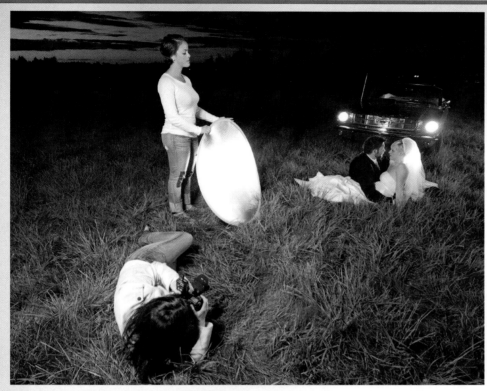

Alycia waited for the perfect moment to blend a dramatic sky with the glow of the car headlights. The reflector kicked the headlights back to the couple. Simple and beautiful!

Exposure Info:
28mm lens setting
f/4.5 at 1/60 sec.
ISO 2000
Exposure comp. −1

Tools Used:
Nikon D700
28mm f/1.8 Nikkor Lens
Car headlights
Calumet 42″ silver disk reflector

Energy Fighters

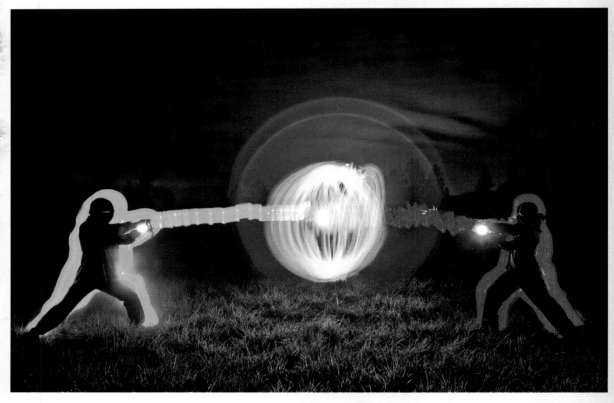

Derek is our creative young mind. He loves to shoot photos for live bands, and also had great ideas to contribute to our photo sessions. He can also eat a ton. Here's what Derek shared about his concept photo, which was light-painted.

"For this image I wanted to try something different and fun. When I was younger I always enjoyed waking up early Saturday morning, watch my favorite cartoons, and imagine what it would be like to be a superhero. Today my dreams have changed, but it's never too late to have a happy childhood. Light-painting is one of those

great techniques where you can get that Photoshopped look right off your camera and for almost no money. Although this shot was a five-strobe setup, the most important light came from two $6 glow sticks that were key in creating the 'energy' around and coming out of the fighters. To create the 'atom ball' look I spun the glow sticks around while walking in a circle. It helps if you pick a spot on the ground and have the glow stick pass over the same spot as you walk. On your own, try mixing different colors and spinning patterns; with light-painting the possibilities are endless."

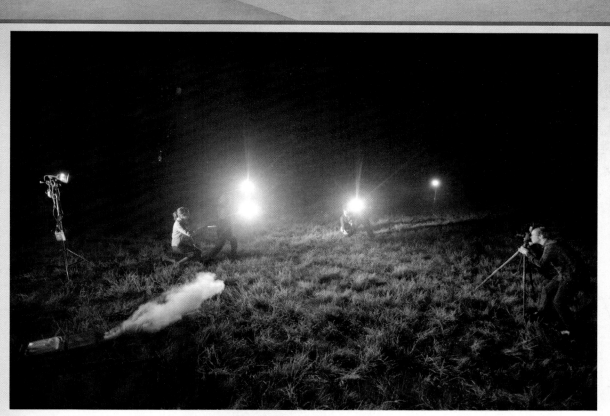

Derek opened the shutter and then ran in to the center with glow sticks to paint the energy ball. Two other assistants painted the two fighters.

Exposure Info:
24mm lens setting
f/3.5 at 61 sec.
ISO 250
Exposure comp. +/− 0

Tools Used:
Nikon D700
24 mm f/1.4 Nikkor lens
Nikon SB900 Speedlight
Nikon SB800 Speedlight
2 Photoflex Triton Flash monolights
AlienBees B800
Paul C. Buff Vagabond Mini battery pack
PocketWizard TT1/TT5 wireless trigger system
Colored glow sticks

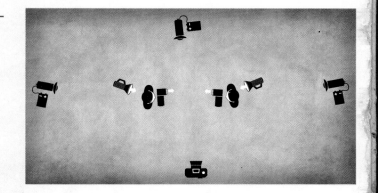

Appendix

A FEW SELECT LIGHTING BOOKS

This is my short list of recommended books. Many, many are out there, but these offer great detail, have relevant information, and are fun to read.

Painting with Light, by John Alton. Originally published in 1949, this book covers some essential classic lighting styles and techniques. It's fun to read. Yah, it's a classic!

Speedliter's Handbook: Learning to Craft Light with Canon Speedlites, by Syl Arena. Although it has specifics for Canon Speedlites, the overall lighting information is very good and applicable to all "speedlighters."

The Complete Guide to Light & Lighting in Digital Photography, by Michael Freeman. Michael has several good books on a broad range of photography subjects.

Lighting Tools

A hot-linked, and frequently updated wiki of the latest in lighting tools and manufacturers is available on The Lighting Notebook website: www.TheLightingNotebook.com/tools_wiki. Be sure to check it out!

The following is a very partial list of lighting tools and accessories. It will cover the basic needs of most photographers. Some of the products are listed to give you options to products we use. Items that we've used or were featured in this book and are recommended are marked with an asterisk (*). Highly recommended items are marked with two asterisks (**).

Monolights—A/C Powered

** Profoto D1 500ws Monolight
 * Alien Bees B800 (320ws)
 * Photoflex StarFlash 300
 * Wescott Photo Basics monolight
 Photogenic
 Bowens Gemini
 Norman
 Calumet Travelite
 Broncolor
 Elinchrom
 Speedotron

Monolights—Battery Powered
(Most Also Run Off A/C)

** Photoflex Triton
** Impact LiteTrek (Sold through B&H)

Norman Allure DP320
Interfit Stellar Xtreme
Photogenic StudioMax III
Quantum QFlash
Dynalite Uni

Speedlights

** Nikon
 Canon
 Metz
 Photoflex Starfire
 Scott Robert LA Strobie 130

Ring Flash Systems—Speedlight

** Ray flash
 Orbis Ring Flash Adapter
 Coco Ring Flash Adapter
 Photojojo Ring Flash Adapter

Ring Flash Systems—Stand-Alone or Monolight

* Personal Touch Portrait Studio Ring Flash (Flourescent)
* Paul C. Buff ABR800
 Profoto Acute 2-Ring Flash (Requires Power Pack)

Wireless Trigger Systems—Basic

* Photoflex FlashFire
* Scott Robert Wireless Sync System
* Tamrac Microsync Digital

Wireless Trigger Systems—Advanced

** Pocket Wizard PWM-TR MultiMax Transeiver
** Pocket Wizard N90M3-P Nikon (camera trigger)
** Pocket Wizard AC3 ZoneController
** Pocket Wizard Mini TT1
** Pocket Wizard Flex TT5
** Profoto Air Sync and Trigger
 * Radio Popper PX Receiver/Transmitter
 * Radio Popper JrX Receiver/Transmitter

Modifiers—Softboxes

** Photoflex XS OctoDome nxt Kit–1.5'
** Photoflex OctoDome: Small 3'
** Photoflex HalfDome NXT: Medium
 * Photoflex LiteDome softboxes
** Profoto 1' × 6' Striplight Softbox
** Profoto Softbox 3' Octagon Softbox
 * ProFoto ProGlobe
 Photogenic 36" × 36" Square Softbox
** Lastolight Ezybox
** Lastolite HiLite (primarily a high-key background, but also works as a large softbox)
 * Westcott Apollo Softbox 28"
** Westcott 7' Octobank
 * Creative Light Softboxes
 Westocott 12" × 36" Stripbank

Modifiers—On-flash Reflectors:

 * Paul C. Buff Beauty Dish for AlienBees
 * Profoto Softlight Reflector 65D (Beauty Dish)
 Norman 22" Soft Reflector (Beauty Dish)

Modifiers—Stand-Alone Reflectors, Diffusers, and Umbrellas

** Photoflex aluminum LitePanels: 39 × 72" and 77 × 77"
** Photoflex LiteDisc Folding Disc Reflectors
 * Calumet Light Panels: 42 × 78"
 * California Sunbounce Reflectors

* Westcott 6' Parabolic Umbrella (white, silver)
* Lastolite TriGrip Folding Triangular Reflectors and Diffusers
 Photoflex Umbrellas
 Wescott Umbrellas
 Paul C. Buff Parabolic and Standard Umbrella
 Calumet Folding Disc Reflectors
 Creative Light Folding Disc Reflectors
 Interfit

Speedlight On-Light Modifiers

** Rogue Grid 3-in-1
** Rogue 3 Piece FlashBender Kit
** Speedlight Pro Kit Beauty Dish
 * Lumodi Beauty Dish Model 14
 * Lumiquest (several speedlight modifiers available)
 * Harbor Digital Design
 * Gary Fong
 Kacey Beauty Reflector from Kacey Enterprises
 Interfit
 Impact Beauty Dish (sold through B&H)

Portable A/C Batteries

** Paul C. Buff Vagabond Mini Portable A/C Battery Pack
 * Profoto BatPac Portable A/C Battery Pack
 Innovatronix

Color Filter Gels

 * ExpoImaging Rogue Gels (speedlight specific)
** Sticky Filters (speedlight specific)
 LumiQwest FXtra (speedlight specific)
 Smith Victor 12" × 12" Gels
 Opteka SB-110 (speedlight specific)
 Rosco Color Effects Kit

Accessories

** Lastolite TriFlash Sync Adapter
** Singh Ray Vari ND Neutral Density Filter
 * Genus Variable Neutral Density Filter
 * Innovatronix A/C Adapter for Speedlights
** Manfrotto Super Clamp
** Manfrotto Magic Arm
 * Photoflex LiteDisc holder

Booms and Extensions

** Lastolite Ezybox Boom Arm 65–150cm
 * Photoflex Lightreach
** Manfrotto Super Boom

Interfit INT308 C-Stand with Boom Arm (on stand)
Westcott 6.5' Boom Arm with Counterweight (on stand)

Where to Buy Photographic Lighting Equipment

A hot-linked and frequently updated list of the latest in lighting tools and manufacturers is available on The Lighting Notebook website: www.TheLightingNotebook.com/tools_wiki

B&H Photo

One of the largest resources for photography and video equipment in the world. An efficient and easy-to-use website makes finding the products you need—and ordering them—painless. The fastest shipping and best prices I've found anywhere. Great customer service. www.bhphotovideo.com

Buy local! If you have a retailer in your area, pay them a visit and support them whenever you can. Occasionally, they can match or come close to online pricing, if you ask. It's OK to pay a bit more for personalized service and support.

Websites for Manufacturers of Lighting Tools

www.alienbees.com (a division of Paul C. Buff. Monolights and modifiers)

www.calumetphoto.com (photographic equipment)

www.expoimaging.com (RayFlash, RogueGrid, Rogue FlashBender, ExpoDisc for WB)

www.fjwestcott.com (lighting tools and modifiers)

www.harbordigitaldesign.com (speedlight modifiers)

www.hoodmanusa.com (pro level media cards, camera hoods, and accessories)

www.innovatronix.com (portable battery packs for monolights and A/C adapters for speedlights)

www.jtlcorp.com (photographic equipment)

www.lastolite.com (wide range of lighting tools and modifiers)

www.lumiquest.com (speedlight modifiers)

www.lumodi.com (beauty dish for speedlight)

www.manfrotto.us (wide range of photo equipment)

www.nikon.com (cameras, lenses, flash equipment)

www.paulcbuff.com (monolights and modifiers)

www.photoflex.com (wide range of monolights, video lights, and modifiers)

www.photojojo.com (wide variety of photo gadgets)

www.pocketwizard.com (wireless sync systems)

www.profoto.com/us (lighting tools)

www.products.bronimaging.com/CaliforniaSunbounce

www.promarkbrands.com (Photogenic, Norman, Cool-lux)

www.ptps.com (Personal Touch Portrait Studios...large ring light)

www.radiopopper.com (wireless sync systems)

www.scottrobertla.com (affordable basic wireless trigger system)

www.speedlightprokit.co.uk (speedlight beauty dish)

www.stickyfilters.com (reusable colored gels for speedlights)

www.tamrac.com (camera cases and carrying accessories)

Index

P

Your Notes